THE
NORTH
AMERICAN
INDIANS
IN EARLY PHOTOGRAPHS

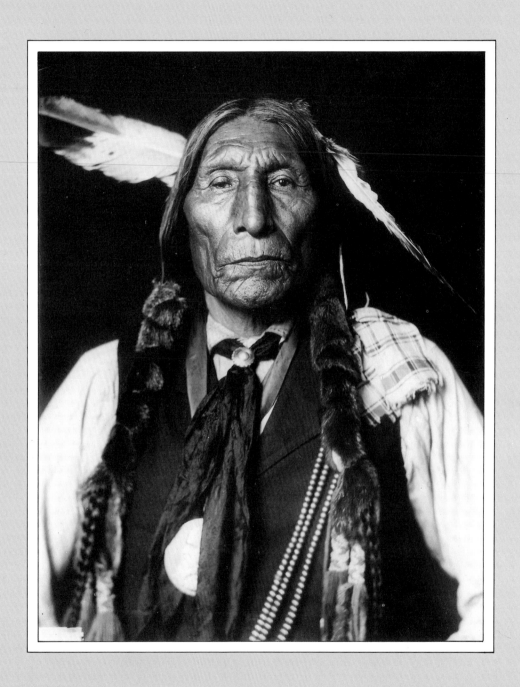

*Wolf Robe, a Southern Cheyenne. By De Lancey Gill,
June 1909.*

THE
NORTH
AMERICAN
INDIANS
IN EARLY PHOTOGRAPHS

PAULA RICHARDSON FLEMING

AND JUDITH LUSKEY

1817

HARPER & ROW, PUBLISHERS, New York
Cambridge, Philadelphia, San Francisco, London
Mexico City, São Paulo, Singapore, Sydney

Dedicated to our families:
Sara, Norton and Marion Richardson
and
Agnes and Irving Luskey

This edition first published 1986 by Harper and Row,
Publishers

Library of Congress Cataloging in Publication Data
Fleming, Paula Richardson.
The North American Indians in early photographs.
Includes index.
1. Indians of North American – Pictorial Works.
I. Luskey, Judith. II. Title.
E77.5.F54 1986 970.004'97 86–45097

ISBN 0–06–015549–3

This book was designed and produced by
John Calmann and King Ltd, London
Designer: Peter Bridgewater

Typeset by Butler and Tanner Ltd, England
Printed in Singapore by Toppan Ltd

CONTENTS

ACKNOWLEDGMENTS

THIS book would not have been possible without the help of many people. Dr John C. Ewers, Ethnologist Emeritus, Smithsonian Institution, read drafts, offered valuable critical comments, and provided intellectual stimulation. We are greatly in his debt for his willingness to share his time and support our efforts. As mentors, Dr Waldo Wedel, Archeologist Emeritus, and Mildred Mott Wedel, Research Associate, both of the Smithsonian Institution, gave us unending encouragement and set the standards for our work. Francis D. Lethbridge, FAIA, Architectural Historian, Dr John Greenway, University of Colorado at Boulder, and Dr Bruce Wardlaw, Smithsonian Institution, provided incentive and taught the value of rigorous research. A special note of thanks must be given to Margaret Blaker, who provided the original opportunity to work on this valuable material.

Approval was received from the Smithsonian Institution to allow the authors to produce and publish this work. A special note of thanks is offered to Dr Adrienne Kaeppler, Chairman, Department of Anthropology; Dr Herman J. Viola, Director, National Anthropological Archives; Sylvia Williams, Director, and Dr Roy Sieber, Associate Director, National Museum of African Art; and Alan Ullberg, Associate General Counsel.

We received professional support and stimulation from many individuals. Of special note are: John Carter, Curator of Photography, Nebraska State Historical Society; Richard Rudisill, Curator of Photo History, Museum of New Mexico; and Will Stapp, Curator of Photography, National Portrait Gallery, Smithsonian Institution.

Additional contributions were provided by Siamak Bayat, graphic designer; Margaret Blackman, State University of New York at Brockport; Elizabeth Edwards, Librarian, Pitt-Rivers Museum, Oxford University; Nan Fawthrop; Dan Fitzgerald, Kansas State Historical Society; Jonathan King, Assistant Keeper, Ethnography Department, British Museum; Constance Stuart Larrabee, photographer; Lonna Malmsheimer, Director, American Studies Program, Dickinson College; Cesare Marino, Handbook of North American Indians, Smithsonian Institution; Joan Mark, Peabody Museum, Harvard University; Miles Max Miller; Lynn Mitchell; Peter Palmquist; William Reese; Carol Roark, Assistant Curator of Photographs, and Martha Sandweiss, Curator of Photographs, Amon Carter Museum; and Charles Stein, photographer.

In September 1985, Princeton University held a conference on photography and the North American Indian. This conference brought together many scholars, both Indian and non-Indian, and provided many new avenues of viewing this topic. As the conference came at a critical point in the writing of this work, special thanks are extended to the organizers, Lee Mitchell, Director of American Studies Program, and Alfred Bush, Curator, Princeton Collections of Western Americana.

Special support was provided by relatives of photographers and other personalities involved with Indian photography. Of note were the contributions made by Jack Scott, grandson of James Mooney, who provided information and comments on the chapter relating to anthropology. Additional information was obtained from Mrs Carl G. Meyer, great-granddaughter of Governor Faulk; E. Marshall Pywell, a relative of photographer William Pywell; and Ann Shumard, great-niece of photographer Sumner Matteson.

This book was conceived by Laurence King, of John Calmann & King Ltd. Without his foresight, this research would not have been published. Sue Wagstaff was instrumental in the early formation of the work, and we thank her for this. Paula Iley, Senior Editor, provided us with expert editorial advice and guidance, and with Pauline Batchelor displayed a wonderful sense of patience throughout the final production. Our thanks are also due to Jonathan King.

The majority of the illustrations were provided by the Smithsonian Institution Office of Printing and Photographic Services. Individuals who provided special services were Hannelore Aceto, Roberta Diemer, Joyce Goulait, Alan Hart, Mary Ellen McCaffrey, and Louie Thomas.

Our thanks are also extended to the staff of the National Archives and Record Administration, as well as the other repositories that provided illustrations.

Finally, a special word of thanks must be said to all the friends and families who provided support and patience during the writing of this book, especially Edward Donnen, Maureen Downey, the Snarbis family, Judi Runner and the C. Duck family, Allen and Maryellen Rossmiller, and Dianne Walker.

FOREWORD

Since the discovery of the New World nearly five centuries ago, pictures have been helping people of other lands and cultures to visualize the appearance and life-styles of some of the world's most picturesque inhabitants – the North American Indians.

For the first three-and-a-half centuries – until the appearance of photography – those other people depended upon the creations of graphic artists to help them comprehend how Indians looked and lived. And artists' pictures of Indians varied greatly. Some were highly imaginative works based upon little or no first-hand knowledge of Indians. Some others possessed a kind of spurious realism because their creators looked upon Indians as New World peoples who epitomized the classic ideals of beauty to be found in Greek and Roman sculpture – men and women with sharply defined facial features, and beautifully rounded bodies only partially concealed by lightly draped robes.

It is important to recognize that photography is a relatively recent development in the five-century-long pictorial record of Indian–White contact in North America. By the time the first photographs of Indians were taken during the mid-1840s, many of the tribes living nearest the constantly expanding frontiers of white settlement had been displaced from their aboriginal homelands, their numbers greatly decreased as a result of warfare and disease, and their life-styles greatly modified by influences from the white man's culture. Long before the first photographs of Indians were taken, the tribes of the Woodlands forsook their skin garments in favor of the cloth ones worn by whites. The buffalo-hunting Indians on the Great Plains had changed from plodding footmen to mobile horsemen through acquisition of Spanish horses. And the Indians of the North Pacific Coast had adopted white men's sharp metal tools for carving their imposing totem poles, their awesome ceremonial masks, and their wooden boxes and bowls.

Photography has documented continued changes in Indian life-styles over the last 140 years. During the first half of that span of years – the years before World War II – cameras served most frequently and effectively to record the physical appearance of individual Indians. In this respect photography followed the precedent set by artists.

During the Colonial Period the individual Indian began to emerge as a subject for portraiture when leaders of powerful Indian tribes whose allegiance the English coveted were escorted across the Atlantic to visit London, the seat of English power, to meet the ruling monarch and to be impressed by the strange wonders of English civilization. There professional artists – men trained to observe and to record the subtleties of facial proportions and contours that define the individuality of a sitter – drew or painted likenesses of these prominent Indians. Pocahontas was painted as early as 1616. Many chiefs of the larger tribes of the Eastern Woodlands were portrayed during their visits to London prior to the Revolutionary War.

The English custom of picturing chiefly visitors to the seat of government was adopted by the new United States – at first on a sporadic basis, and later as a matter of government policy. As early as 1790 John Trumbull drew a series of pencil portraits of Creek Indians from the pine woods of Georgia and Alabama who had come to the temporary capital of New York City to meet President George Washington and to sign their first treaty with the United States.

By the early years of the nineteenth century government officials, recognizing that the Indian population was declining and their traditional customs changing rapidly, conceived the idea of establishing a government collection of portraits of prominent leaders of the many tribes who visited Washington. Beginning in 1822, Charles Bird King, who had studied under Benjamin West in London and become a well-known Washington portraitist, was hired to paint many of these Indian visitors. By 1842 he had painted some one hundred Indian leaders from at least twenty tribes from life, and had copied twenty-six other Indian portraits painted in the Indian country by James Otto Lewis.

By the 1850s photography began to replace artistry as a means of recording the likenesses of members of Indian delegations to Washington. The earliest known delegation photographs were taken in 1852, of leaders from Plains Indian tribes who had signed the important Fort Laramie Treaty in the West the previous fall. But it was not until 1867 that the Smithsonian Institution, with the aid of private funds and the cooperation of the Indian Bureau, launched a program for making a photographic record of members of Indian delegations to Washington. These photographs comprise the nucleus of the world's largest collection of Indian photographs now preserved in the Smithsonian's National Anthropological Archives.

During the 1850s the first outdoor photographs of Indians west of the Mississippi River were made — mostly by artists who accompanied exploring parties, who recognized photography as an ally rather than an enemy in compiling a pictorial record of explorations. Unfortunately, few of these pioneer photographs have been preserved, compared with the large number taken on later scientific expeditions in the West.

The slow-shuttered cameras in use at the time could not have pictured the dramatic actions in the Indian Wars of the second half of the nineteenth century when numerous encounters, large and small, took place between the US Army and hostile Indians of the Great Plains, the Southwest, and the short-lived Modoc War farther west. Even so, photographs did record the likenesses of nearly all the leaders of the combatants on both sides, as well as forts and battlefield sites, and a few gruesome close-ups of battle victims.

Many non-professional photographers used cameras during the last quarter of the nineteenth and early years of the twentieth century to picture the rapid changes that took place in Indian life after the Indians were housed on reservations. Among them were traders, missionaries, and Indian agents intent upon showing the progress that was being made in Indian acculturation, including settlement upon allotments in permanent homes, the establishment of church and school, and accomplishments in agriculture and ranching by descendants of Indians who had been only hunters and collectors of wild foods.

At the same time some photographers traveled long distances to picture surviving aspects of the Indians' old ways of life before they disappeared — such as the Snake Dance of the Hopi, the masked ceremonies of all the Pueblo Indians and the tribes of the Northwest Coast, and the Sun Dance among the Plains Indians.

By the early years of this century some photographers, bent upon recreating a romantic image of Indians of the past for sale to tourists, placed colorfully costumed Indian men and women in carefully selected natural settings of limpid lakes or rugged, snow-capped mountains. They seem to have brought the pictorial record of the North American Indians full circle — back to the imaginative attempts of some sixteenth-century white artists to picture the innocent Indian inhabitants of a New World Eden.

This book tells the story of ways in which photography was used to picture North American Indians prior to the first World War. A unique additional feature is the list of over two hundred individual photographers and photographic studios known to have played active roles in photographing Indians in their studios and/or in the field during this period. On pages 230–45 these photographers are named, their places of business located, their photographic activities dated, and the cultures represented by the Indians they pictured are indicated. If a photographer or studio has been the subject of a previously published study, that source is cited also. Surely this list will provide a helpful reference to collectors of photographs of Indians in identifying pictures and in properly crediting those who made them. These were the photographers who took the great majority of the finest-quality and most important images of North American Indians during the first seven decades after photography was introduced into North America.

JOHN C. EWERS, ETHNOLOGIST EMERITUS, SMITHSONIAN INSTITUTION

TIMELINE OF AMERICAN – INDIAN RELATIONS

1803, April 30. Louisiana Purchase. 828,000 square miles of the center of the North American Continent are purchased from France by the United States.

1812–14. War of 1812, arising from the effects of British blockades and the press gang. It is ended by the Treaty of Ghent on December 24, 1814, with a return to the status quo. This is the last British involvement with a major Indian attempt to defeat the United States.

1813, October 5. Battle of the Thames, near Chatham, Ontario, in which the British and Indian forces under the Shawnee leader Tecumseh are defeated and Tecumseh killed. Tecumseh had formed an important confederacy against the United States; his death marks the end of Indian resistance to US settlement in the mid-west.

1817–18. First Seminole War, started by a US attack on the Seminole.

1819, February 22. Treaty with Spain: Florida is ceded to the US.

1822–42. Removal of the Five Civilized Tribes (Cherokee, Chickasaw, Choctaw, Creek and Seminole) from the Southeast to Indian Territory. The Cherokee are herded into camps and moved west by soldiers during the winter of 1838–39, calling their march the 'Trail of Tears'; a quarter of their number perishes en route.

1824, March 11. Thomas L. McKenney is appointed first chief of the Bureau of Indian Affairs. The management of relations with native peoples is the responsibility of the War Department between its creation in 1789 and the founding of the Department of the Interior in 1849.

1832, July. Creation of the post of Commissioner of Indian Affairs to be responsible for the 'direction and management of all Indian affairs'.

1835–42. Second Seminole War. A war fought in repudiation of the treaty signed at Paynes Landing in 1832 which provided for the

removal of the Seminole to Indian Territory. The defeat of the Seminole results in the exodus of most of their number from Florida.

1846–48. War with Mexico. By the Treaty of Guadalupe Hidalgo, February 2, 1848, Mexico cedes New Mexico and California to the US for $15,000,000, and gives up claims to Texas.

1846, June 15. Oregon Treaty. Settlement of the boundary dispute between the US and the UK. Under a treaty of 1818, renewed in 1827, the area between 42° and 54°40' has been jointly occupied. Now the boundary is set at 49° latitude, between the Great Lakes and Pacific coast.

1848, January 24. Discovery of gold on the estate of John Sutter, near Sacramento, California. This leads to the gold rush of 1849, and the displacement of the native population in that state.

1851. Fort Laramie Treaty. Representatives of the United States meet with the Cheyenne, Arapaho, Crow and Sioux to discuss the building of roads and forts in their territories. No lands are surrendered but despite the swearing of both sides 'to maintain good faith and friendship' the treaty will be broken and valueless within ten years: the wagon trains and forts will be followed by stage-coaches, the telegraph, more forts, the Pony Express, the Pike's Peak gold rush of 1858 and in 1859 the building of Denver. Finally, ten years after the signing of the treaty, in 1861, Colorado will be organized as a territory.

1853, December 30. Gadsden Purchase. Treaty with Mexico signed by James Gadsden, providing for the purchase of a tract south of the Gila River in the Southwest to enable the construction of a railway to California.

1860, April 3. First Pony Express mail leaves St Joseph, Missouri and delivers letters in Sacramento, California on April 13.

1861–65. United States Civil War. The conflict intensifies relations with the Indians, particularly in areas which have suffered

Confederate incursions and in Indian Territory amongst slave-owning Indians.

1861, February. Attempt by Lieutenant George N. Bascome to take Cochise, the Chiricahua Apache leader, hostage at Apache Pass leads to general guerilla warfare between the Apache and the US in the Southwest. This is led initially by Mangas Colorado, the Mimbreño Apache leader, but continues after Mangas' death in 1863 and Cochise's surrender in 1872 until the mid-1870s.

1862. Santee Sioux revolt led by Little Crow. The Santee had yielded most of their land in return for annuities, which were not paid on time; white traders tricked them out of much of their money. Little Crow's revolt is defeated by General Henry H. Sibley; Little Crow is killed the following year while on a raspberry-picking expedition.

1862, May 20. Homestead Act, which provides for the settlement of the West: 160 acres can be allotted to anyone who has created a farm and remained in occupation there for five years (as opposed to 25 years for Indians under the 1887 Dawes Act).

1863–64. Destruction of the Navaho by General James Carleton and Colonel Christopher (Kit) Carson. The destruction of food resources results in the surrender of several thousand Navaho and their enforced march in the spring of 1864 to Fort Sumner and the Bosque Redondo, New Mexico, known as the Navaho 'Long Walk'.

1864, November. Sand Creek massacre, Colorado. A camp of six hundred Cheyenne and Arapaho is attacked by Colonel John M. Chivington with a force of Colorado militia, despite assurances of safety from Major Scott C. Anthony and Major Edward W. Wynkoop. 105 women and children are killed, with 28 men. The effect of the massacre is to destroy the position of chiefs such as Black Kettle who wanted peace with the United States; it also paves the way for a treaty the following year which effectively means the abandonment of

all Cheyenne and Arapaho claims to Colorado Territory.

1864, September 28. Camp Weld Council, near Denver, Colorado. An inconclusive meeting between Governor John Evans and the Cheyenne and Arapaho brought about at the insistence of Major Edward W. Wynkoop. Evans is reluctant to agree to any peace since he has obtained money to raise a Colorado militia to fight the Indians: he has to show Washington that there are Indians to fight. As a result of the meeting the Indians move nearer to Synkoop's fort, but Wynkoop is relieved shortly afterwards for being too friendly towards them.

1867. Fort Laramie Treaty. Red Cloud refuses to sign the Treaty unless the government abandons the military forts on the Powder River (Indian country); it does so.

1867–79. The Four Great Surveys: King, Wheeler, Hayden and Powell.

1868, June 1. Treaty with the Navaho creating the Navaho Reservation, the largest in the United States.

1868, August 13. The 370th US–Indian Treaty, and the last, signed with the Nez Perce.

1868, September. Battle of Beecher's Island, Colorado, between the Cheyenne and the Sioux and a scouting party, led by George A. Forsyth for General Philip Sheridan. This follows on the failure of the US forces at Fort Larned to provide food or ammunition. Roman Nose of the Cheyenne is killed in the battle.

1869, April 10. Establishment of the Board of Commissioners for the administration of Indian affairs by President Grant to effect his peace policy. Grant appoints a Seneca, Ely Parker (Donehogawa), to be the first Indian Commissioner. He is involved especially in negotiations with Sioux leaders, for instance Red Cloud, and is only partially successful in resolving misunderstandings with the Indians. Parker resigns in 1871 after accusations of fraud have been levelled at him.

1869, May 10. Central Pacific and Union Pacific Railroads meet at Promontory Point, Utah, marking the completion of the first transcontinental railway.

1870–90s. Ghost Dance religion, the revitalization movement to unite Indian tribes. A result was the tragedy at Wounded Knee.

1871, April 30. Massacre of 144 Avaraipa Apache near Camp Grant Arizona. Following an agreement between Eskiminzin, head chief of the Avaraipa Apache, and Lieutenant Royal E. Whitman, the Avaraipa settle near Whitman's camp, giving up their firearms. Responding to a raid by another group of Apaches on a US settlement, a group of 140 men led by William S. Oury from Tucson attack the camp and kill most of the Avaraipa women and children.

1873, October 3. Execution of Captain Jack or Kintpuash, leader of the Modocs, in the War of 1872–73 in the lava beds of northern California. Captain Jack had led his men against the United States army in an attempt to avoid moving from California to Oregon, then to avoid surrendering Hooker Jim, a Modoc responsible for the reprisal killing of Americans. At the time of Captain Jack's surrender on June 1 he was the leader of 71 Indians facing 985 US soldiers; the 153 Modocs remaining after Captain Jack's death are sent into exile in Indian Territory.

1876. Centennial Exhibition, Philadelphia, including substantial collections made by Spencer F. Baird for the Smithsonian Institution.

1876, June 25. Battle of the Little Bighorn and the Custer massacre. The Indians summarily defeat the American forces.

1876, September 9. Battle of Slim Buttes. The rout of American Horse's village of Oglalas and Miniconjous followed by the death of American Horse.

1877, September 5. Death of Crazy Horse, last of the Sioux war chiefs. He was pursued by Colonel Nelson Miles and General George Crook before being persuaded to surrender to Crook through the promise of a reservation in the Powder River country; however, later in the year, he became disillusioned and decided to leave the camp. He is captured, taken to Fort Robinson, Nebraska, and killed during a scuffle.

1879. End of the Great Surveys and formation of the Bureau of Ethnology, later the Bureau of American Ethnology (BAE).

1879, November 1. Opening of the first non-reservation residential school at Carlisle, Pennsylvania, with 136 pupils from Rosebud, Pine Ridge and other reservations, through the efforts of General R. H. Pratt.

1886, September 4. Surrender of Geronimo, the Chiricahua Apache leader, marking the end of Indian warfare in the United States.

1887, February 8. Dawes (or General Allotment) Act. This provides for the division of Indian reservations: 160 acres are to go to each family after 25 years of occupation. Between 1887 and 1934 the amount of tribally held lands is reduced from 138,000,000 to 48,000,000 acres.

1890, December 29. Battle of Wounded Knee, South Dakota. Massacre of the Sioux, following their surrender, by Major James W. Forsyth. This brings to an end the disturbances caused by the Ghost Dance religion among western Indians.

1893. Columbian International Exposition. The anthropological exhibits organized by E. W. Putnam include Kwakiutl, Penobscot, Apache, Navaho, Iroquois, and 58 Labrador Inuit, as well as innumerable people from Africa, Malaya, Asia, the Pacific and South America.

1898–1900. Alaskan gold rush. In the first Alaskan census of 1880, 430 people out of the total of 33,426 were white. There is an influx of 30,000 whites in a brief period – the first substantial settlement of the territory.

1898. Trans-Mississippi and International Exposition (Indian Congress) held in Omaha, Nebraska. Photographs of Indians by A. F. Muhr are copyrighted by the official exposition photographer, F. A. Rinehart.

1901. The Pan-American Exposition, Buffalo, NY. Seven hundred Indians from 42 tribes include US prisoners Geronimo and Crazy Snake.

1904. Louisiana Purchase Universal Exhibition, St Louis, Missouri, held to celebrate its 100th anniversary. The anthropological section, organized by W. J. McGee, includes Cocopa, Dakota, Pawnee, Puebloan, Pima and Northwest Coast people as well as representatives of the peoples of the Philippines, Patagonia, Ainux and Africans.

1907, November 16. Oklahoma becomes a state. Set aside as Indian Territory in 1834 to receive the displaced peoples from east of the Mississippi, nevertheless in 1889 it was opened to homestead settlement, and in 1890 organized as a territory. As Indian Territory, Oklahoma was used as a place to send unwanted Indian tribes – from the west as well as the east, from the north as well as the south.

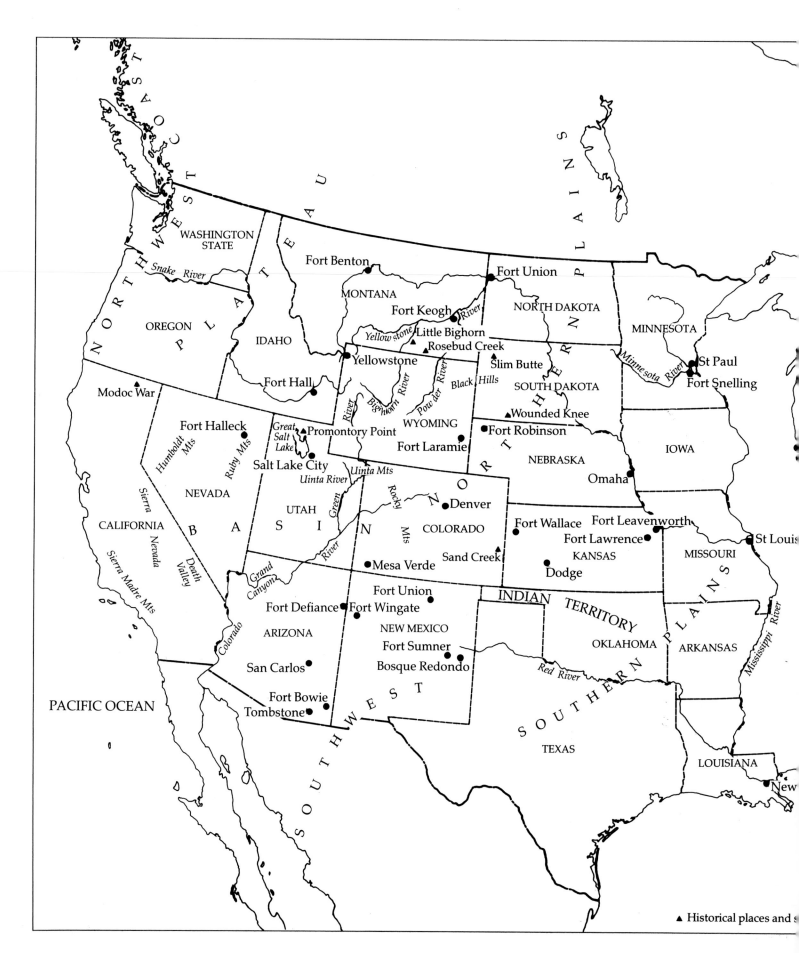

SASO POH TSEWITRON

WASHINGTON
STATE

P
L
A
T
E
A
U

N
O
R
T
H
W
E
S
T

Snake River

OREGON

IDAHO

MONTANA

Fort Benton

Fort Union

NORTH DAKOTA

Fort Keogh

River

Little Bighorn

Rosebud Creek

Yellowstone

Slim Butte

MINNESOTA

Minnesota River

St Paul

Fort Snelling

Yellowstone

Fort Hall

Modoc War

Fort Halleck

Humboldt Mts

Ruby Mts

Great Salt Lake

Promontory Point

Salt Lake City

Uinta Mts

Uinta River

Bighorn River

Powder River

Black Hills

SOUTH DAKOTA

Wounded Knee

WYOMING

Fort Laramie

Fort Robinson

N
O
R
T
H

NEBRASKA

IOWA

N

Omaha

Sierra Nevada

NEVADA

CALIFORNIA

B A S I N

Green River

Rocky Mts

Denver

COLORADO

O

Fort Wallace

Fort Leavenworth

Fort Lawrence

St Louis

UTAH

Sierra Madre Mts

Death Valley

Grand Canyon

Colorado

River

Mesa Verde

Sand Creek

KANSAS

Dodge

MISSOURI

PACIFIC OCEAN

Fort Defiance

Fort Wingate

Fort Union

INDIAN

TERRITORY

ARIZONA

NEW MEXICO

San Carlos

Fort Sumner

Bosque Redondo

OKLAHOMA

ARKANSAS

Mississippi River

Fort Bowie

Tombstone

Red River

S
O
U
T
H
W
E
S
T

TEXAS

S
O
U
T
H
E
R
N
P
L
A
I
N
S

LOUISIANA

New

▲ Historical places and s

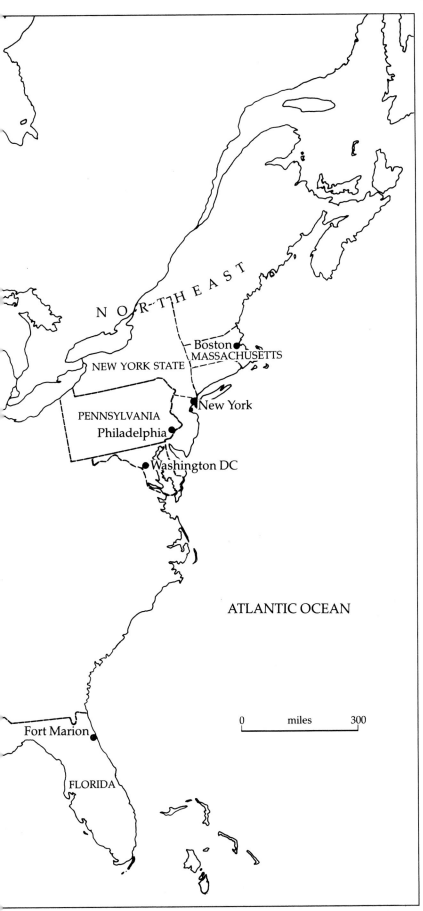

These tribe listings by cultural area follow the National Geographic Society map *The Indians of North America* (1979), except that the Woodlands and Plains have been further subdivided. Although it overlaps with the Southern Plains and the Southeastern cultures, the Indian Territory has also been included as it was an important photographic center. Only those states which have special relevance to the history of photography of the North American Indians are featured on the map, and only those tribes generally found in photographs are listed here. Many, such as the Dakota/Sioux and the Apache, have further subdivisions. Textual references to these divisions are always accompanied by the name of the larger tribal affiliation. For a detailed breakdown of tribes, specialized sources should be consulted.

SOUTHWEST
Acoma
Apache
Cocopa
Havasupai
Hopi
Isleta
Jemez
Maricopa
Mohave
Navaho
Papago
Pima
Quechan (Yuma)
Seri
Taos
Tewa
Yavapai
Zuni

NORTHERN PLAINS
Arikara
Assiniboin
Blackfoot
Crow
Dakota
Gros Ventre
Hidatsa
Iowa
Mandan
Northern Arapaho
Northern Cheyenne
Omaha
Pawnee
Plains Cree
Plains Ojibwa
Ponca

SOUTHERN PLAINS
Caddo
Comanche
Kansa
Kiowa
Kiowa-Apache
Osage
Quapaw
Southern Arapaho
Southern Cheyenne
Tonkawa
Waco
Wichita

NORTHWEST COAST
Bella Bella
Bella Coola
Chinook
Clallam
Comox
Cowichan
Duwamish
Haida
Kalapuya
Kwakiutl
Makah
Nisqually
Nootka
Siletz
Tillamook
Tlingit
Tututni
Twana

CALIFORNIA
Hupa
Karok
Maidu
Pomo
Tolowa
Yurok

PLATEAU
Cayuse
Coeur D'Alene
Flathead
Kalispel
Klamath
Klikitat
Kutenai
Modoc
Nez Perce
Palus
Umatilla
Wallawalla
Yakima

BASIN
Bannock
Chemehuevi
Mono
Paiute
Shoshoni
Ute
Washo

INDIAN TERRITORY
Apache
Arapaho
Caddo
Catawba
Cherokee
Cheyenne
Chickasaw
Choctaw
Comanche
Creek
Iowa
Kansa (Kaw)
Kickapoo
Kiowa
Missouri
Modoc
Oto
Ottawa
Osage
Pawnee
Peoria
Ponca
Potawatomi
Quapaw
Sauk and Fox
Seminole
Seneca
Shawnee
Tonkawa
Wichita
Wyandot

NORTHEAST
Iroquois

MIDWEST WOODLANDS
Kickapoo
Menominee
Ojibwa
Potawatomi
Sauk and Fox
Winnebago

THE BACKGROUND

Sitting bull. Geronimo. Feather bonnets and tipis. Totem poles. War dances. These words instantly conjure up images of North American Indians – images formed for many of us by the tireless efforts of early artists and photographers.

Many of the images reveal the complexity and cultural diversity of the hundreds of North American Indian tribes before the influx of settlers; other images are mere stereotypes, created not only by early still photography but also by movies and television. It is to the early still photographers that we turn our attention.

What value can there be in a stiff studio portrait of a famous Indian chief posed in front of fake rocks and a scenic backdrop? Surely it does not capture a candid moment. It might reveal elements of costume of interest to students. It could even depict a facial expression to inspire reflection upon the whole of Indian history. Each viewer will have a different reaction to and interpretation of an image, whether taken in a studio or in the field. However, it is our belief that even a stiff studio photograph can provide us with a face that makes the sitter come alive. We are lucky to have so many 'living' documents of the North American Indians.

EARLY PHOTOGRAPHIC TECHNIQUES

In 1826, Joseph Niépce, a Frenchman, produced the earliest surviving photograph made by a camera obscura. The camera obscura, used to observe solar eclipses by means of a pinhole, merely produced shadows. Niépce used a process called heliography to produce an image on a polished pewter plate. Eventually he went into partnership with Louis Jacques Mandé Daguerre.

It was Daguerre who perfected the first practical method of producing a permanent image. His images were formed by a compound of mercury acting upon a sensitized silver-coated copper plate. In effect, light tarnished the silver in varying degrees as reflected by the subject. This kind of photograph was called a 'daguerreotype' in honor of its inventor. On January 7, 1839 Daguerre's invention was announced to the French Academy of Sciences. By September the first printed account of the process reached America. People who saw these images for the first time were astonished: in 1839, Lewis Gaylord Clark, editor of *The Knickerbocker*, described daguerreotypes as being 'the most remarkable objects of curiosity and admiration, in the arts, that we ever beheld. Their exquisite perfection almost transcends the bounds of sober belief.'[1]

The science of photography spread rapidly. There were many experiments in new techniques to produce the best possible images in the shortest amount of time. People rushed to have their portraits made by this new and fascinating invention. In time, the American public also became interested in photographs of scenes that they could not directly experience. Views from foreign countries were in demand, as were images of Indians:

curiosity was fueled by frontier stories and newspaper reports.

However, there were drawbacks to daguerreotypes and other later forms such as ambrotypes and tintypes. Ambrotypes were negatives produced on glass and then backed with black paint or paper to reverse the image to positive. Tintypes were images produced on a lightweight metal base. The major disadvantage of these techniques was that only one image was produced directly upon the base material. To obtain multiple copies or prints required either several repeated exposures of the same scene, or the use of multiple-exposure cameras. Both systems were expensive and did not produce any great volume to answer public demand.

In 1851 Frederick Scott Archer invented a method of photographic processing by coating a glass plate with a sticky chemical called a collodion, which had been mixed with the sensitized silver. As it had to be exposed and developed while the collodion was still moist, this became known as the wet-plate process. It was extremely time-consuming, and like daguerreotypy, was generally practiced only by professionals. Unlike daguerreotypy, however, the new process produced negatives from which an unlimited number of positives could be made.

The 1850s also saw the popularization of stereographs. These were produced by taking two separate images of a scene, the second image being slightly to one side of the first – in other words, two views produced as two separate eyes would see them. (Plate 5.13; only one image of each stereograph has been reproduced in this book.) These images were then mounted together, and viewed through a stereoscope, a device that made the eyes combine the separate scenes into one three-dimensional image. The effect was astounding. Instantly the viewer became part of a scene – one moment looking down from a high cliff, the next standing at the very edge of Niagara Falls, then peeking into an Indian encampment. With stereographs, the viewer could travel around the world without leaving the security of home.

There was a great demand for photographs at this time, before the invention of techniques for the mass-production of images in newspapers or books: it was not until 1880 that the first photographic halftone was produced in a newspaper. People's curiosity about the Indians created a strong enough market to inspire adventurous professional photographers to leave their families and combat the dangers of the frontier. For these pioneers wet-plate photography had drawbacks other than simply being cumbersome. The emulsions were too 'slow' to stop action. Dances could be recorded only if posed. For one individual to keep still for what seemed like an interminable time was difficult enough even with a head vice, but for a group poised in unsteady positions it was almost impossible. Equally impossible were candid photographs. With two hundred pounds of equipment, a darkroom tent, and a huge camera with its attendant black cloth and tripod, one could scarcely hope to photograph someone unaware – especially if the subject was an Indian, alert to movements in his territory.

1.1 *The Rev. Peter Jones (Kahkewaquonaby), the son of a Welshman and a Mississauga Indian. The earliest photograph of an American Indian, taken by Hill and Adamson during a visit to Great Britain between October 1844 and April 1845.*

Eventually easier photographic techniques evolved. In the 1870s, dry plates were introduced. These plates, still made of glass, could be purchased from a manufacturer all ready to be used. With each new photographic development, more and more people became involved in the craft. In the late 1880s, the Kodak camera with its easy-to-use roll film, placed photography firmly in the hands of amateurs. New developments allowed professional photographers to explore more artistic and intricate ways of recording their subjects.

THE INDIANS DISPOSSESSED

While photography was undergoing rapid changes from the 1840s until the turn of the century, so were the Indians. In the 1700s the 'Permanent Indian Frontier' had been defined as the land west of the Mississippi River. With new acquisitions of land such as the Louisiana Purchase of 1803, there was an increase in the number of settlers. In 1860, Congress passed a bill providing free land to settlers in some western areas. At the same time, the Pony Express started delivering mail from Missouri to California. By 1865, Congress had been able to organize the entire West into states and territories (with the exception of modern-day Oklahoma), and 'invited their settlement by civilized people'.[2] Land rushes were also used to open Indian areas. During a rush, thousands of prospective homesteaders would line up with wagons, on horseback or on foot, and await an official signal. Then they would thunder into the country to stake out claims (plate 1.3).

On May 10, 1869, two great railroad lines met at Promontory Point, crossing the country, East to West, with tracks, and bringing more settlers into Indian Territory. By the 1870s, the Northern Pacific Railroad even offered free transportation to purchasers of Northern Pacific land.[3]

Life for the Indians was changing ever more rapidly. Although they achieved limited victories in the attempt to hold on to their land and traditional life-styles, ultimately the sheer number of settlers overwhelmed them. The American frontier ceased in 1890 when the government included the Territory in its census. That same year, the Indian wars largely ended with the tragedy at Wounded Knee. By the turn of the century, the Indians had ceased to be a threat for the average citizen. They were no longer viewed as bloodthirsty savages, but could be seen as the 'noble red man'.

INDIANS AND PHOTOGRAPHY

During this time (1840–1900), awareness of the power of the photograph grew. At first, photographs of the Indians were produced for and used by the white population. Many Plains Indians called photographers 'Shadow Catchers', thinking that somehow a photograph captured an element of their being which might be translated into power over them. There is no evidence that Indians sought to collect, and therefore 'control', whites or other Indians by this means. However, in time they learnt that photographs could be used politically to help document their problems and perhaps bring about change.

Unfortunately, many important events in Indian history either predate photography, or simply were not covered. There are, for example, no photographs relating to the 700-mile 'Trail of Tears' of the Choctaw, Chickasaw, Seminole and Creek to Indian Territory in 1820–45. However, many aspects of two cultures in conflict were recorded by photographers.

The many eastern Indian tribes had already changed their life-styles by the time photography entered the scene. The first recorded photographs of an Indian were of the Rev. Peter Jones, taken some time between

October 1844 and April 1845 by Hill and Adamson (plate 1.1). In 1845–46 the artist George Catlin met several Indians in Europe, exhibiting them alongside his paintings. They too were photographed after they returned, c.1851–55 (plate 1.5).

These examples aside, most early Indian photographs document the US government's many Indian-related activities. Peaceful delegations, tense treaty negotiations, reservation life and battles, were each covered in their own way, as were the efforts of government surveyors and anthropologists. Although many important frontier photographers recorded Indians for their own purposes, this book focuses on the images produced in connection with government actions. Images have therefore been drawn primarily from the government collections in the National Anthropological Archives of the Smithsonian Institution and the National Archives and Record Administration. Unfortunately, through the years many of these important images have been misidentified, misdated, and attributions confused or lost. As Robert Taft, the photograph historian, once wrote:

> How often have I had occasion to curse the individual or individuals who failed to title, date and otherwise describe in writing what was apparently an important historical photograph! Even if the photographer who could not look farther than the lens of his camera and realize that he was an historian, did not do it, the buyer of his photograph should have thought of it ... Such undocumented photographs are not always a total loss as historical fact, but their proper documentation in many cases becomes a laborious search to identify the original photographers.[4]

In addition to lost attributions, photographers often copied works by others, either through trade agreements or outright pirating. In 1867 Alexander Gardner commented of himself that although images had been printed on mounts which credited him as photographer, this 'should not be taken to mean that he himself had made the picture in question ... only [that it had been] copied in his Washington gallery and that not even the copying had been done by himself'.[5]

This book not only attempts to show the general history of photography of the North American Indian, but also presents preliminary research aimed at untangling problems relating to credits. In general there has been no attempt to cover important incidents in Indian history not covered by photography, nor to interpret the anthropological, sociological or historical significance of the images; but a timeline of important events, and a cultural map of the United States, have been included.

Many interesting stories of the reactions of Indians and photographers to each other were not recorded or have been lost. Those stories that survive frequently reveal contemporary white attitudes. One should take these attitudes into account when reading stories recounted here. The most important losses, however, have been the photographs themselves. As daguerreotypy produced only one image, the loss of a plate was irrevocable. With negatives that could produce thousands of copies, specific images were more likely to survive, even if, as frequently happened, studios were demolished by fires, and the old glass plates were broken, or even sold as scrap glass for greenhouses. The photographers who pirated others' works did at least unwittingly help to insure that more images ultimately survived.

What remains today is a rich photographic legacy. This book presents that legacy which first reveals Indian life of the early contact days as recorded by daguerreotypists, then depicts the decades of change, finally coming full circle to the art photographers and Indians who alike attempted to recreate bygone, pre-contact days; World War I was to begin another era, outside our present scope.

1.2 *William Henry Jackson at Laguna Pueblo, New Mexico. By an unidentified photographer.*

1.3 LEFT *Land rush, just after high noon on September 16, 1893. By an associate of William S. Prettyman, taken from a high platform.*

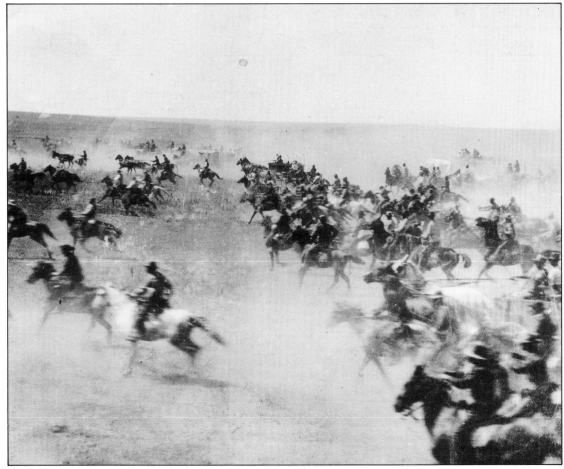

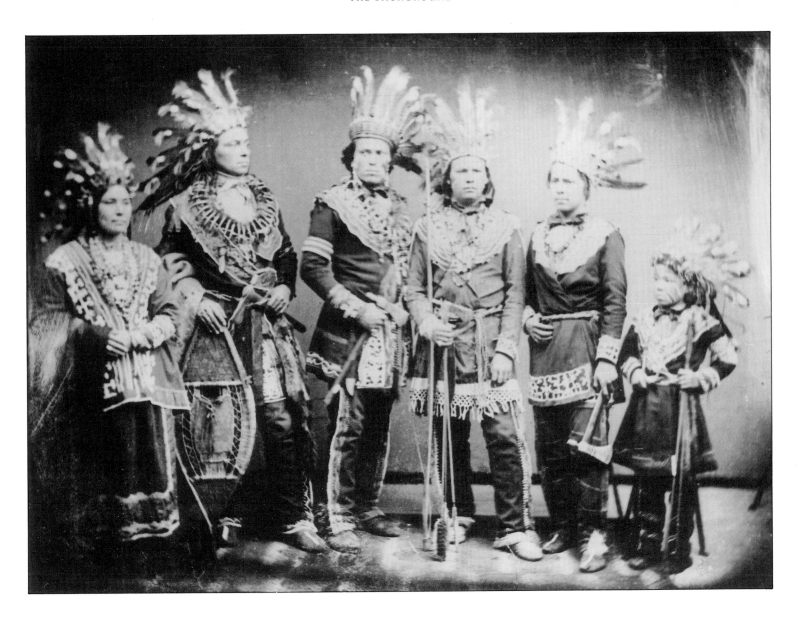

1.4 LEFT *A group of Kickapoos migrating to Mexico. Possibly by Martin J. Bentley, agent for the Mexican Kickapoos.*

1.5 ABOVE *A group of six Ojibwa Indians who met the artist George Catlin while touring in Europe. Left to right: The Great Hero, Bird Of Thunder, The Elk, The Pelican, Woman Of The Upper World and The Furious Storm. A daguerreotype taken in 1851, five years after their return.*

CHAPTER TWO

PEACEFUL ENCOUNTERS

IN 1831 The Light, an Assiniboin chief, came to Washington DC as an official delegate and guest of the Secretary of War. He arrived in the capital wearing a buffalo-skin robe decorated with porcupine quills and fringed with scalp locks taken from the heads of his enemies; his headdress was decorated with eagle plumes – all befitted his status. When he returned home in the spring, he was so transformed by his visit that his own people could hardly recognize him. He wore a beaver hat, a colonel's blue uniform with gold epaulettes, a sword, high-heeled boots, carried a keg of whisky and a blue umbrella and whistled 'Yankee Doodle'.[1]

George Catlin, the famous Indian artist, captured the results on canvas by painting a 'before and after' portrait of the Chief (plate 2.3). Catlin related The Light's attempt to describe the sights he had seen to an ever growing crowd:

> He told ... of the distance he had traveled; of the astonishing number of houses he had seen; of the towns and cities, with all their wealth and splendor; of traveling on steamboats, in stages, and on railroads. He described our forts and seventy-four gun ships which he had visited; their big guns; our great bridges; our great council-house at Washington, and its doings; the curious and wonderful machines in the Patent office (which he pronounced the greatest medicine place he had seen); the ascent of the balloon from Castle Garden; the numbers of the white people; the beauty of the white squaws; their red cheeks, and many thousands of other things.[2]

Unfortunately for The Light, the stories 'were so much beyond their comprehensions that they "could not be true", and "he must be the very greatest liar in the whole world"'. His people's astonishment finally turned to fear and hostility, and he was murdered by a young Indian to rid them of his menacing presence.[3] The administration's attempt to impress the Indians with their culture and might had worked in the extreme.

In recording this delegate, Catlin was continuing an already established tradition of portraiture. Thomas McKenney, the Superintendent of Indian Trade, and later Commissioner of the Bureau of Indian Affairs, had conceived of a government collection of portraits of visiting Indian delegates. Charles Bird King painted the first portraits for him in 1821. By 1865 approximately 150 portraits were in the government collection.[4] These portraits recorded the élite of the Indian world – leaders and diplomatic envoys who were sent, as were other foreign emissaries, to visit and to negotiate treaties with the US government.

The use of delegations as a form of diplomacy had become firmly established in the colonial period as a result of early European contact, and the young American nation realized that it had to continue the practice or risk offending the powerful tribes around its borders. By diplomatic means the government hoped to impress the Indians with its power and the size of the eastern cities, and especially to negotiate treaties, generally aimed

at obtaining Indian land. At first the various Indian tribes were treated as independent, sovereign nations with whom treaties were negotiated and formally ratified. Congress changed this in 1871, thereafter viewing Indians as wards of the state – but despite this, delegations continued.

Photography had developed sufficiently by the mid-nineteenth century for photographers to record some of these diplomatic encounters. A trip to the photographer's studio became an increasingly routine part of a diplomatic visit. Like the artists, photographers recorded these leaders for posterity, but unlike them, they could also capitalize upon the images by selling copies to a white population which was as curious about the feathered Indians as the Indians were about them.

Photographs of Indians at this time were mainly posed studio portraits that, in appearance, could have been taken in any of the hundreds of studios already thriving in the East. An 1863 photograph taken of Southern Plains Indians in the White House conservatory is a notable exception (plate 2.14). Normally, illustrators had to make drawings based upon photographs to convey a diplomatic event. Only later in the 1870s had techniques of photography developed enough to permit views of delegations in the relatively dark interiors of art galleries or in front of the US Treasury building (plates 2.31, 2.32), revealing the Indian posed in a white culture.

THE BEGINNINGS OF DELEGATION PHOTOGRAPHY, 1851–52

The earliest known delegation photographs were made early in 1852. Immediately after the Fort Laramie Treaty in September 1851, a delegation of nineteen Arapaho, Cheyenne, Sioux, Oto and Iowa traveled to Washington DC, and stayed from November 1851 to January 11, 1852. The Indians visited the Navy Yard and Arsenal, and met with President Fillmore and the exiled Hungarian statesman Lajos Kossuth. They received flags and medals from both the President and Kossuth.[5] At some point in their trip, Alights On A Cloud had his daguerreotype taken with the world-famous actress and dancer, Lola Montez,[6] who had sailed to the US on the same ship as Kossuth (plate 2.8).

On their way home, the delegation stopped in Philadelphia. This prompted John McIlvain, a collector, to write to President Fillmore to ask if he might be allowed to purchase one of the Indians' bows, and to note: 'you are aware that a delegation of Indians from the Laramie Treaty are at present juncture on a visit to our city ... I have them Daguerotype [sic] some in Groups and others separately & I have also made arrangements to have Lythographs [sic] taken therefrom.'[7]

McIlvain does not identify the daguerreotypist, but he was probably a leading Philadelphia operator such as James E. McClees or Marcus Aurelius Root, who was also a noted photo historian. The resulting daguerreotypes have not been located, but they may have been those copied by Antonio(n)

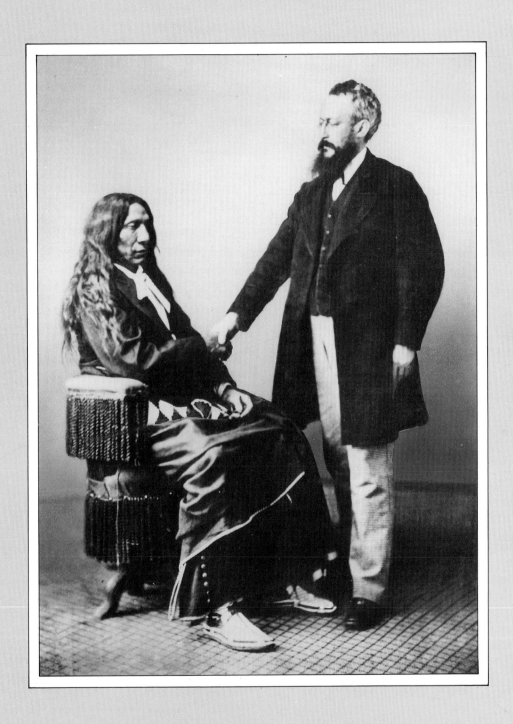

2.1 *Englishman William Henry Blackmore and Red Cloud, the chief of the Oglala Dakota who would not attend negotiations at Fort Laramie until the US abandoned its forts on the Powder River. By Alexander Gardner, Washington DC, 1872.*

Zeno Shindler in 1869 when he made wet-plate copy negatives of at least eight uncredited daguerreotypes of the 1851–52 delegation (plates 2.4–2.7).

Indian delegates were high-ranking members of their tribes, who were justifiably proud of their positions. Unfortunately, one member of the 1851–52 delegation had simply been picked up along the way. Known as both 'Goose' and 'Corn Nubbin', he caused considerable discussion among the delegates who felt that he was not their equal and should not be able to represent his tribe (plate 2.6).[8]

Even though the delegates were important members of their own tribes, portraits could still be misidentified, as shown by one classic group portrait from the 1851–52 series. This group (plate 2.4) has been identified as White Antelope, Alights On A Cloud and Roman Nose. However, Roman Nose, an important Southern Cheyenne chief who led the attack at Beecher's Island in 1868 and died in that battle, was not a member of the delegation. The man pictured is Little Chief.[9] Little Chief is known to have had his portrait taken during the delegation. In 1880, his son wrote to the Commissioner of Indian Affairs requesting a copy of his famous father's photograph, taken, as he noted, during the early delegation trip. The Commissioner regretted that his request could not be met.[10] This suggests that the identification had already been lost, if not the image itself.

DELEGATION PHOTOGRAPHY, 1857–58

As white contact increased, so did the numbers of delegations to the East. At the height of the winter season of 1857–58, approximately ninety delegates from thirteen tribes were in Washington DC. They were involved in the normal diplomatic tours of the capital, as well as in difficult treaty negotiations. One tense moment in these negotiations occurred when Little Crow, one of the Mdewakanton from the eastern group of the Sioux, doubted the promises of the government and refused to give up any more land. He was accused of acting like a child. His speech was reported in the local paper, and interpretation problems aside, his feelings were no doubt accurately conveyed when he was thus quoted:

You use very good and pleasant language, but we never receive half what is promised or which we ought to get. I came here about the Reserve in 1854; I recollect you [the recorder] very distinctly; and you were then writing at the table as you are now, surrounded by papers. You then promised us that we should have this same land forever; and yet, notwithstanding this, you now want to take half of it away … I thought we would do business … but it appears you are getting papers all around me, so that after a while, I will have nothing left. I am going to see that paper which you gave the Agent, and if, after examining it, I shall find anything good in it, I will come and see you again; and when I do, you will hear me talk like a man, and not like a child.[11]

Ultimately, under extreme pressure, treaties were signed. But in 1862 Little Crow led his starving people in a massive revolt killing as many as 800 whites and taking 400 captives.

Before the Indians returned home in 1858, they were involved in the first systematic effort to photograph Indian delegations to the capital. These photographs (frequently miscredited to Philadelphia artist, A. Zeno Shindler) were taken by Julian Vannerson and Samuel Cohner of the James E. McClees Studio.

McClees, a successful Philadelphia photographer, expanded his business to the capital in the winter of 1857.[12] He realized the importance of recording the Indians on film, not only for the profit he could make by satisfying public curiosity, but also to document a changing culture that was probably heading for extinction. In advertising the photographs, he claimed:

The gallery of portraits includes those of some of the principal Chiefs, Braves, and Councilors … Some of them are since dead – killed in battle. To the student of our history, as additions to libraries and historical collections, and as momentoes of the race of red men, now rapidly fading away, this series is of great value and interest.[13]

The collection was offered as a bound volume, or as separately mounted prints. The images were $6\frac{1}{2} \times 8\frac{1}{2}$ inches, the same size as the negatives, and could be ordered hand-colored, by the studio artists, Messrs Aubert and Kerchove.[14]

In his advertising circular, McClees also claimed authorship of the portraits, probably on the basis of his ownership of the studio. As a successful businessman with studios in two cities, he himself could not handle all of the photographic work. He therefore relied upon his talented staff composed of Samuel A. Cohner, a noted operator; Julian Vannerson, a former gallery owner who joined the staff as a photographer and solicitor; and C. H. Brainard, a well-known Boston print publisher who also acted as solicitor for the gallery.[15] *The Photographic and Fine Art Journal* reported:

McClees' gallery has a fine start; and well it might, for such a host of noted men in his employ are bound to succeed … Mr. Samuel Croner [sic] is the operator. Of him I have spoken before, but his pictures have improved so much of late, that I may add a kind word for him again. Some pictures that he has taken of a tribe of Indians would do credit to the first photographers in the country.[16]

A set of prints, developed with salt, of the same portraits was circulated under the name of 'Julius Vammerson',[17] which suggests that Vannerson was also credited for the images.

In 1865 the Trustees of the future William Blackmore Museum in England published the 1857–58 delegation portraits without credits, and dates listed as '1850–1863'.[18]

THE INTERVENING YEARS, 1858–67

Between 1858 and 1867, the next major delegation year, several important events occurred. The Civil War caused an interruption to delegations; it also produced a corps of trained photographers centered around Mathew B. Brady.

On January 24, 1865 a disastrous fire at the Smithsonian Institution destroyed the Gallery of Art which housed the exhibition of Indian paintings by John Mix Stanley and the Charles Bird King delegation portraits. In 1859 Joseph Henry, the Smithsonian's first Secretary, had proposed that photographs be made of the visiting Indian delegates.[19] The idea lay dormant until the tragic fire when Henry suggested to Commissioner of Indian Affairs Bogy, that it was time 'to begin anew … a far more authentic and trustworthy collection of likenesses of the principal tribes of the US. The negatives of these might be preserved and copies supplied at cost to any who might desire them.' Like McClees, he felt that preserving good photographic portraits was important:

The Indians are passing away so rapidly that but few years remain, within which this can be done and the loss will be irretrievable and so felt when they are gone. The photographs … should be single and of

what is known as imperial size, the half length being sufficient, and the head divested of any covering so as to show its conformation. In short the pictures should be portraits of the men and not of their garments or ornaments.[20]

He then appealed for funds to cover the endeavor, but was refused.

Fortunately, Henry's desire to make Indian photographs available to scholars was shared by two other men, Ferdinand V. Hayden of the US Geological Survey of the Territories, and William Henry Blackmore, a wealthy English collector and speculator. Blackmore supported Hayden with money; he also purchased images, and contracted photographers such as Gardner and Shindler who recorded visiting delegates and copied his photograph collection. Thus, when the US government resumed relations with the Indians after the Civil War, the machinery was in place for a full-scale photographic effort.

DELEGATIONS AND COMMISSIONS, 1867–69

1867 was a banner delegation year. So many Indians descended on Washington that they had to be housed in vacant army barracks.

At times, even getting a delegation to Washington was difficult. This was certainly the case when Agent J. R. Hanson was given the task of bringing specific chiefs to Washington for the 1867 meetings. After barely surviving seven days in a mid-winter Dakota blizzard, vainly trying to locate the chiefs, Hanson finally reached Crow Creek, 'alive & sound much to the surprise of every body there & [the] exquisite delight of myself'.[21] He finally decided to bring the most senior tribal officials he could find. The Indians at first refused to make the trip: to them, delegations meant treaties, which meant the loss of land. Eventually they relented and left in wagons, accompanied by women singing death songs, children yelling and dogs barking. Hanson reached the capital with a fairly representative delegation, but was still reprimanded for not bringing the originally designated chiefs.

Some of the delegates had been on the 1857–58 delegation. When they returned in 1867, they found that the McClees Studio which had produced the earlier portraits had changed hands. James E. McClees had returned to Philadelphia;[22] Julian Vannerson continued his photographic career in his native Richmond;[23] and Samuel Cohner eventually went to Havana.[24] The McClees gallery was now owned by Robert W. Addis and managed by Antonio(n) Zeno Shindler & Company. Shindler was supported in his work by P. B. Marvin and Louis Fountaine,[25] who was apparently a relative of his wife, Justine Fountaine Shindler.

One of the Indians photographed by Shindler was Scarlet Night (plate 2.15). On the evening of February 24, 1867, he disappeared. When he was not discovered, an advertisement offering a $100 reward was run in the lost-and-found section of the *Washington Chronicle*.[26] His body was found two weeks later in nearby Alexandria, Virginia, the victim of foul play.[27] No motive was ever uncovered, although officials guessed that his captors had murdered him so that they could claim the reward in safety. It was also feared that this type of incident would increase, but fortunately it did not.

Alexander Gardner photographed the 1867 delegates at the White House. Individual portraits are also credited to him, but they are less meticulously executed, and may have been taken by studio operators rather than Gardner himself.

Not all peaceful meetings took place on the white man's territory. Peace commissions also went to the Indians to make treaties. In 1868 one such Commission went to Fort Laramie to investigate the conditions of the Arapaho, Northern Cheyenne, Crow, and the Brule, Oglala and Miniconjou Sioux. The Commission also hoped to put a permanent end to Indian hostilities, restrict Indians to reservations and open up land for settlement.[28] These proceedings were photographed by Alexander Gardner, and constitute the only known images of such commissions (plates 2.20, 2.21).[29]

Alexander Gardner was listed as the 'Government Photographer', and was furnished with transportation and food by the Army. It is likely that he volunteered, hoping to make a profit from the sale of the images. The Commission first met with the Indians at Fort Laramie on April 4, 1868. Gardner arrived on approximately April 24, missing the earlier meeting and treaty with the Brules, but still recording their chief, Spotted Tail, and the various camps. On May 6 and 7, he recorded the treaty meeting with the Crows, and attested the treaty as did the phonographer, George B. Willis[30] (also known as G. B. Withs, and occasionally misidentified as the photographer). On May 10, treaties were negotiated with the Cheyenne and Arapaho.

Man Afraid Of His Horses was also at the Fort Laramie negotiations (his name meant that he was so fierce in battle that even his horses were feared). On May 21, he brought the news that the most important Oglala chief, Red Cloud, would not attend the meetings until the US abandoned its forts on the Powder River.

Faced with an impasse, the Commission negotiated a treaty with the Oglalas who were in attendance on May 24 and 25. As in all important undertakings of a solemn council, a pipe was smoked by all present. Gardner's candid views show not only an important treaty negotiation, but also the only known photograph of the ritual smoking of the pipe (plate 2.20).[31]

On May 28 the Commission met with the Miniconjou Sioux and another treaty was signed. Red Cloud, however, remained adamant, refusing to negotiate. This forced the Commission to leave Fort Laramie and continue its mission to other tribes, leaving behind a treaty for Red Cloud to sign, should he change his mind. The impasse was finally resolved in July when the white forces abandoned the forts as Red Cloud wished – a notable victory for the Indians. Red Cloud kept his word and went to Fort Laramie in November to sign the treaty.

Gardner did not continue with the Commission, but returned to Washington DC with approximately a hundred 8 × 10 inch, and ninety-eight stereograph glass negatives.[32]

On October 16, 1868, Commissioner of Indian Affairs N. G. Taylor notified his field officers that Congress had reduced his Bureau's funds and there would be no money for unauthorized delegations.[33] Agents were therefore instructed to halt impromptu trips. Taylor's decree, however, could do little to stop determined Indians who wanted to meet with white officials. When the Sauk and Fox decided to send an unauthorized delegation that year (plate 2.22), Agent Albert Wiley wired his superiors for instructions. He was ordered to stop the delegates, which had by then made their way to Fort Lawrence, Kansas. When they refused to turn back, Wiley had the US Marshal arrest them. The group spent the night in jail, were tried and declared innocent as there were no laws restricting Indian travel. The delegation proceeded to Washington, eventually suing Wiley for false arrest, and claiming $40,000 in damages. The Indians won, but were awarded only $1,900. Liens were placed upon Wiley's personal property. As it turned out, the Indians had wanted to complain to the Commissioner about Wiley. Meanwhile, there had been a change of presidential administration, and with the attendant personnel changes,

Wiley was dismissed from the service. The new Commissioner eventually reinstated him and approved the payment of his legal fees.[34]

Although Mathew Brady and others did some of the 1868 delegation work, the bulk of the photography still fell on A. Zeno Shindler, who ran the Addis Gallery.

At the same time, William Blackmore had obtained several volumes of *The Peoples of India*, the first major ethnographic study based upon photographs. Blackmore decided to use this as a model for a series of North American Indian portrait volumes. He envisioned a set of six to ten volumes, with fifty photographs in each, and six to eight photographs devoted to each tribe. The series was to cost about £22 per volume and would be limited to 300 copies.[35] This specific series was never produced.

Delegations continued to visit Washington DC in 1869, and were again recorded by Shindler. By now, the results of the collaboration of William Blackmore, Joseph Henry and the local Washington photographers were accruing. Their efforts, along with the 1857–58 images from the McClees/Shindler studio, created an incomparable collection that was deposited in the Smithsonian Institution, forming its first photograph collection and filling the gap in exhibitions of Indian portraits left by the 1865 fire.

These photographs were exhibited in the Gallery of the Smithsonian and were listed in an 1869 visitors' leaflet, *Photographic Portraits of North American Indians*, commonly referred to as the *Shindler Catalogue*.[36] In composing the *Catalogue*, Shindler was careful to credit himself and Gardner, but he also credited himself for the McClees Studio portraits although he had only printed them. The leaflet was circulated by the Institution until the early 1900s, by which time the misattributions were accepted without question.

DELEGATION PHOTOGRAPHY: THE FINAL YEARS, 1870–1900

The story of delegation photography does not stop with the 1869 Smithsonian exhibition. 1872 was another significant year for delegations. Alexander Gardner, working for the Office of Indian Affairs, replaced Shindler as the major photographer of delegations (plates 2.1, 2.24–2.26). Doubt has been cast on the authenticity of some of his pictures. It has been suggested that 'Mrs Gardner had the unhappy task of assisting her husband in the posing of the Indians, and outfitting them in feathers and beads, and tribal garments from a smelly collection of native costumes maintained by the Gallery'.[37] Although Gardner may have had such a collection, this use of it is not supported by the photographs. Of the many images attributed to Gardner, only two show any similarity in clothing, and that is restricted to a sharing of a tobacco pouch held by two Blackfoot Sioux.[38]

Gardner's 1872 portraits were used by William Blackmore in partial realization of his grand publication scheme. Although covering only the tribes represented by the delegates, Blackmore's own museum produced at least eight albums of approximately 200 portraits.[39]

Other Washington DC photographers were involved in recording the Indians. Julius and Henry Ulke, for example, photographed Apache, Ute and Crow delegations of 1872 (plates 2.27, 2.28).

During the 1870s, the collection of delegation negatives continued to build up under the control of the US Geological Survey of the Territories. Also in their files were negatives taken by the Survey photographers William Henry Jackson, John K. Hillers and others. In 1874 Jackson published a preliminary catalog to these negatives,[40] including not only his own field views, but also the delegation images originally covered in the *Shindler Catalogue*. Only general credits were mentioned in the introduction.

In 1877 Jackson produced a second, expanded catalog.[41] This included more images as well as some biographical details and physical measurements. The photographs were credited in the introduction as coming 'from various sources'. Jackson did not intend to be credited as the original photographer of all the images. The catalog, however, became famous, completely overshadowing its predecessors. It was popularly known as the *Jackson Catalogue*, and Jackson thus started to receive credit for the images.

The 1877 *Jackson Catalogue* included the works of another important Washington photographer, Charles Milton Bell formerly of Bell & Brothers. This firm had a complex history of partners, but eventually Charles became the sole owner. Under his guidance the firm took over the delegation work (plate 2.2).

To compound the problem of original attributions, both Bell and Jackson printed the negatives belonging to the US Geological Survey of the Territory. Jackson, an employee of the Survey, used Hayden survey mounts which carried a pre-printed credit to himself. Bell also used his own studio mounts with his name and address on the reverse.[42]

Once the *Jackson Catalogue* had been produced an attempt was made to turn out large photographic versions of it. The albums were costly to produce and few were actually made. All known extant copies are in public institutions.

In 1879 the various American Surveys were consolidated into the United States Geological Survey. The negatives of Indian photographs then came under the care of the newly created Bureau of American Ethnology, and now reside in the Smithsonian's National Anthropological Archives.

As for the photographers, Jackson continued his illustrious career and turned back to private enterprise. William Blackmore committed suicide when his business dealings in the American West failed.[43] A. Zeno Shindler resumed his artistic skills, becoming the colorist for the United States National Museum on August 14, 1876,[44] a position he held until his death in 1899. Alexander Gardner continued his photographic career, but later devoted more efforts to the Masonic Mutual Relief Association.[45] Charles M. Bell's studio continued to play a major part in photographic circles in Washington DC until the turn of the century.

By the early 1900s, most of the Indian tribes were adapting with varying degrees of success to the new way of life imposed by the Bureau of Indian Affairs. Delegations no longer dominated American-Indian policy, and photography of visiting delegates was largely covered by government studios (see chapter seven).

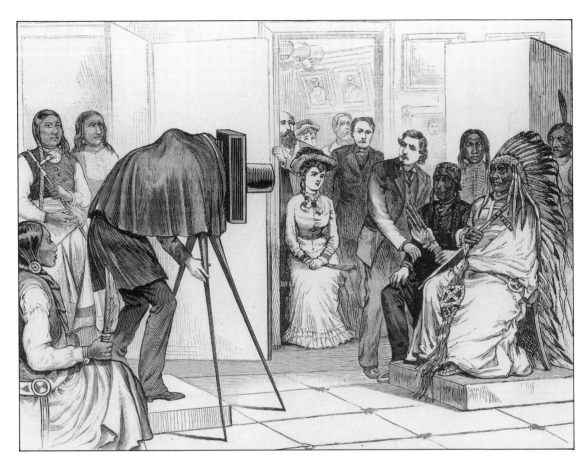

2.2 *Charles M. Bell photographing Ponca and Sioux delegates. From 'Frank Leslie's Illustrated Weekly', September 10, 1881.*

2.3 RIGHT *The Light, an Assiniboin mistakenly called 'Pigeon's Egg Head', depicted by George Catlin 'before and after' his transformation due to a delegation visit to Washington DC in 1831.*

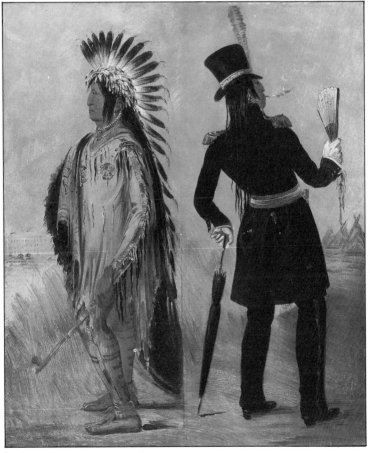

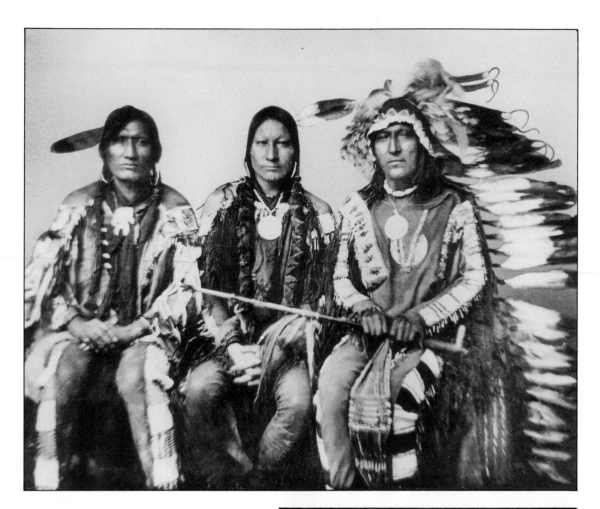

2.4 *Three Cheyenne Indians, White Antelope, Alights On A Cloud (Man On A Cloud) and Little Chief (mistakenly identified as Roman Nose), from a daguerreotype taken during their delegation trip to Washington DC in 1851–52. Probably photographed in Philadelphia, Pennsylvania by Marcus Aurelius Root or James E. McClees.*

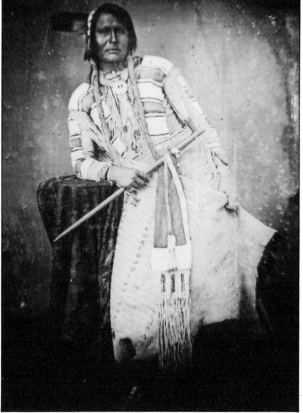

2.5 *Friday, an Arapaho, from a daguerreotype probably taken during the 1851–52 delegation trip to Washington DC. By an unidentified daguerreotypist.*

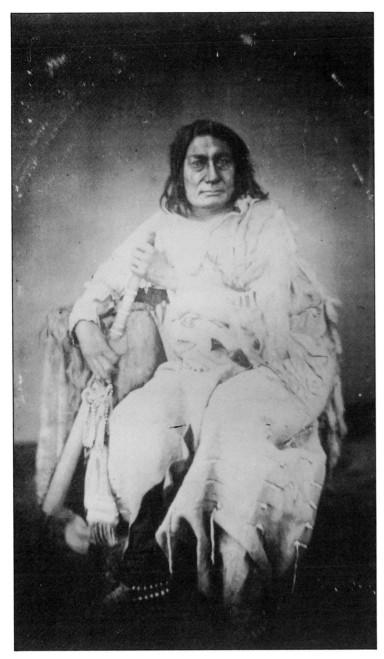

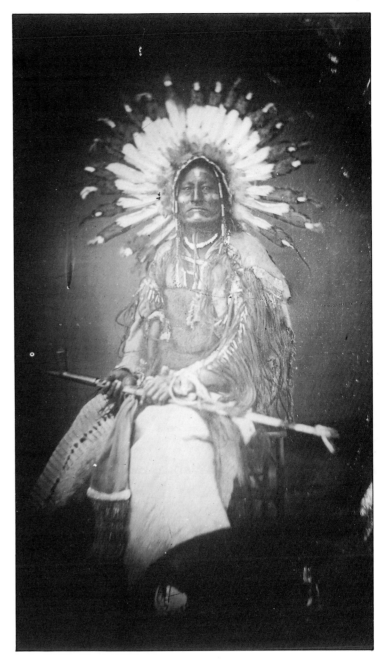

2.6 *Goose, a Dakota also known as 'Corn Nubbin', who – much to the irritation of the official delegates – became an unofficial member of their 1851–52 trip to Washington DC when he was picked up along the way to the capital. By an unidentified daguerreotypist.*

2.7 *Red Plume, a Siouan Blackfoot, from a daguerreotype taken during the 1851–52 delegation trip to Washington DC. By an unidentified daguerreotypist.*

2.8 *Actress Lola Montez and Alights On A Cloud (Man On A Cloud), a Cheyenne member of the 1851–52 delegation to Washington DC. A daguerreotype possibly by J. Hawes, 1852 or 1854.*

2.9 BELOW *A delegation group of 1857–58 in front of the White House, Washington DC. By Mathew B. Brady.*

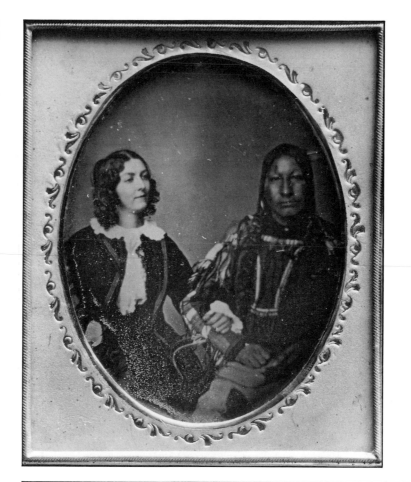

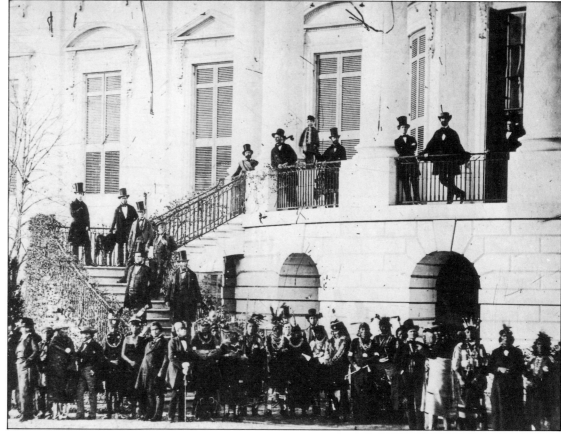

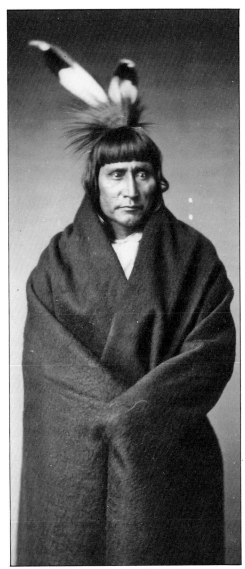

2.10 *Little Crow, a Mdewakanton Dakota, a leader in the Sioux revolt of 1862. Taken by Julian Vannerson and Samuel Cohner of the James E. McClees Studio, Washington DC, some time between March 13 and June 21, 1858.*

2.11 RIGHT *Passing Hail, a Mdewakanton Dakota delegate who made at least two trips to Washington DC. Taken by Julian Vannerson and Samuel Cohner of the James E. McClees Studio, Washington DC, some time between March 13 and June 21, 1858. During another visit in 1867, Passing Hail became ill with dropsy and refused to be left in Washington to die. He died the day after he returned home.*

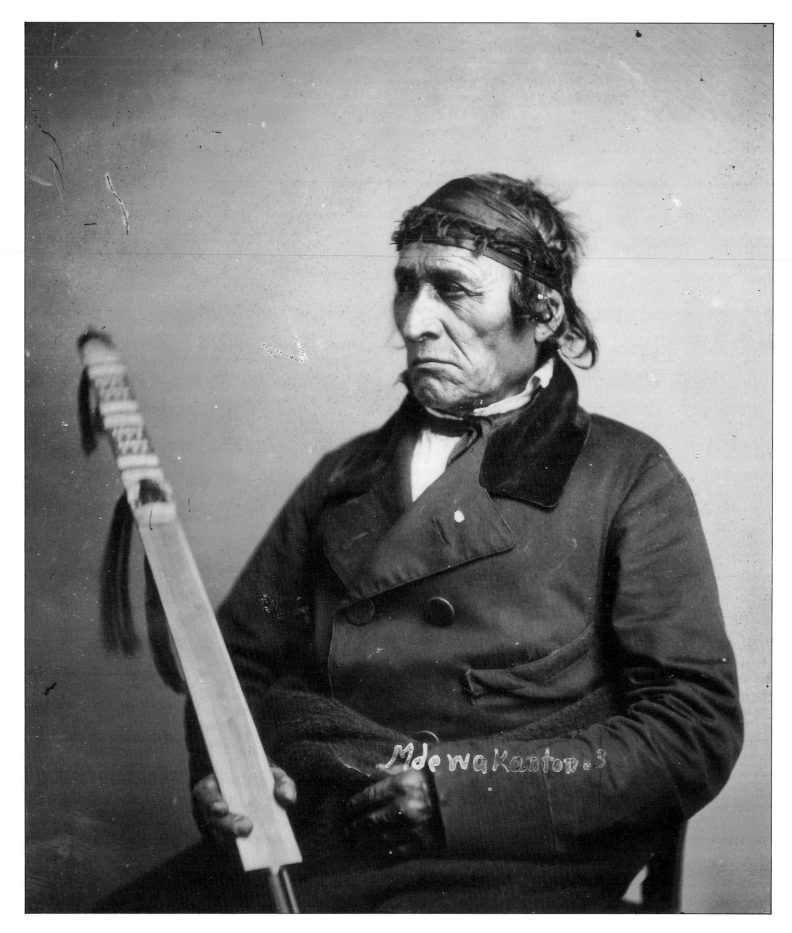

2.12 LEFT *Little Six (Shakopee), a Mdewakanton Dakota. Taken by Julian Vannerson and Samuel Cohner of the James E. McClees Studio, Washington DC, some time between March 13 and June 21, 1858. Shakopee was a leader in the Sioux revolt of 1862, for which he was hanged near Fort Snelling, Minnesota. See also plate 3.5.*

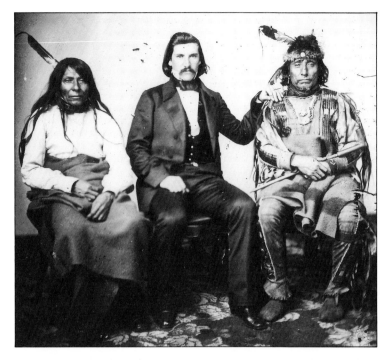

2.13 LEFT *Three Yankton Dakota, Struck By The Ree, Charles Picotte and Smutty Bear. Taken by Julian Vannerson and Samuel Cohner of the James E. McClees Studio, Washington DC, some time between December 31, 1857 and April 26, 1858.*

2.14 BELOW *Cheyenne and Kiowa delegates in the White House conservatory, March 27, 1863. The woman standing to the far right may be Mary Todd Lincoln. Within eighteen months, all four Indians in the front row had died: War Bonnet and Standing In The Water, on the left, were killed in the Sand Creek massacre; Lean Bear, third from the left, was mistaken for a hostile and killed; and Yellow Wolf (right) died from pneumonia a few days after this photograph was taken. By an unidentified photographer.*

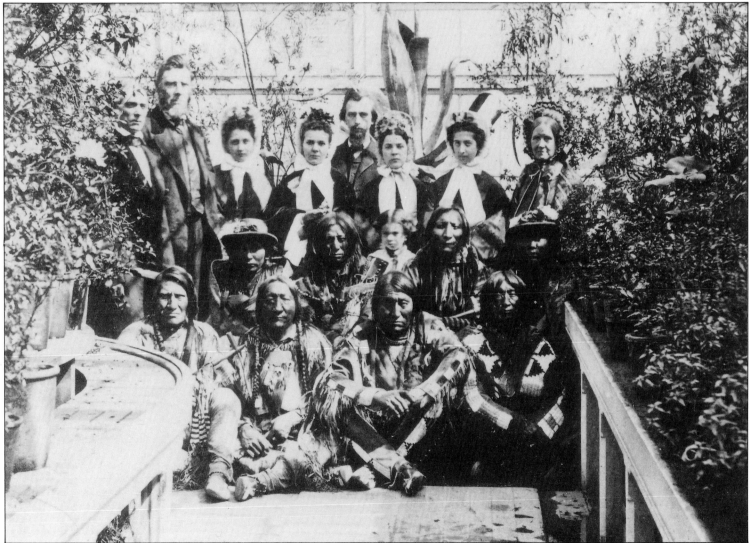

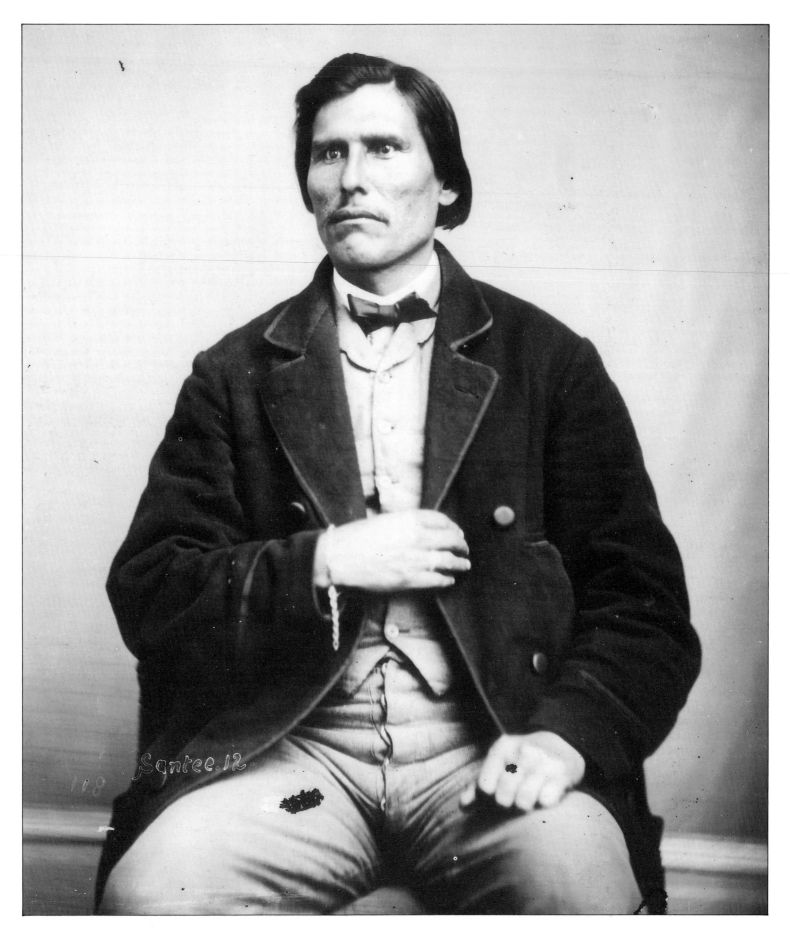

2.15 LEFT *Scarlet Night, a Santee Dakota who disappeared while on a delegation trip to Washington DC and was found murdered two weeks later in Alexandria, Virginia. As there was a reward for his discovery, it was suspected that his captors had killed him in order to claim their $100 in safety. Taken by A. Zeno Shindler some time between February 17 and February 24, 1867.*

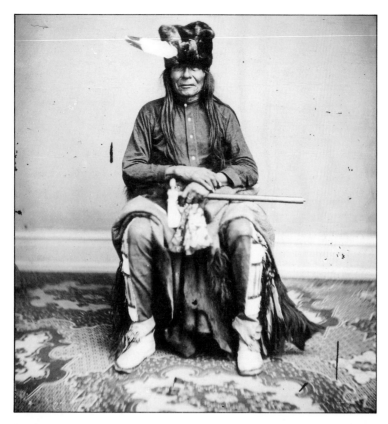

2.16 LEFT *Struck By The Ree, who was born on August 30, 1804 at Yankton, South Dakota, while the explorers Lewis and Clark were encamped there. Captain Lewis, on learning that a male child had been born in the camp, sent for it, wrapped it in an American flag and declared it 'an American'. Struck By The Ree took great pride in his 'Americanism'. Taken by A. Zeno Shindler during a delegation visit to Washington DC some time between February 17 and April 8, 1867.*

2.17 BELOW *War dance simulated by Yankton Dakota delegates (the photographic technology of the day could not capture the action of a real dance). Taken by A. Zeno Shindler some time between February 17 and April 8, 1867.*

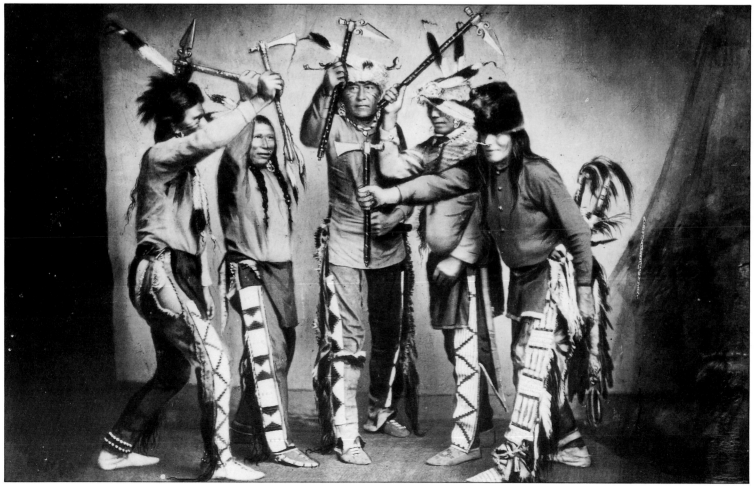

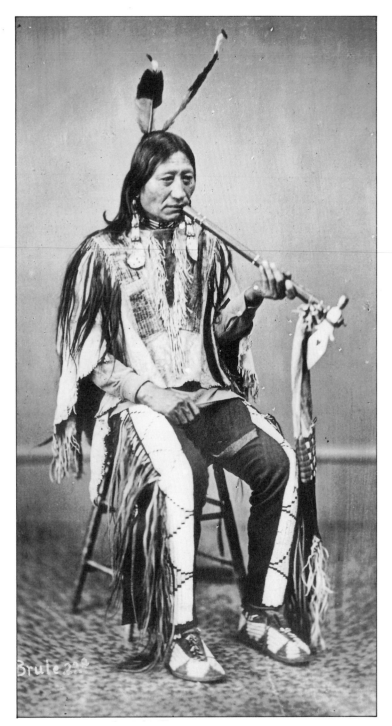

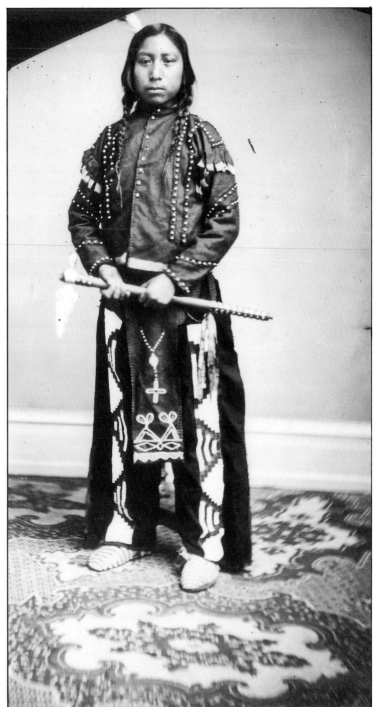

2.18 *Iron Nation, a Brule Dakota. Taken by Alexander Gardner or his studio some time between February 17 and April 8, 1867.*

2.19 *Pretty Rock, a Yankton Dakota. Taken by A. Zeno Shindler some time between February 17 and April 8, 1867.*

2.20 RIGHT *The Peace Commission treaty meeting with the Oglala Dakota at Fort Laramie, Wyoming in 1868. This is the only known image of an Indian (Man Afraid Of His Horses) smoking a council pipe. Taken by Alexander Gardner, probably on May 24 or 25.*

2.21 BELOW *The Peace Commission treaty negotiations with the Cheyenne and Arapaho at Fort Laramie, Wyoming in 1868. Taken by Alexander Gardner on May 10.*

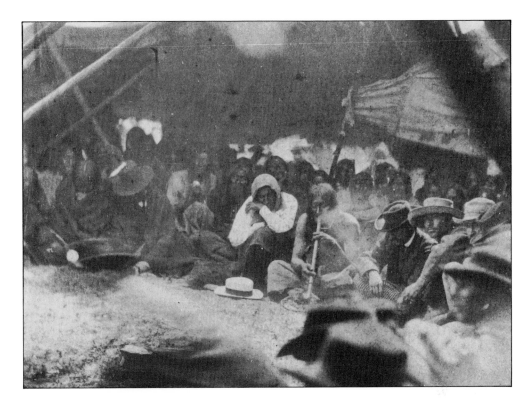

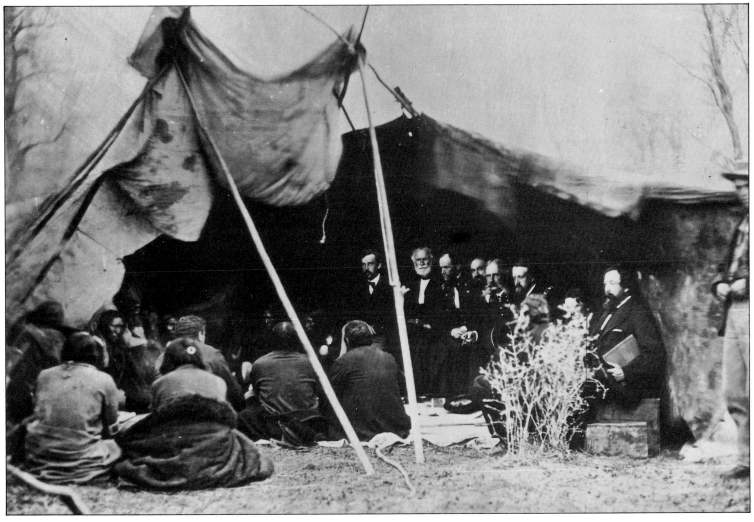

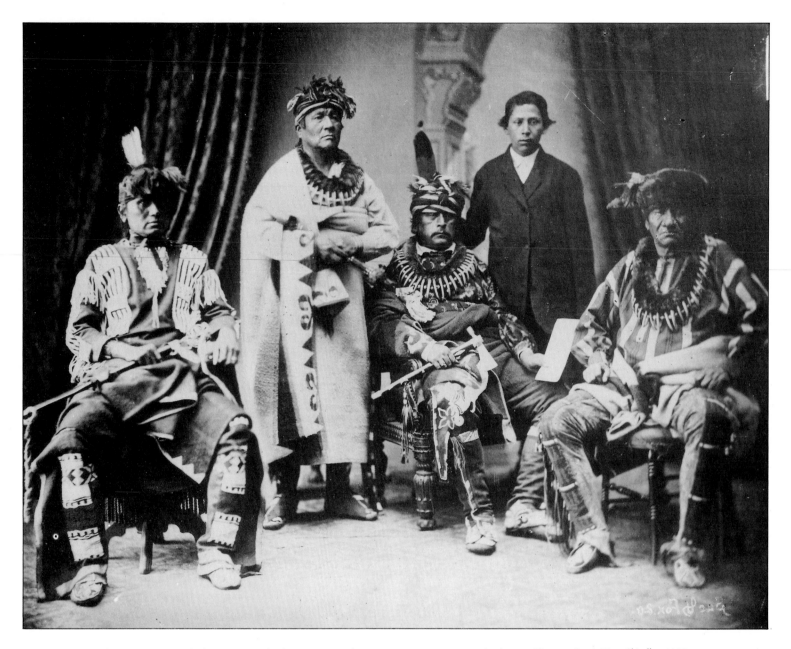

2.22 *A Sauk and Fox delegation group which, against official orders, went to Washington DC to complain about their agent, Albert Wiley. Wiley had had them arrested on their journey to the East on the grounds that they were an unofficial delegation. By Mathew B. Brady, 1868.*

2.23 RIGHT *Samuel Folsom, a Choctaw. By A. Zeno Shindler, 1868.*

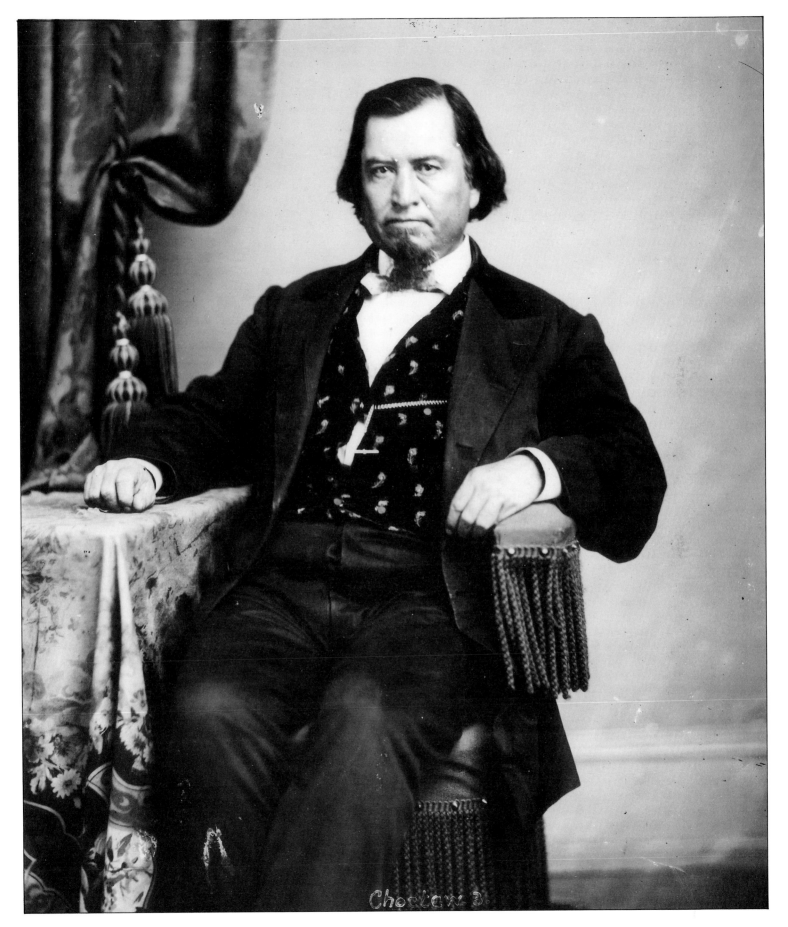

Choctaw 3

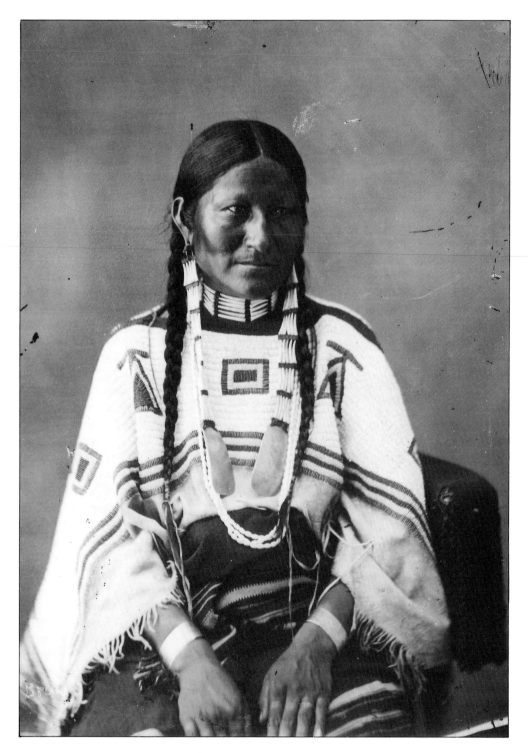

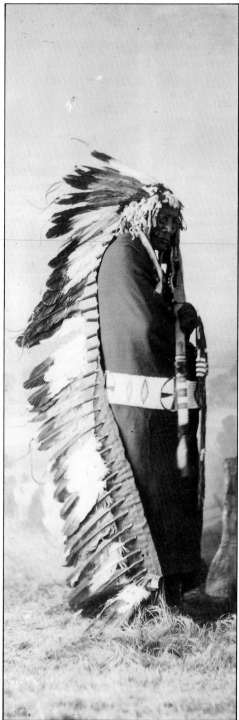

2.24 *The wife of Spotted Tail, a Brule Dakota (see plate 2.26). By Alexander Gardner, Washington DC, 1872.*

2.25 *Iron Shell, a Brule Dakota. By Alexander Gardner, Washington DC, 1872.*

2.26 RIGHT *Spotted Tail and his wife,*
Brule Dakota. By Alexander Gardner,
Washington DC, 1872.

2.27 BELOW *A Crow delegation group.*
By Julius or Henry Ulke, 1872.

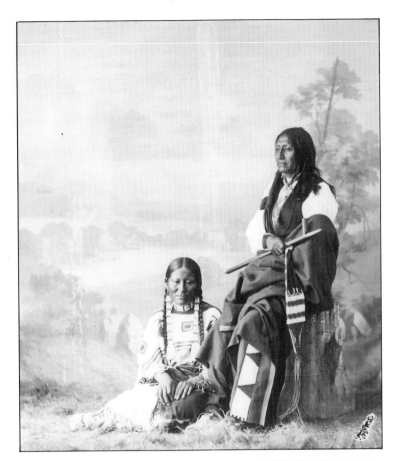

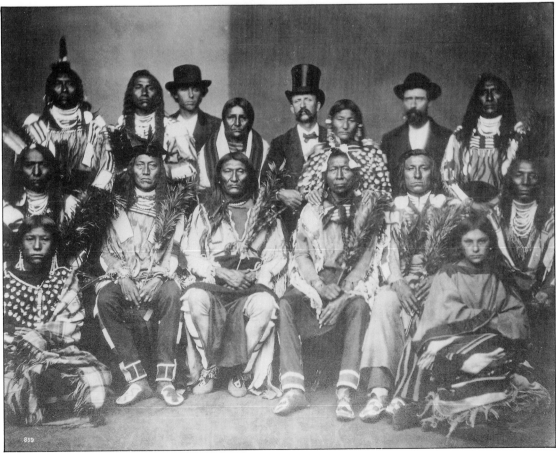

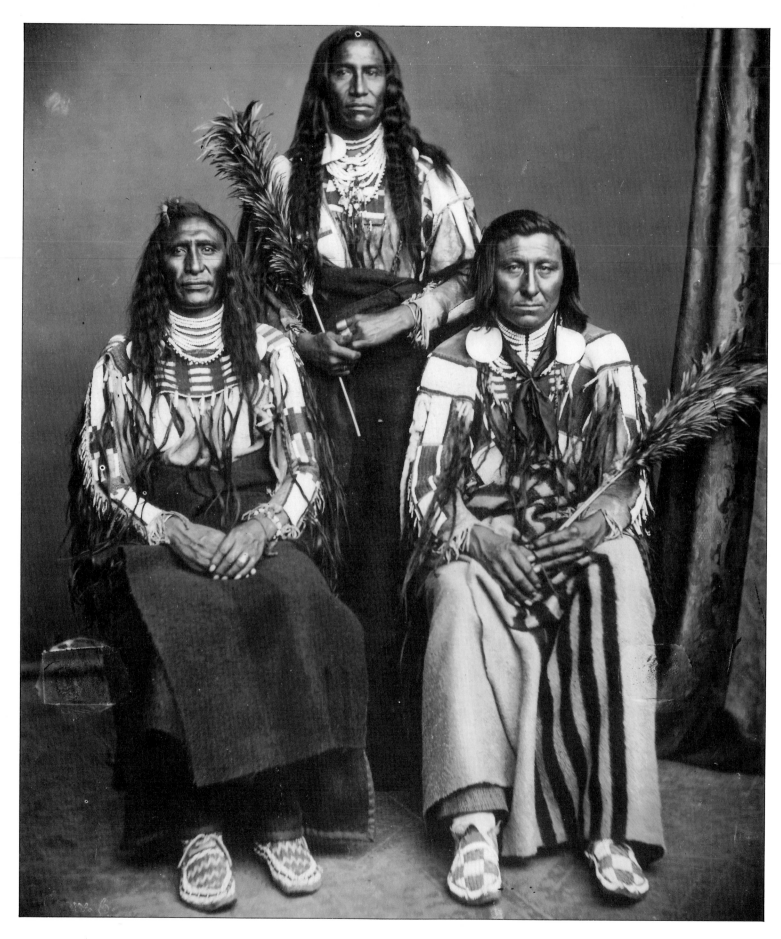

2.28 LEFT *A Crow delegation. Left to right: Mo-Mukh-Pi-Tche, Thin Belly and One Who Leads The Old Dog. By Julius or Henry Ulke, Washington DC, 1872.*

2.29 *George Harvey, a Tututni. By Charles M. Bell, some time around 1875. Many of Bell's identifying props are on display.*

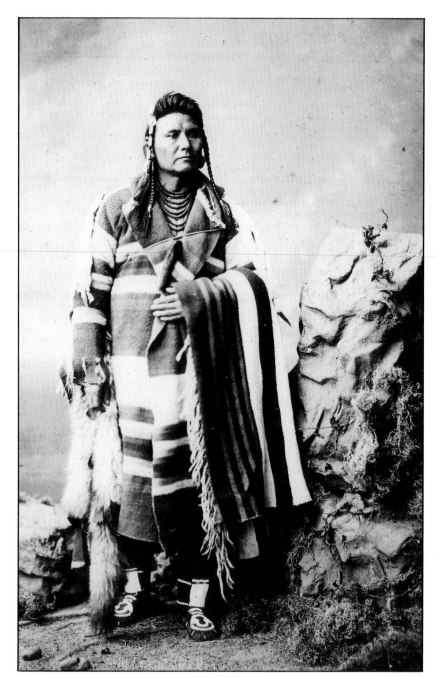

2.30 ABOVE *Chief Joseph of the Nez Perce. By Charles M. Bell.*

2.31 RIGHT ABOVE *A Dakota delegation group in front of the US Treasury building, 1875. Third from the left, seated, holding a fan, is Big Foot, a Miniconjou Dakota who hoped to help make peace with the 'hostile' Indians before the massacre of Wounded Knee in 1890. His frozen body has come to symbolize the tragedy (plate 3.31). By an unidentified photographer.*

2.32 RIGHT BELOW *A Dakota delegation led by Spotted Tail and Red Cloud at the Corcoran Gallery of Art, Washington DC, on October 30, 1877. By an unidentified photographer.*

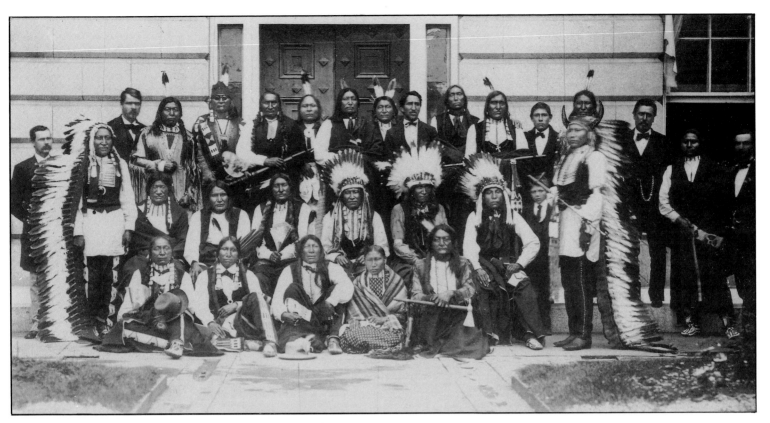

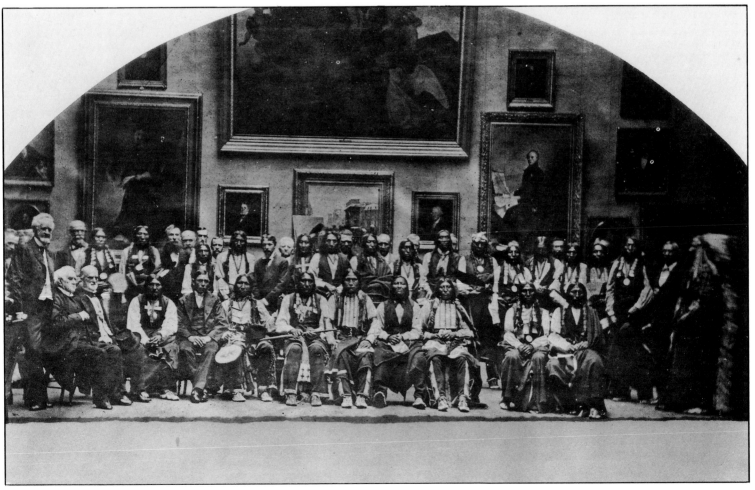

THE INDIAN WARS

IN 1844, James K. Polk was elected President of the United States on a platform of territorial expansion to fulfil the country's 'Manifest Destiny'. The acquisition of land after the Mexican War in 1847, and the rush for Californian gold in 1848, also helped to demolish the 'Permanent Indian Frontier'.[1] By 1860, approximately 300,000 Indians living west of the Mississippi River had felt the effects of this 'Destiny', as thirty million whites expanded their boundaries.[2] This expansion added to the injustices resulting from treaties and acted as a catalyst for the Indian Wars that inevitably followed.

Many of the wars involved the Plains Indians, whose nomadic way of life required vast areas of land,[3] and who believed that the highest prestige was gained by success in battle.[4] Of the approximately thirty different tribes, relatively few actually fought with the settlers. Those that did were the more powerful tribes that had already taken over the lands of smaller tribes, who in turn sided with the white settlers in the wars that lasted from the 1850s to the 1870s.[5] Thus, after years of intertribal warfare, many Indians reacted to white territorial pressures in a traditional manner. By contrast, the pre-Civil War US army consisted of generally mediocre enlisted men and unambitious officers. This army of 18,000 was scattered throughout one million square miles in an attempt to control the Indians.[6]

Documentation of hazardous military encounters was almost impossible. The laborious process of making daguerreotypes and wet-plate negatives that could not stop motion, meant that no action photographs were taken during a battle, Indian or otherwise. Photographers were thus limited to recording the aftermaths, portraits of participants and battle sites, and scene recreation.

A photographer, burdened by his many supplies and provisions, could not expect to survive in unsafe wilderness areas without the protection of a large group. Occasionally they were protected by the military, but even officially sponsored photographers were rarely paid. They were expected, instead, to profit from the sale of views to a curious white population.

During the Civil War, the frontier forces were replaced by patriotic volunteers, which resulted in a higher-caliber military force.[7] As the pace of settlers increased, the Indians revolted against their resulting concentration.

THE SIOUX REVOLT OF 1862

The first revolt recorded by photographers was in 1862. At that time, the Santee Sioux were confined to a small strip of land along the Minnesota River. Emotions ran high as settlers hunted Indian game, insects destroyed crops, and the agency storehouse, full of foodstuffs, was ordered to close. Adding fuel to the fire, traders, seeking to divert into their own pockets the annuities which were supposed to be paid to Indians as part of treaty agreements, refused to extend credit for provisions, trusting only ready cash. (In reality the government often owed the Indians the money to which they were entitled, so that they were unable to pay.) In August, Little Crow, a peace advocate and former delegate to Washington DC (plate 2.10), led his starving people in the famous Sioux revolt, killing as many as 800 whites and taking 400 captives. Military forces under General Sibley later overpowered the Sioux, and took more than 2,000 prisoners. A military commission sentenced 303 Indians to death. President Lincoln reprieved all but thirty-eight, who were hanged on December 26, at Mankato, Minnesota (plate 3.2).

In the meantime, Little Crow and Medicine Bottle escaped with their bands to Canada, where they hoped to enlist British help. In July 1863, while picking raspberries with his son, Little Crow was killed by bounty hunters. Later that year, Medicine Bottle was captured, drugged and smuggled back across the border tied to a dogsled. He was sentenced and hanged with Shakopee, another Indian, an event recorded by an unknown photographer.[8]

Most of the images relating to the uprising were taken by Joel Emmons Whitney. He recorded the missionaries with the Sioux before the revolt (plate 3.3), and when the Indian prisoners were brought to Fort Snelling, near his St Paul studio, he made portraits (plates 3.4–3.6). He also photographed the Sioux, under guard and awaiting trial outside a log-cabin 'courtroom' (plate 3.7).

Adrian J. Ebell, a member of the Rev. Stephen Riggs's escape party, took a photograph of the group of fleeing missionaries and settlers on August 21, 1862. This is the only known image taken during the uprising.[9]

No photographs were taken of the mass hanging, although Whitney did publish a drawing (plate 3.2). That winter, the Indians who were judged innocent awaited removal to Dakota Territory in a stockade near Fort Snelling. Benjamin Franklin Upton, also of St Paul, recorded their crowded tipis (plate 3.8).

WARS WITH THE CHEYENNE

The Cheyenne also responded to the push of immigrants by mounting sporadic raids. After the Sioux revolt in Minnesota, Colorado settlers were panic-stricken when raids started in their territory. One group of Cheyenne, led by Black Kettle and White Antelope, and including a few Arapahos, wanted peace. After much negotiation, a council was arranged with Colonel John M. Chivington and Governor John Evans at Camp Weld near Denver, Colorado on September 28, 1864. This historic meeting was recorded by at least one anonymous photographer (plate 3.9). No formal agreements were signed, but the Indians felt that peace had been made, and turned in their weapons. They then camped beside Sand Creek. Two months later, Colonel Chivington led his troops in a surprise attack, killing the defenseless Indians.[10] This became known as the Sand Creek massacre.

Wars with the Cheyenne continued, and on June 26, 1867 Roman Nose

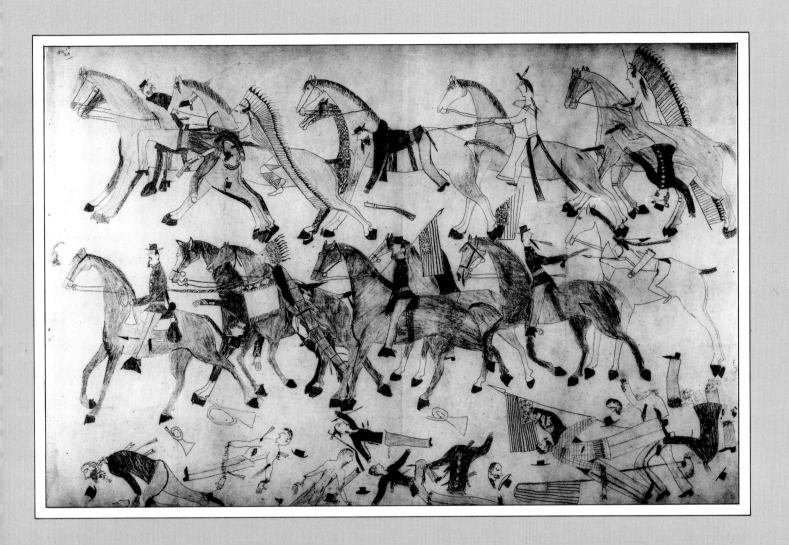

3.1 *Custer's column fighting at the Battle of the Little Bighorn in 1876. Drawing by Red Horse, a Miniconjou Dakota.*

led his people into battle near Fort Wallace, Kansas. This time a portion of the tragic aftermath was recorded. One of their antagonists on that day was Sergeant Frederick Wylyams, an Englishman and former scholar at Eton College, who had lost the good graces of his family through indiscriminately 'sowing his wild oats'. In an attempt to restore himself to their favor, he enlisted in the American army hoping to win a commission.[11] Wylyams was attached to G Troop of the Seventh Cavalry, and soon became friendly with another Englishman, Dr William Abraham Bell. Bell was a photographer to the Kansas Pacific Survey, and during the survey operation the party had joined with the Seventh Cavalry. Wylyams frequently helped Bell with his work. But when the Cheyenne attacked on June 26, Wylyams was killed and his body fearfully mutilated (plate 3.10). Bell later wrote:

> The day on which he was killed he had promised to help me in printing off some copies of the photographs which I had taken on the way, … so I had to print off my negatives alone, and to take a photograph of him, poor fellow, as he lay; a copy of which I sent to Washington that the authorities should see how their soldiers were treated on the Plains.[12]

William S. Soule also recorded the aftermath of an attack on a hunter, Ralph Morrison. On December 7, 1868, Morrison was killed and scalped by the Cheyenne within a mile of Fort Dodge. Soule, an excellent photographer, was working nearby in Tappin's Trading Company, and came to record the scene within an hour (plate 3.11). This image appeared in *Harper's Weekly* of January 16, 1869.

Even though images of mutilated whites were being circulated, the memory of the Sand Creek massacre brought an outcry for the reform of Indian policy. Before his inauguration in 1869, President Grant presented a policy whereby 'All Indians disposed to peace will find the new policy a peace-policy.' The Indians would be safe and cared for on reservations, but if any 'felt the pull of old habits and strayed off the reservation, they could expect to be treated as hostiles'.[13]

THE MODOC WAR, 1872–73

The conditions that led to Indian resistance, however, could not be reversed. In 1872–73, the new Peace Policy almost collapsed. The Modocs, Klamaths and Northern Paiutes had ceded their land. Unhappy with their reservation in Oregon, they went home to California. When troops tried to return them to the reservation, fighting broke out. The forbidden territory was familiar to the Indians, and enabled the militants to resist. A Peace Commission arrived, but little progress was made. On April 11, 1873, General Canby and other officers of the Peace Commission were shot by the Indians. The military stepped up its efforts, and eventually the Indians surrendered. On October 3, four Modocs, including Captain Jack (plates 3.12, 3.13), were executed; the remaining 152 Modocs were exiled to Indian Territory in the south.[14]

Both Louis Herman Heller and Eadweard Muybridge took photographs during the conflict, creating for the first time an almost complete record of an Indian war (plates 3.12–3.18). Nearly a hundred images exist showing military camps, panoramic views, the topography of the battlefield, and the participants. Heller and Muybridge also produced stereographs which gave a life-like, three-dimensional quality to their scenes.

Muybridge, a successful photographer, was employed by the US government, while Heller, a talented local photographer, worked independently.

It is possible that the government hired Muybridge to justify the army's poor field performances against the Modocs.[15]

Conditions were hazardous. Heller, the first to arrive on the scene, was near the war area when the Thomas patrol was ambushed on April 26. Muybridge was probably near the Battle of Sorass Lake on May 19.[16] Both photographers attempted to capture the mood by posing friendly scouts in 'action' positions (plate 3.17).

Only Heller recorded the Modoc captives. These images bore the affidavit: 'I certify that L. Heller has this day taken the photograph of the above Modoc Indian prisoner under my charge – Capt. C. B. Throckmorton, 4th US Artillery, Officer of the Day. I am cognizant of the above fact – Gen. Jeff. C. Davis, USA.'[17]

After his return to San Francisco, Muybridge's images were produced and issued by Bradley and Rulofson. In 1881, he described his experiences of the war in the San Francisco *Examiner*:

> Mr Muybridge was dispatched to the front during the Modoc War, and the wide-spread and accurate knowledge of the topography of the memorable Lava Beds and the country round about, and of the personnel of the few Indians … is due chiefly to the innumerable and valuable photographs taken by him.[18]

Heller produced his own first set, but then had them mass-produced at Carleton E. Watkins' gallery. Watkins was a competitor of Bradley and Rulofson. He later purchased Heller's negatives, and Heller's name as creator was lost.[19]

Taken together, the Heller and Muybridge photographs present a thorough record of an Indian military encounter, a feat which was not to be repeated until 1890.

Like the Modocs, the Kiowas and Comanches on the Southern Plains found reservation life difficult. They would not stay confined to the area assigned to them, and frequently left the reservation to raid across the Red River into Texas. Troops were sent to subdue the Indians, but in 1875 a new tactic was tried. The most aggressive and incorrigible warriors were captured and sent to Fort Marion in St Augustine, Florida. With the exception of portraits by William S. Soule, the photographic record is scarce.

WARS ON THE NORTHERN PLAINS, 1870–81

The Indians on the Northern Plains also disliked reservation life. Both sides violated the 1851 treaty of Fort Laramie. The Indians raided settlements in Montana, Wyoming and Nebraska, and the whites continued to move into Indian Territory. Adding to the problem were the military surveys, which also made forays into Indian lands.

In 1873, General David S. Stanley escorted the Northern Pacific Railroad surveyors into Montana. William R. Pywell, a photographer from Washington DC, accompanied the survey which became known as the Yellowstone Expedition of 1873. For many years Pywell's negatives were lost, but some have been located in the National Anthropological Archives, including the famous image of General Custer posing with a slain elk (plate 3.19). This expedition is historically important as the preliminary campaign into the Northern Plains for Custer and the Seventh Cavalry.[20]

Custer then led a survey into the sacred Indian Black Hills in 1874. According to the military, the purpose of the Black Hills Expedition was to reconnoiter the area and possibly establish a fort; but rumor, combined with the economic pinch of a country in severe depression, provided the

image of a gold hunt. The Expedition included the St Paul photographer, William Henry Illingworth, who was officially listed as a teamster. The fact that he was paid by the army suggests that his presence was officially desired. The military provided him with the same wagon used by another photographer, Stanley J. Morrow, during the Yellowstone Expedition of 1873.[21] Illingworth traveled from July 2 until August 30, photographing camp sites, expedition staff, geological features and the wagon train on the move.[22] Although there were no photographs of Indians, the images did document an important event leading to the famous Battle of the Little Bighorn.

When Illingworth returned to St Paul, he pleaded that lack of funds prevented him from providing the military with the promised sets of images. The military countered that Illingworth was already profiting from sales through the company of Huntington and Winne. Illingworth was charged with embezzlement, but the case was dismissed on a technicality. The court ruled that the glass used for the negatives was Illingworth's property.[23]

During the summer of 1875, thousands of miners poured into the region, increasing tensions. By June 1876 many Indians, including the bands of Sitting Bull and Crazy Horse, had camped on Rosebud Creek. General Crook's forces were also in the area. On June 17, the two sides met in battle.

After the battle of Rosebud Creek, a new Indian camp was made near the Little Bighorn River. More Indians arrived, and there were soon more than 7,000 Sioux and Cheyenne, 1,800 of which were warriors.[24] On June 25, 1876, they achieved total victory over General Custer at the Battle of the Little Bighorn. Although no photographs of the battle exist, drawings were made by Red Horse, a Miniconjou Sioux, depicting all phases of the action (plate 3.1).[25]

It has been reported that Stanley J. Morrow gained permission to accompany Custer on his fatal campaign, but did not go as his photographic chemicals had not arrived.[26] Morrow did, however, record other events relating to the Sioux War that year. In September, he crossed paths with General George Crook's troops returning from the Battle of Slim Buttes. The troops were starving, and allegedly resorted to eating their emaciated horses. Morrow came with others to their aid. While there, he photographed the hungry, wounded soldiers, and the camp, as well as a group of Sioux prisoners with Custer's recaptured flag (plate 3.20). Continuing with the military to Red Cloud Agency, he photographed more Indians.[27]

On June 20, 1877, Lieutenant Colonel Michael Sheridan led a detail to exhume the dead at the Little Bighorn battlefield. All unauthorized personnel, especially reporters and photographers, were banned. Morrow has been wrongly credited with accompanying the detail. He was in Yankton, South Dakota until June 22, and could not have made the trip in time.[28]

Photographer John H. Fouch tried to gain authorization to accompany the detail, but failed. Not long after the party left, Fouch joined forces with Philetus W. Norris, of the *New York Herald*. Disregarding Sheridan's ban, Norris followed the bank of the Bighorn River while Fouch struggled behind with his equipment. Norris finally reached the Little Bighorn itself, but was stopped by an officer; undeterred, he made a dugout canoe and disguised himself as a mountain man. He arrived in the army camp just in time to see Sheridan's men starting for home, but persuaded an old friend to return to the battlefield and describe the events. Two days later Fouch finally caught up with them; Norris gave him supplies and best wishes. A series of photographs has recently surfaced proving that Fouch was the first photographer of the Custer battlefield; they are in private hands.[29]

By 1879, the battlefield was again in disreputable shape. This time, Morrow did accompany the reburial detail led by Captain George Sanderson, and photographed the scene. These are the images that have been misidentified as the 1877 exhumation. The photographs showing the newly refurbished gravemarkers and mounds of horse bones were part of Sanderson's official report. In 1883 Laton A. Huffman, who purchased Morrow's Fort Keogh gallery, published a catalog containing Morrow's images, which has led to miscredits.[30]

Immediately after the Custer massacre, the Indian country was flooded by soldiers. While Crazy Horse, Sitting Bull and the Cheyenne warriors were free, the battles continued. A dedicated photographer recorded Colonel Nelson A. Miles's march after Crazy Horse in the blizzard conditions of January 1877. Eventually Crazy Horse surrendered, and in September was killed. He appears to have spent too little time in white society to have been photographed: no authenticated portrait has yet been found.

Sitting Bull fled to Canada with his band. Although famine forced some members to return, Sitting Bull declared that 'so long as there remains a gopher to eat, I will not go back'.[31] However, on July 19, 1881 he surrendered at Fort Buford in Dakota Territory. Some historians believe that the first portrait of Sitting Bull was taken while he was still in Canada by a photographer named Anderton;[32] others feel that his first portrait was made after his surrender by Orlando Scott Goff;[33] and there are other candidates, as well.

By 1882, Sitting Bull and some of his band were prisoners at Fort Randall, where they were recorded by Bailey, Dix and Mead, and by A. G. Johnson. Again, incontrovertible identifications and attributions are difficult. One image by Bailey, Dix and Mead appears to have been taken by Sitting Bull himself (plate 3.21). The image shows a man wrapped in a blanket, with the caption 'Sitting Bull trying to steal the trade'. Presumably the photographer set up the camera and then posed while Sitting Bull released the shutter. If this is so, it is the first recorded photograph taken by an Indian. In 1886 Sitting Bull was tried at Standing Rock Agency for instigating the Crow to go to war. This trial was captured on film by David F. Barry (though the picture has not been definitely identified).

One group of Cheyennes, led by Little Wolf, surrendered at Fort Robinson, Nebraska. In an attempt to keep the peace, Little Wolf went south with his people to Indian Territory, but found the new reservation unacceptable. After being refused permission to return to their home on the Northern Plains, Little Wolf and Dull Knife nonetheless fled northward with their bands, whereupon a raid — unusual for them, and uncharacteristic in its brutality — cost them public sympathy and increased the military chase. Dull Knife's people surrendered at Fort Robinson. After being locked up without heat, food or water, they escaped, were pursued and many were killed. Little Wolf's band reached Montana, but were met by soldiers and surrendered near Fort Keogh. Their camp was photographed by Christian Barthelmess (plate 3.22). Another group was photographed on the steps of the Dodge County courthouse on their return south in 1879 (plate 3.23).[29]

THE APACHE WARS, 1872–86

Military encounters with the Indians were not restricted to the Northern Plains. Attempts to confine the Southwest Apaches also resulted in battles (plate 3.24). In 1872–73 General George Crook overpowered many of the bands. Numbers of Apaches were concentrated at San Carlos, but under

their chief, Victorio, raids still continued. When Victorio was killed in 1880, they were led by Geronimo.[35]

Enlisting the help of Apache scouts, Crook pursued Geronimo and his warriors, and finally held a conference on March 25, 1886 at Canyon de los Embudos in the Sierra Madre Mountains. Crook pushed for the Apaches to put an end to the raids and agree to live on a reservation. Geronimo finally accepted.

This famous meeting was recorded by Camillus S. Fly, of Tombstone, Arizona (plates 3.25–3.27). Fly had watched the shootout at the O.K. Corral in 1881, and with equal bravery, accompanied Crook on his Sierra Madre campaign. During the peace conference, 'with a nerve that would have reflected undying glory on a Chicago drummer', Fly 'coolly asked Geronimo and the warriors with him to change positions, and turn their heads or faces, to improve the negative' (plate 3.25).[36] These photographs are the only known views taken inside a hostile Indian camp.

Crook's triumph was short-lived. Geronimo soon led another raid, and Crook was replaced by General Nelson A. Miles. On September 4, 1886 Geronimo and his band finally surrendered and were taken to Fort Bowie. From there they went by wagon and train to join other Indians at Fort Marion, Florida.

THE TRAGEDY AT WOUNDED KNEE

By the 1880s many Indians were confined to reservations, dependent upon the issuance of clothing, and of food that was inadequate and of poor quality, leaving them hungry. When crops failed, Congress cut rations, and more of their land was sold, the Indians resorted to spiritual solutions. An intertribal movement known as the Ghost Dance grew up. This looked to reunion with the dead and a return to an idealized pre-European way of life. (For a more detailed account of the movement, see pages 143–44.)

By far the most important messianic leader of the movement was Wovoka, a young Paiute who stirred visions of an Indian promised land. By November 1890, conditions at Pine Ridge and Rosebud reservations bordered upon anarchy. The Indians broke into two factions, the 'friendlies', who feared resistance, and the 'hostiles', who were committed to the Ghost Dance and fled to a corner of the Pine Ridge Reservation.

At the request of the friendly Indians, Big Foot and his band of Miniconjou Sioux arrived in an attempt to make peace. Unfortunately General Miles presumed they were heading for the hostile encampment and tried to intercept them. On December 28, they were tracked down by the Seventh Cavalry, and the Indians and soldiers camped side by side at Wounded Knee Creek. On December 29, the Cavalry was joined by Colonel Forsyth's forces. The 340 Indians were surrounded by over 500 soldiers and four Hotchkiss cannons. Emotions ran high, and when an attempt was made to disarm the Indians, shots were fired. Within a short time, two-thirds of Big Foot's band had been killed or wounded. The wounded were taken to a makeshift hospital at Pine Ridge, but because of a blizzard, the dead were left to be buried later.

There are no photographs of the massacre, but George E. Trager, a local Chadron photographer, did record the terrible aftermath (plates 3.29–3.34). Previously, Trager had attempted to cash-in on the sensationalism of the Ghost Dance. During the fall of 1890, he had made several trips to the Pine Ridge Reservation to photograph Indian activities, leaders, and the Ghost Dance itself.[32] Trager left Chadron on December 29, after obtaining permission from General Nelson Miles who was leading the First Infantry to Pine Ridge. Arriving on December 30, he was the first to record the sad scene. Other photographers came later, including Clarence Grant Morledge (also known as Clarence Morledge Grant), W.R. Cross, John C.H. Grabill, and possibly A.G. Johnson.

Trager's prints were widely distributed. Within days, he had established the Northwestern Photographic Company to advertise and market them. His success soon ran its course: within a few months he began advertising a cure for epilepsy on the backs of the photographs. Trager sold his gallery in 1892, went to Yellowstone Park, and finally settled in Nebraska.[38]

For the Indians, the tragedy at Wounded Knee ended their hopes. Although a few scattered skirmishes followed, the Indian Wars were over. As Black Elk, a survivor of Wounded Knee, noted: 'A people's dream died there.'[39]

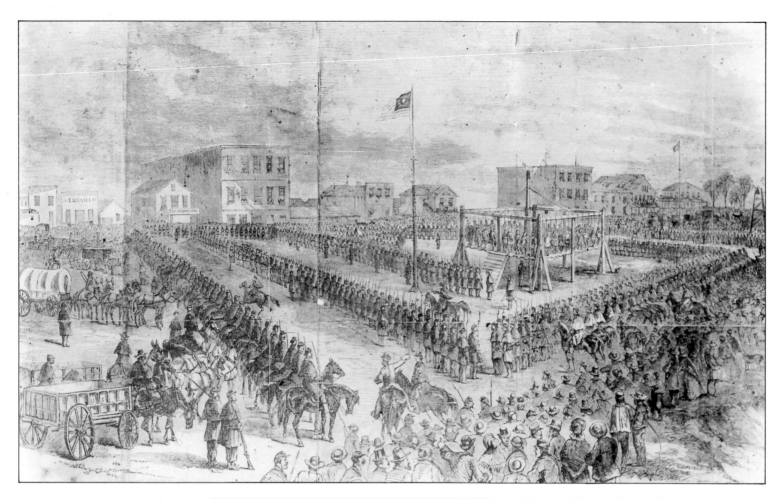

3.2 ABOVE *The mass hanging of thirty-eight Santee Dakota Indians at Mankato, Minnesota on December 26, 1862 for their participation in the Sioux revolt of that year. Drawing by W.H. Childs, from 'Frank Leslie's Illustrated Weekly', January 24, 1863, circulated by Joel Emmons Whitney.*

3.3 RIGHT *A group of Dakota Indians in front of a settler's brick building. Reported to have been taken in August, 1862, the day the Sioux revolt commenced. By Joel Emmons Whitney.*

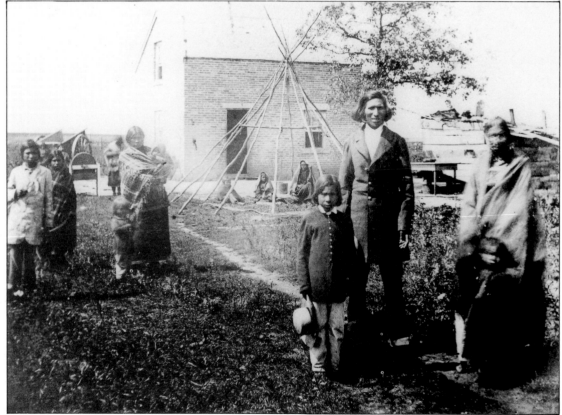

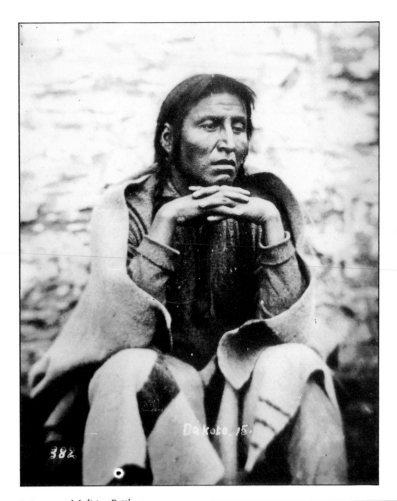

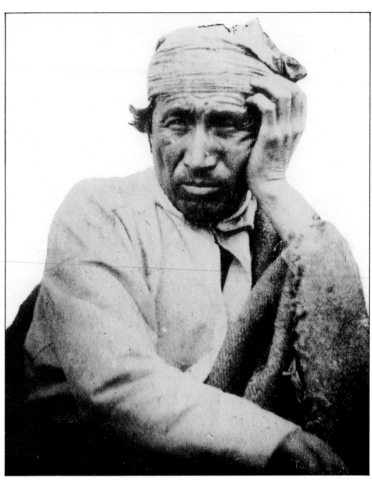

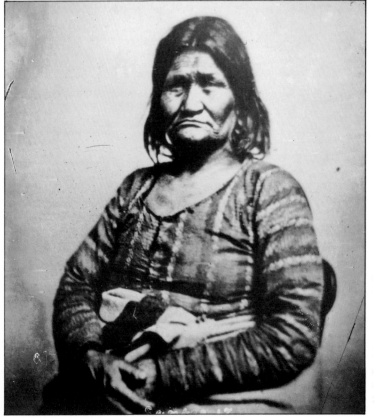

3.4 ABOVE *Medicine Bottle, a Mdewakanton Dakota. Taken by Joel Emmons Whitney at Fort Snelling, Minnesota on June 17, 1864. Medicine Bottle was a prisoner at the fort for his participation in the 1862 Sioux revolt, for which he was hanged along with Little Six (plate 3.5) in November, 1865.*

3.5 ABOVE *Little Six (Shakopee), a Mdewakanton Dakota delegate to Washington DC in 1858 (plate 2.12). A leader in the Sioux revolt of 1862, he was hanged for his participation. Probably taken by Joel Emmons Whitney while Little Six was in captivity at Fort Snelling, Minnesota in 1865.*

3.6 LEFT *Old Bets, a Santee Dakota who helped white captives during the Sioux revolt and massacre of 1862. By Joel Emmons Whitney.*

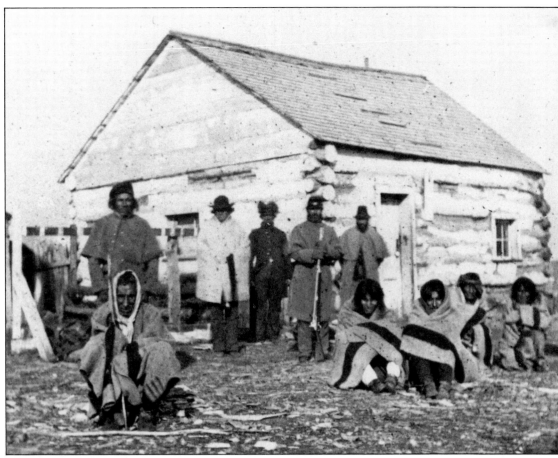

3.7 LEFT *The log house of François La Bathe, used as a courtroom for many Sioux trials after the revolt of 1862. Soldiers guard the Indian prisoners. By Joel Emmons Whitney, 1862.*

3.8 BELOW *The fenced enclosure on the Minnesota River below Fort Snelling where the uncondemned prisoners spent the winter of 1862–63 after the Sioux revolt. By Benjamin Franklin Upton, 1862.*

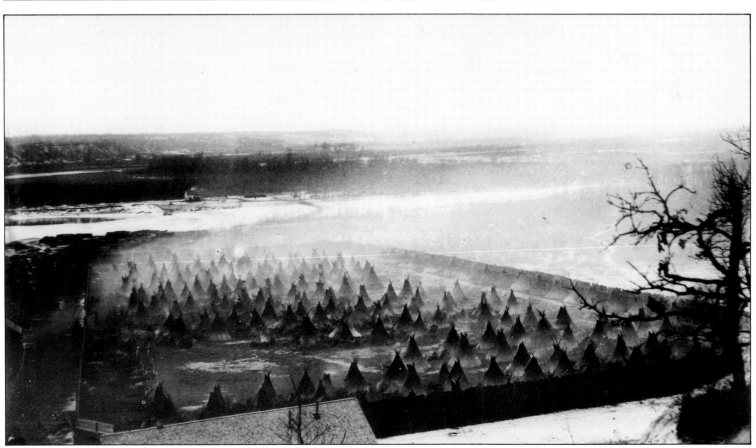

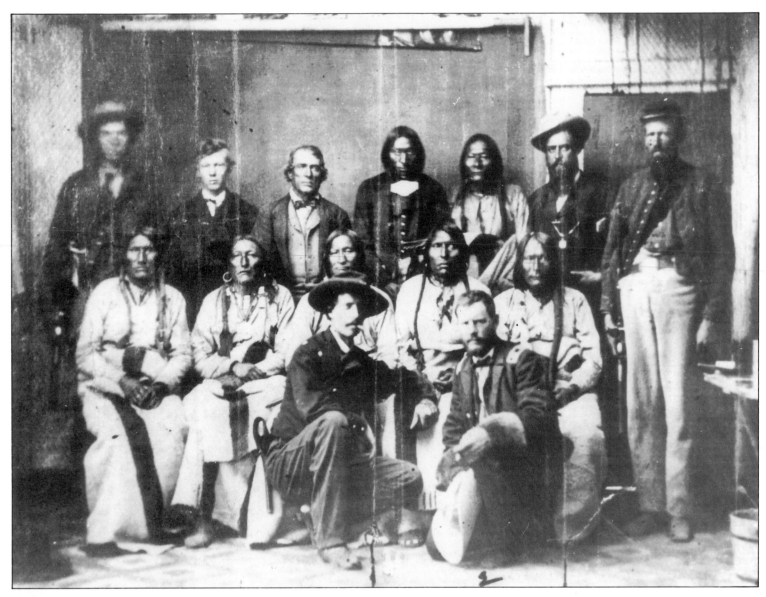

3.9 ABOVE *The famous meeting at Camp Weld, Colorado in September 1864 between Colonel John M. Chivington and the Cheyenne and Arapaho. The Indians, led by Black Kettle and White Antelope, believed that peace had been obtained, and camped without weapons nearby on Sand Creek. In November, Chivington massacred the camp in a surprise attack. By an unidentified photographer.*

3.10 LEFT *Sergeant Frederick Wylyams, who was killed and mutilated by a band of Sioux, Arapaho and Cheyenne near Fort Wallace, Kansas on June 26, 1867. By his friend, the photographer Dr William Abraham Bell.*

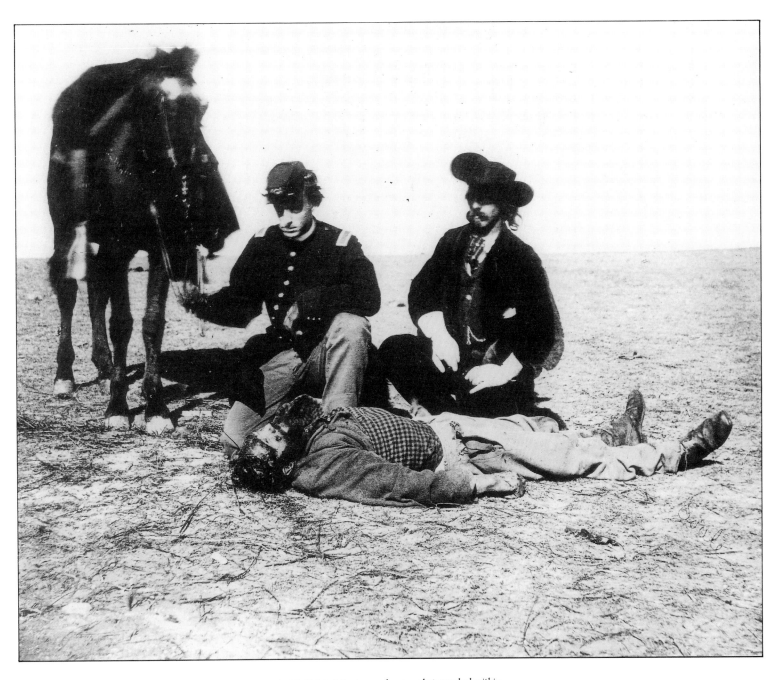

3.11 *Ralph Morrison, a hunter, photographed within*
an hour of being killed and scalped by Cheyennes near
Fort Dodge, Kansas on December 7, 1868.
By William S. Soule.

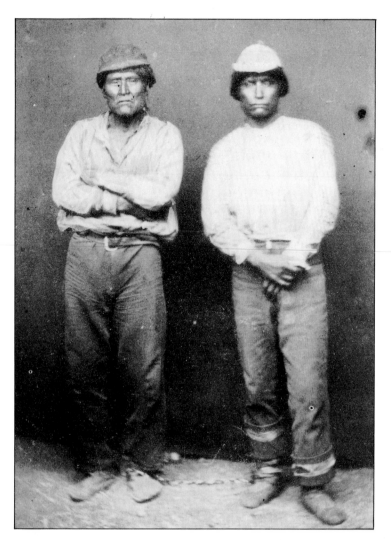

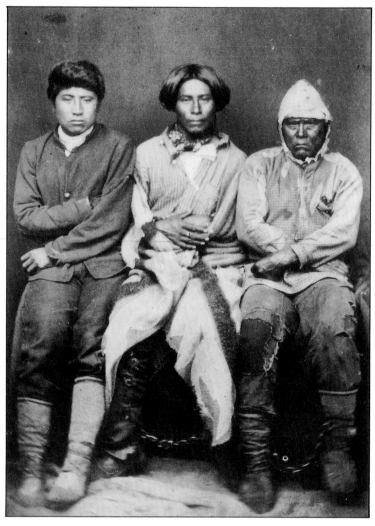

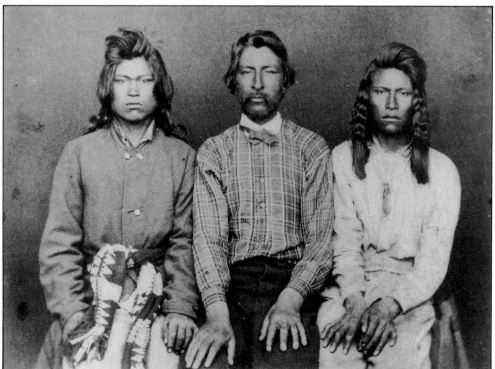

3.12 LEFT ABOVE *Two captured Modocs, Schonchin John and Captain Jack. Both were hanged at Fort Klamath on October 3, 1873 for their participation in the Modoc War of 1872–73. By Louis Herman Heller, 1873.*

3.13 ABOVE *Chained Modoc prisoners: Captain (Curly-Headed) Jack (on the left), Wheum and Buckskin Doctor. Taken by Louis Herman Heller in 1873, and circulated by him under the title 'Lost River Murderers'.*

3.14 LEFT *Scouts of the Warm Springs tribe. Donald McKay (center) helped the US army capture Captain Jack (plates 3.12, 3.13) for his participation in the Modoc War. Taken by Louis Herman Heller in 1873, and published by Carleton Watkins' Yosemite Art Gallery.*

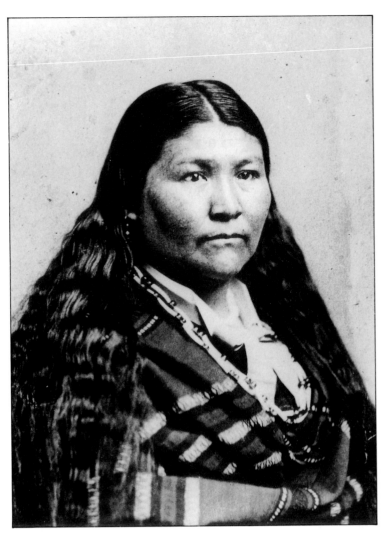

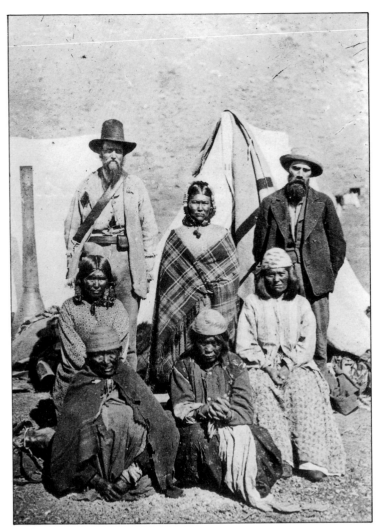

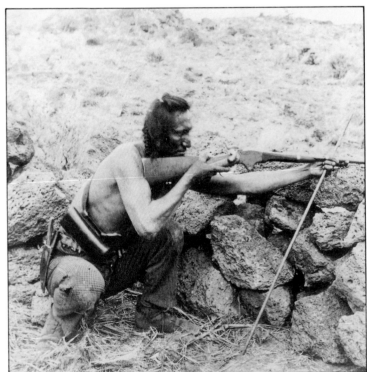

3.15 ABOVE *Toby Riddle (Winema), the wife of a Modoc interpreter. She warned the US Peace Commission leader General Canby during talks that trouble was brewing. On April 11, 1873, while still negotiating, Canby, with several others, was murdered. By Louis Herman Heller, 1873.*

3.16 RIGHT ABOVE *A group including the Modocs Toby Riddle (Winema) and her husband Frank, who acted as an interpreter during the Modoc peace negotiations, and Captain O.C. Applegate, an Indian agent. Taken by Eadweard Muybridge some time between May 3 and May 11, 1873.*

3.17 RIGHT *Loa-Kum Ar-Nuk of the Warm Springs tribe, a scout for the US army during the Modoc War. By Eadweard Muybridge, 1873.*

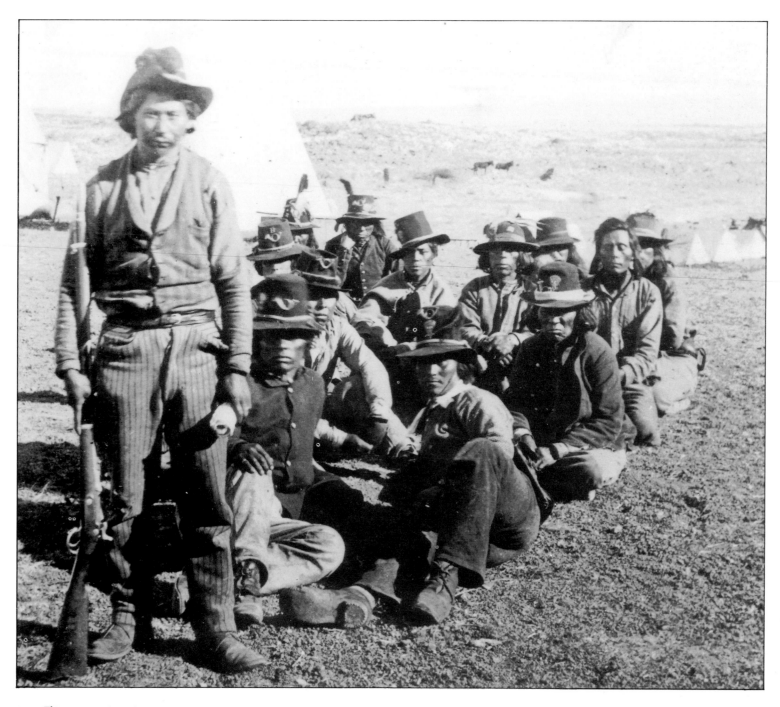

3.18 *Thirteen scouts from the Warm Springs tribe who assisted the US army during the Modoc War. By Eadweard Muybridge, 1873.*

3.19 RIGHT *General George Custer with a slain elk. Taken by William Pywell during General David Stanley's Yellowstone Expedition in 1873.*

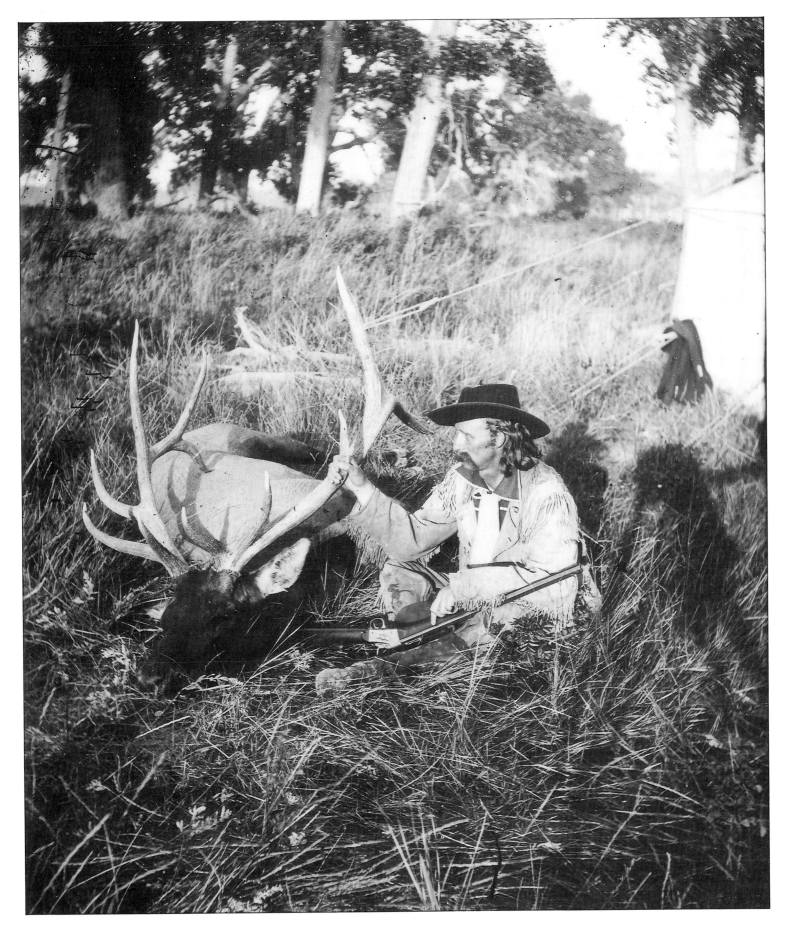

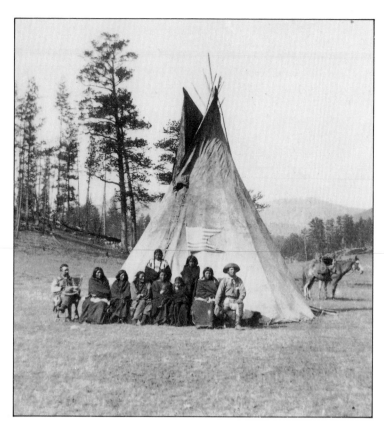

3.20 ABOVE *Sioux prisoners in front of a buckskin lodge displaying Custer's flag, recaptured at the Battle of Slim Buttes. By Stanley J. Morrow, September 1876.*

3.21 RIGHT *Dakota leader Sitting Bull may be the first Indian to have taken a photograph: this picture of a photographer from Bailey, Dix and Mead, 1882.*

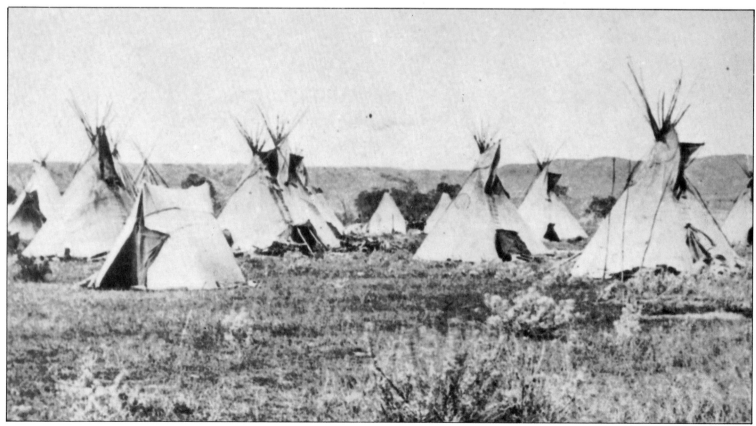

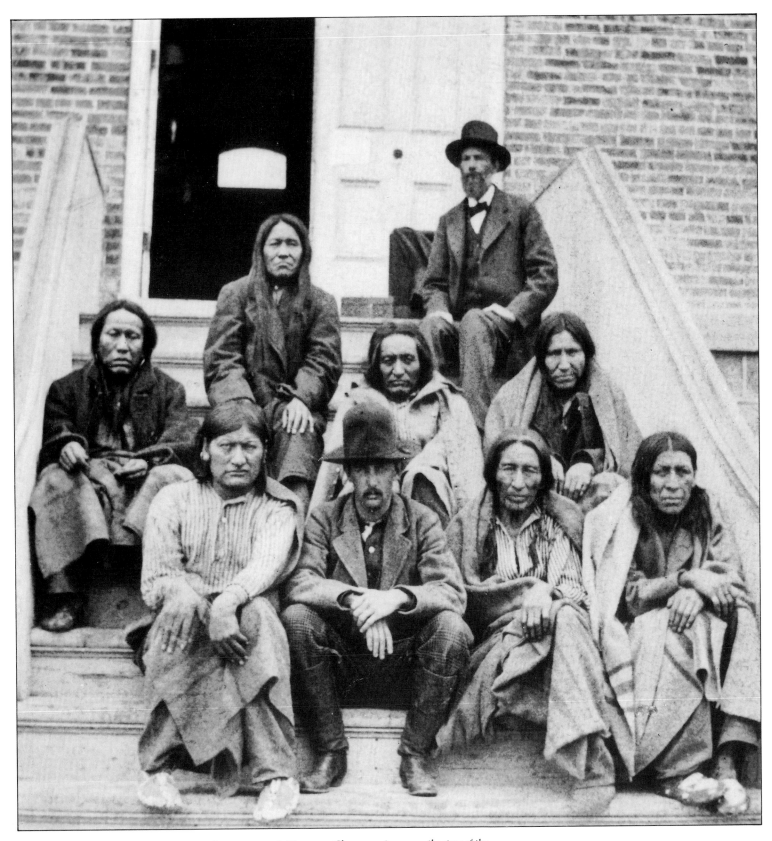

3.22 LEFT *The Cheyenne camp near Fort Keogh,*
Montana where Little Wolf's band was held. By
Christian Barthelmess, March 1879.

3.23 ABOVE *Cheyenne prisoners on the steps of the*
courthouse in Dodge City, Kansas in 1879. By an
unidentified photographer.

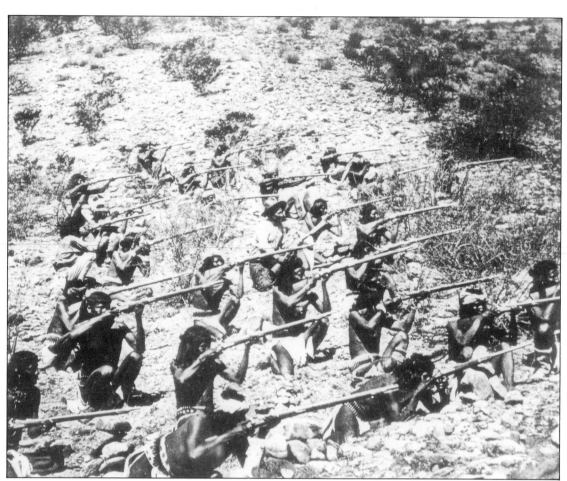

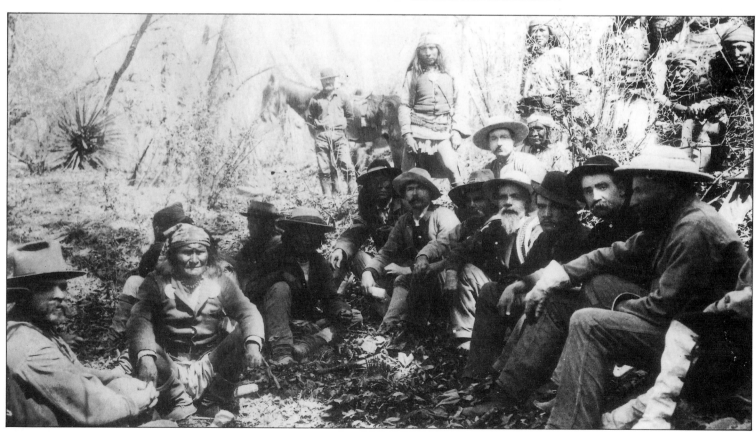

3.24 LEFT *A group of Apache scouts aiming rifles in a posed 'action' shot. Possibly by J.C. Burge.*

3.25 BELOW *The council between General George Crook (second from the right) and the famous Chiricahua Apache Geronimo (second from the left) in the Sierra Madre Mountains between March 25 and March 27, 1886. By Camillus S. Fly, who 'coolly asked Geronimo and the warriors with him to change positions, and turn their heads or faces, to improve the negative'. See also plate 4.21.*

3.26 RIGHT ABOVE *Geronimo (right) and three of his warriors during their conference with General Crook in the Sierra Madre Mountains, March 1886. By Camillus S. Fly.*

3.27 RIGHT BELOW *Geronimo (on the left, mounted) with a group of warriors during negotiations with General Crook in the Sierra Madre Mountains, March 1886. By Camillus S. Fly.*

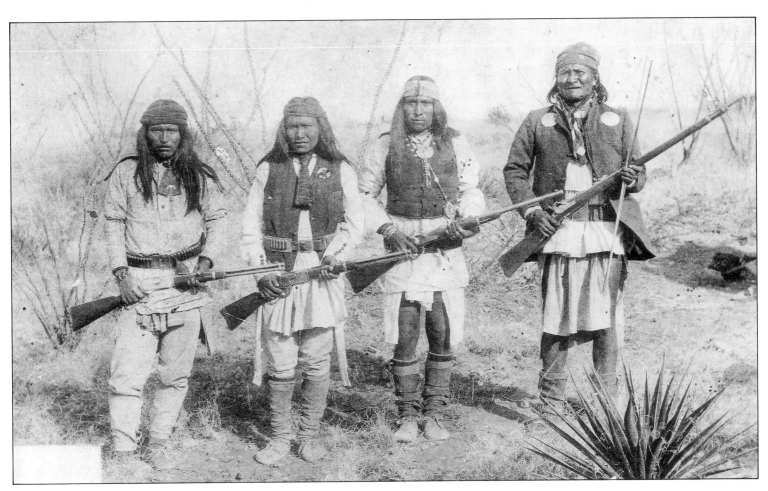

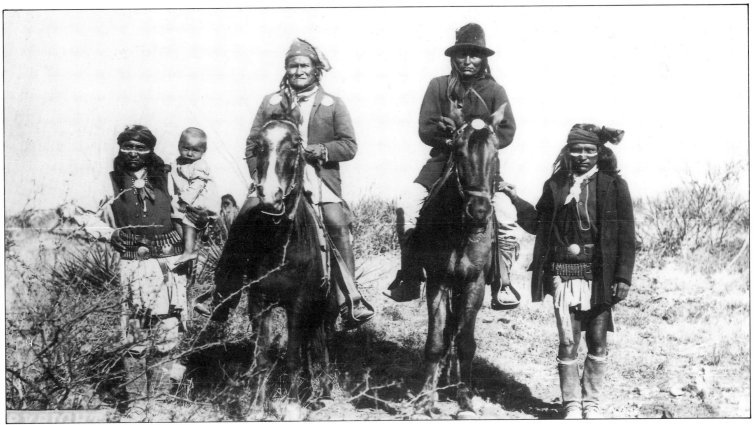

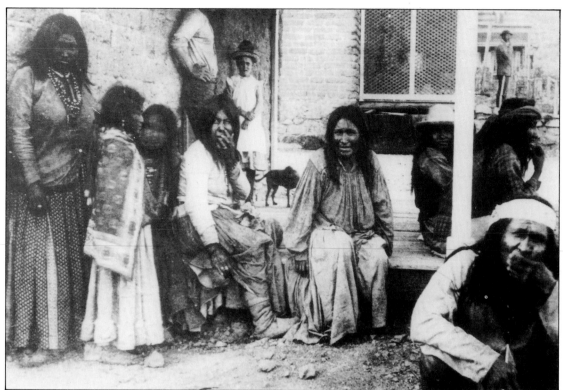

3.28 LEFT *Apache prisoners at Fort Bowie in 1886, after Geronimo's surrender. By an unidentified photographer.*

3.29 BELOW *The scene of the massacre of two-thirds of Big Foot's band at Wounded Knee, South Dakota. By George Trager, January 1891.*

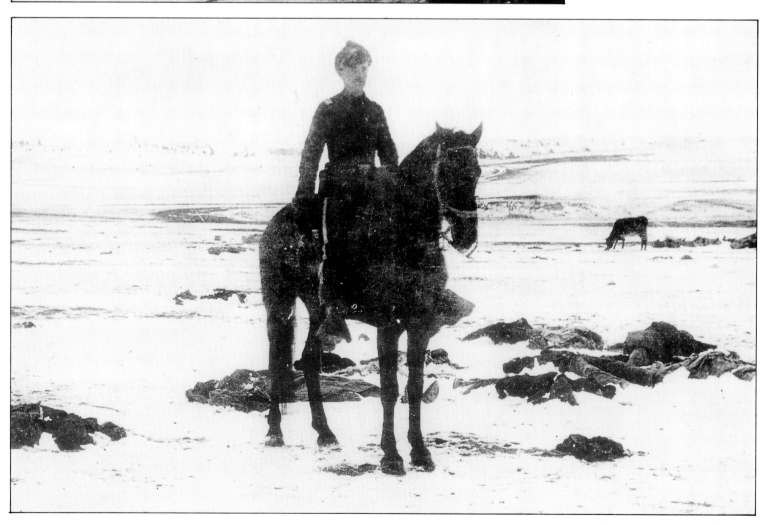

3.30 RIGHT *The battlefield at Wounded Knee, South Dakota. By George Trager, Northwestern Photographic Company, 1891.*

3.31 BELOW *Big Foot lying dead in the snow at Wounded Knee, South Dakota. By George Trager, January 1891.*

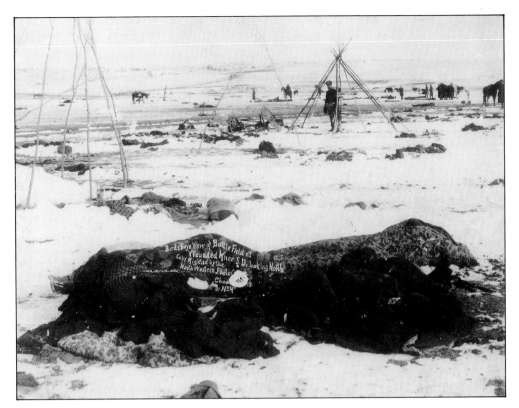

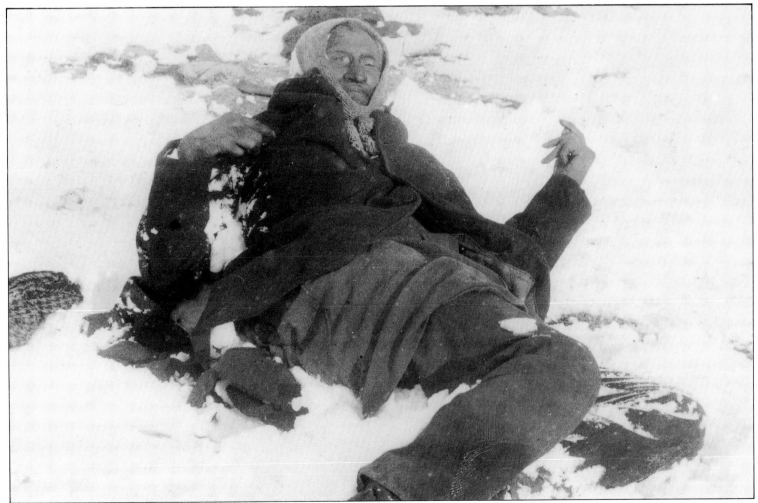

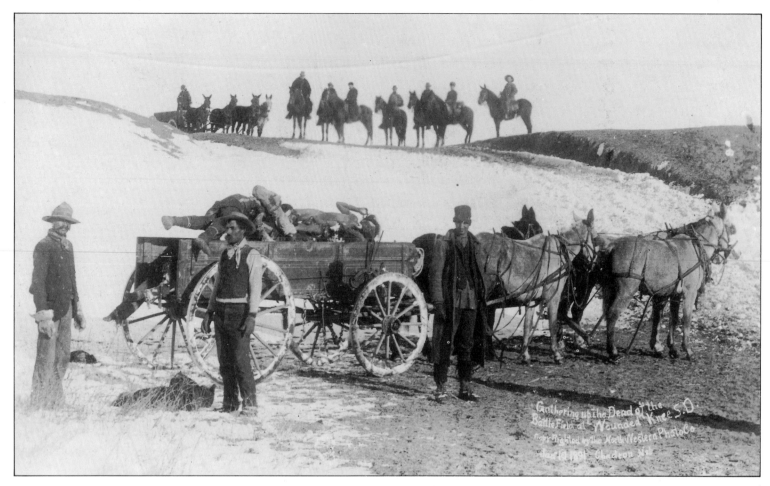

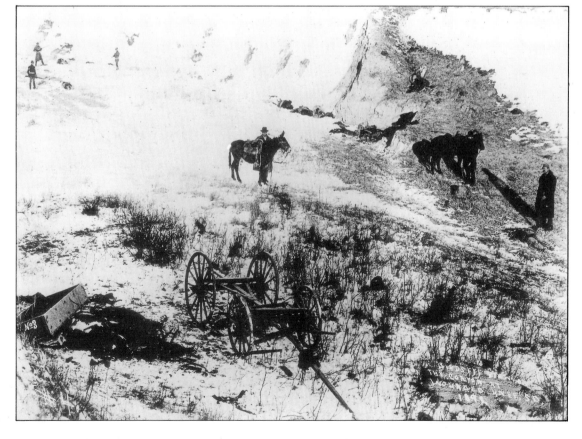

3.32 ABOVE *Gathering the dead at Wounded Knee, South Dakota. Taken by George Trager on January 1, 1891.*

3.33 LEFT *The scene at Wounded Knee, South Dakota. By George Trager, January 1891.*

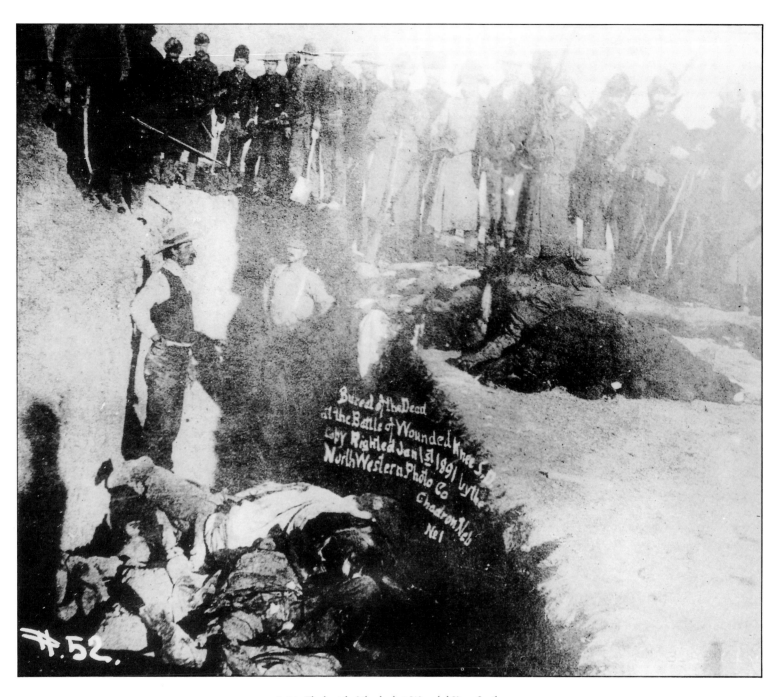

3.34 *The burial of the dead at Wounded Knee, South Dakota. Taken by George Trager on January 11, 1891.*

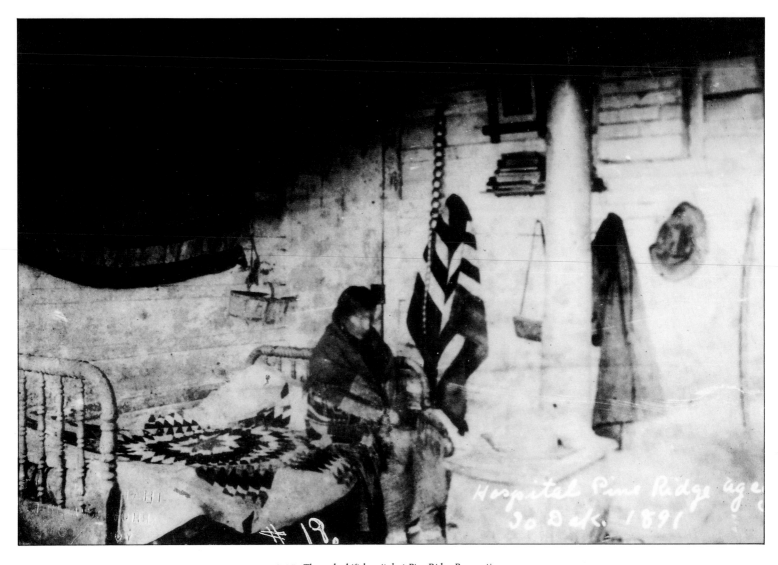

3.35 *The makeshift hospital at Pine Ridge Reservation,
South Dakota after the tragedy at Wounded Knee. By
George Trager, Northwestern Photographic Company,
1891.*

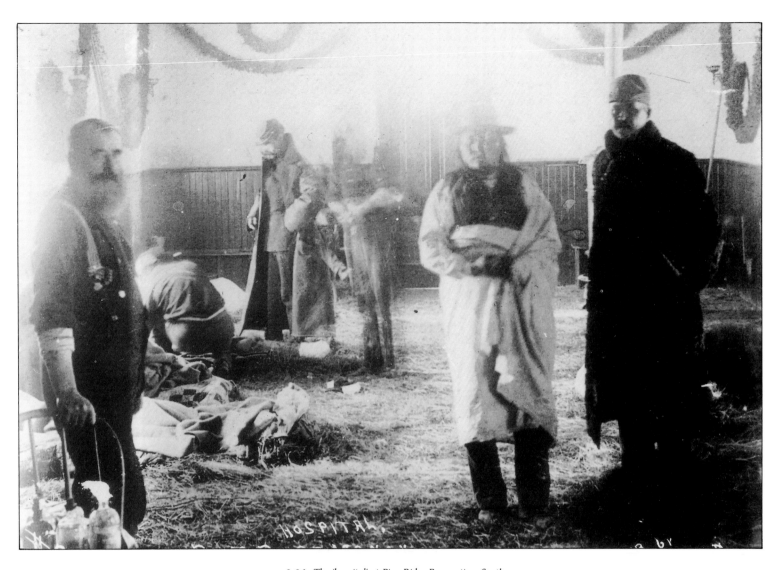

3.36 *The 'hospital' at Pine Ridge Reservation, South Dakota which was set up after the massacre at Wounded Knee. Christmas garlands deck the walls. By George Trager, Northwestern Photographic Company, 1891.*

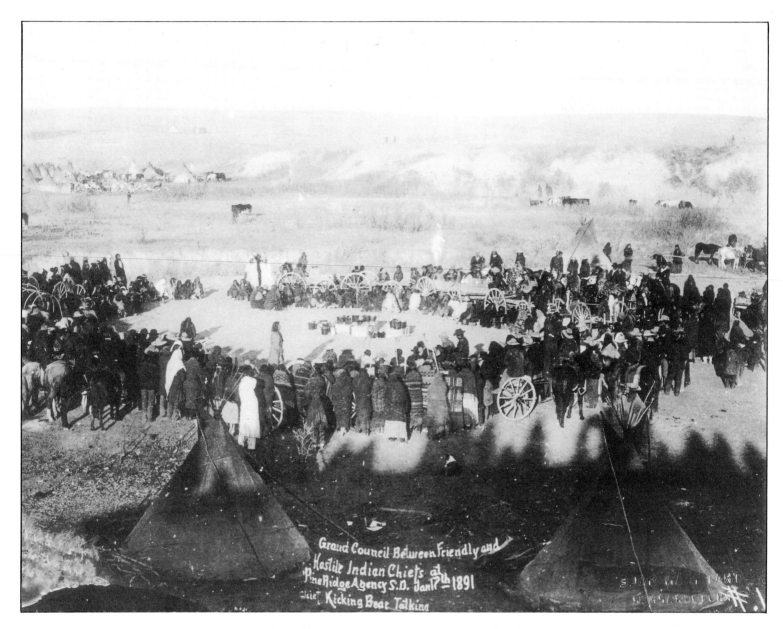

3.37 *A grand council between the 'friendly' and the 'hostile' Indians at Pine Ridge Reservation, South Dakota. Chief Kicking Bear is talking. Taken by George Trager, Northwestern Photographic Company, on January 17, 1891.*

3.38 RIGHT ABOVE *The Indian encampment at Pine Ridge, South Dakota. By George Trager, Northwestern Photographic Company, 1891.*

3.39 RIGHT BELOW *'Hostile' Sioux leaders after the tragedy at Wounded Knee: Two Strike, Crow Dog and High Hawk. By George Trager, Northwestern Photographic Company, 1891.*

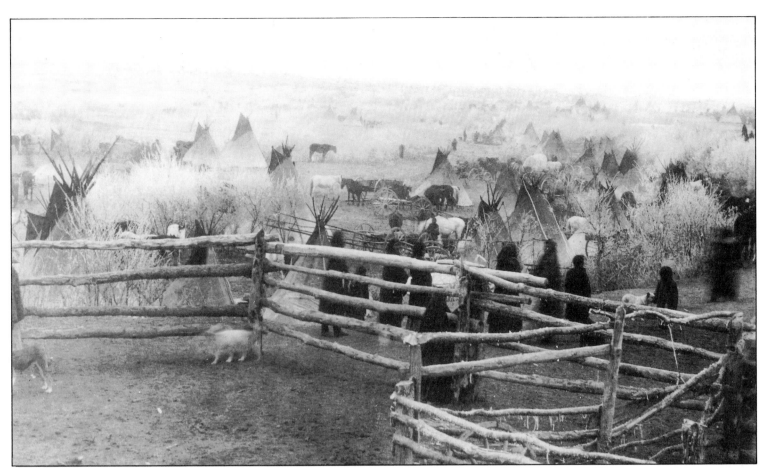

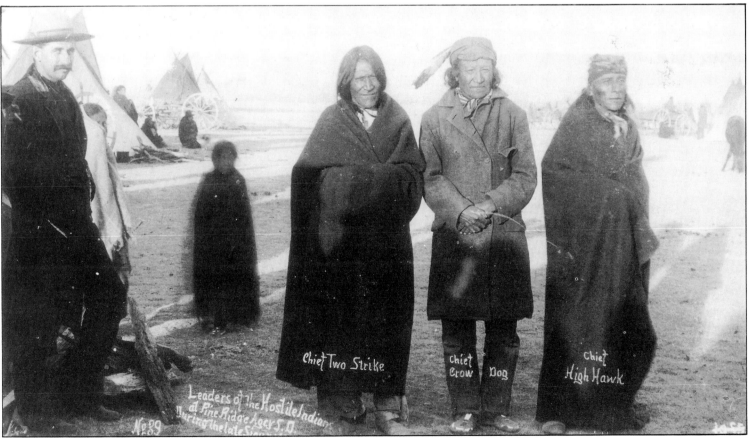

Chief Two Strike Chief Crow Dog Chief High Hawk

Leaders of the Hostile Indians at Pine Ridge Agency S.D. during the late Sioux war

No 39

PLANNING FOR THE FUTURE

ONE of the most sought-after commodities in America in the late 1800s was land. The growing white population continually wanted more, while open spaces were also basic to many Indian tribes, especially those roving the great plains. The 'Permanent Indian Frontier' west of the Mississippi River soon became the 'American Frontier' as Indians were first confined to general territories and then to ever smaller reservations.

In treaties made by the government with individual sovereign tribes, provisions were sometimes included defining territories within which the Indians were to stay. This is what was attempted during the 1851 Fort Laramie treaty negotiations, when individual tribes reluctantly agreed to give up land and remain in specific areas.[1] Black Hawk, an Oglala Dakota, summed up his reaction to the new territories: 'You have split my land and I don't like it. These lands once belonged to the Kiowas and the Crows, but we whipped these nations out of them, and in this we did what the white men do when they want the lands of the Indians.'[2]

THE BOSQUE REDONDO RESERVATION

The Indians attempted to preserve their lands and life-styles by warring with the encroaching white settlers. One government solution to the problem was to isolate the Indians on remote reservations, such as the Bosque Redondo in New Mexico. But by 1862, continuing Apache and Navaho depredations in New Mexico called for new solutions. In August, Brigadier General James H. Carleton became the new military commander of the area. Colonel Kit Carson was ordered to subdue the Mescalero Apaches while Carleton established the new military post of Fort Sumner at Bosque Redondo in the eastern part of the state. The army used Indian-like guerilla tactics in their ceaseless pursuit of the Indians. By November 1862, the Apache chiefs were ready to make peace. Carleton insisted that those interested in peace must move to the new reservation and adopt an agrarian life-style. By March 1863, most of the tribe had come to Bosque Redondo.[3]

Carleton's attention then turned to the Navahos. He issued an ultimatum: all Navahos who wanted peace must come to the new reservation by July 20, 1863, or be considered hostile and treated accordingly.[4] Faced with starvation as the military destroyed their crops and livestock, 6,000 Navahos surrendered. They made their way under military escort to Bosque Redondo on the infamous 'Long Walk', when nearly 200 Indians died. By the end of 1864, 8,000 Navahos – almost three-quarters of the tribe – had gathered at Bosque Redondo with the Apaches.[5]

Carleton then began an experiment to transform the Indians by creating what he hoped would be a model reservation. While continuing his military rule, he planned to 'teach their children how to read and write, teach them the arts of peace, teach them the truths of Christianity. Soon they will acquire new habits, new ideas, new modes of life, the old Indians will die

off.' He also noted that 'you can feed them cheaper than you can fight them'.[6]

The Bosque Redondo experiment soon proved to be a disaster. The Navahos and Apaches were enemies, and neither were agriculturalists by tradition. This might have been overcome if nature had not prevailed against them. Even though irrigation ditches had been dug, crops failed year after year due to droughts, inappropriate soil, alkaline water and insects. At the same time, government rations, already inadequate, were reduced still further. The model reservation had become a prison for hungry, diseased and demoralized Indians[7] who were not to find relief until after the American Civil War.

Once the War ended in 1865, the government turned its attention back to Indian affairs to prepare for the future. White expansion had not been halted by the War – indeed, with the exception of modern-day Oklahoma, all areas of the West had been organized into either states or territories.[8] Indian resistance increased. The government tried to solve the problems by receiving peaceful Indian delegations, by taking military action, and by increasing the efforts towards confinement. Secretary of the Interior James Harlan summed up the administration's new Indian policy in a letter to the Commissioner of Indian Affairs:

> The nation having now triumphed over the gigantic rebellion ... the President deems the present an auspicious and fitting time for the renewal of efforts to impress upon the Indians ... the rapidly increasing and pressing necessity for the abandonment of their wild and roving habits, and the adoption ... of the more peaceful and industrial arts of life.[9]

In July 1867, Congress created a Peace Commission. This Commission was to negotiate treaties whereby the Indians would give up their nomadic life and settle on reservations, in exchange for schools, instruction in farming, and temporary support in the form of clothing and food. If, however, the Commission failed, the military would be called in.

The Commission was primarily interested in the Plains tribes, but also turned its attention to the appalling conditions at the Bosque Redondo Reservation. In May 1868, Lieutenant-General William Sherman and Samuel Tappan met with the Indians. On June 1, a treaty was signed finally allowing the Navahos to return to their original homeland, which was now designated a reservation.

Few photographers covered the events at Bosque Redondo. William A. Smith was the photographer during an investigation of conditions by special Indian Commissioner Julius K. Graves. Although Smith recorded taking wet-plate negatives and tintypes, no images have been located.[10] In his diary, now in the Museum of New Mexico History Library, Smith reveals that another photographer, J. G. Gaige, also recorded events at the Bosque Redondo.[11] A third photographer of the Bosque Redondo has also

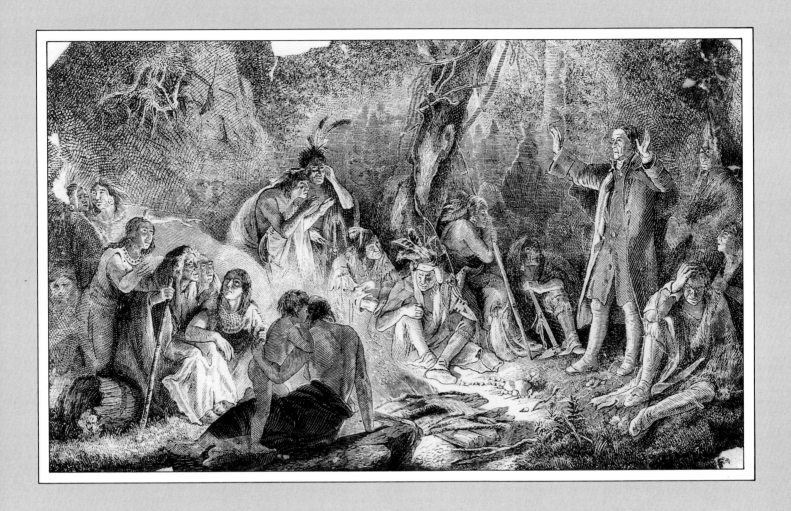

4.1 *The Indians' response to missionary preaching.*
Drawing by James E. Taylor.

been identified. In 1868 Swedish immigrant Valentine Wolfenstein set up a studio at Fort Sumner, and was present during the Bosque Redondo Peace Commission meetings; he also made glass negatives and tintypes of the event.[12] A photograph of guarded Navahos awaiting a head-count at Bosque Redondo (plate 4.2) may have been the work of any of these men.

RECORDING RESERVATION LIFE

The post-Civil War Indian reformers viewed the new reservation policy as an enlightened version of the old one. Humanitarian and economic arguments triumphed over advocacy of brute force. Secretary Harlan further expounded the government's goals for the Indians. While on reservations, the Indians would be allowed to support themselves to some extent in the traditional manner as hunters, but they would also be introduced to an agricultural life-style. During the difficult transition period, the government would make up the difference between the Indians' needs and what they were able to provide as farmers and hunters. Once the Indians became self-supporting, the government rations would cease and any surplus acreage would be given to the white population. At the same time, the young Indians would be educated in manual labor schools for their new way of life.

Harlan hoped that church and charity groups would aid in the endeavor.[13] It was also thought that on reservations, this transformation process could proceed unhindered by outside forces, and that soon the old tribal ways would change to those of the white society.[14]

Attached to both their homelands and their ways of life, the Indians resisted reservation life. Ten years were to pass before the Indians were contained upon reservations.[15] The government obtained Indian land by treaty, law and executive order, but the Indians were actually forced on to reservations by the millions of settlers who moved into Indian land, disregarding treaties.[16]

By the mid-1880s, there were 187 reservations for 243,000 Indians, ruled by the Indian Bureau which had grown from fewer than 300 employees in 1850 to over 2,500.[17] The reservations were under the charge of Indian agents and superintendents. These men liaised between the Indians and the government, and the success or failure of Indian relations depended heavily upon them.

A major problem for reservation agents was the provision of food for the Indians. Originally hunters were allowed off the reservations, but confrontations with white settlers who shot any Indian found away from these areas led to the restriction and finally the elimination of this provision.

The ration system was originally viewed as a stop-gap measure, designed to last a few years. The government issued food, cloth and clothing, wagons, tools and other necessities, but unfortunately the quality was poor. The clothing, which was supposed to be substantial and woolen, was made instead from one-ounce canvas and did not fit.[18] Tools were almost useless, and food, issued in insubstantial amounts, was of poor quality. With the loss of hunting privileges, the diminishing buffalo herds, and their lagging agricultural conversion schedule, the Indians were ultimately forced to depend upon the system:[19] the government had replaced the buffalo as their source of life. Photographer Katherine T. Dodge described her photograph of an issue day (plate 4.9):

The Indians stand in line against the wall of the agency building, and the pressure of many shoulders on innumerable Issue-days, have worn a long deep hollow in the adobe wall. The rule is, 'First come, first served.' The pushing and shoving and pulling and hauling, to get in ahead of their proper turn, is vigorous and unceasing. The scouts are kept busy, protecting the weak against the strong. The rations are issued once a week and consist mainly of raw beef, flour, cornmeal, salt, coffee, a modicum of sugar and the same of soap.[20]

Originally steers were issued directly to the Indians who could relive their old days by hunting them down. The cattle, however, were usually too weak to give chase, and finally the slaughter was taken over by agency personnel. Attempts at cattle raising failed as the animals were more immediately valuable as food than as a future income-producing commodity.

Congress, not understanding why the Indians were taking so long to become self-sufficient, curtailed the money provided for the benefits, or, as in the 1874 Indian Service Appropriation Bill, specified that rations would only be given to those able-bodied men engaged in some type of labor.[21] The agents, however, would not enforce this provision, knowing that revolts would occur if food were withheld.

Indian life on the reservations was infinitely easier and safer to photograph than that of the marauding, roving bands. Additionally photography became increasingly easy with various technical advances. By the early 1880s, the dry-plate negative had become popular. These negatives were easy to use and replaced the cumbersome wet-plate process. Studios sprang up in most medium-sized cities, producing thousands of photographers available to record the Indians. Both amateurs and professionals were attracted to the rich subject-matter afforded them by the Indians as well as to the potential for making a profit from the sale of the images. Their photographs found a market with the white population, who continued to be curious about the 'savages' of the frontier, and would remain so as long as the Indian Wars continued.

Studios were built at military installations; these provided both military and civilian photographers with the opportunity of making portraits not only of the troops, but also of the nearby Indians. Fort Keogh, established in Montana in response to the Battle of the Little Bighorn,[22] had such a photographic studio. This studio was first occupied by John H. Fouch from May 22, 1877 until November 11, 1878.[23] It was during this time that he photographed the Custer battlefield (see p. 47). In the fall of 1878, Stanley J. Morrow took up residence in the studio. He also operated a second studio at Fort Custer and took many photographs of the Indians. In December 1879, Morrow sold the Fort Keogh studio to Laton A. Huffman,[24] who took advantage of the location until about 1881.

On June 6, 1888 Christian Barthelmess arrived in Fort Keogh. He built his own studio in the north part of the Fort in an area known as 'Soap Suds Row'. Barthelmess, a very competent photographer, took images in his spare time and while on detached military service from his normal duty as military musician. He was assisted by R. C. Morrison of Miles City, and remained approximately ten years until he was transferred.[25] Barthelmess photographed Indian reservations on many occasions. He was able to record the formation of Lieutenant Casey's scouts in 1889, as well as many issue days (plate 4.7). His military career had also taken him to Fort Apache in Arizona, Forts Wingate and Bayard in New Mexico, and Fort Lewis in Colorado. In 1903, he returned to Fort Keogh, and remained there until his death in 1906.[26] He recorded the Indians at most of these forts, especially the Navahos in New Mexico.

Apart from hunger, boredom was another hardship on the reservations. Apache women at the San Carlos Reservation gathered hay and sold it for

one cent a pound to the army for its horses (plate 4.12).[27] The men, former hunters and warriors, were not eager to adopt a farming life-style. Even those who attempted to learn found it difficult, as the land was infertile and there was only one farming instructor for each reservation. The instructor could not hope to guide several hundred fledgling farmers over an area that might be the size of a small state.[28]

One solution to the problem of providing useful occupations for the men was to establish Indian police forces. These forces paralleled or replaced similar tribal organizations, and were a natural extension of the use of Indians as scouts.[29] Police forces were formed on such reservations as the Pawnee, Navaho, Klamath, the Chippewa in Wisconsin, and the Blackfoot. A notable Indian police force was created by agent John P. Clum on the San Carlos Apache Reservation. The Standing Rock Dakota Police Force was involved in the killing of Sitting Bull when he resisted arrest in 1890 (see p. 47).[30]

The uniformed police forces were another element of reservation life recorded by photographers. Agent Clum's San Carlos police were photographed while on parade with their new uniforms purchased by popular subscription (plate 4.11).

During the 1880s the continued influx of settlers and cattlemen, and the changes made by the railroads, continued to reduce the Indians' land base. A general dismantling of the reservation system was under way, stopped only by the Dawes Act of 1887 which allotted reservation land in severalty to some of the Indians.[31] The Great Sioux Reservation was finally broken up. After many attempts to press the Sioux into selling their land, they finally settled for $1.25 an acre in 1889.[32] Some of the negotiations and portraits of the major participants were recorded for posterity by photographers such as David F. Barry.

MISSIONARIES AND INDIANS

The agents running the reservations controlled both the Indians' life and property. While many worked selflessly for the Indian cause, others abused their positions. In 1870 President Grant attempted to remedy this situation by introducing his new Peace Policy; this included the assignment of Indian reservations to particular Christian denominations, which were given authority to nominate agents.[33]

Working with the Indians was not new to the missionaries, indeed, 'missionary zeal to convert the Indians to Christianity accounted for much of the contact between Indians and whites in the US'.[34] Missions and schools had been established by Roman Catholics and Protestants alike from early colonial times.

The new Peace Policy was meant to transform the Indians by instruction and good Christian example. The peaceful Quakers were involved early in the new program when their Agent Laurie Tatum was assigned to the Kiowa and Comanche Reservation. Although he encouraged the Indians to adopt a peaceful, agricultural life-style and to cease their raiding, he ultimately needed military help to insure peace. In resorting to military force Tatum had violated his Quaker principles, and he resigned. As Hagan so aptly described the almost impossible situation:

There was no more incongruous spectacle than that of a Quaker agent preaching the virtues of peace and agriculture to a plains warrior, treating this man, rightfully proud of his highly developed skills as a horseman, hunter, and fighter, as a simple, misguided soul who could be brought to see the error of his ways by compassion and sweet reason.[35]

None the less, many religious denominations became involved with the Indians (plates 4.1, 4.15–4.20). The Roman Catholics were especially active, with Jesuits, Franciscans and many congregations of nuns devoting themselves to evangelizing the Indians. The Methodists, Presbyterians, Baptists, Episcopalians, Mennonites, Moravians and Mormons were also actively involved, as was the American Board of Commissioners for Foreign Missions (the ABCFM).[36]

Some of the missionaries were also amateur photographers, and the Indians were recorded through their eyes. In the 1890s, Father Pietro Paolo (Peter Paul) Prando took many photographs of the Indians. Born in Italy, he entered the Society of Jesus and volunteered for service in the Rocky Mountains Missions. He arrived at St Peter's Mission in Montana in 1880, and in 1883 joined the St Francis Xavier Mission. He worked among the Dakota, Cheyenne and Blackfoot Indians, and especially the Crow, before his death near Spokane, Washington in 1906.[37] Prando's close relationship with the Indians is revealed in his sensitive photographs. His portrait of She Likes To Move The Camp (plate 4.19) confirms his comment: 'The name was good when she was young, now she is old and rather: "She Likes To Sit Down" ... She went through many hardships in her life and she chops wood yet. And she is very happy when I call her my mother.'[38]

Pretty Eagle, another Crow Indian, revealed the Indians' changing attitude to photography. He had learned the potential power of the photograph and asked that his portrait be taken by Father Prando so that it could

... be sent to Washington ... to let everybody know that with the Indian money the price of a portion of their reservation, which money over $200,000.00 is laying down somewhere in Washington, he wants a big ditch to be taken out from Big Horn River and come down and irrigate all big valley...[39]

Other missionary photographers include Father Zimmerman, and later Father Buechel who took photographs of the Indians at the Rosebud Sioux and St Francis Missions from the late 1890s until 1950. In covering this time span, they created an incomparable collection of photographs (now in the St Francis archives) that shows the continuing changes in Indian life-style.[40]

Some missionaries, then, were able to take off enough time from their duties to photograph the Indians in their charge. Brother Simeon Schwemberger, a Franciscan monk, actually had a photographic studio in Gallup, New Mexico and photographed the Blackfeet, Hopi Navaho and other Indians in the area.[41]

By the late 1880s, lightweight, hand-held Kodak cameras had put photography firmly in the hands of the general public. The ease of the new technology allowed everyone to record events in their own lives and surroundings whenever they wished. Missionaries and non-missionaries alike were thus able to capture elements of the Indians' changing religion and life-style.

'EDUCATING' THE INDIANS

Education was the cornerstone of the government's transformation plan. Without an education program, there was no hope for any permanent changes. Ironically, the first major government boarding school was not on a reservation, but at Carlisle, Pennsylvania and had grown out of the Plains Indian Wars.

In an attempt to end hostilities with Plains Indians, the government

rounded up inveterate Kiowa, Comanche and Cheyenne warriors who could not be subdued, and sent them as prisoners to Fort Marion at St Augustine, Florida. The first group arrived on May 21, 1875, and were recorded by an unidentified photographer.[42] These Indians were joined by some Apaches whose journey to Fort Marion took twenty-four days by horsecart, wagon, steamboat and train. Their railroad journey was covered by A. J. McDonald of New Orleans (plate 4.21).

Once at Fort Marion, the Indians were placed in the seventeenth-century dungeons, where several died of malaria.[43] Richard Henry Pratt, a military officer, was in charge of the prisoners. He set out to change their conditions and to train them: he relaxed authority, allowed privileges, put them in uniforms and employed them to help build new, habitable barracks.

During their incarceration at Fort Marion the Indians were recorded by the many amateur and professional photographers who visited the prison (plates 4.23). Pratt undoubtedly supported this unsolicited publicity for his work of civilizing the Indians, a publicity he would rely upon more as time went by. The Indians in turn recorded their experiences in drawings (plate 4.22). One of the artists was Making Medicine, a Cheyenne who surpassed expectations and later became an Episcopal deacon at his own tribe's reservation in Indian Territory.[44]

Pratt was also interested in educating the prisoners, and he trained them as bakers, fishermen and field laborers. When their imprisonment came to an end, he persuaded the army to let him continue his work in Indian education. Pratt was assigned to the Hampton Normal and Agricultural Institute, a black school in Virginia. He arrived with twenty-two of his students in April 1878. Pratt soon went West to recruit more Indian students for his experimental school (plates 4.24, 4.25).[45] He returned with forty-three more Indians, but was dissatisfied with Hampton as he wanted the Indians to have their own independent chance to change. He therefore proposed a separate Indian school.

The army agreed with Pratt, and a new school was set up at the abandoned military barracks at Carlisle, Pennsylvania. In 1879, Pratt again went West, recruiting students from the Rosebud and Pine Ridge Reservations. Eighty-two children came East with him, joining fifty-five new students from the Indian Territory. On November 1, 1879 the school was officially opened.[46]

Pratt wanted to produce a model Indian school. His motto was emblazoned on the school newspaper: 'To civilize the Indian, get him into civilization. To keep him civilized, let him stay.'[47] Students were transformed with haircuts and clothing changes, and all classes were taught in English.

The children, who had grown up relatively freely, were undoubtedly lonely and resentful of the restrictions imposed by the regimented life of a boarding school. Their parents found it difficult to understand how 'book learning' would teach their children to survive on the frontier as they had known it.

Students were even given new names, either before coming to the school or shortly afterwards. Some were named after famous white people, while others were named after whites they had known. Thus, the Zuni students shown in John K. Hillers' photograph (plate 4.26) carried names associated with their pueblo such as 'Frank Cushing', after the anthropologist, and 'Taylor Ealy', 'Mary Ealy', and 'Jennie Hammaker', named after their missionary teachers, whom they had left behind to go to Carlisle.

For many years, Pratt lectured on the school's achievements, frequently using photographs taken by the local, semi-official school photographer, John N. Choate. 'Before and after' portraits were made of the students,

such as the Ealys (plates 4.27, 4.28); and pictures were taken of visiting Indian delegations and of the school itself. By now Pratt had developed a skilful ability to exploit the power of photographs. He used these portraits repeatedly to support his belief that the Indian could be changed, and that he knew how to do it.

As a result of his strong political views, Pratt was eventually relieved of his Carlisle post on June 15, 1904.[48] The school stayed open until 1918, and during those years it was supervised by other military officers, and recorded by other photographers such as A. A. Line, Choate's successor, and Frances Benjamin Johnson.[49] Interestingly, Johnson had received some of her early photographic training from the Smithsonian photographer, Thomas M. Smillie.[50]

A few off-reservation schools such as Carlisle could not hope to re-educate all Indians. Schools were therefore set up on the reservations. By 1884 there were approximately 200 Indian schools at places such as Chilocco in Indian Territory, at Lawrence, Kansas and at Genoa, Nebraska. Many of the boarding schools were run by churches under government contract, while others were independent missionary schools. By 1887, 10,000 Indian children were in school.[51]

The staff soon found that their duties did not stop at teaching reading, writing and arithmetic. They were frequently responsible for teaching agricultural and technical skills, as well as for feeding and caring for the students. Like the missionaries, these teachers occasionally found time to photograph the Indians.

In 1898, Arthur E. McFatridge went to the Rosebud Reservation in South Dakota to teach Oglala Dakota students. While there, he recorded his life as a schoolteacher and that of his students. Later he compiled his photographs into an unpublished manuscript entitled, 'Among the Indians: A Study of the Habits, Customs and Characteristics of the Oglala' (now in the hands of relatives).[52] Although his photographs were typical amateur images, McFatridge's comments reveal him to be a caring man whose life was enriched by the Indians. He wrote:

In going about my regular duties while working among the Indians, I was sometimes led to do things and see places that I would not otherwise have sought, but in so doing was brought close to the red man and given some understanding of his nature ... I knew them as chiefs and as paupers with the pride starved out of them, and while I may have taught them a few things, they taught me many things.[53]

Another teacher on the Rosebud Reservation was Jesse Hastings Bratley. Bratley also worked hard caring for and educating the Indians, but still found time to photograph his surroundings. Besides turning his camera on student activities, he also photographed the school, and even Arthur McFatridge (plates 4.30–4.34).

Bratley's photographs eloquently reveal the changing Indian life-style in which he played a role. His first post as a teacher was in 1893–95 at the Port Gamble Indian School in Puget Sound, Washington (plate 4.29). From 1895 until 1899 he worked and photographed at the Lower Cut Meat Creek School on the Rosebud Reservation. He then went to the Cheyenne and Arapaho Cantonment Boarding School in Oklahoma until 1900, and was with the Havasupai at Cataract Canyon, Arizona until 1901 (plate 4.35). From there he went to Polacca, near the Walpi Pueblo in Arizona, staying until approximately 1903.[54] All his pictures can be accurately dated to these periods and we are lucky to have such a complete sequence. Although Bratley photographed some of the Indians in Wash-

ington, and many in the Southwest, most of his images are from the Dakota Reservation at Rosebud.

The Indian school system, like the reservations, was heavily dependent on the government for funds. The government had planned for the Indians' future, but once the Wars ceased, more responsibility was placed in the hands of humanitarian organizations. Congress gradually reduced funds to the Indian schools, until 1896 when the budget was cut by 80 per cent. In 1900 government support for church-run Indian schools was completely withdrawn.[55]

RECORDING NEW LIFE-STYLES, 1900–14

A new era of life had begun on the reservations. The once hostile 'savages' had been safely confined, and as time passed, the attitude changed and the Indian was seen as the 'noble red man'. Photographers armed with new artistic techniques were able to reveal this attitude. Others, however, preferred the techniques of good documentary photography and recorded life on the reservations in the early years of the twentieth century.

Two of the best such documentary photographers differed radically in their backgrounds. The first, Fred E. Miller, was a civil servant on the Crow Reservation in Montana from 1897 to 1910. As a government employee he kept records on various Indian activities on the reservation; as a photographer he recorded the division of their life-style between traditional and white elements (plates 4.39, 4.40). He did not attempt to condemn or romanticize the Indians with his images – he simply documented Indian life as he found it.

During much the same period, Walter McClintock was recording the Blackfoot Indians' reservation life, starting in the 1890s. Enjoying the benefits of independent wealth, McClintock was able to study and record the Indians. He spent much time talking to the older Indians, and recorded many of their memories and stories. He backed up his research by taking photographs of their ceremonies (plate 4.41), images which he sometimes used in writings published by the Southwest Museum.

McClintock shared his interest in photography with Thomas Magee, the husband of one of his informants. It is possible that some of the images credited to McClintock were actually the work of McGee, and vice versa. None the less, these photographs provide an important documentary resource for scholars of traditional Blackfoot life.[56]

By the time of World War I, the reservation life of the Indians had changed drastically (plate 4.42); it had taken only sixty years – approximately one lifespan. Most of the great reservations had been reduced or eliminated, with many Indians consolidated upon Indian Territory in present-day Oklahoma. An era of change resulting from cultures in conflict had been recorded for posterity through the efforts of photographers.

4.2 ABOVE *Navahos awaiting a head-count under guard at Bosque Redondo, New Mexico. By an unidentified photographer.*

4.3 RIGHT *A Cherokee payment, probably for land. By an unidentified photographer.*

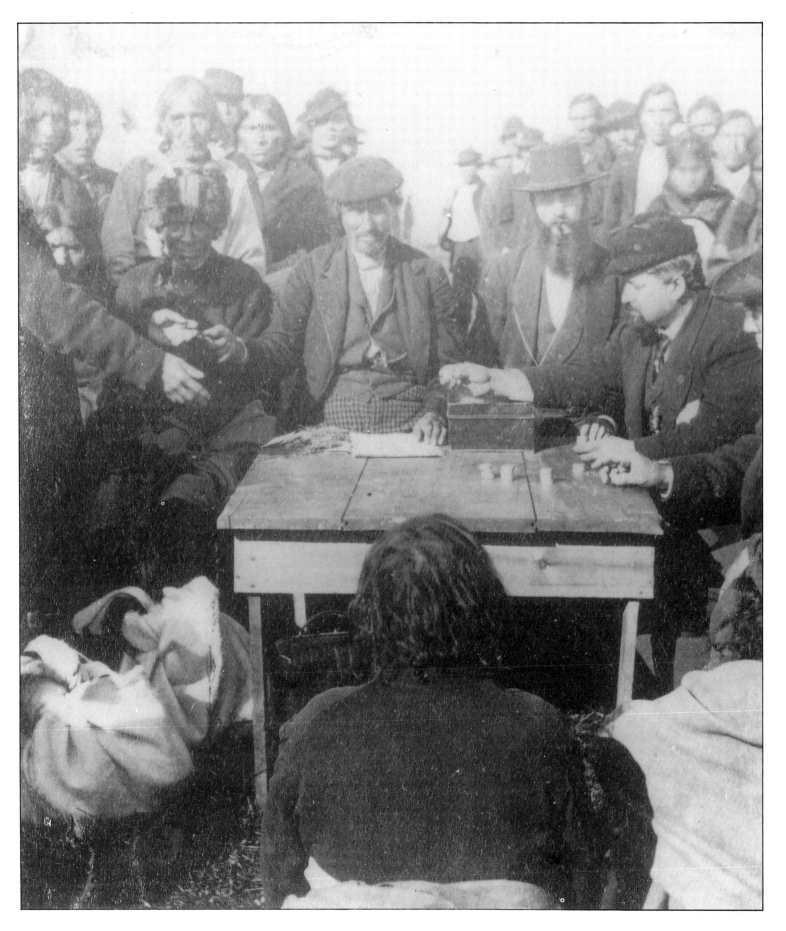

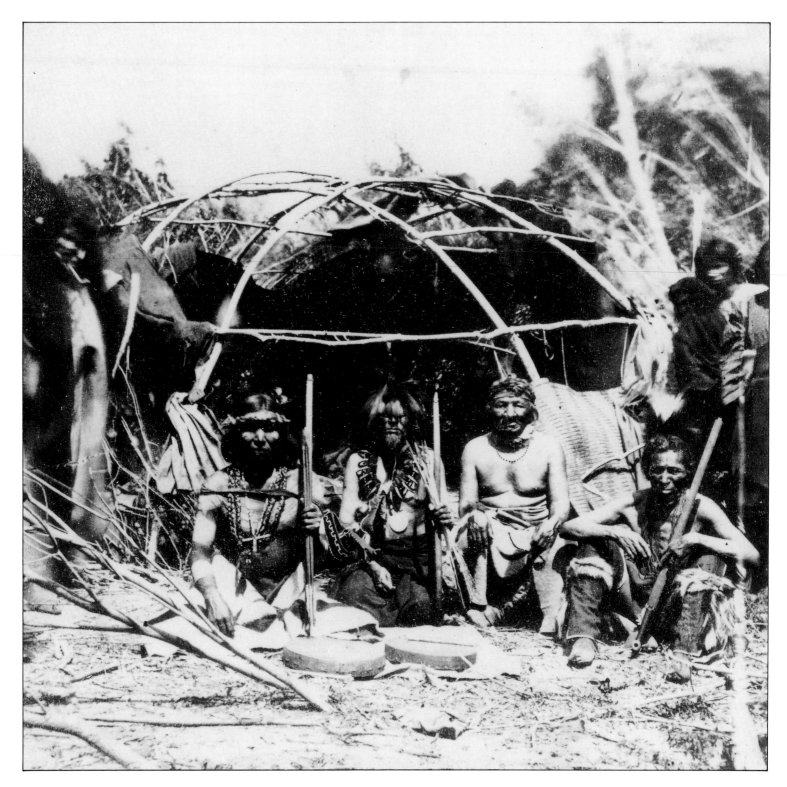

4.4 *A group of Winnebagoes at Fort Snelling at the time of their removal in 1863. Winnesheik (center) refused to go with his band to the new reservation, and soldiers had to be sent for him. By Benjamin Franklin Upton.*

4.5 RIGHT ABOVE *The scene at the Cherokee payment of 1894. By an unidentified photographer.*

4.6 RIGHT BELOW *A government agent distributing food rations to the Dakota Indians. By an unidentified photographer.*

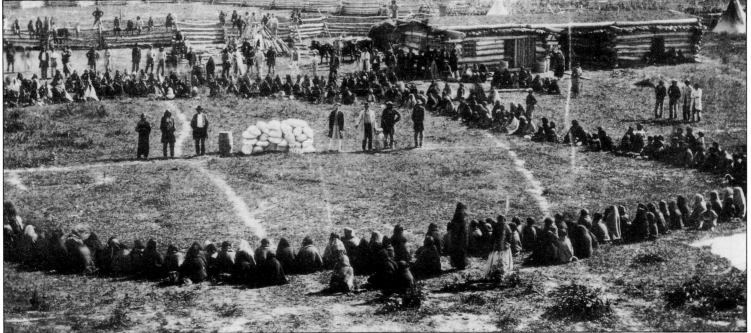

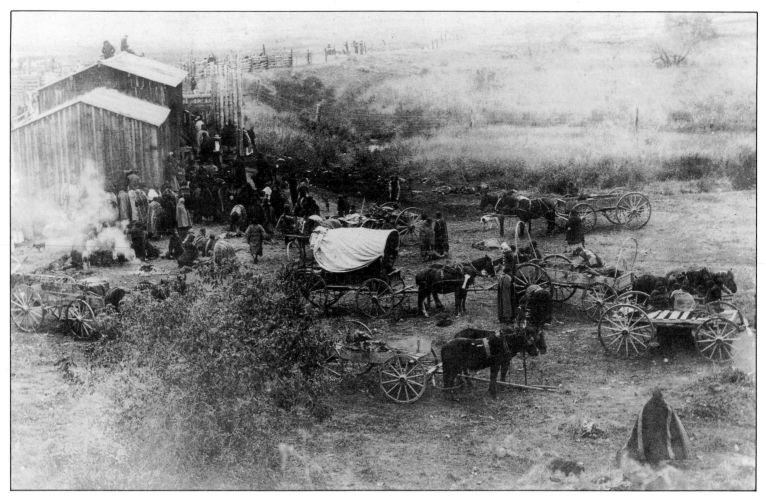

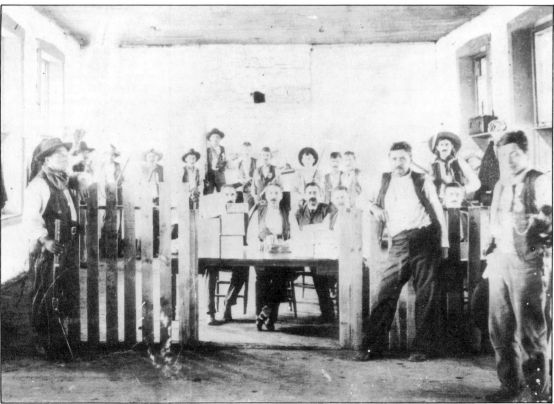

4.7 ABOVE *Beef issue for the Cheyenne Indians of Lame Deer, Montana. Taken by Christian Barthelmess some time between 1888 and 1897.*

4.8 LEFT *The scene at the Cherokee payment in the barracks at Fort Gibson, Oklahoma. Although this photograph was taken several days after the payment began, there are still hundreds of thousands of dollars left. The man seated in his shirtsleeves at the table is Treasurer E. E. Starr; the large man beside him is Cherokee Chief C. J. Harris. The amount paid to each Cherokee man, woman and child was $267.70. By an unidentified photographer.*

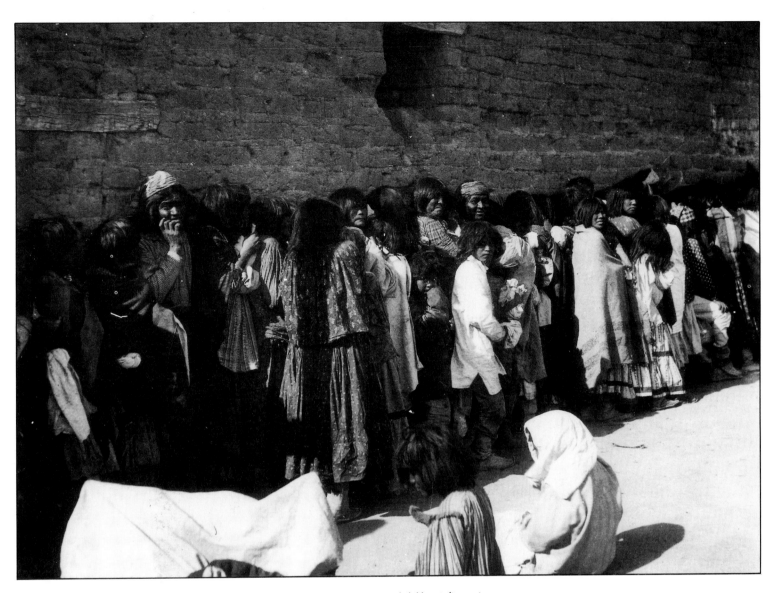

4.9 *Apache men, women and children in line on issue day at San Carlos, Arizona. By Katherine T. Dodge, 1899.*

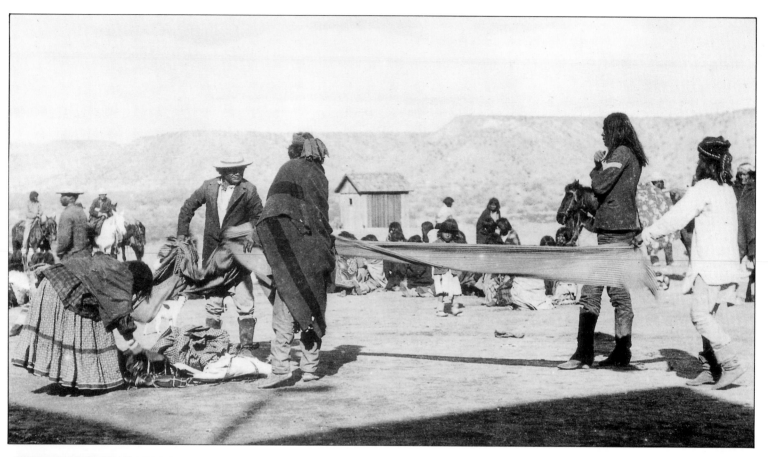

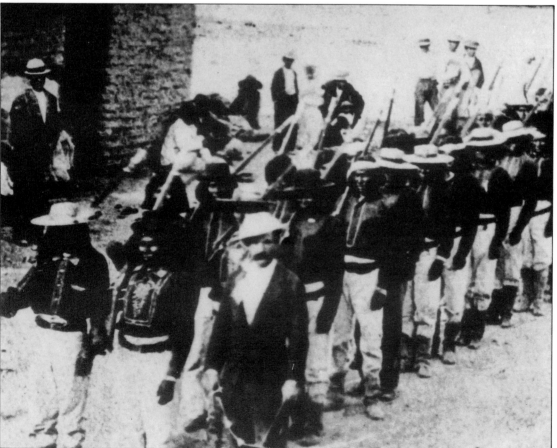

4.10 ABOVE *Measuring cloth during a government issue at the Apache reservation, San Carlos, Arizona. Possibly by C. A. or D. A. Markey, 1887.*

4.11 LEFT *Agent John P. Clum and the San Carlos Apache police on parade at Tucson, Arizona in May 1876. The Indian police are in new uniforms, purchased by popular subscription. By an unidentified photographer.*

4.12 RIGHT ABOVE *Apaches bringing in hay in order to sell it for one cent a pound to the US military. By C. A. or D. A. Markey, San Carlos, Arizona, 1887.*

4.13 RIGHT BELOW *Issuing wood to Apaches at San Carlos, Arizona. By Camillus S. Fly, possibly in 1886.*

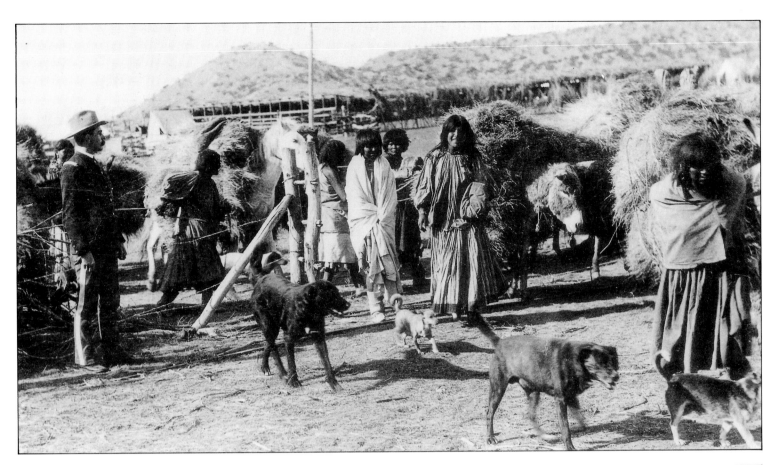

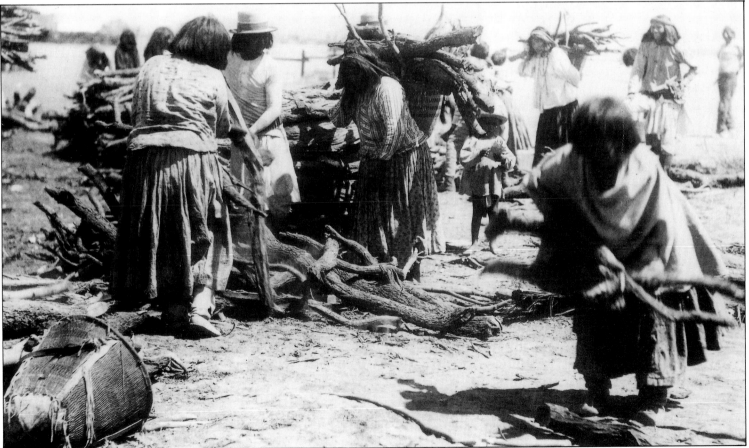

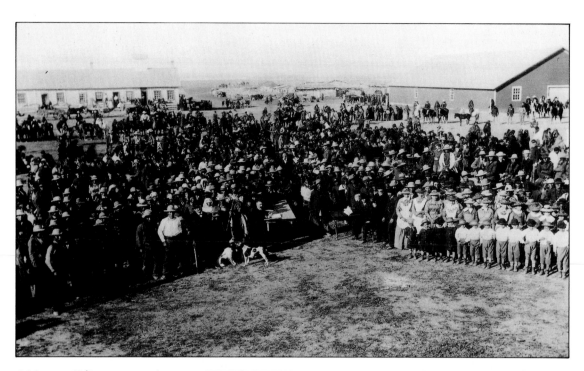

4.16 RIGHT ABOVE *An Indian brush church with cross and bells. By the Elite Studio of San Diego, California.*

4.17 RIGHT BELOW *The Christian funeral of Haida Chief Somihat, January 1912. By an unidentified photographer.*

4.14 ABOVE *Taking a census at the Standing Rock Reservation, Dakota Territory. By David F. Barry.*

4.15 RIGHT *The baptism of Paiute Indians near St George, Utah. By Charles R. Savage, 1875.*

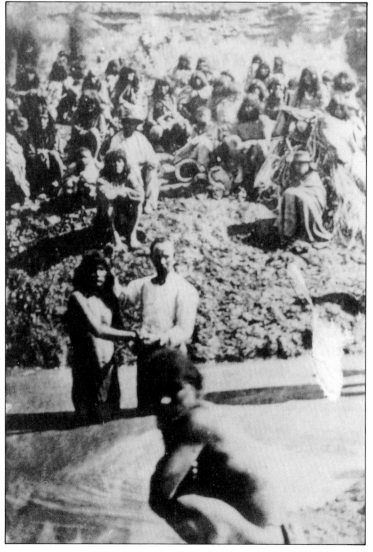

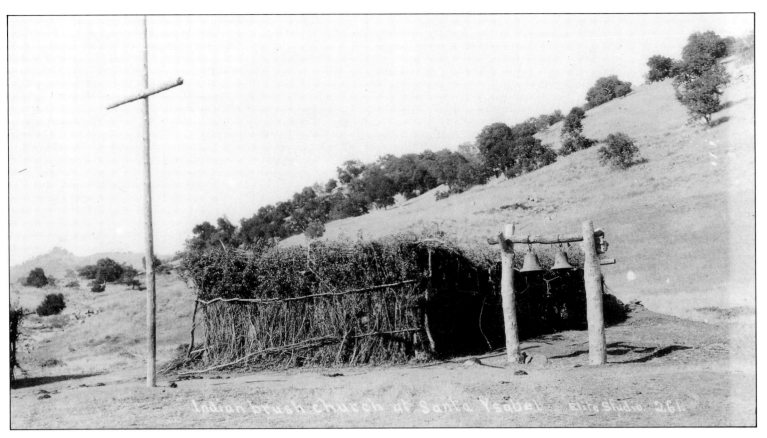

Indian brush church at Santa Ysabel. Elite Studio. 261.

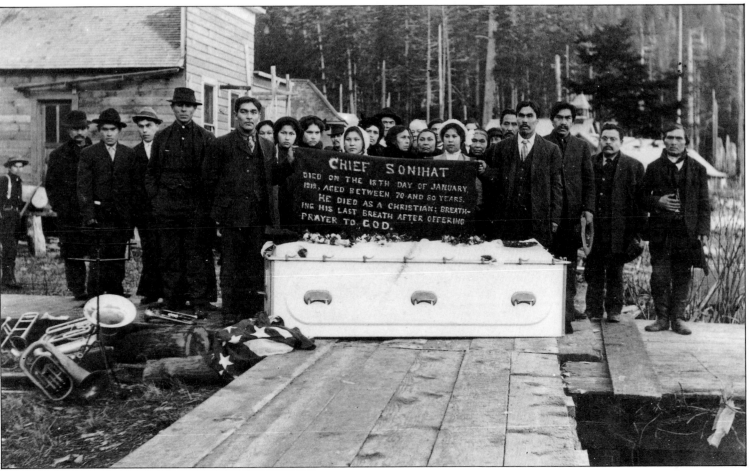

CHIEF SONIHAT
DIED ON THE 18TH DAY OF JANUARY,
1918, AGED BETWEEN 70 AND 80 YEARS.
HE DIED AS A CHRISTIAN; BREATH-
ING HIS LAST BREATH AFTER OFFERING
PRAYER TO GOD.

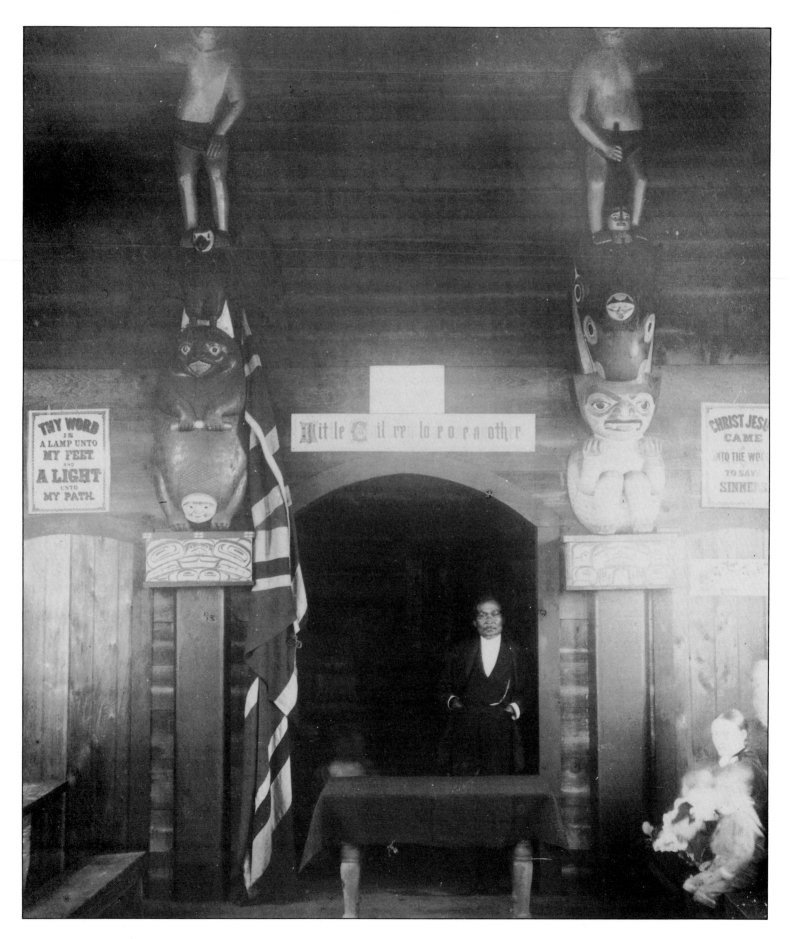

4.18 LEFT *The Mission Sunday School of the Rev. William Duncan, a Tsimshian, Old Metlakatla, British Columbia, before 1883. By an unidentified photographer.*

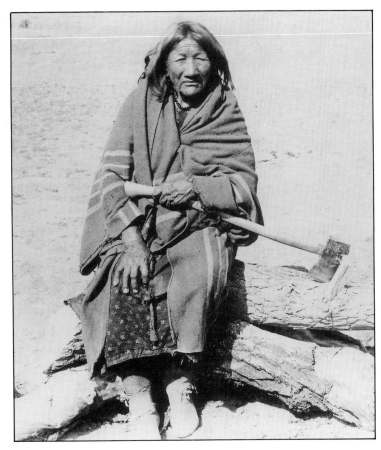

4.19 LEFT *She Likes To Move The Camp, a Crow Indian, at the St Francis Xavier Mission, Montana. By Father Peter Paul Prando, c. 1890.*

4.20 BELOW *Long Feather, a Dakota, wearing a crucifix. By David F. Barry.*

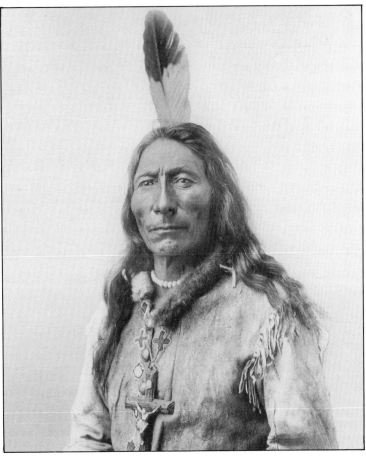

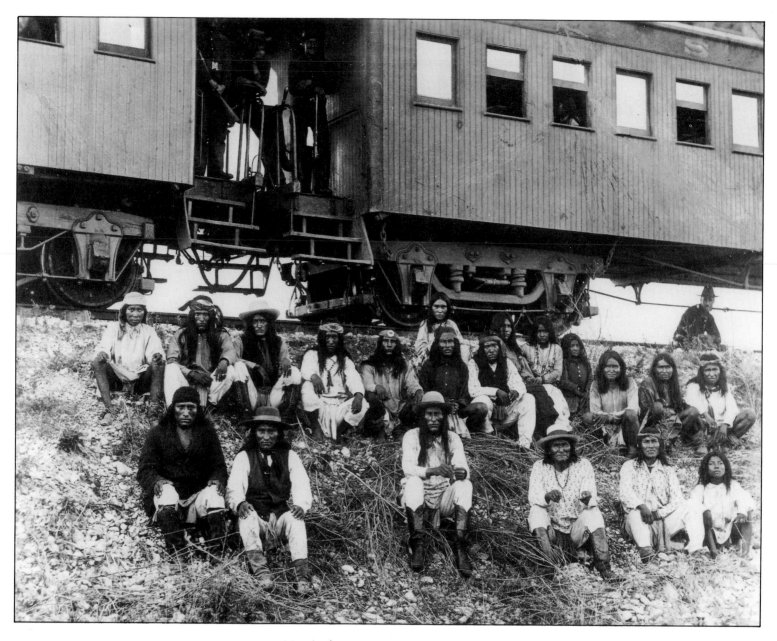

4.21 *Apache prisoners, including Geronimo (fourth from the left, front row), in transit to Fort Sam Houston, Texas and Fort Marion, Florida. Probably by A. J. McDonald, 1886. See also plates 3.25–3.27.*

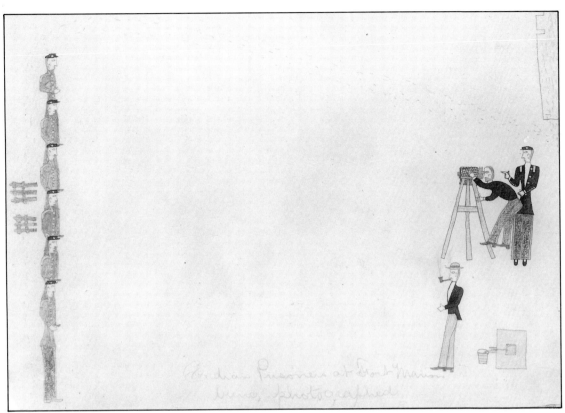

4.22 LEFT *Indian prisoners being photographed. Drawing by Making Medicine, a Cheyenne prisoner at Fort Marion, St Augustine, Florida, August 1875.*

4.23 BELOW *Arapaho, Caddo, Cheyenne, Comanche and Kiowa prisoners at Fort Marion, 1875–8. By an unidentified photographer.*

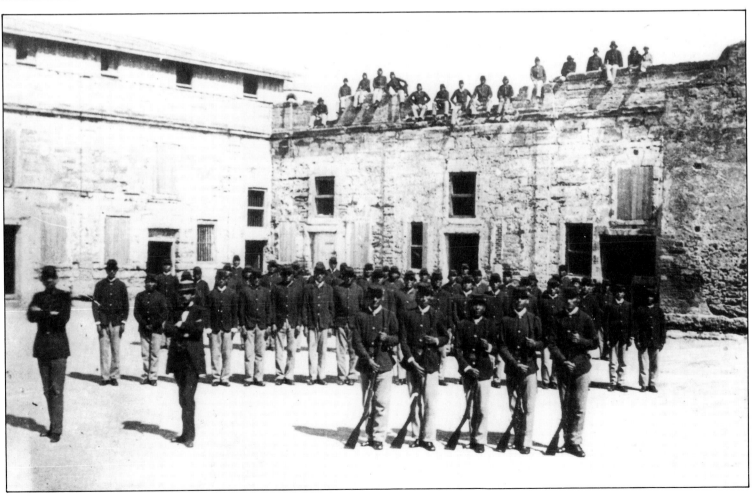

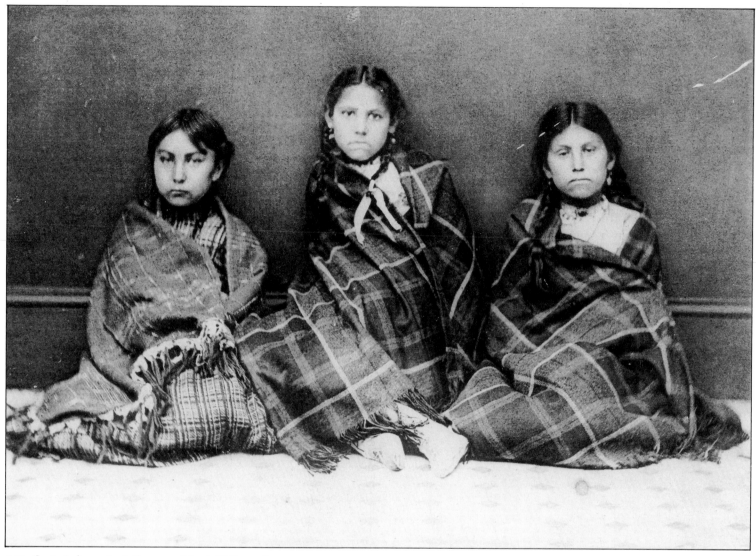

4.24 *Carrie Anderson, Annie Dawson and Sarah Walker on their arrival at the Hampton Normal and Agricultural Institute, Virginia in November 1878. By an unidentified photographer.*

4.25 RIGHT *Annie Dawson, Carrie Anderson and Sarah Walker fourteen months after their arrival at the Hampton Normal and Agricultural Institute, Virginia in February 1880. By an unidentified photographer.*

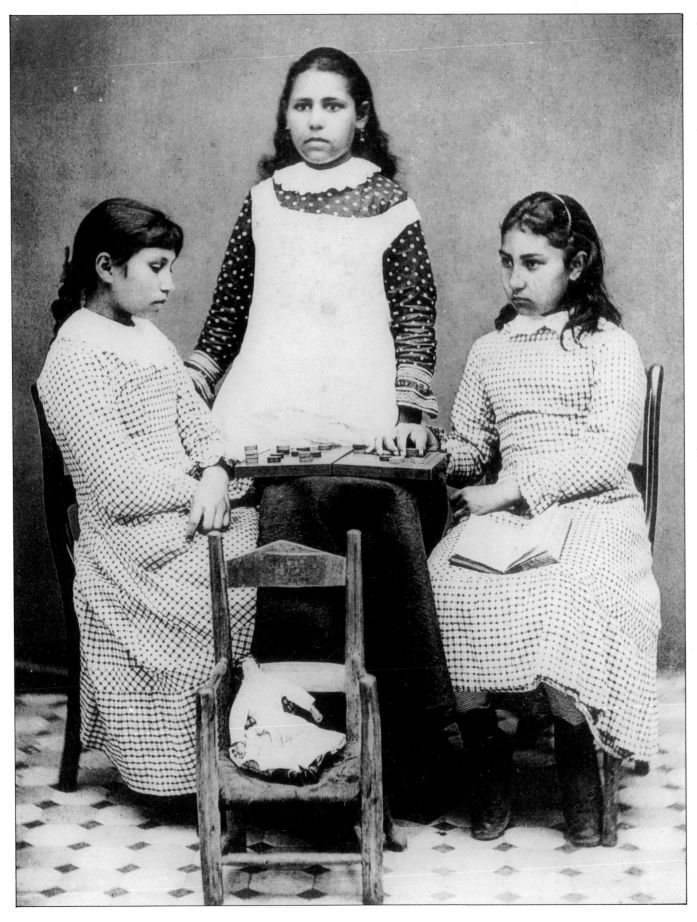

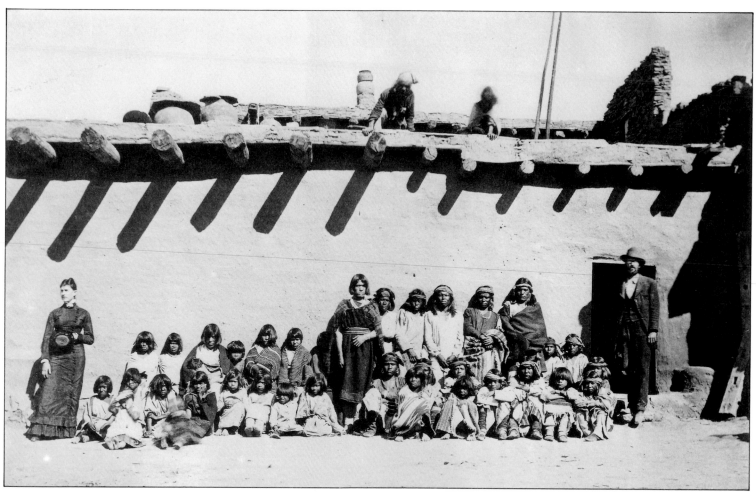

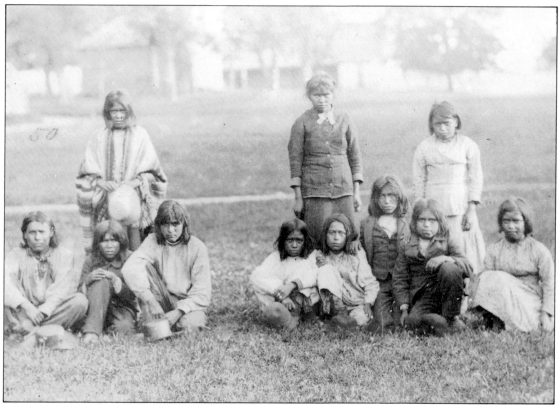

4.26 ABOVE *Children at the Zuni Pueblo school in Carlisle, Pennsylvania run by Taylor Ealy (standing, right). Miss Jennie Hammaker (standing, left) was their teacher. Some later left the pueblo for further education in the East. By John K. Hillers, 1879.*

4.27 LEFT *Pueblo and Apache Indian students on their arrival at Carlisle Indian School, Pennsylvania. This 'before' photograph includes four Zuni students who were to adopt the names of whites on the pueblo: Frank Cushing, an anthropologist, and Taylor Ealy, Mary Ealy and Jennie Hammaker, missionaries and teachers. Probably by John N. Choate.*

4.28 *Zuni students Frank Cushing, Taylor Ealy, Mary Ealy and Jennie Hammaker after their stay at the Carlisle Indian School, Pennsylvania. Probably by John N. Choate.*

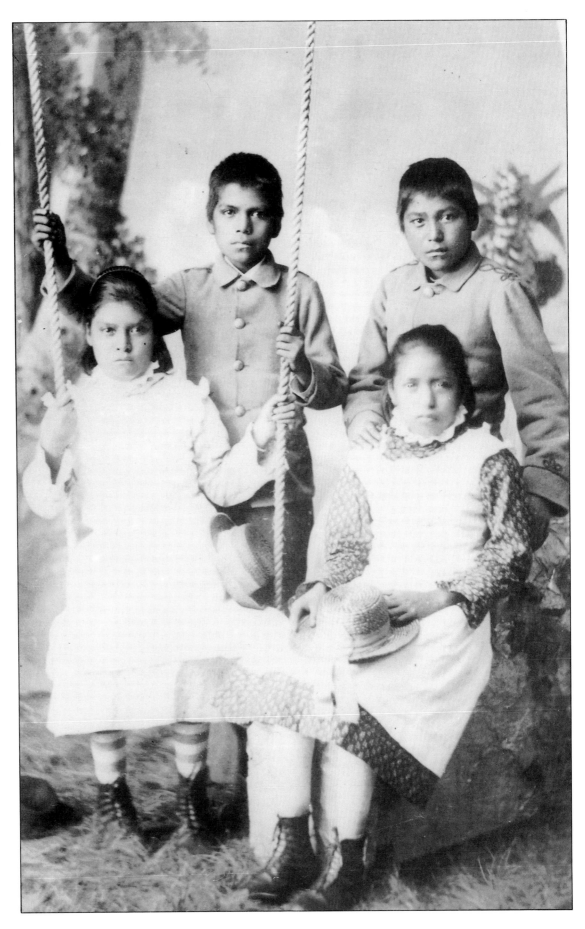

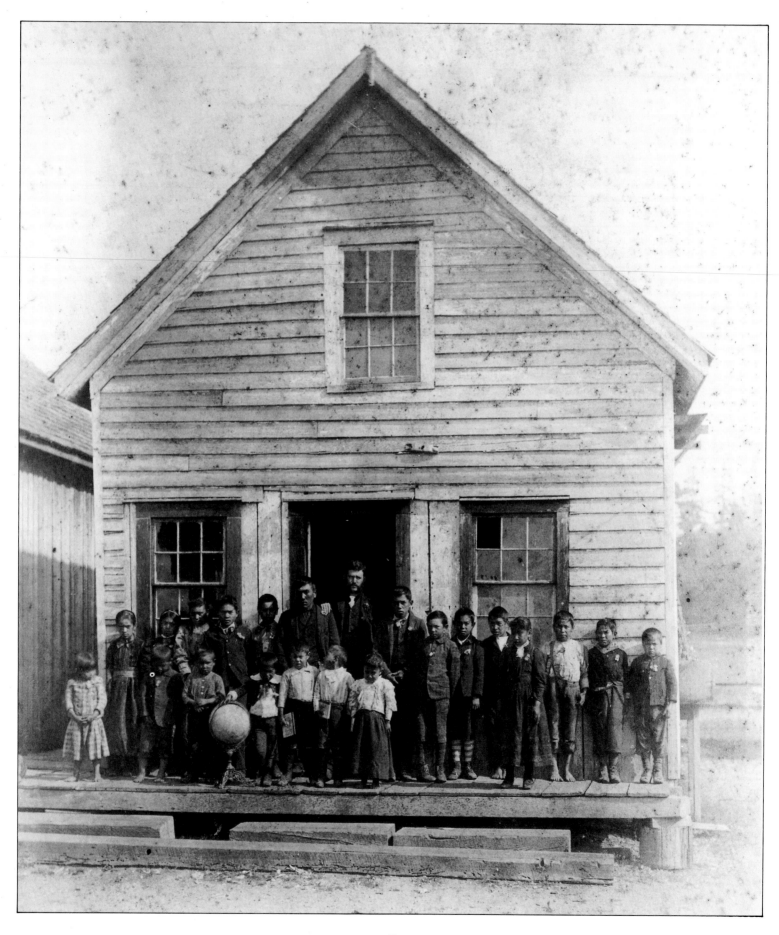

4.29 LEFT *Port Gamble Indian School, Puget Sound, Washington. Taken by Jesse Hastings Bratley, who was a teacher there, some time between 1893 and 1895.*

4.30 RIGHT *Dakota boys with a wagonload of water-melons grown at the Lower Cut Meat Creek Camp Indian Day School, Rosebud Reservation, South Dakota. Taken by Jesse Hastings Bratley some time between 1895 and 1899.*

4.31 BELOW *Mr and Mrs Arthur E. McFatridge, teachers, with pupils of the He Dog Creek School, Rosebud Reservation, South Dakota. Taken by Jesse Hastings Bratley while teaching at the Lower Cut Meat Creek Camp Day School, Rosebud Reservation, South Dakota, some time between 1895 and 1899.*

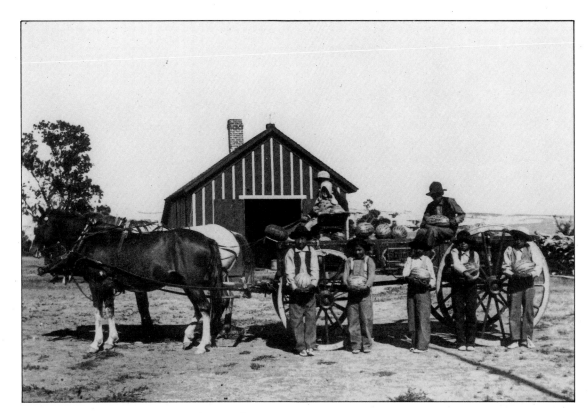

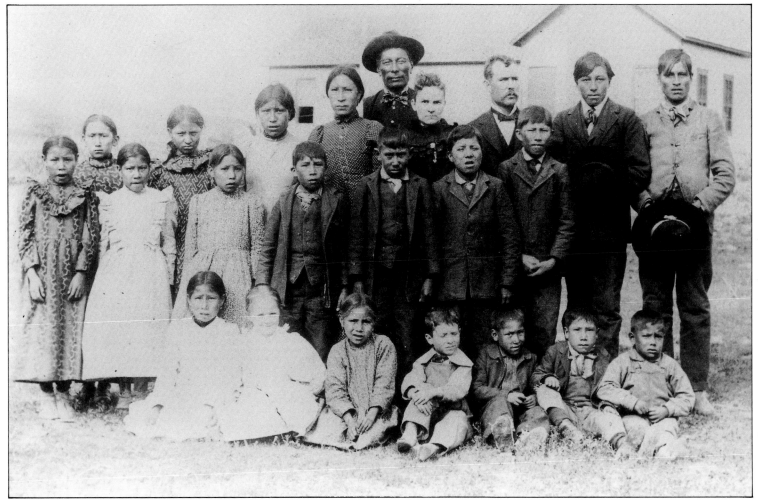

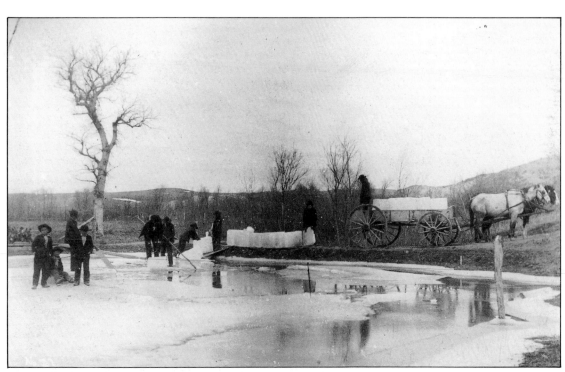

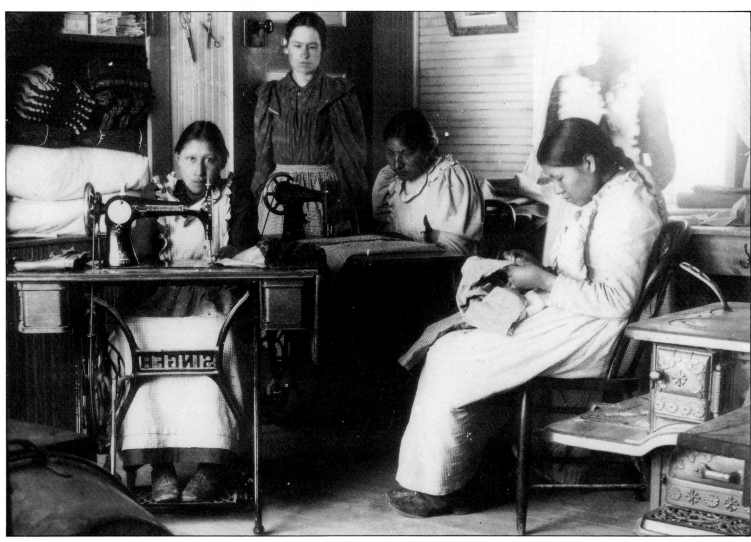

4.32 LEFT *Cutting ice at the Lower Cut Meat Creek Camp Indian Day School, Rosebud Reservation, South Dakota. The ice was used to keep milk and butter cool in an ice house built by the students. By Jesse Hastings Bratley, 1898.*

4.33 BELOW *Dakota girls in the sewing room of the Lower Cut Meat Creek Camp Indian Day School, Rosebud Reservation, South Dakota. By Jesse Hastings Bratley, 1897.*

4.34 RIGHT *Harry With Horns, a Dakota Indian, on the Rosebud Reservation, South Dakota. Taken by Jesse Hastings Bratley some time between 1895 and 1899.*

4.35 BELOW *A group of students at the Havasupai Reservation, Arizona. Taken by Jesse Hastings Bratley while he was a teacher on the reservation, some time between 1900 and 1901.*

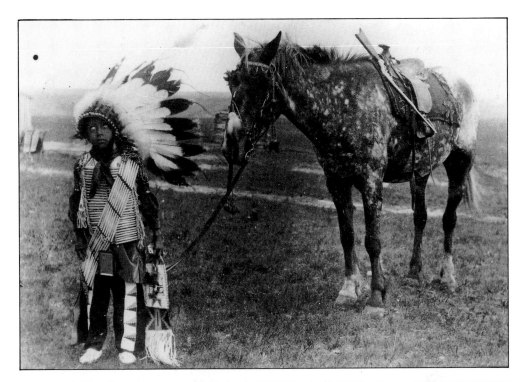

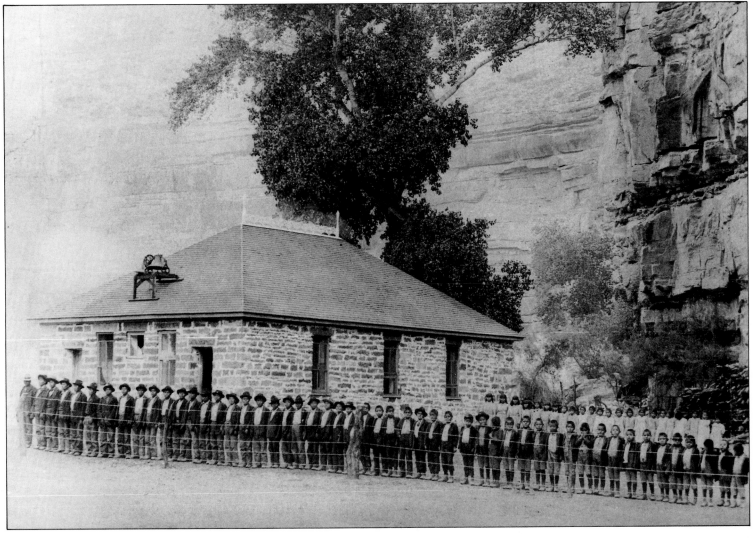

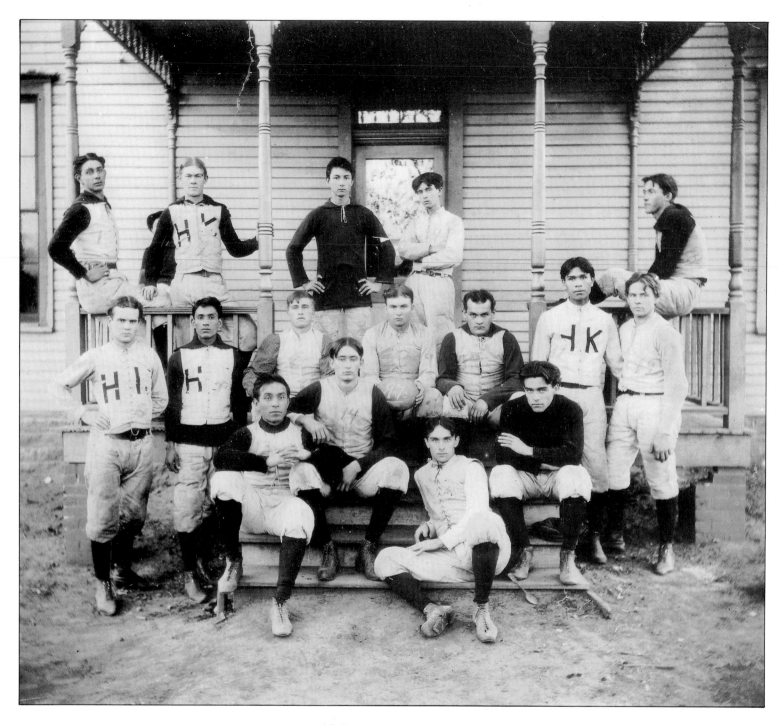

4.36 *A football team, mostly of Choctaw Indians. By an unidentified photographer.*

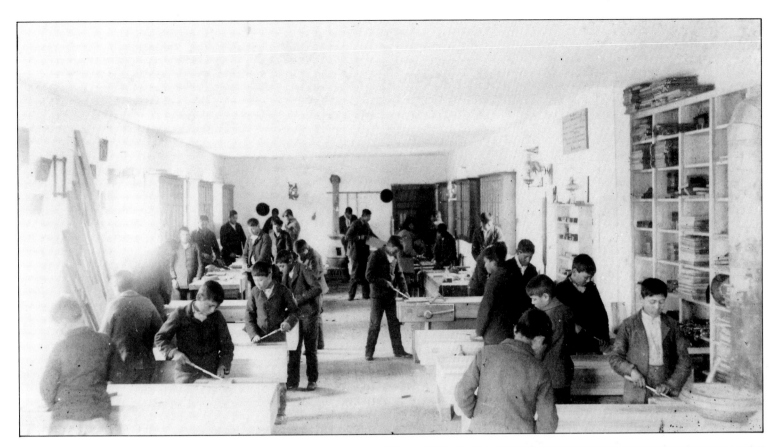

4.37 ABOVE *Indian boys in a school carpentry shop. By an unidentified photographer.*

4.38 RIGHT *A Haida band from Howkan, Alaska, some time around 1905. By an unidentified photographer.*

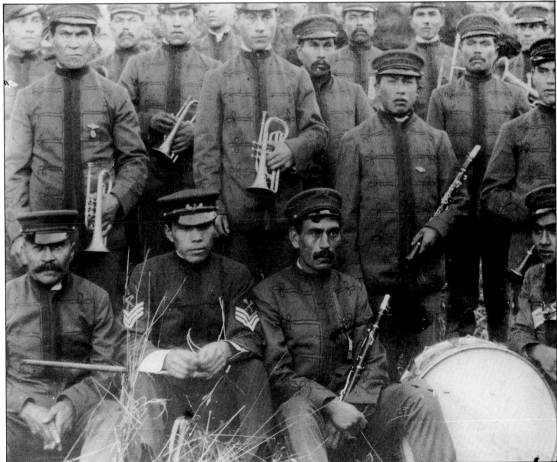

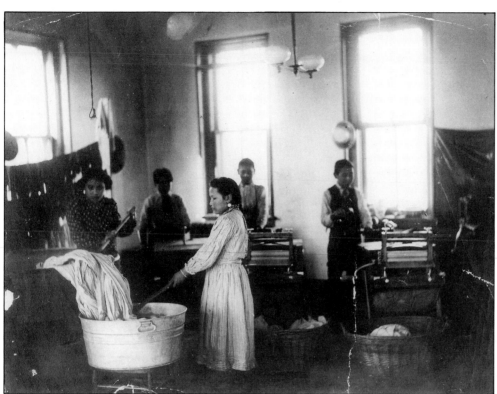

4.39 LEFT *Boys and girls washing clothes at the boarding school on the Crow Reservation, Pryor, Montana. Taken by Fred E. Miller some time between 1897 and 1910.*

4.40 BELOW *Crow Indian women playing a game of chance. Taken by Fred E. Miller some time between 1897 and 1910.*

4.41 RIGHT ABOVE *A horse race of the Blackfoot Indians. Taken by Walter McClintock in 1906, and titled by him 'Trial of Speed in the Blackfeet Camp'.*

4.42 RIGHT BELOW *The interior of a Crow Indian home in Montana in 1910. By Richard Throssel.*

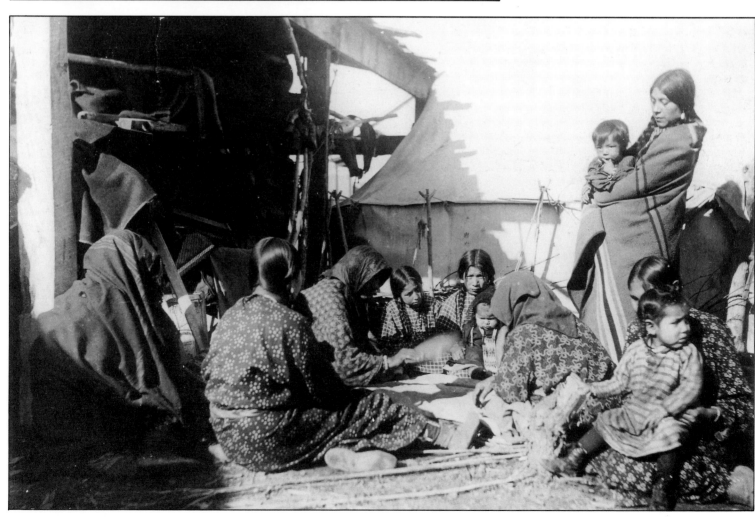

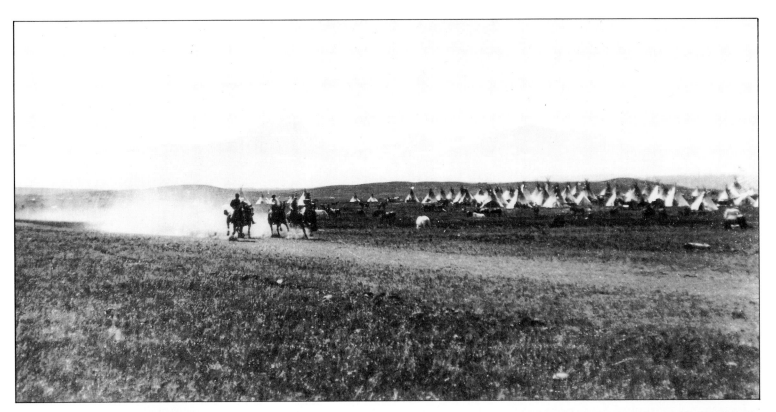

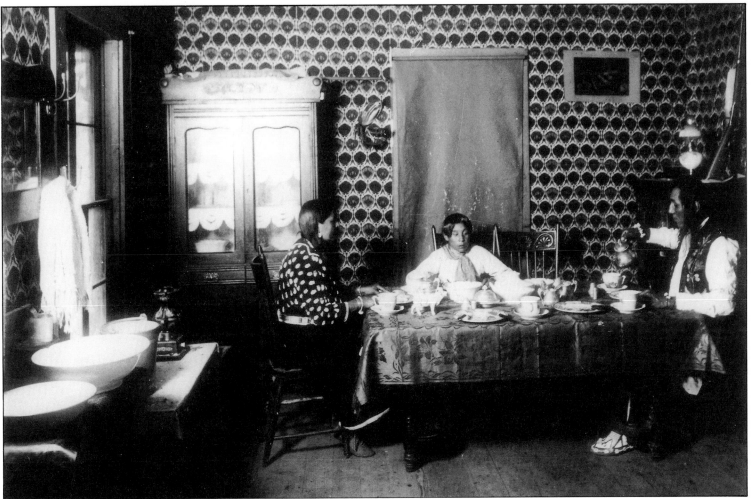

CAPTURING
THE GOLDEN MOMENT

RECORDING EARLY GOVERNMENT EXPEDITIONS

A NEW era of knowledge and awareness of the American West was ushered in by the development of photography in the nineteenth century. The expeditionary photographer could go places and record things no painter could capture. The documentary accuracy of an artist's work was open to question, but the apparent realism of a photograph generated the belief that the image showed the truth. All the wonders of a vast continent and its peoples could now be accurately visualized.

The first government expedition was in 1804–06, many years before the invention of photography. President Thomas Jefferson sent Meriwether Lewis and William Clark to explore the lands west of the Mississippi, newly acquired from France. It was the first such journey of discovery which reported to the nation the diversity of Indian tribes encountered along the 7,689 miles from St Louis, Missouri to the Pacific Ocean.

After the American–British War of 1812, President James Monroe grew apprehensive about Lord Selkirk's Hudson Bay Company settlement on the Red River and possible British moves towards American territory before boundaries were established. He sent Major Stephen Long on an expedition to the Yellowstone area in 1819 to explore the possibility of establishing a military outpost there. Samuel Seymour, the first government staff artist on record, made sketches of Indian villages along the way.[1]

American exploration shifted in character when an 1813 Act of Congress created an élite expeditionary unit, the Corps of Topographical Engineers. The Corps was reorganized into a separate branch of the War Department in 1838 and continued until the end of the Civil War, when it became a part of the Army Corps of Engineers, still in existence today.[2]

The Corps was a central institution of 'Manifest Destiny' which evoked the spirit of romantic nationalism. Its members were officers, most graduates of the military academy at West Point. Their total complement at any time never exceeded thirty-six. They served first of all as federal troops, escorting emigrant wagon trains or engaging in local battles. Their civilian duty was to explore and map the land and, in close collaboration with scientific staff, to make collections for the government. As representatives of national policy and concerns, the Engineers were to record all Western phenomena, including Indians. Many of them were among America's first photographers.[3]

In 1842, only three years after photography was introduced to America, the era of the 'Great Reconnaissance' began.[4] Edward Anthony of the New York Photographic Supply Company traveled with the Topographical Engineers on the Northeast Boundary Survey. His daguerreotype images have apparently been lost.[5]

That summer, a twenty-nine-year old Topographical Engineer, Lieutenant John Charles Frémont, led his first expedition to the Rocky Mountains accompanied by the German artist and cartographer, Charles Preuss. Following the advice of the Prussian geographer Alexander von Humboldt to use photography in scientific exploration, Frémont took with him a daguerreotype camera. With a view of the Wind River Mountains five miles away, he attempted his first pictures. Preuss's diary noted the results:

> August 2 (Tuesday) ... Frémont set up his daguerreotype to photograph the rocks; he spoiled five plates that way. Not a thing was to be seen on them. That's the way it often is with these Americans. They know everything, they can do everything, and when they are put to a test, they fail miserably ... Frémont wasted the morning with his machine. Now ... we see smoke rising in the mountains. Here that can mean nothing else but Indians.[6]

President James K. Polk did not consider the expedition much of a success but as 'rhetoric and symbol, it was sublime'.[7]

Frémont's 1843–44 expedition accomplished much more. He described the tribes he encountered and noted their 'attitude towards settlement'. His work remained the most significant model for scientific surveying before the Civil War. His romantic narratives made him a public hero and made Western expeditions part of national politics. Despite his failure with a camera, Frémont should be honored for making one of the first attempts at expeditionary photography of the American West.

The Mexican War Surveys of 1845–48 were the first large-scale projects by the Topographical Engineers in the West. The Corps located supply routes and battlefields. They also quieted Southwestern tribes in the area. After the War ended, the Engineers surveyed the new territory to establish boundaries. There was little time to experiment with photography.[8]

During the 1850s, the railroad companies brought pressure to bear on Congress to commission major expeditions to survey all possible principal routes to link the continent. Expeditionary photography took on a new importance with the Pacific Railroad Surveys.

In the spring of 1853, Governor Isaac I. Stevens left St Paul, Minnesota, to explore the northern route through Washington Territory. With him went John Mix Stanley, the official government artist, who had been accompanying expeditions to the West for over ten years. It is not known whether he attempted photography during that earlier period, but his daguerreotype portraits of Assiniboin at Fort Union and Blackfeet at Fort Benton on the Upper Missouri River were noted in Stevens' diary: 'August 7th ... [the Blackfeet] were delighted and astonished to see their likeness produced by the direct action of the sun. They worship the sun and they consider Mr Stanley was inspired by their divinity ... he thus became in their eyes a great medicine man.'[9]

That same summer Lieutenant Amiel Weeks Whipple led an expedition to the Southwest to survey the southern railroad route. Heinrich Baldwin Mollhausen, a Swiss artist sent to America by Humboldt, made sketches of the Indians. Whether or not he had a camera is not known.[10]

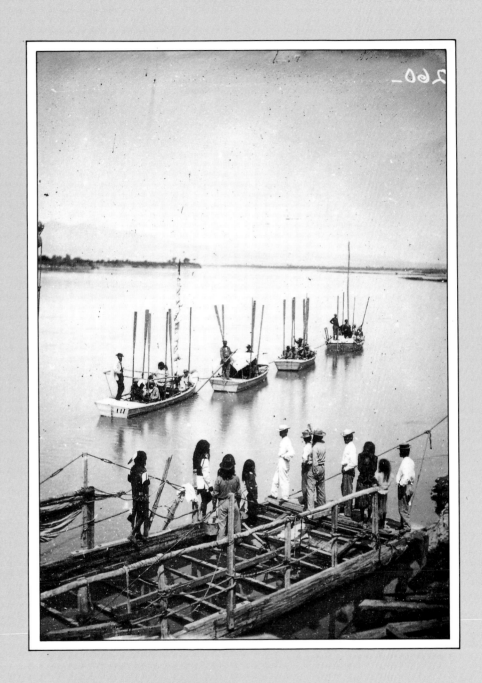

5.1 *The departure of Wheeler Survey members from Camp Mohave, Arizona to the Grand Canyon, accompanied by Chief Asquit and Mohave guides. Taken by Timothy H. O'Sullivan, September 15, 1871.*

In the fall of 1853, Frémont headed an expedition from Missouri to Utah. Taking no chances regarding photography, Frémont invited Solomon Nunes Carvalho, a Baltimore artist, to take pictures. Carvalho made daguerreotypes of Indian settlements in Kansas for official reports. Frémont never published the reports, as he became involved in his presidential candidacy. Carvalho wrote the only other account of the trip and stated that the Cheyenne wanted him to live with them. They would have worshipped him as possessing extraordinary powers of necromancy. Carvalho's use of mercury to produce sun pictures and to 'silver' their brass ornaments had astonished the Indians.[11]

Frémont engaged Mathew B. Brady, one of America's leading contemporary photographers, to copy Carvalho's images by the new wet-plate process. It was reported that fire had destroyed all the originals and copies. The Library of Congress has one image of Plains tipis probably taken by Carvalho and it is hoped that more have survived (plate 5.2).

In 1854 the War Department under Jefferson Davis reorganized the army. A new name, 'The Office of Western Exploration and Surveys', was assigned to the Corps of Topographical Engineers. Few Western surveys were conducted, however, during the years 1854–60. The Great Sioux War, which was to continue until 1890, had begun. The Engineers became part of the fighting force and conducted punitive expeditions. Four exploring parties attempted photography during this time but with scant results.

Lieutenant Joseph Christmas Ives was sent to explore the Colorado River in 1857. Ives seems to have attempted the new wet-plate process but lost his equipment in a gale. Only one lithograph of a photograph is reproduced in the official report. If Ives had persisted, he would have been the first to photograph the Grand Canyon.[12]

The British government had more success. Henry Youle Hind directed an expedition through Rupert's Land in the Great Lakes area in 1857–58. Humphrey Lloyd Hime served as photographer. He took pictures of Lord Selkirk's settlement, and also photographed Ojibwa (Chippewa) birchbark tipis near the Red River (plate 5.3).[13]

In 1859, Colonel Frederick West Lander's survey left Salt Lake City. Its aims were to locate a new wagon road to the East for the Interior Department and to make collections for the Smithsonian Institution. Lander was accompanied by Albert Bierstadt from New York and his assistant, S. F. Frost of Boston. Bierstadt headed a corps of skilled artists and photographers which produced the first technically successful set of eighty stereographs, many depicting Indians, including a Shoshoni, possibly near Fort Laramie (plate 5.4).[14]

The 1859–60 expedition led by Captain William Franklin Raynolds to Yellowstone and the Wind River Mountains was the last War Department survey of a major unexplored region in the Far West. Raynolds' orders were not only to record resources but also to ascertain the 'numbers, habitats and disposition' of the Indians. J. D. Hutton headed the photographic unit and photographed Plains Indians, including Arapaho chiefs in buffalo robes (plate 5.5).[15]

From 1857–61 Lieutenant John C. Parke, Topographical Engineers, and Colonel J. S. Hawkins, Royal Engineers, led the cooperative American–British Northwest Boundary Commission Survey to establish an international boundary from the Rocky Mountains to the Strait of Juan de Fuca. James Alden, watercolorist, and a unit of British photographers were part of the team. It was to be the last expedition of the Topographical Engineers to leave the West before the Civil War.[16]

On July 21, 1861, the half-blind Mathew B. Brady strolled on to the field at the first Battle of Bull Run, Virginia, to photograph the Civil War.

His apprentice, twenty-one-year-old, Irish-born Timothy H. O'Sullivan, was probably with him to take the first pictures. It was reported that 'The Battle of Bull Run would have been photographed close-up but for the fact that a shell from one of the Rebel field pieces took away the photographer's camera.'[17]

O'Sullivan was part of Brady's semi-official photographic unit. He was a civilian photographer, without rank, assigned to the Union Army's Corps of Topographical Engineering. He served under six generals from the Battle of the Second Manassas through Gettysburg to the final surrender at Appomattox.

Another photographer, Alexander Gardner, managed Brady's Washington studio and served as a captain with General McClellan's staff of the Army of the Potomac. In 1863, when Gardner went independent from Brady, O'Sullivan joined him. They continued to work together after the War. Gardner's *Photographic Sketchbook of the Civil War* credits forty-two of the hundred original albumen prints (made with egg whites) to O'Sullivan. Brady made several attempts to hire O'Sullivan back from Gardner but was refused.[18] The War had forever changed him. He wanted to continue recording people and events as they happened. The government expeditions to the West offered him the opportunity.

Two other photographers who were to share that same adventure, William Henry Jackson, and John K. Hillers, also served in the Civil War. Twenty-year-old Jackson joined Company K, Twelfth Regiment, Second Vermont Brigade, as staff artist and saw action until 1863.[19] Hillers, also aged twenty, enlisted with the New York Naval Brigade and later transferred to the army. He re-enlisted at the end of the War and served with the Western garrisons until 1870.[20]

Photography of the Civil War was a dramatic change from romantic studio portraiture. Realistic scenes of battle leave an indelible image on the mind. The experience must have greatly influenced the way O'Sullivan, Jackson and Hillers photographed the American West.

The War took its toll on the leaders of the élite Corps of Topographical Engineers. Many were killed in battle or resigned to join the regular army. The remnants of the division were absorbed into the larger Army Corps of Engineers which became occupied with another foe – the Plains tribes who were fighting to save their traditional way of life before reservations enfolded them.

THE FOUR GREAT SURVEYS

At this time, there was great demand from all quarters for more information about the West. Railroad trains were advancing from both directions – the Union Pacific pushing westward and the Central Pacific breaking the High Sierras to meet at Promontory Point, Utah, on May 10, 1869. On the survey maps, dots of villages stood in the way of tracks and trains. The government's curiosity about the Western tribes began to change to a national policy of relocation.

European and American interest in the West had never been greater. It was an age desperately trying to be 'scientific' about all things. Specific knowledge about the vanishing frontier had to be obtained and communicated. It was time for experienced scientists to step into the scene.

The results of this quest for knowledge about the American West were four geographical and geological surveys conducted from 1867 until 1879. Two of these surveys were under the administration of the War Department: the United States Geological Exploration of the 40th Parallel, headed by a civilian, Clarence King; and the United States Geographical Surveys

West of the 100th Meridian, commanded by Lieutenant George Montague Wheeler. The other two surveys were under the Department of the Interior: the United States Geological and Geographical Survey of the Territories, directed by Ferdinand Vandiveer Hayden; and the United States Geographical and Geological Survey of the Rocky Mountain Region, led by John Wesley Powell. They are often grouped together and referred to as the 'Four Great Surveys'.[21]

These extensive government surveys all entered areas of the West where the inhabitants' only previous contact with the outside world had been with a few trappers and miners. The Indians were fighting any intruders to hold on to their territories. Army escorts accompanied expeditions not only to protect the crew (most of whom were veteran soldiers), but also the scientists, reporters, relatives, friends and guests who trailed along. The Indians must have found it quite an awesome, threatening sight.

Between 1867 and 1879, the control of the expeditions shifted from military reconnaissance and geographical mapping of the land, directed by the War Department, to the geological and ethnological studies of the Department of the Interior. The whole of the West became a laboratory in an effort to take stock of natural resources, with photography as the new scientific tool to assist the government in that endeavor.

THE KING SURVEY, 1867–79

Clarence King was a civilian geologist who through powerful political connections obtained his own survey for the War Department at the age of twenty-five. King was the only one of the four leaders of the 'Great Surveys' to have a college degree; he had been in the first graduating class of Yale's Sheffield Scientific School. During the Civil War years, King headed for California to join Whitney's survey of Yosemite. He traveled with the photographer Carlton Watkins. Watching Watkins work with his 'mammoth' camera, King learned the value of photography in the field, to support his scientific theories.

King wanted to hire Watkins, 'the finest photographer I know', for his 1867 survey. Watkins, on an independent trip to California at the time, declined. King probably turned next to the Army Corps of Engineers, which was organizing his surveys from Washington, and they recommended Timothy H. O'Sullivan.[22]

For the first field season, O'Sullivan was given an old army ambulance to serve as a darkroom and two mules to carry his photographic equipment, including a 20 × 24 camera, purchased from the E. & H. T. Anthony Company in New York.

On May 1, 1867, the King expedition sailed from New York via the Isthmus of Panama for Sacramento, California. In July, King headed for the Great Basin on a proposed survey of an eastwards route for the Central Pacific Railroad. Exploring and mapping were not the only duties on the agenda: King's secret mission for the War Department also included reconnaissance of the Indian tribes he encountered.

The entire summer was spent in a harsh wonderland of strange beauty inhabited by only a few Mohave and Paiute Indians. Images of the desolate desert, once two ancient inland seas, were recorded by O'Sullivan's camera. Surviving the loss of collections and equipment, near drownings, desertions and malaria attacks, the survey party returned to Washington in September.[23]

During the next two seasons, the expedition divided into three sections to cover Nevada and Utah. O'Sullivan recalled those years as the toughest

of his Western experience. On one occasion he spent thirteen hours crossing one divide between the Ruby and Humboldt Mountains. The mules, with his photographic equipment, kept disappearing into snowdrifts.

For months O'Sullivan wandered in the Ruby Mountains occasionally meeting a few Paiutes gathering pine-nuts. Several times the news of Shoshoni on the warpath reached him. They believed that the survey's army escort was there to massacre all the Indians of Nevada. A council was held with their chief, 'Captain' Frank, and a peaceful agreement reached.

One day, King sent O'Sullivan out alone to photograph the Carson Sink. O'Sullivan reported that 'it was a pretty location to work in, and viewing was as pleasant work as could be desired'.[24] The view of his mule-drawn darkroom/ambulance near a sand dune, with footprints trailing off into space, captures the vast loneliness of the place (plate 5.6).

The last summer was spent surveying the Great Salt Lake. Members of the King Survey remember O'Sullivan as a mysterious loner but a 'good fellow' who pulled his own weight. He had a droll Irish sense of humor, even though one of the men became bored with his Civil War stories: 'One would think he had slept with Grant and Meade and was the direct confidant of Stanton.'[25]

At the end of the season, O'Sullivan and King returned to Washington to produce official reports. During the first two years of the survey, O'Sullivan had made a few field prints. He later sent most of his negatives to L. E. Walker, chief of the Treasury Department's photographic laboratory, for processing. In 1869, O'Sullivan hand-printed his own prints. King presented a portfolio of 18 × 24 individually mounted prints to Congressmen and used lithographs drawn from the photographs for his reports. King, an excellent writer and a lover of the arts, used O'Sullivan's prints to illustrate his poetry books. A romantic view of the West was presented to the public; a more realistic one to the federal government.[26]

The King Survey served to show the highly successful use of expeditionary photography to gain public recognition, commercial success and future government funding. Now everyone wanted to get in on the act.

King spent most of 1870 in Washington writing, so he was able to recommend O'Sullivan as an official photographer to Lieutenant-Commander Thomas O. Selfridge. Selfridge was to lead the Darien Expedition to the Isthmus of Panama.

THE WHEELER SURVEY, 1871–79

O'Sullivan was back in the West again in 1871 with another War Department survey commanded by a military man, Lieutenant George Montague Wheeler. The army had changed since the old days of the Topographical Engineers and the Civil War. Its size and power had been greatly reduced: from one million men in 1865, it was down to 25,000 regulars by 1871. It was not the time to make one's mark as a career officer; but the expeditions to the West offered an opportunity. After graduating from West Point Academy in 1867, Wheeler had surveyed in California, Nevada and Utah and gained the attention of the War Department.

The growing competition from surveys sponsored by other government departments caused the army to shift to a 'more scientific' approach. Wheeler's survey was also broader in scope, his instructions being to 'chart astronomical, geographical, topographical observations, artificial [i.e. man-made] and economic [i.e. potentially profitable] features' for an assessment of the region's potential. His hidden orders were to conduct a military reconnaissance in the Southwest to aid in General Crook's campaign to expel the Apache and Paiute from the area.[27]

Wheeler urged the War Department to establish a permanent Photographic Corps consisting of several photographers who could be assigned to different expeditions. Their images would document the enemy which the military now faced. Wheeler himself wanted the most experienced army photographer of the West to dramatize his findings, so he hired O'Sullivan.[28]

In 1871, after a short survey with King in Utah, O'Sullivan joined the Wheeler expedition which was already in progress. Members of the crew included Frederick H. Loring, a reporter from Boston. Loring was listed as a 'naturalist' (as were all journalists at the time). His unofficial role was both to publicize the survey in order to gain support from Congress and to provide intelligence reports for the War Department in their punitive actions against the Indians.

The survey party left Fort Halleck, Nevada in May and headed south for Death Valley. Wheeler, in an attempt to apply military discipline to his crew, conducted eighty-hour forced marches. Two guides met their deaths in the desert in still unexplained circumstances. On the day the survey reached Death Valley, the temperature read 120 degrees, and O'Sullivan's photographic chemicals boiled over.

On September 15, 1871 the survey party departed from Camp Mohave, Arizona, with Mohave Chief Asquit and thirteen of his men as guides, for the first ascent of the Colorado River to Diamond Creek (plate 5.1). O'Sullivan was in charge of the second boat, which he dubbed *The Picture*. He took the first photographs of the Grand Canyon.

The trip was disastrous. The distance covered upstream was 261 miles in thirty-one days; the return downstream took five days. At one point, O'Sullivan courageously plunged overboard in a vain attempt to recover collections and supplies from the rapids. By October 20, the crew was on emergency rations. Yet time and again, Wheeler reported, O'Sullivan dragged his heavy equipment up sheer cliffs and 'in the face of all obstacles made negatives at all available points, some of which were saved, but the principal ones of the collection (having survived the perilous river trip) were ruined during transport'.[29]

On November 5, O'Sullivan and Loring were to return to Washington to report to the War Department about the tribes and to show Congress their amazing scientific results. O'Sullivan was delayed, but Loring caught an overland stagecoach to California. Apaches attacked near Wickenburg, Arizona, and Loring was one of three survey men killed. $25,000 in gold was taken and possibly something else: Loring's notes and some of O'Sullivan's negatives relating to the Apache which the government might have used against them. A bullet ended Wheeler's dream that Loring's words and O'Sullivan's images would show Congress that the army should once again lead all the government surveys. For the Apaches and the Paiutes that bullet meant only a delay to their ineluctable fate.[30]

Despite all the hardships and disasters, O'Sullivan took the greatest number of photographs of his entire government career – over 700 stereographs, including images of the Grand Canyon, Mohave and Apache guides, Paiute and Shoshoni chiefs, as well as a portrait of Loring four hours before he was killed (plates 5.1, 5.7–5.12, 5.14, 5.15).[31]

O'Sullivan spent the entire 1872 season with King in Utah and Montana. He took only a handful of stereographs there.[32] For part of the trip King also hired Watkins and his 'mammoth' camera at the astronomical cost of $3,000.[33] Wheeler replaced O'Sullivan with William Bell, a photographer from Philadelphia (not to be confused with the Englishman Dr William Abraham Bell, another survey photographer). Bell, unlike most expeditionary photographers of this period, used the new dry process. He produced

images of the Grand Canyon for Wheeler, including Kanab Canyon (plate 5.13).[34]

When O'Sullivan returned to the Wheeler Survey in 1873, he was made 'executive-in-charge of the main party'. He also directed field parties which moved out with Apache scouts from base camps at Fort Wingate and Camp Apache. From July 15–August 30 Wheeler sent O'Sullivan to photograph the Hopi and Zuni Pueblos, and Navahos near Fort Defiance (plates 5.16–5.18). At the summer's end, O'Sullivan detached himself from the main survey party to go to Canyon de Chelly. His masterpiece of the White House Ruins of the ancient Anasazi culture, tucked between the sunlit strata of cliff walls, was one of his last photographs (plate 5.19).

The 1875 survey to the Southwest ended O'Sullivan's career as a government expeditionary photographer. Wheeler recognized O'Sullivan's leadership qualities and appointed him as liaison official between the military and civilian authorities. The congenial, sensitive O'Sullivan also served as mediator with the Indians in the area. He had little time to take photographs.

That winter, O'Sullivan went back East to Baltimore. He produced over 2,500 original albumen prints by hand in order to compile albums containing a set of fifty stereographs to supplement Wheeler's seven-volume reports presented to Congress. About a hundred prints were published by the Anthony Company. O'Sullivan's negatives were reportedly transferred from the War Department to the Treasury Department at this time.[35]

THE HAYDEN SURVEY, 1870–79

From the early 1850s the Smithsonian Institution (among others) had financed Dr Ferdinand Vandiveer Hayden's explorations from the Missouri River westward to the Rockies. Hayden, a professor of geology at the University of Pennsylvania's Medical School, spent his summers surveying for the government and collecting fossils for the Smithsonian Institution Museum. The Plains Indians got to know him well. The Sioux named him Man-Who-Picks-Up-Stones-Running.[36]

In 1868, while conducting fieldwork in Wyoming, Hayden attended the Fort Laramie peace conference, where he met William Blackmore, an English entrepreneur. Blackmore was serving on the President's Commission investigating the railroad surveys. He was also speculating for substantial land holdings in the American West, and he hired Hayden for his private surveys. In the coming years, Blackmore was to give Hayden considerable sums of money to augment Congressional funds allocated for his government surveys.[37]

While surveying in Wyoming in the summer of 1869, Hayden met William Henry Jackson taking photographs along the railroad lines. The next year he went to Jackson's studio in Omaha to obtain pictures of rock formations along the Green River and to see his portraits of Indians. Hayden had worked with photographers on the early surveys by the Topographical Engineers. He knew the impact of images that conveyed the wonders of the West. Hayden was so impressed with Jackson's work that he invited him to be part of his forthcoming survey to the Great Basin. Hayden's budget did not cover a photographer, so Jackson volunteered his services in exchange for traveling expenses and the right to retain his negatives for commercial sales. He promised to produce prints for official reports, and when he became a permanent survey member, to donate his 10,000 railroad stereographs to Hayden.

The survey left Cheyenne on August 7, 1870 and traveled along the

Oregon Trail for four months. James Stevenson, who had accompanied Hayden on surveys since the 1856 Warren Expedition to Yellowstone, served as executive officer. Jackson was assigned to Stevenson's party.

Jackson's photographic equipment consisted of a stereo camera, a $6\frac{1}{2} \times 8\frac{1}{2}$ camera, and 400 glass negative plates. His pack mule, Hypo (Hyposulphite of Soda), had the burden of carrying the 300 pounds of equipment up and down mountains. Two army ambulances served for darkroom and storage facilities. Hayden wanted to be the first survey leader back to Washington with developed images, so he persuaded Jackson to take all his printing material into the field. Jackson used local studios to produce prints, such as those of Charles R. Savage in Salt Lake City and J. Crissman in Montana.

On September 20, the Stevenson party reached Fort Stambaugh. A party of Shoshoni on a buffalo hunt were camping along the Sweetwater River nearby. Due to the willingness of their leader to be photographed, Jackson obtained several images of Chief Washakie and his village (plates 5.21, 5.22). These are often misdated to later surveys.[38] At Fort Laramie, with Blackmore's support, Hayden hired Jackson as his official photographer.

On June 11, 1871 Hayden led his first expedition to the Yellowstone area. Near the head of Medicine Lodge Creek, Idaho, Jackson accidentally discovered a shy family of the Bannock tribe, belonging to the Sheep-eater band, hidden in a grove of willows. They were wandering free but were near starvation. 'The present of a handful of sugar and some coffee reconciled them to having their photographs taken' (plate 5.20).

During the summer, Jackson photographed Mammoth Hot Springs and Yellowstone Canyon; landscape artist Thomas Moran sketched nearby. Jackson and Moran remained friends for over fifty-five years and greatly influenced each other's work.

On the way home at the end of the field season, Jackson took some classic photographs of the Pawnee (plate 5.23). (These are often misdated to later surveys.) 'The Pawnee village series were made by myself in 1871 on my return from the first Yellowstone expedition of the survey.'[39] It seems probable that Jackson had witnessed a naming ceremony – the ceremony for a warrior whose valor had won him an honored name. The Pawnee earth lodges were located at Loup Fork, Nebraska, a hundred miles west of Omaha; indeed, Hayden had made a trip to the Pawnee and Omaha Reservations especially to have Jackson take photographs. These negatives started the North American Photographic Collection made by Blackmore and Hayden for the Smithsonian Institution.

In 1871 the Pawnee were the last people living traditionally on the upper Missouri River. Five years later, their earth lodges were plowed under and they were removed from their ancient homeland forever.

The field season of 1872 had a tragic beginning for Jackson. In February his wife Mollie died in childbirth, along with his newborn daughter. Jackson, burying his grief, headed out with the Stevenson party of the Hayden Survey on the second expedition to Yellowstone and the Grand Teton. Jackson carried a new 11×14 camera which he used exclusively to capture some of his most breathtaking landscape views of the West.

During the summer, there were several uprisings of Bannocks and some of the survey members were nearly killed. However, Jackson managed to take pictures of a Bannock group which had camped along the Snake River near Fort Hall, Idaho. They were his only ethnographic photographs on record that year.

The Indians of Montana and Wyoming were on the warpath in 1873, so Jackson could not return to Yellowstone and the Tetons. Instead, the Hayden survey divided into three large divisions and headed for the Rocky

Mountains in Colorado. For the first time, Jackson worked without a staff artist. He led his own photographic unit and covered the entire field by linking up with the different parties. He reported, 'This was my expedition.'

At the end of the field season Jackson went to the Omaha Reservation at Blair, Nebraska, to take photographs. He had met the agent's daughter there before the survey started. Emilie Painter, a Quaker from Baltimore, was to become his wife. According to Jackson, Emilie took photographs at the reservation between 1870–73.[40]

The 1874 survey of the Rocky Mountains included Ernest Ingersoll, a *New York Tribune* journalist, and Edward Anthony, one of the family that owned the Photographic Supply Company. Anthony was Jackson's assistant on the trip. Jackson had a new folding box-darkroom and took with him both a 5×8 and a stereo camera.

Throughout the month of August, Jackson met large bands of traveling Utes who were moving their reservation from Clear Creek near Denver to Sagauche. At the Los Pinos Reservation, he photographed the Ute Chief Ouray and Chipeta, his wife. The chief had served as an interpreter on delegations to Washington and lived in an adobe house at the reservation on a pension of $1,000 a year. Both house and pension were given to him by the government in exchange for most of his tribe's homeland. Jackson also took pictures of Tush-A-Qui-Not ('Peah'), a Ute sub-chief (plate 5.24). He then photographed Peah's infant who had been left in a cradleboard on the agent's porch. Peah threw a blanket over the camera and accused Jackson of 'Making all Indians sick ... all die ... OK for groups of men but not women and children ... not whole village'. Two other chiefs, Shavano and Guerro, started talking against Jackson. They had been on delegations to Washington where their photographs had been taken; they had learned to distrust government representatives who used pictures against them. Jackson's friend, Chief Billy, warned him to leave before he was used as target practice.

Jackson headed for the Southwest and at the end of the month visited Canyon de Chelly. He met an old Omaha acquaintance, Tom Cooper, driving a supply train to Captain John Moss's mining camp. Moss had made his own treaties with the Utes and knew their language and their country. He told Jackson that he had discovered some ruins when he had been in the area in 1856 and would take Jackson to see them. The Utes called them Moki (Hopi) towns. Jackson believed they were Aztec. At the time he did not realize that he was taking the first pictures of Anasazi ruins (the ancient pueblo culture dating from 600 to 1300 AD) in Mancos Canyon, Colorado (plate 5.25). They returned to camp through Montezuma Valley, all the while encircling the Anasazi ruins (now more famous) at Mesa Verde.

When the field season ended in October, Jackson went with Stevenson and his wife, Matilda Coxe Stevenson, to a site seven miles from Denver. There were 'Indians camped around town that the doctor [Hayden] desired to be taken'. Jackson made four negatives of the 'old fellows', including Chief Douglass, and Stevenson paid them $8.00 (plate 5.26).

The next month, Jackson and Ingersoll left their party and went on a trip to the Southwest. John Moss again served as guide. On November 3, they finally discovered the Mesa Verde ruins. Hayden immediately recognized the significance of the find. Jackson wrote, 'Before he had glanced at half a dozen photographs, my work for the following season was determined in his mind.' Jackson returned in 1875 and 1876 to photograph the ruins (plate 5.27). His images had such an impact on Congress that the 50,000 acres of Mesa Verde were made a national park in 1906.

Before the field season of 1875, Jackson headed for Okmulgee, Indian Territory. The Grand Council was in session and all nations living in the territory were represented. Jackson took pictures of the various groups, as did another survey photographer, John K. Hillers. In October 1876, Jackson visited seven Hopi towns – Shongopovi, Mishongovi, Shipaulovi, Sichomovi, Tewa (Hano) and Walpi Pueblos (plate 5.27) – with his new 20 × 24 view camera. At Tewa, he photographed the famous potter, Nampeyo (Serpent That Has No Tooth), who was then eighteen years old (plate 5.28). Fifty-one years later, he was to meet her once again.

In 1876, Jackson represented the US Geological Survey at the Centennial Exposition in Philadelphia. The exhibition of models of the Southwest cliff dwellings, along with Jackson's photographs, won him a bronze medal. At the Exposition, new panoramic cameras were shown, and the new dry-plate process demonstrated. Jackson had made dry plates back in September 1869 but had thought the process 'too risky'.

In midsummer in Montana, the Battle of the Little Bighorn took place (see chapter three) and the area was unstable. Jackson decided to make a short winter trip to the pueblos. He returned again in 1877 on an independent visit. He had limited time available, and without the survey's packers, he had to carry his own photographic equipment; so to minimize the weight he took only his 8 × 10 camera and new sensitive negative tissue bands for 400 exposures to try the new dry process. Jackson waited at Santa Fe for the film to arrive. Because of the delay, he had time to test only one negative.

Jackson photographed Acoma, Laguna, Taos and Zuni Pueblos. He took pictures of the Navaho at Fort Defiance and obtained images of Chaco Canyon. While there, he discovered the 'Chaco Skull' in a fourteen-foot-deep wash. These were the first human remains ever unearthed to testify to the existence of the vanished peoples of the canyon. Jackson rushed back to Washington to develop his prints. All 400 negatives had failed.

The 1878 expedition to Yellowstone was Jackson's last as a government photographer. It started from Cheyenne, as had the expedition eight years before. At Mammoth Springs, an army escort joined the survey party: the previous summer a group of Nez Perce of Chief Joseph's band, fleeing General Howard, had killed two tourists in the Yellowstone area.

On the journey home, Jackson stopped at Camp Brown to see Chief Washakie, whom he had first photographed in 1870. The Shoshoni were out hunting. Jackson was ready to depart when he discovered a group of Bannock prisoners. Among them was someone he recognized. Jackson's last photograph on the survey was of his old guide on the first expedition to Yellowstone, Beaver Dick Leigh.

When the survey party disbanded at Fort Steele in Rawlings, Wyoming, Jackson took the train back to Washington. Before departing, he sold his photographic equipment for $200 to his friend, James Stevenson.[41]

THE POWELL SURVEY, 1871–79

During the summers of 1867 and 1868, Professor John Wesley Powell of Illinois Wesleyan University took his geology students on field trips to the Rocky Mountains in Colorado. Powell became well-known to the local Utes. They named him 'Karpurats' (One-Arm Man): in the Civil War, at the Battle of Shiloh, Powell had raised his right arm to give a battle signal and lost it when a Rebel shell exploded.

In winter camps at Kanab Canyon, Powell's lifelong interest in North American Indians was first roused. He was invited by the Utes to sit in the council ring of a hundred, next to Chief Tsu-Wi-At's wife. He learned their language and witnessed their secret ceremonies. He recorded myths and vocabularies and collected artifacts for the Smithsonian Institution. He also formulated a plan to explore the Colorado River in the Grand Canyon.[42]

On May 24, 1869 Powell's first expedition down the Colorado River left Green River Station, Wyoming. There were nine men (none of them a photographer) in four boats. On August 30, six men and two boats emerged from the Grand Canyon: Paiutes had killed three men who had gone overland rather than face the danger of the rapids. Almost as soon as the last boat landed, news of the great adventure was reported back to the East. Powell returned to Washington a national hero and Congress promptly granted him funds for another journey. The fourth and last of the Great Surveys entered the field.[43]

Powell's second expedition down the Colorado River was in 1871; it was the first scientific exploration of that region with a photographer. The previous year Powell had attempted to hire Charles Zimmerman, a photographer from St Paul, Minnesota, for his forthcoming survey. Zimmerman wrote to Powell: 'regrets but would be away from family too long … could they come along? … could I keep the negatives? … I have just obtained a gallery which I have to run myself and cannot undertake the trip.'[44]

Powell continued his search. The following spring, when he went to purchase his photographic equipment from Anthony's in New York, they recommended a local photographer, Edward O. Beaman.[45] Powell's twenty-one-year old first cousin, Walter 'Clem' Powell, acted as Beaman's assistant. Powell knew the commercial value of the expedition's images. He instructed Clem to learn the trade and become a permanent survey member. Negatives worth $500 would then be his, to make his fame and fortune after the journey ended.[46]

From May 6–12, Beaman and Clem took views of an adobe town, fifty miles from the Uinta Mountains. On May 15, John K. Hillers arrived from New York to serve as boatsman. The year before the German-born Hillers had been working as a teamster in Salt Lake City, where Powell was gathering supplies. Powell needed a crew replacement and after a chance meeting with Hillers, he hired him. The survey members called Hillers 'Jolly Jack' or 'Bismarck' because of his German heritage. He entertained them with Irish stories and songs – he had a ribald sense of humor and was the only one who could tease Powell. When Hillers saved Powell from drowning in the rapids, they formed a special bond. It was a working and personal friendship that was to last thirty-one years.[47]

The Powell Survey left Green River Station, Wyoming, on May 16, 1871. Six days later, three boats – the *Nettie Powell* containing Thompson, Bishop, Steward and Richardson; the *Canolita* with Beaman, Clem Powell and Hatton, the cook; and the *Emma Dean* with Powell's armchair strapped to the deck and Powell himself atop it (so he could see to navigate), plus Jones, Hillers and Dellenbaugh – headed down the Green River.

Beaman photographed the canyonlands and ancient 'Aztec' picture writing on the cliff walls. Dellenbaugh reported that 'the dark box was the special sorrow of the expedition, as it had to be dragged up the heights from 500 to 300 feet'.[48] Clem, who had to carry that dark box, called it an 'infernal howitzer'.[49] He attempted to take several views of the canyon but failed to mix the chemicals correctly.

Hillers was instantly fascinated with Beaman's camera and Dellenbaugh instructed him on how the chemical processes worked. After only two weeks, Hillers volunteered to be Beaman's assistant and took over the job and its duties from Clem.

As the boats wound their way downstream, Powell read Sir Walter Scott's *Lady of the Lake* out loud to the crew. Most of the survey members read the classics by the evening's campfire. Powell instructed all of them to keep diaries. At the junction of the Green and Uinta Rivers, Camp Number 31 was established. All the diaries relate parts of the following story:[50] 'Thursday, the 13th of July ... before breakfast, a young Ute warrior came into camp. He wanted Powell's "water ponies" to ferry he and his bride across the river.'[51]

The warrior returned again on July 27 and traded with Steward for some sugar. Four days later, Powell, Hillers and Jones went to the Uinta River for fresh water where they met the young married couple. He proved to be the son of Chief Douglass of the White River Utes. She was a Uinta Ute chief's daughter, about fifteen or sixteen years old, and had been promised to another warrior, Ton-E-Emp-Cho. Chief Douglass's son had kidnapped her from the war lodge. The rejected lover was in pursuit and threatened death to the groom.

For three weeks the survey party helped the young couple avoid capture, so that they could remain together and be welcomed back by their people. The crew christened them 'Lochinvar and Ellen', but Powell learned that their Ute names were Gray Eagle and Pi-Av (Honey Dew Of The Mountains).[52]

On Sunday, August 1, some of the men crossed the Green River to get water from the Uinta. They took breakfast to the warrior and his bride. Thompson got them into a good humor and brought them back to camp. As Hillers wrote: 'Beaman took a photograph of these two children of nature ... [who] had no objection to having their photograph taken' (plate 5.33).[53] Beaman gave them a copy, but they did not show any curiosity.[54] Beaman reported that it was 'the first case of genuine affection we have seen ... We immortalized them through the camera, and bidding them farewell started on the 5th of August again down the river.'[55] The warrior and his bride headed for home. This classic photograph has previously been miscredited to Hillers.[56]

At the end of the month, Hillers and Clem went to the Hopi villages of Oraibi, Hotevilla and Moenkapi. Hillers took some pictures, including one of Chief Patnish, a half Navaho, half Ute who had been a guide on Powell's 1870 trip to the pueblos. The chief invited them for dinner and songs. Hillers mixed a brew of photographer's alcohol, sugar and water which they all had a good time drinking.

Beaman was to have gone on the Hopi trip but had a dispute with Powell. Beaman had been a river boat captain on the Great Lakes and throughout the trip he had fought with Powell over navigation. Powell discharged him on November 25, having purchased 250 of his negatives. The parting was not friendly.

On November 21 and 22, members of the Wheeler Survey, including photographer William Bell, visited Powell's winter camp at Kanab. Hillers and Clem showed Bell their negatives, and he invited them to see his. Clem wrote: 'Bell showed us how to develop dry plates; do not like the process as well as the wet ... too much bare glass to make them first class ... admired his dark tent ... conveniences he had for taking pictures'.[57]

Beaman's government appointment did not officially end until January 31, 1872, when Powell paid him $800 for ten months' work. Beaman attended the Ta-Vo-Koki (Circle Dance) of the Paiutes on January 2, and took some of the first photographs of an Indian ceremony (plate 5.35). Powell probably directed the subject-matter, since the Paiutes wear winter costumes in some images and summer in others. He retained the negatives, so they must have been part of his deal with Beaman.[58]

Beaman went on an independent trip to the Southwest pueblos later that summer. He then returned East and published these photographs along with a second set of negatives from the Powell Survey in a series of articles called 'The Canyon of the Colorado' for *Appleton's Journal*, and in Dellenbaugh's romantic narrative *A Canyon Voyage*.[59]

Powell took his Beaman negatives to the Charles R. Savage studio in Salt Lake City. Savage's assistant, James Fennemore, a British-born Mormon photographer, did the work. Powell was impressed and offered him a job on the survey.

From March until August 1872, Fennemore took photographs along the rim of the Grand Canyon with Hillers as his assistant. He photographed the ancient ruins in Glen Canyon, and Ute women gathering seeds nearby.[60] He was a gentle man who patiently taught Hillers all that he knew about photography. Before the trip down the Colorado River through the Grand Canyon, Fennemore became ill and had to resign. Powell purchased seventy of his negatives. Fennemore later opened his own studio in Salt Lake City where he designed a new lightweight, portable camera. Although he practiced photography for many years, most of his negatives were destroyed by fire.[61]

Hillers became Powell's chief photographer for the trip down the Grand Canyon which set out on August 14, 1872; Clem was his assistant. Under Powell's direction, Hillers took successive negatives of canyons from origin to end. No other nineteenth-century photographer used this method to imply continuity in natural phenomena. Throughout the journey, the Mohaves and the Paiutes were at war. On September 8, at the mouth of the Kanab just before descending the Grand Wash, Powell halted the voyage. His Mohave guides warned him that the Paiutes planned an ambush further downstream. Powell did not want to risk lives again, having already undertaken this spectacular journey successfully in 1869.

The next month, Hillers and Clem went back to the Hopi villages for the winter dances. Hillers photographed the Tewa (Hano), Sichomovi, Mishongovi, Shongopovi, Shipaulovi, Walpi and Oraibi Pueblos. He was to return twice more, at the end of the summers of 1875 and 1876.[62]

In 1873 the Secretary of the Interior appointed Powell as the Commissioner of Indian Affairs to report on the wisdom of the reservation system for the Ute, Paiute and Shoshoni tribes. His official reports included photographs. Powell wanted to make his expeditions seem like one continuous journey of exploration down the Colorado River and the Grand Canyon, so he put together all the images taken between 1871–73, and dated them 1873. He then credited them to one photographer, Hillers. Beaman, Fennemore and all the other survey members for those years were never mentioned.

The 1873 photographs actually taken by Hillers were 'doctored' for popular articles published by Powell in *Scribner's Magazine*. Powell invited the artist Thomas Moran (who had worked with Jackson on the 1872 Yellowstone Expedition) to accompany him that year, to arrange the Indians in artistic poses. 'Myself In The Water', as the Paiutes and Utes called Hillers, then photographed them in romantic settings (plates 5.36–5.41). Powell's captions to the images used real Indian names but fictional titles to tell the story of their former, traditional way of life to Congress and the general public. The reality of starving, half-naked people driven from their land was not shown. In one photograph, the White River Ute buckskin dress worn by a Paiute woman had actually been collected by Powell in 1868: in 1873 he took it out of the Smithsonian collections back into the field and asked her to wear it. Note the National Museum accession number on her bodice (plate 5.39).[63]

AFTER THE SURVEYS...

1874 was the first year that Congress requested publication of Powell's ethnographic studies with photographs. In the same year, Hayden got Jackson to publish a preliminary catalog of his negatives. The first section included photographs of Indians from delegations and in the field. The second section covered landscape views from the surveys. The following year a second edition was compiled. Then in 1877 Jackson published his second catalog, popularly known as *The Jackson Catalogue*. Jackson erroneously received credit for all the photographs which had been collected by Hayden and Blackmore.[64]

When *Contributions to North American Indians* was published that same year by Powell, the Smithsonian considered him their leading expert on Indians. The Interior Department then asked him to conduct a general census to classify tribes linguistically in order to aid in the reservation system. All government ethnographical collections, including photographs, came under his control. Powell assigned a series of numbers to the negatives from his surveys and once again credited them to one photographer, Hillers, excluding Beaman and Fennemore. Photographs taken by Hillers at the Grand Council in Okmulgee, Indian Territory, from May to August 1875, were accurately documented by Hillers: 'I grouped the whole and made a No. 1 negative ... I found six Cheyenne who had just left the warpath ... I took them among the rocks and set them up as food for my camera' (plate 5.46).[65] Powell's agreement with Hillers regarding his survey negatives published commercially by the Jarvis studio in Washington stated that 40 per cent of the profit was to go to Powell, 30 per cent to Thompson and 30 per cent to Hillers.[66]

During the last years of the surveys, Powell and Hayden continued their competition and clashed several times over duplication of fieldwork and photographs. On May 19, 1877 the Interior Department divided their tasks: both were to produce geological information, but Hayden was to specialize in a geographical study of resources, while Powell was to continue all the ethnographical research.[67]

In 1879, Congress consolidated all the surveys into one, the United States Geological Survey (USGS), still in existence today. Clarence King was appointed its first director and hired O'Sullivan as his photographer. The following year, King resigned from USGS and Walker, chief of the Treasury Department's photographic laboratory, died. O'Sullivan applied for Walker's post, but he served for only five months before his failing health forced him to retire to his father's home at Staten Island, New York. The 'Shadow Catcher' died of tuberculosis on the snow-filled morning of January 14, 1882, aged forty-two.[68]

The Bureau of Ethnology was created to continue, under the direction of John Wesley Powell, the ethnographical work of the surveys, and to serve as a repository for the photographs and documentation collected. After King's resignation in 1880, Powell succeeded him as director of USGS. Hillers served as Powell's photographer in the fields of both geology and ethnology. He has been credited with 3,000 negatives from the Powell surveys and 20,000 negatives in association with the Bureau of Ethnology.[69]

The Army Engineers, whose survey work had been supported by President Ulysses Grant from 1869–77, were virtually eliminated from the field, and George Montague Wheeler with them. Wheeler was promoted to Captain but, broken in defeat, was put on disability leave from 1880–84 and retired in 1888. He died of pneumonia in New York City in 1905.[70]

Dr Ferdinand Vandiveer Hayden, who had been on those first expeditions of the Topographical Engineers, continued to collect fossils and write scientific papers for USGS and the Smithsonian until 1887, when the disease *locomotor ataxia* killed him.[71]

Jackson resigned as a government photographer because he thought the pay was too low to support his growing family. He opened his own studio in Denver near the Rocky Mountains he loved and had photographed on his first Hayden expedition. At the Explorer's Club in 1942, the ninety-nine-year old Jackson was honored for his 80,000 images of the American West. On June 30, 1942, after a fall, Jackson died. He was the last survivor of the original surveys.[72]

The Four Great Surveys were the heritage of hundreds of years of exploration by traders, mountain men and the Topographical Engineers. They were indeed 'great' – in the number of years they operated, in the vast territories they covered, and in their scope which embraced all the physical, natural and social sciences, including the study of man. Their contributions to the knowledge of the American West were enormous. The King Survey produced eight publications, as well as brief annual reports. The Powell Survey published eighteen. Forty were distributed for the Wheeler Survey; about fifty for the Hayden Survey. In addition, numerous articles and books were written by survey members for the general public.[73]

These volumes of work produced from the surveys may now be gathering dust on archives' shelves throughout the nation. Yet the images of the expeditionary photographers live on in our memories. From the first attempts at a landscape view to the sensitive portraits by O'Sullivan, Jackson and Hillers which reflect the proud dignity of the peoples they encountered, they answered Hayden's urgent plea to record a frontier which was rapidly vanishing: 'Hurry ... You are losing golden opportunities.'[74]

5.2 LEFT *A Plains village in Kansas Territory. Taken by Solomon Nunes Carvalho on the Frémont expedition in 1853.*

5.3 BELOW *Ojibwa birchbark tipis near the Red River, Rupert's Land, Lord Selkirk's settlement (now in Canada). Taken by Humphrey Lloyd Hime on the Hind expedition, c. 1857–58.*

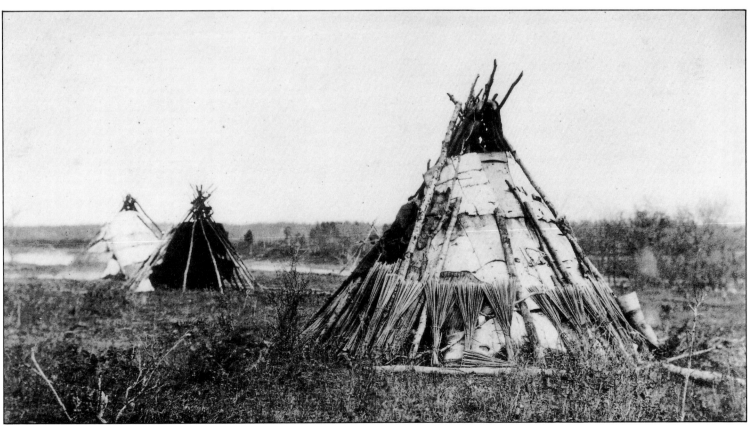

5.4 RIGHT *A Shoshoni man along the trail, possibly near Fort Laramie, Wyoming Territory. Taken by Albert Bierstadt on the Lander expedition in 1859.*

5.5 BELOW *Arapaho chiefs in buffalo robes. Taken by J. D. Hutton on the Raynolds expedition, c. 1859–60.*

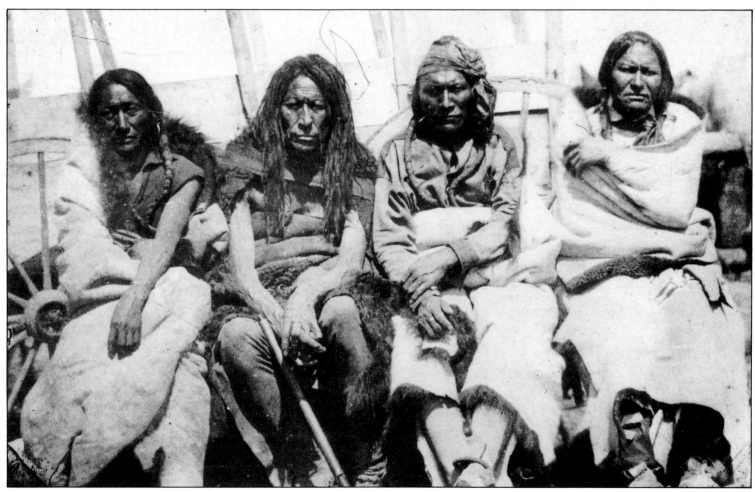

5.6 *Timothy H. O'Sullivan's mule-drawn darkroom/ambulance in the desert dunes southwest of Carson Sink, Nevada. Taken by O'Sullivan on the King Survey in 1868.*

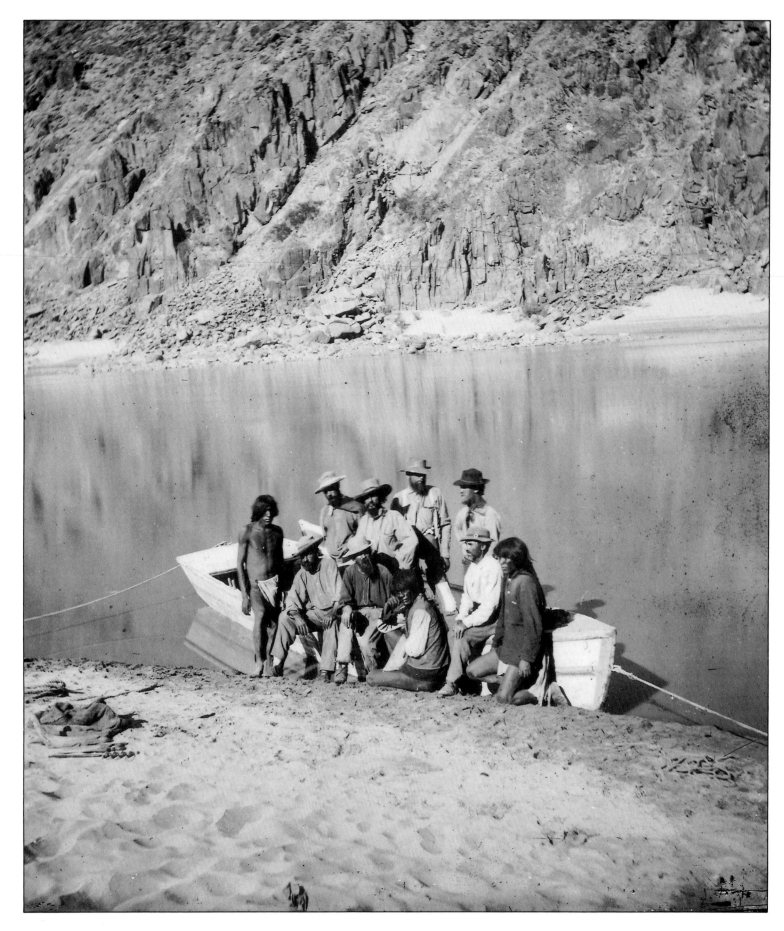

5.7 LEFT *Mohave guides with members of the Wheeler Survey on the Colorado River, Grand Canyon, Arizona (the photographer may be the figure second from the left). By Timothy H. O'Sullivan,*

5.8 LEFT *Mohave guides caught napping on the beach of the Colorado River, Grand Canyon, Arizona. Because of their fear of photography, this was the photographer's first opportunity to capture them on film. G. K. Gilbert, a geologist, sits on rocks nearby. Taken by Timothy H. O'Sullivan on the Wheeler Survey in 1871.*

5.9 BELOW *Panambono and Mitiwara, two of the Mohave guides on the Wheeler Survey, with whom the photographer became friendly. Taken by Timothy H. O'Sullivan on the Wheeler Survey, Colorado River, Grand Canyon, Arizona in 1871.*

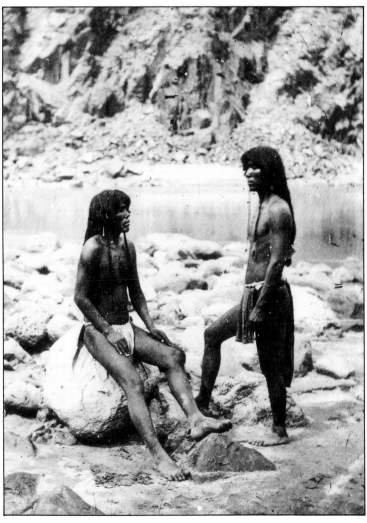

5.10 RIGHT *Probably Frederick H. Loring, the Boston reporter and crew member of the Wheeler Survey, with his mule 'Evil Merodach', four hours before Apaches attacked his stagecoach and killed him near Wickenburg, Arizona. Taken by Timothy H. O'Sullivan on the Wheeler Survey, November 5, 1871.*

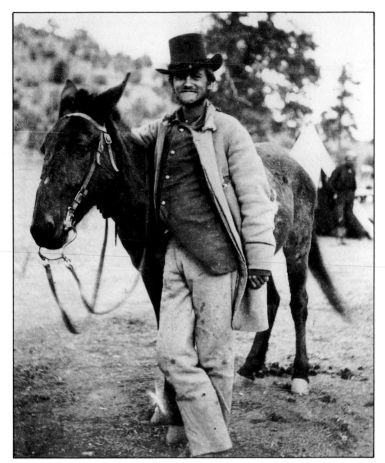

5.11 BELOW *Maiman, a Mohave guide on the Wheeler Survey and the friend of Frederick H. Loring and the photographer. Maiman spent over a year hunting for Loring's Apache killers. Taken by Timothy H. O'Sullivan on the Wheeler Survey, Colorado River, Grand Canyon, Arizona in 1871.*

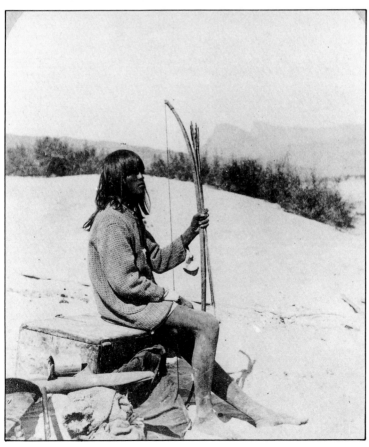

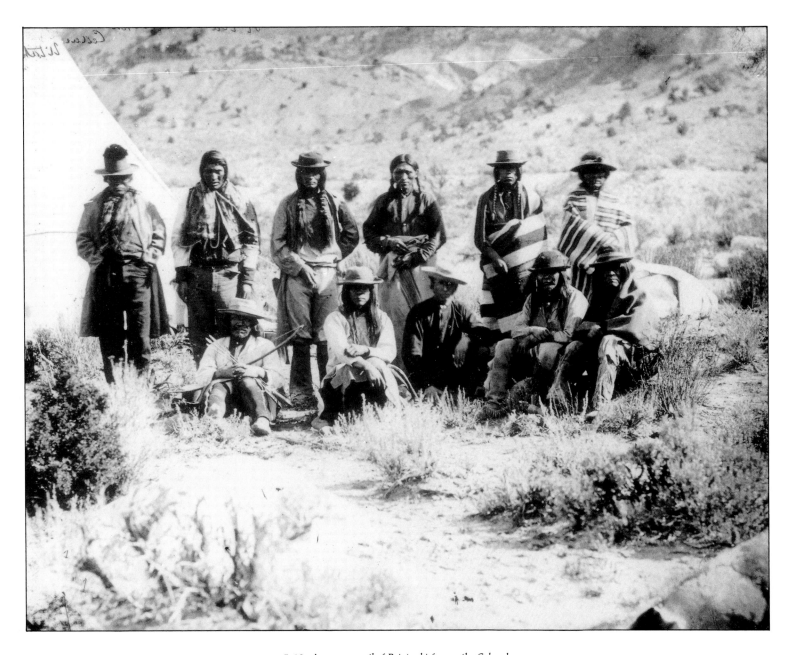

5.12 *A peace council of Paiute chiefs near the Colorado River, Grand Canyon, Arizona. The photographer himself participated in such talks, necessitated by frequent uprisings of Paiutes and Apaches against General Crook. Taken by Timothy H. O'Sullivan on the Wheeler Survey in 1871.*

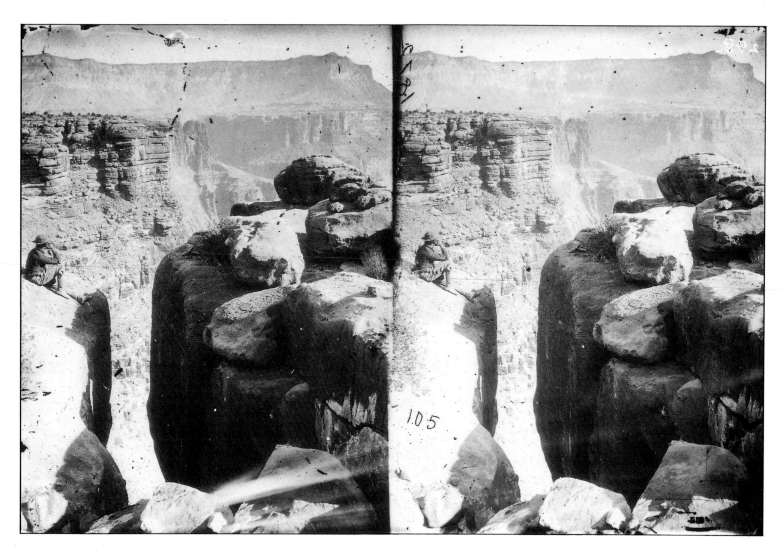

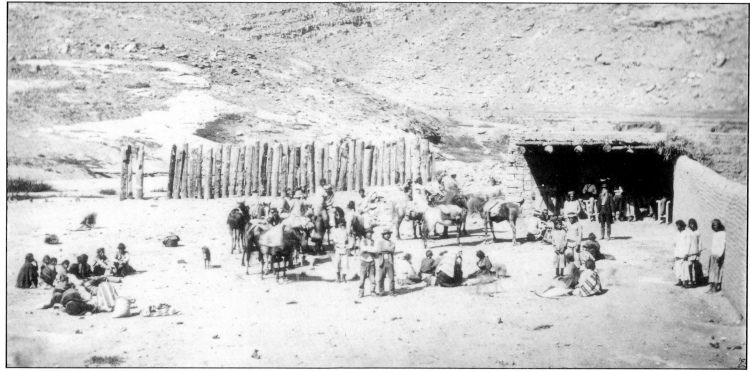

5.13 LEFT ABOVE *A stereograph of Kanab Canyon, the northern wall near the foot of To-Ro-Weap Valley, Grand Canyon, Arizona. Taken by William Bell on the Wheeler Survey in 1872.*

5.14 LEFT BELOW *An Apache trading post at either Fort Defiance, New Mexico or Camp Apache, Arizona, on ration day. Taken by Timothy H. O'Sullivan on the Wheeler Survey in 1873.*

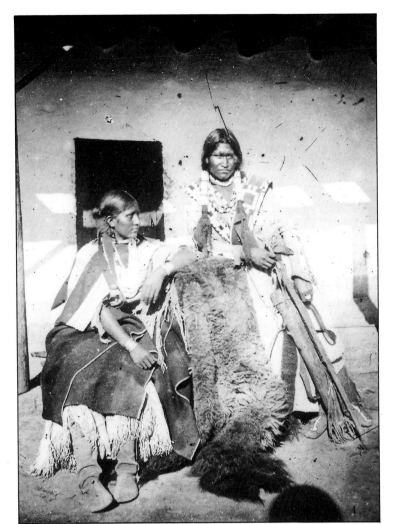

5.15 LEFT *A recently-wed Apache and his bride on the Apiquiu Reservation, New Mexico. Taken by Timothy H. O'Sullivan on the Wheeler Survey in 1873.*

5.16 BELOW *A Navaho group including a woman weaving on a horizontal loom (one of the first photographs demonstrating Navaho weaving), Canyon de Chelly, near Fort Defiance, New Mexico. Taken by Timothy H. O'Sullivan on the Wheeler Survey in 1873.*

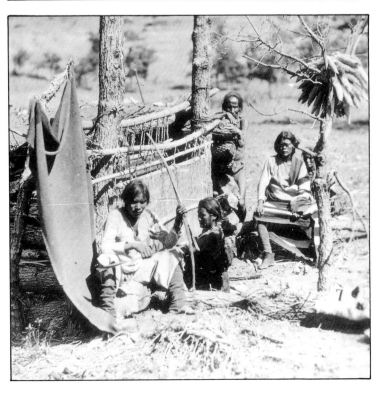

5.17 RIGHT *A view of Zuni Pueblo, New Mexico from the interior, the first image of the Pueblo by a survey photographer. Taken by Timothy H. O'Sullivan on the Wheeler Survey in 1873.*

5.18 BELOW *Zuni war Chief Match-Olth-Tone holding in one hand a Lincoln cane, in the other a Spanish cane and rifle, the symbols of office of a governor. Taken by Timothy H. O'Sullivan on the Wheeler Survey at Zuni Pueblo, New Mexico, 1873.*

5.19 RIGHT *Wheeler Survey members in the White House Ruins of the ancient Anasazi culture (600–1300 AD), Canyon de Chelly, New Mexico. By Timothy H. O'Sullivan, 1875.*

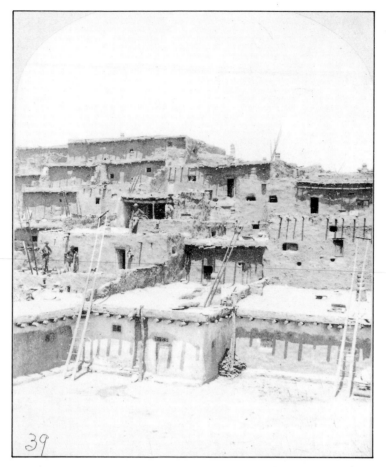

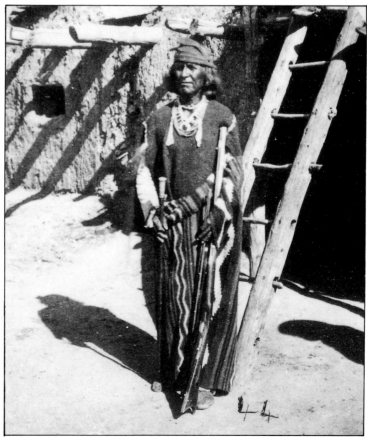

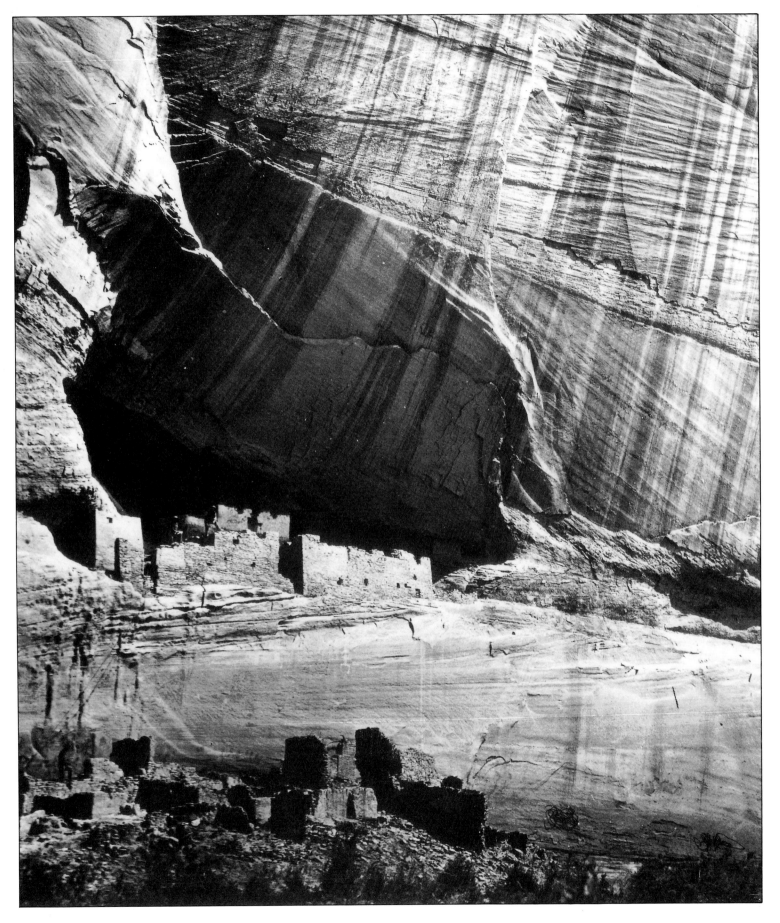

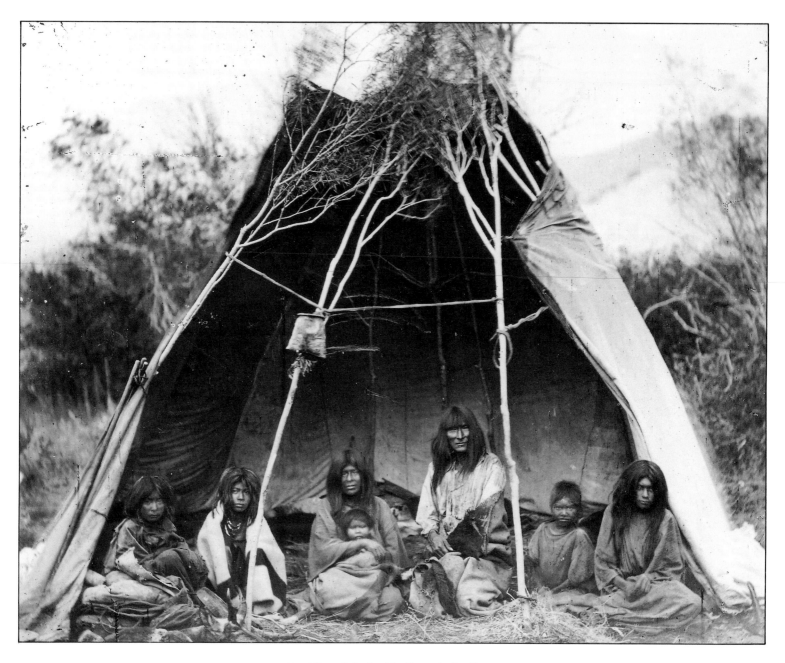

5.20 *A Bannock family of the Sheep-eater band in camp at the head of Medicine Lodge Creek, Idaho. Although shy, 'a handful of sugar and some coffee reconciled them to having their photographs taken'. Seven years later, most Bannocks were prisoners (plate 5.29). Taken by William Henry Jackson on the Hayden Survey, June 11, 1871.*

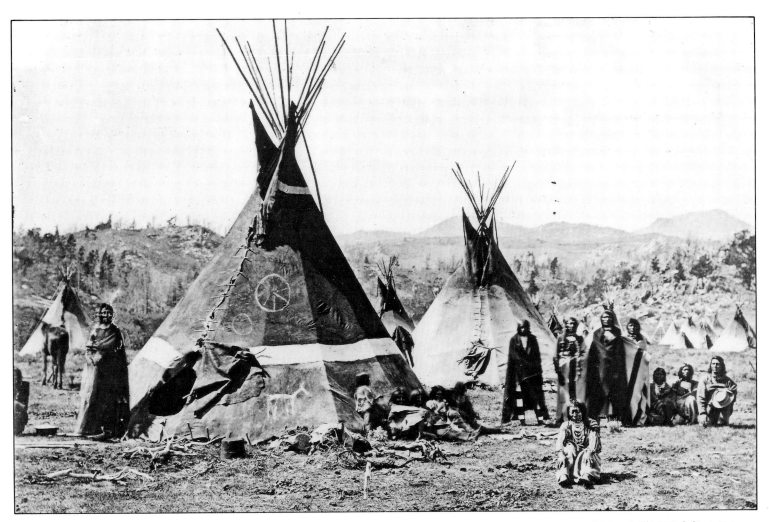

5.21 ABOVE *Shoshoni Chief Washakie's village near the Sweetwater River, Fort Stambaugh, Wyoming. Taken by William Henry Jackson on the Hayden Survey, September 1870.*

5.22 LEFT *Chief Washakie at Fort Stambaugh, Wyoming. Taken by William Henry Jackson on the Hayden Survey, September 1870.*

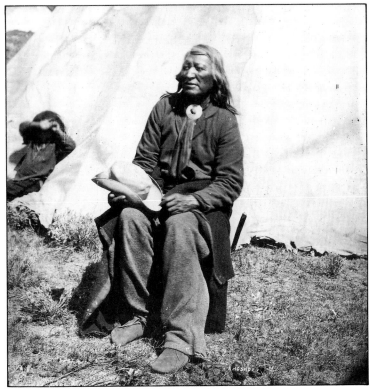

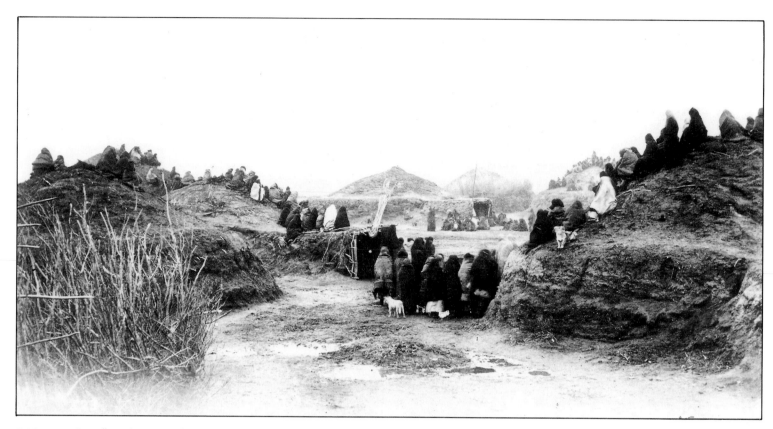

5.23 ABOVE *At a village of Pawnee earth lodges, Loup Folk, Nebraska, a group seems to be watching a naming ceremony to grant an honored name to a warrior who has shown bravery. In a few years such lodges had been plowed under and the Indians moved to reservations. Taken by William Henry Jackson on the Hayden Survey, September 1871.*

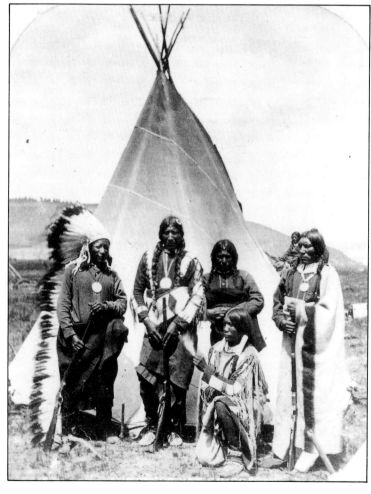

5.24 LEFT *The Ute sub-chief Tush-A-Qui-Not, called Peah, and warriors outside a tipi at Los Pinos Reservation, Colorado. Taken by William Henry Jackson on the Hayden Survey, August 1874.*

5.25 *John Moss (standing) and Tom Cooper (seated),
guides for the photographer, in the ancient Anasazi ruins,
Mancos Canyon, Colorado. Taken by William Henry
Jackson on the Hayden Survey, August 1874.*

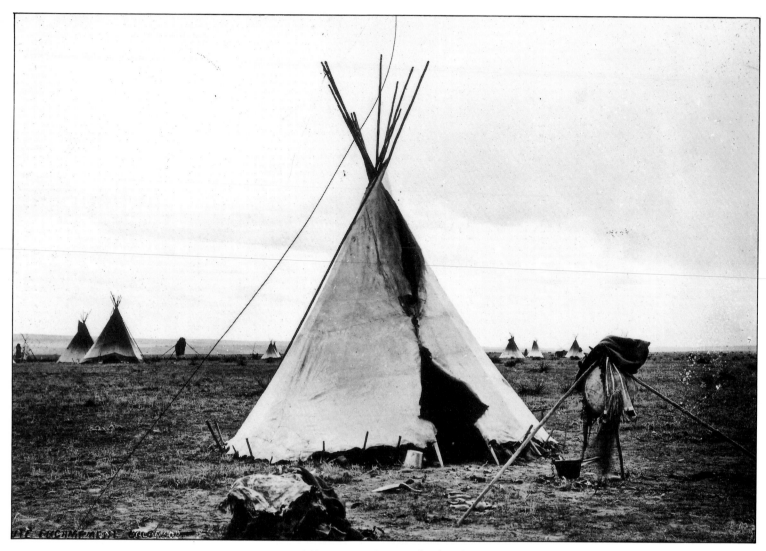

5.26 *A Ute camp near Denver, Colorado. Taken at the request of Ferdinand Vandiveer Hayden, the survey leader, by William Henry Jackson, October 1874.*

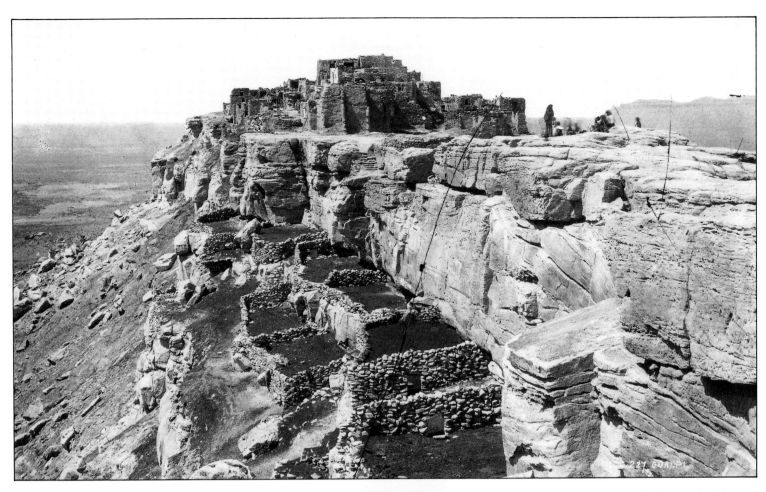

5.27 *Walpi Pueblo, Arizona. Taken by William Henry Jackson on the Hayden Survey, October 1876.*

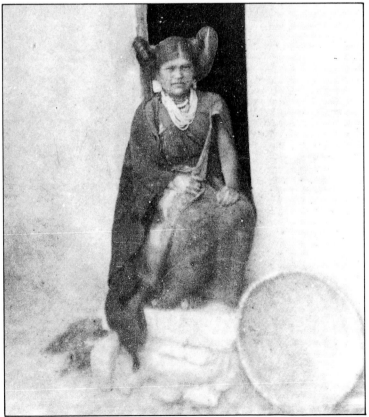

5.28 LEFT *The famous potter Nampeyo (Serpent That Has No Tooth) when only eighteen, at Tewa Pueblo, Arizona. Taken by William Henry Jackson on the Hayden Survey, October 1876.*

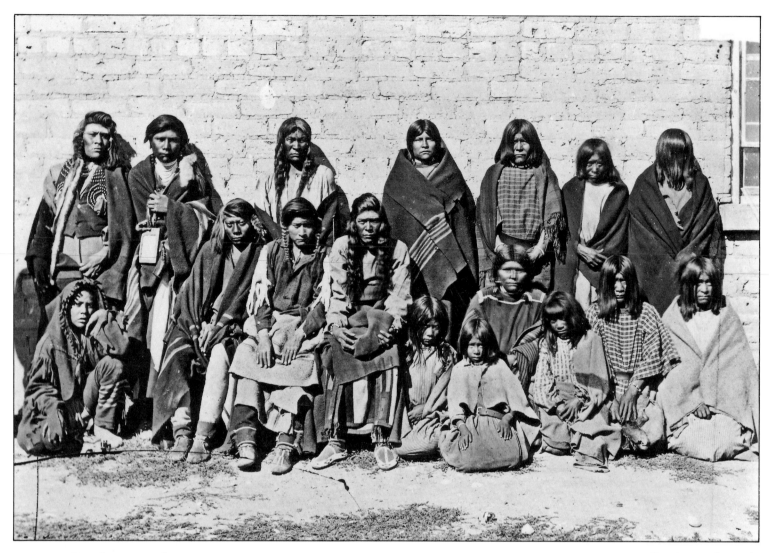

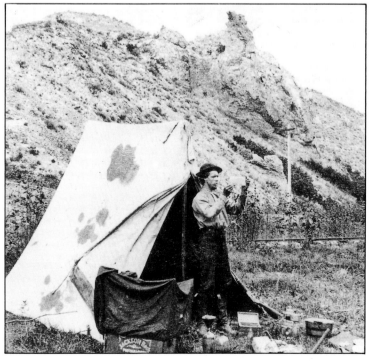

5.29 ABOVE *Bannock prisoners at the Snake River Reservation, Fort Hall, Idaho. Taken by William Henry Jackson on the Hayden Survey, September 1878. See also plate 5.20.*

5.30 LEFT *William Henry Jackson and his photographic equipment in field camp, Echo Canyon, Utah. Taken by William Henry Jackson on the Hayden Survey in 1869.*

5.31 RIGHT *Ferdinand Vandiveer Hayden, leader of the Hayden Survey, on horseback. By William Henry Jackson.*

5.32 BELOW *The Hayden Survey party in field camp, including the photographer (second from the right). By William Henry Jackson, 1872.*

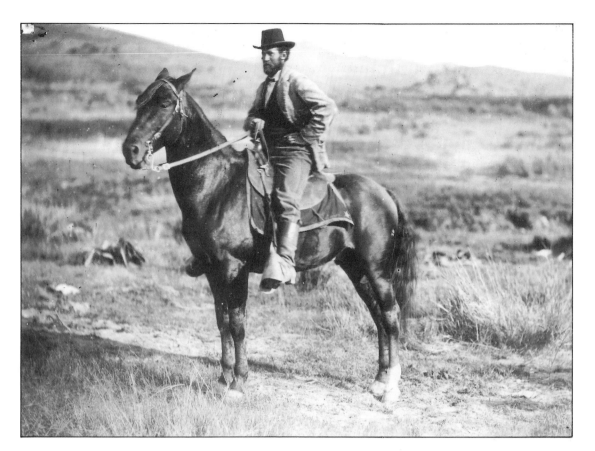

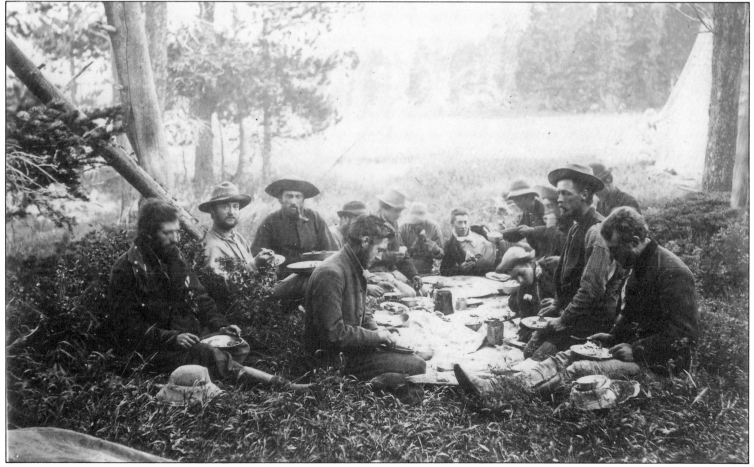

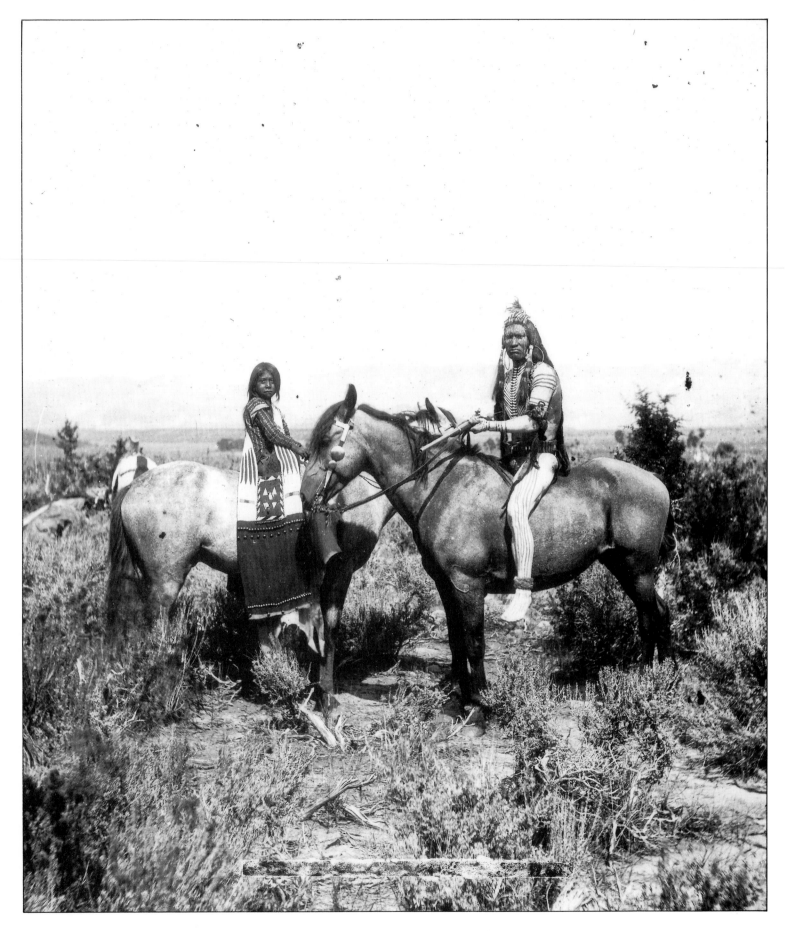

5.33 LEFT *Gray Eagle, son of Chief Douglass, a White River Ute, and his bride Pi-Av (Honey Dew Of The Mountains), near the junction of the Green and Uinta Rivers, Utah. They had eloped and hoped soon to be welcomed back to their people. Taken by Edward O. Beaman on the Powell Survey, August 1, 1871: it was 'the first case of genuine affection we have seen'.*

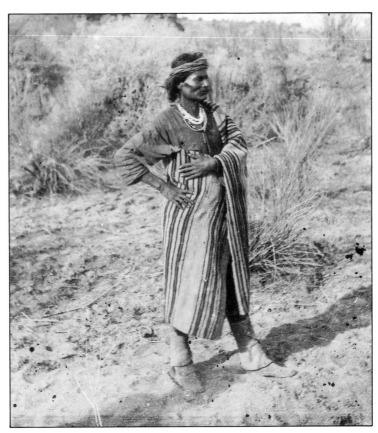

5.34 LEFT *Navaho Chief Ashtiahkel on a trading expedition to Zuni and Hopi Pueblos. Taken by Edward O. Beaman on the Powell Survey in 1871.*

5.35 BELOW *A group of Paiutes wearing traditional winter buckskin costumes dance the Ta-Vo-Koki (Circle Dance) near Kanab, Utah, in one of the first photographs of a ceremony in progress (John Wesley Powell may be the figure at the far left). Taken by Edward O. Beaman on the Powell Survey, January 2, 1872.*

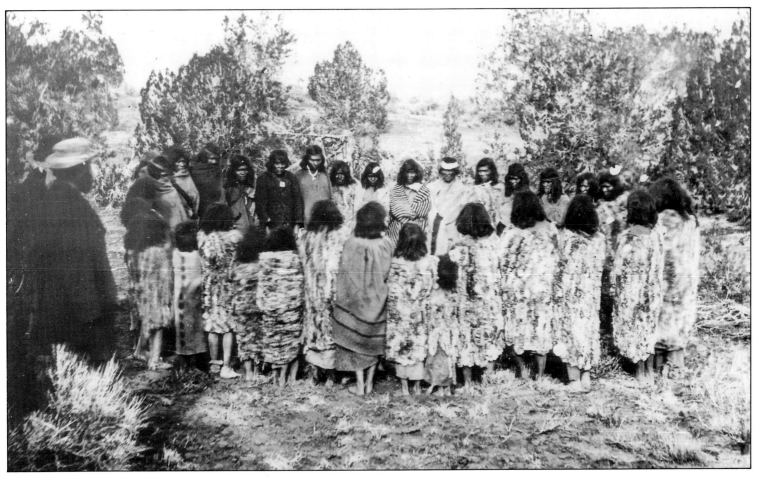

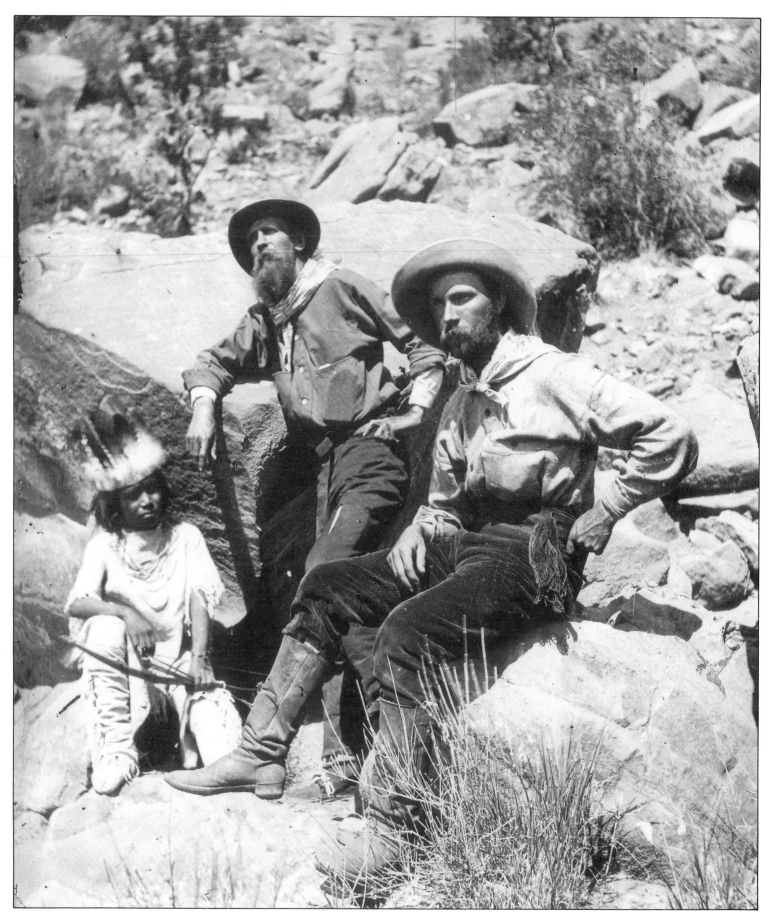

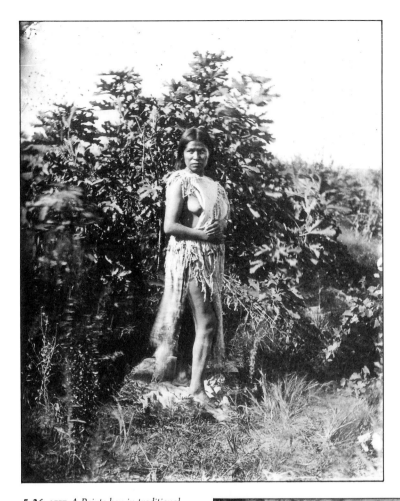

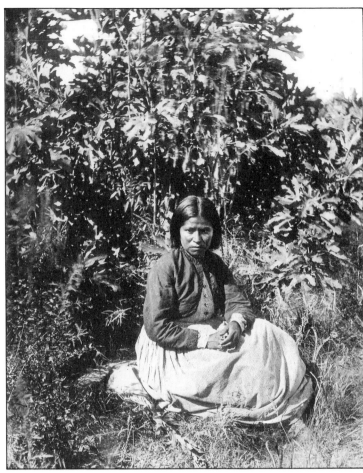

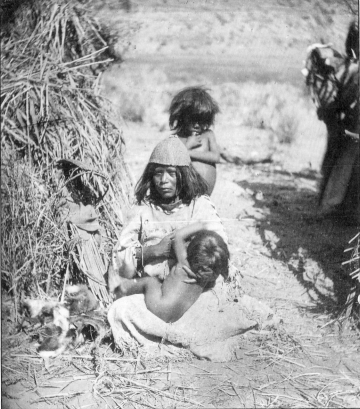

5.36 LEFT *A Paiute boy in traditional buckskin costume, the artist Thomas Moran (center) and survey member L. Coburn (right) near Kanab, Utah. Moran's job was to arrange the Indians in artistic poses. Taken by John K. Hillers on the Powell Survey in 1873.*

5.37 ABOVE *A Paiute, Kaiar, wearing native summer dress in Vegas or the Meadows, Nevada. Taken by John K. Hillers on the Powell Survey in 1873.*

5.38 ABOVE *A Paiute, Kaiar, in a calico dress in Vegas or the Meadows, Nevada. Taken by John K. Hillers on the Powell*

5.39 LEFT *A Paiute woman clothed in a White River Ute buckskin dress, Kaibab Plateau near the Grand Canyon, Arizona. John Wesley Powell brought the costume back into the field from the Smithsonian collections: the access number on her bodice reads 'Colorado territory 10800'. Taken by John K. Hillers on the Powell Survey in 1873.*

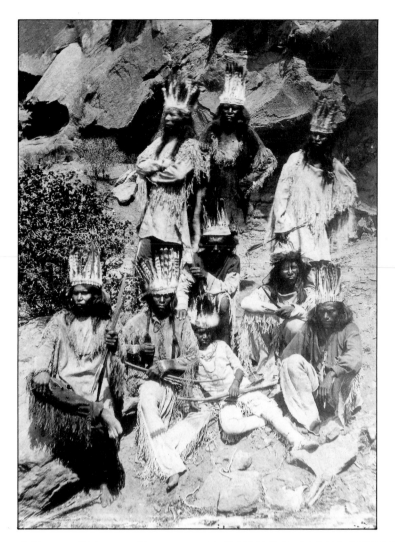

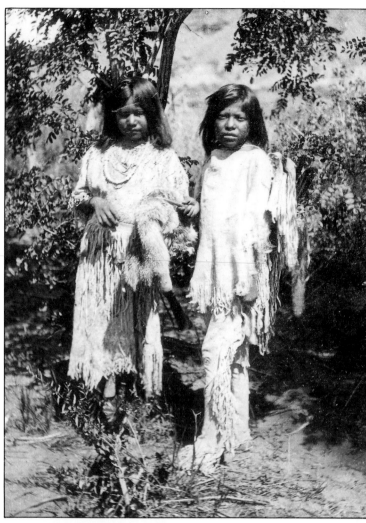

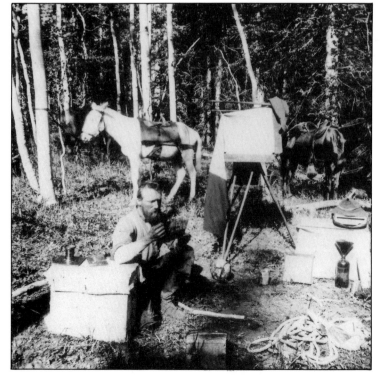

5.40 ABOVE *Paiute men and boys wearing traditional buckskin costumes, posed by the artist Thomas Moran (plate 5.36). Taken by John K. Hillers on the Powell Survey in 1873.*

5.41 ABOVE *'The Little Hunter and his Sweetheart'; Paiute children wearing native buckskin costumes near St George, Utah, posed by the artist Thomas Moran. Taken by John K. Hillers on the Powell Survey in 1873.*

5.42 LEFT *The photographer John K. Hillers studying his negatives in field camp. By an unidentified photographer on the Powell Survey in 1872.*

5.43 RIGHT *'Inquiring for the Water Pocket': Tau-Gu, head Chief of the Paiutes in Arizona and Utah, and John Wesley Powell, leader of the Powell Survey, Kaibab Plateau, near Grand Canyon, Arizona. By John K. Hillers, c. 1872–73.*

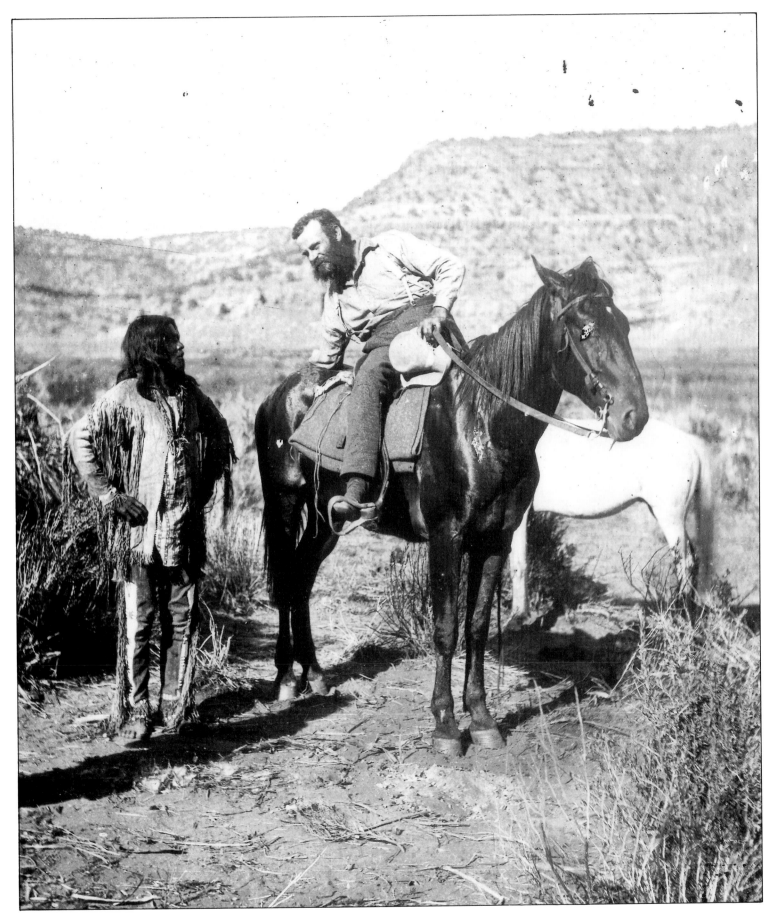

5.44 *Paiute Chief Tau-Gu and John Wesley Powell, Kaibab Plateau, near Grand Canyon, Arizona. Taken by John K. Hillers on the Powell Survey, c. 1872–73.*

5.45 BELOW *Various bands of the Paiute tribe, Mormon settlers and survey leader John Wesley Powell, recently appointed Commissioner of Indian Affairs for the Department of the Interior, near Rio Virgin, Utah. Taken by John K. Hillers on the Powell Survey in 1873.*

5.46 RIGHT *The Cheyenne Little Bear posed among the rocks at the Grand Council in Okmulgee, Indian Territory. Taken by John K. Hillers on the Powell Survey, May 10, 1875.*

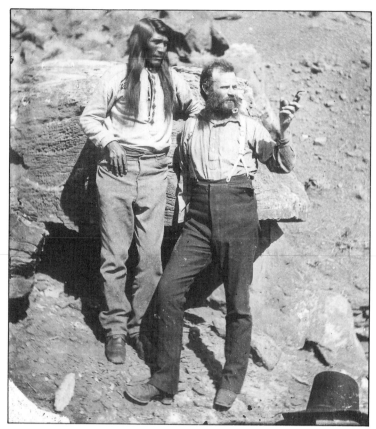

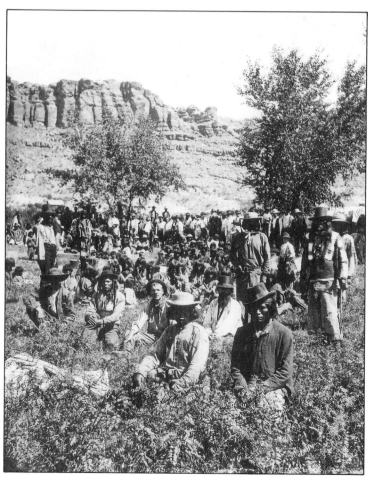

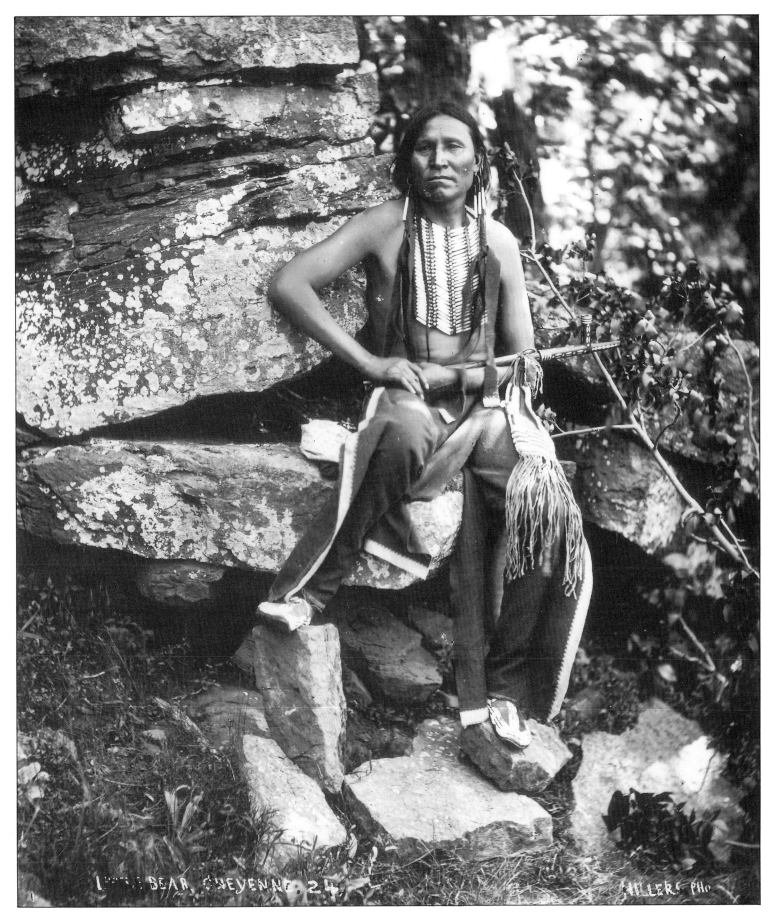

'THE CULTURE OF IMAGINING'

EARLY ANTHROPOLOGISTS AS PHOTOGRAPHERS

'ANTHROPOLOGY is the study of human beings as creatures of society.'[1] What distinguishes it from other social sciences is that it includes the study of cultures apart from one's own. Culture is the sum total of what makes us different from other animals. American anthropologist Leslie White defined culture as 'anything founded on the symbolic process and transmitted to another generation'.[2] Whatever culture is, it definitely determines the way we live and take photographs.

Photographs, even the most abstract, are always images of something and they are always made by someone.[3] Behind their creation lies what is called 'the culture of imagining' – the beliefs and patterns of behaviour brought to photographing a subject – a culture quite apart from that contained in the image.[4] The early American anthropologists who directed picture-taking or became photographers themselves were, without recognizing it, part of such a culture.

In the days of first contact, the federal government dealt with the North American Indian tribes as separate nations or cultures. First as a scholar and later as president, Thomas Jefferson implemented the early theories and methods of American anthropology. He created a comprehensive plan for anthropological inquiry into the cultures of North American Indians. Letters were circulated to the intellectual community, with questionnaires to be completed by government officials and collaborators in the field whose data could be analysed by scientists. In the field of ethnography (the history of a culture), Jefferson directed Lewis and Clark to record information about the Indian tribes they encountered on their 1804–06 expedition to the Pacific.[5] In the field of archaeology (the study of man's past material culture), he excavated a burial mound in the state of Virginia in 1784. But as the first priority, he emphasized linguistics (the study of languages), for he recognized the loss of the words of the Indians to literature as a whole. Jefferson's pure scientific interest in North American Indians was augmented by his belief that their culture should be preserved for future generations to study in the overall history of mankind. This was his legacy to American anthropologists and to the Indians.

In August 1846, around the council fire of the New Confederacy of the Iroquois in New York, Henry Rowe Schoolcraft, an ethnologist, challenged a group of young students to devote themselves to the study of America's 'free, bold, wild, independent, native race ... Their history is to some extent, our history ... a past full of deep tragic and poetic events.'[6] Eight days after that address, he sent to the new Smithsonian Institution his 'Plan for the Investigation of American Ethnology', outlining his intended areas of research: a 'Library of Philology', archaeological investigations ... and material collections from living tribes to create a 'Museum of Mankind'.[7]

On March 3, 1879, the Bureau of Ethnology was created under the Department of the Interior, in the scientific framework proposed by Jeffer-son and Schoolcraft. The Smithsonian Institution was appointed administrator. The title was later changed to the Bureau of American Ethnology (or BAE). Early development of the Bureau was based on the broad social evolutionary theories of the nineteenth century, best amplified by ethnologist Lewis Henry Morgan.

Morgan's career from 1851–81 spanned the decades during which American anthropology developed from a scientific curiosity about other cultures to a systematic classification of humanity (including Indian tribes) into stages of development from barbarianism to civilization. Morgan's Smithsonian publications, *Ancient Society* (1851), *Systems of Consanguinity and Affinity of the Human Family* (1871) and *Ancient Society* (1877), were milestones in this transition. He helped American anthropology to become recognized as a science, with the Smithsonian Institution and the federal government as its leader. It was now up to John Wesley Powell, the first director of the BAE, to organize anthropology and make it a profession.

To be an anthropologist in 1879 meant employment by the government at Powell's newly-established Bureau. His staff was initially recruited from personnel of the Four Great Surveys, and included James Stevenson as executive officer and John K. Hillers as staff photographer.[8]

No formal academic programs for anthropology existed, so the staff were all self-taught amateurs. They came from a variety of backgrounds, including other sciences, and most had had some field experience. They were all to maintain a delicate balance between the white man's new world and the ancient world they discovered. The impact of their presence among the North American Indians changed not only the peoples they studied but also the anthropologists themselves.

During the surveys, Powell had learned the value of photography: he had used it to illustrate government publications which publicized his work both to Congress and the general public. Under his direction, the BAE became the central clearinghouse for the publication of anthropological studies in annual reports and bulletins. *The Third Annual Report* (1881–82) was the first to print photographs. From that time until 1964 when the BAE became the Department of Anthropology, over 100,000 volumes on every phase of Indian culture were published.[9]

Funds for the new Bureau were limited, so Powell had to demonstrate a practical use for anthropology in order to gain additional money from Congress. Photographs from the surveys had been taken to publicize the American West and record traditional ways of life in order to make the transition to the reservation system more efficient. Now they were being taken for the national policy of assimilation – the absorption of one culture by another, dominant one. Separate peoples were to become one.

Powell's staff continued the work of the surveys, but emphasis shifted from geography and geology to archaeology and ethnology. While his office worked on the classification of Indian languages, Powell called for those in the field to record ethnographic data and make material collections.

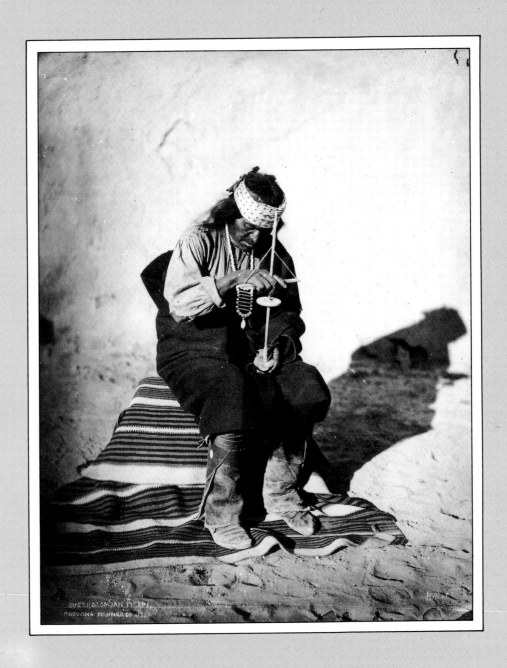

6.1 *Governor Ahfitche, called José Quivera, of the San Felipe Pueblo, demonstrating the pump and drill method of making holes in turquoise and shells. Taken by John K. Hillers at San Felipe Pueblo, New Mexico in the winter of 1880.*

From 1879–87 anthropologists were helped in their fieldwork by professional staff photographers. Large-view and stereotype cameras from earlier expeditions were used. Then in 1888 the world of photography was revolutionized by the introduction of the Kodak box camera by Eastman. The Kodak was mainly created for amateurs to take snapshots, but it was also ideal for anthropologists untrained in technical photographic processes. The quality of their pictures did not compare with the highly technical and artistic views taken by the expeditionary photographers. Yet the snapshot taken impulsively, with no attempt to manipulate the subject nor wait for ideal conditions, perhaps comes closer to answering the needs of the historian than complicated photographic equipment. Snapshots have been called an 'informal retrospective window on history'.[10] Fortunately, the early anthropologists were given Kodak cameras to take to the field along with other scientific equipment.

STUDIES OF THE SOUTHWESTERN PUEBLOS

The Act of Congress establishing the new Bureau also granted funds for its first anthropological expedition. Powell's instructions were to investigate the pueblo villages of New Mexico.

Government surveys and exploratory expeditions continued to be organized under the War Department. While members of the party were traveling, federal troops protected them: the American West was still a hostile environment. But the region of the pueblos was an alluring one – its climate was mild and dry and it was inhabited by sedentary, isolated people with a diversity of cultures – it was an intact scientific laboratory ready to be studied.

On August 1, 1879 the Stevenson expedition set off for the Southwest. James Stevenson, as executive officer, led the investigations. He was accompanied by his wife, Matilda Coxe Stevenson and Frank Hamilton Cushing, a twenty-two-year old naturalist from the National Museum. Cushing had been appointed by Smithsonian Secretary Joseph Henry, and went along both as his representative and as ethnologist. Cushing was also to conduct a census of the pueblos for 1880. Powell's man, John K. Hillers, served as official photographer. He took with him William Henry Jackson's old 11 × 14 view camera used on the Hayden surveys.

Hillers' instructions from Powell were to take views of Hopi and Zuni Pueblos as reconnaissance for future surveys. During September, Hillers reported 'every nook and corner being photographed'.[11] The entire month of October was spent among the Hopi. In addition to scenes around the villages, Hillers photographed their winter dances. The next month he went to Zuni Pueblo to take pictures of the Shalako Ceremony and Basket Dance (plate 6.2).

By the end of December, the Stevenson expedition had returned to Washington. Only Cushing, the 'precocious young genius of the Smithsonian', remained. For the next five years, Cushing entered another world, that of the Zuni. The expedition was at first reluctant to leave him behind. Concerns for his safety were expressed by government officials in Washington: it was one thing to be an outsider – a trader, a missionary, a military man – it was another to attempt to be a Zuni. At first, Cushing was not very enthusiastic. He just wanted to carry out his assignment and do 'scientific work'.

The Governor of the Zuni, Palowahtiwa (Patricio Pino), was not at all pleased that Cushing remained. He directed Cushing to take off his white man's clothes, put on the mixed costume of a Spanish-Navaho, and try to blend in as much as possible (plate 6.6). Cushing did that and more. He

gradually came to understand the deep complexity of Zuni life. He was one of the first American ethnologists to immerse himself in another culture. He learned their language and their customs, and to most people, including the Zuni and maybe even himself, he became a Zuni.

In the fall of 1880, Hillers and the Stevensons returned to the Southwest. Cushing had been introduced to the governors of other Pueblo peoples and gained an entrance to their pueblos so that Hillers could take photographs. With an uncanny ability, Cushing had also discovered numerous archaeological sites near Zuni. From September to November, Hillers photographed sites, winter dances and activities at Taos, San Juan, San Ildefonso, Nambe, Cochiti, Jemez, Sia, Santa Ana, Sandia and San Felipe (plate 6.1). At the end of the month, the party took the railroad to distant Isleta Pueblo before returning to Washington.[12]

Hillers continued to photograph the pueblos for the first few years of the Stevenson expeditions, but after 1883 he became so involved with the BAE's photographic work of Indians in Washington that he did not return to the field.

On March 11, 1881 Powell became director of the US Geological Survey. With new funds available, he was able to hire two brothers, Victor and Cosmos Mindeleff, to collaborate with the Bureau in conducting surveys.[13] For over fourteen years, the Mindeleffs photographed pueblos and archaeological sites. Victor served as senior surveyor; Cosmos acted as his assistant and eventually took over the surveys. Cosmos visited more sites and spent a longer time at the pueblos than Victor – and he probably took most of the photographs. Cosmos also directed the modeling room in Washington where their photographs were used to make model reconstructions of ruined Indian sites; these were exhibited at government expositions. Victor and Cosmos's classic publications on Pueblo and Navaho architecture have never been surpassed. In 1891, the Mindeleffs used their photographs of Casa Grande to help restore the ruins (plate 6.14). In 1981, architects used their photographs to assist in the restoration of Zuni Pueblo.

During the 1881 field season, Cushing obtained the scalp of an Apache, an enemy of the Zuni, and presented it to the Zuni Governor. This gesture made him eligible for initiation into the Bow Priesthood, a warrior society (plate 6.7). Cushing was adopted by the Governor as his son. He eventually became second chief and dramatically changed the social and political organization of the pueblo.[14]

In the following year, Cushing took his new Zuni 'father' and five more of his fellow Bow Priests on a special expedition back East to visit their brothers, the Seneca, on the Iroquois reservation at Tonawanda. The railroads provided free transportation via Omaha and Chicago to Washington, New York and Boston. Cushing was to be initiated into the Ka-Ka-Ka-Thia-Na-Ken (Grand Medicine Society) on the trip. In Washington, the group was entertained at the National Academy of Sciences and met President Chester Arthur. While in Washington, Hillers photographed them for the BAE (plates 6.9). A recently-discovered stereograph shows that the Kilburn brothers of New Hampshire also took their photographs (plate 6.8).

Cushing returned to Zuni Pueblo and in November met the Governor of Oraibi. At first he went alone to reconnoiter the pueblo. Then on December 19, Cushing took with him the Mindeleffs and Hillers and they photographed Oraibi Pueblo for the first time (plate 6.15). They did so with great difficulty, however, because of 'the unfriendly attitude of the natives'.[15]

While on his trip East with the Zunis, Cushing had met the wealthy

Mrs Mary Hemenway of Boston. She was so impressed with him and the Zunis that she offered to sponsor Cushing's anthropological research in the Southwest. In December 1886, Cushing was placed on an indefinite leave of absence from the Smithsonian to organize the Hemenway Archaeological Expedition.[16]

In 1888 James Stevenson died of Rocky Mountain fever which he had contracted in the field in the 1870s. He was a highly respected man with powerful friends in Congress. His widow, Matilda Coxe Stevenson, or Tilly as she was called by her friends, had accompanied her husband since the Hayden surveys. On the Bureau's expeditions from 1879–88, Tilly had gathered ethnographic information at Zuni while the men made surveys and took photographs (she had watched both Jackson and Hillers at work). By all reports, Tilly had a forceful personality. The pueblos tolerated Tilly out of respect for her husband and for Cushing. Yet, she took the time to learn the Zuni language, thereby gaining entrance into the domestic life of the women, which was hidden from the men. She also won her way into the men's realm.

In 1889 she used James's influential friends in Congress to bring pressure to bear on Powell to appoint her to the Bureau's scientific staff, so that she could continue the ethnographic work. The following year, Tilly returned to the Southwest accompanied by the Bureau's stenographer, May Clark, and a new Kodak box camera. They not only stayed at Zuni Pueblo but also visited Jemez and Sia Pueblos. In previous summers, the Stevensons had been invited to a room of masks inside a ceremonial chamber, or *kiva*, at Sia, of which they had made watercolor sketches.[17] In 1890, May Clark took photographs of the altars in the *kiva*. Clark also took difficult interior views of a curing ceremony held by the Priests of the Giant Society inside their chamber (plate 6.18).[18]

Clark may have spent several field seasons in the Southwest and some of the early photographs credited to Stevenson were probably taken by her. But Tilly's intense involvement with the Pueblo Indians and her knowledge of their religious practices enabled her to tell Clark what to photograph. Later field photographs, such as those of the Giant Courier Gods of the Shalako Ceremony at Sia, were taken by Tilly (plate 6.19).

Tilly had started out as a social reformer. She believed that her work in the pueblos was to help 'lift' the Indians to civilization. She brought the white man's world with her – soap, lamps, glass doors, umbrellas, and even liquor to entice her informants. But as she lived among the Indians, Tilly gradually gained an understanding of the culture she was attempting to study and photograph. She was one of the first government anthropologists to campaign for the preservation of native religion. When the Zunis' belief in witchcraft came under investigation by the Bureau of Indian Affairs (BIA), Tilly stated that the Zunis' own witchcraft trials did not appear much different from those that had been conducted by 'civilized' Christians in Salem.[19]

STUDIES ON THE NORTHWEST COAST

While BAE anthropologists were taking pictures of Pueblo Indians in the Southwest, the Smithsonian started its photographic collection of Northwest Coast peoples. Judge James Gilhirst Swan from Port Townsend, Washington Territory, had worked among the Haida and Tlingit Indians since the 1850s. In 1879, Swan became a collaborator in the work of the Bureau: he began collecting photographs of the Haida Indians from local studios for an ethnographic study of their tattoo marks. Swan also took photographs for himself. While he was shaving a young chief of the Clyokwat (Makah) near Nootka he observed the close resemblance of some marks depicting the clan symbol 'Thuklotts' or Thunderbird to the drawings of Habel, an explorer of Central American Indians for the Smithsonian.[20]

During the early 1880s the federal government was growing apprehensive about foreign interests in the Northwest. Congress asked the Bureau to cooperate with geological surveys in that region. Secretary Spencer Baird of the Smithsonian directed Powell to employ five geologists and an ethnologist from the National Museum to work in the area. Powell objected to using his Bureau's ethnographic funds for geology, an ironic shift in his priorities. He had come to realize that geological forms would take eons to change, but not so the Indians. However, Swan was hired as the ethnologist to make collections of photographs and objects for the 1882 International Fishery Exhibition in London.[21]

In the following year, a German anthropologist took his first field trip to the New World. He was Franz Boas, one of the founders of modern anthropology, who eventually became a collaborator with the Bureau. Boas's intensive preparations for his year-long journey included taking lessons in drawing and photography. He wrote to his parents: 'Photography is so important that I want to profit as much as possible from it'.[22] Boas was taught photography in Berlin by Hermann Wilhelm Vogel, a photochemist and inventor whose work involved the sensitizing of photographic film to the colours of the spectrum.[23]

During his first field season, Boas took photographs of the Cowichan people of Vancouver Island, British Columbia. The prints were either lost in transit or are yet to be found in Germany. Those that remain are primarily landscape views, for Boas's purpose was cultural geography rather than ethnography. He wanted to use the camera as a scientific tool to see whether the Cowichan's view of their surroundings actually matched the physical environment they inhabited.

In 1885, a group of Bella Coola Indians from British Columbia were taken to Germany by Johan and Fillip Jacobson. The group had their pictures taken by Carl Gunther. The next fall, Boas supported himself financially on a trip to America's Northwest Coast to study languages, collect artifacts and take photographs. When he arrived in Vancouver on September 18, Boas saw Gunther's photographs in the hands of a Bella Coola on the street. The photographs had made their way home.

Boas had not taken a camera, so he went to the local studio of Oregon Columbus Hastings to borrow one for his fieldwork. Boas took pictures of Comox and Cowichan villages, but not without some hardship. He reported that the people were 'suspicious and unapproachable'. While photographing a totem pole, he encountered the native owner who wanted payment. Boas did not want to pay him – 'naturally I refused so that I would not deprive myself of the possibility of photographing whatever I might wish' – and continued taking pictures of the houses. The totem pole owner followed him and made him another offer: he became Boas's interpreter.[24]

The British Association for the Advancement of Science (BAAS) sponsored Boas's next Northwest trip in 1888. Boas concentrated on gathering linguistic and physical data. In Victoria, he hired E. C. Brooks to take ethnographic photographs. Boas commissioned pictures of five Haida Indian prisoners with 'beautiful tattooing'. He used their portraits, from front and side, as standard images of physical types for use in his research. He recorded their body measurements and used these in comparisons and classifications on the back of the pictures to make them 'more valuable' from a scientific point of view. The new branch of physical anthropology had begun under the BAE's sponsorship.[25]

In 1893 the World's Columbian Exposition was held in Chicago. Frederick Ward Putnam, director of the Peabody Museum at Harvard University, was in charge of anthropological exhibits. Boas acted as his assistant. George Hunt, a Kwakiutl Indian and one of Boas's most important informants, brought an entire house from Fort Rupert, British Columbia, along with a group of fourteen Indians. John H. Gabrill, a Chicago photographer, took a series of pictures of the village with dancers and singers.

After the Exposition ended, the collection of exhibits became the foundation of the new Field Columbian Museum, which employed Boas as curator. After only eighteen months, internal politics forced him out. With the assistance of the BAAS, the Smithsonian's National Museum, and the American Museum of Natural History in New York, Boas returned to the Northwest Coast to continue his fieldwork. Hastings served as Boas' photographer. George Hunt, his Kwakiutl informant (who was also Hastings' brother-in-law), acted as photographic assistant.

They were short of both funds and time, and had only three weeks to take pictures of parts of the Kwakiutl's Winter Ceremonial. Boas took the first few days 'to explain to Hastings what was going on in the ceremony … and instruct him as to what kind of pictures to take' (plates 6.48, 6.49).[26] It is often assumed that Boas obtained pictures of the complete ceremony. In fact, he had to select what to photograph, because of the limited time they were there and the technical restrictions.

Negatives were divided between the two museums which had sponsored the trip. Seventy-one went to the Smithsonian and ninety-seven to the American Museum, for use in exhibitions. Boas was later hired by the American Museum and worked with Charles Frederick Newcombe, a British-born anthropologist and photographer. They took pictures of the Northwest Coast Indians from 1897 until 1900.[27]

ANTHROPOLOGISTS AND ASSIMILATION

While the anthropologists were working in the Southwest and the Northwest in relative isolation, the government was accelerating its program of assimilation of the Plains, Basin and Plateau tribes directly in the path of westward expansion.

The General Allotment Act, or Dawes Act as it was popularly called, was passed by Congress in 1887. Its aim was to divide Indian reservations into individual holdings. An assigned parcel of land was given to each Indian and the surplus was then sold to white homesteaders. Between 1887 and 1930, ninety million acres were lost by the Indian inhabitants and acquired by new settlers.[28]

Anthropologists acted as liaisons between the cultures, to help the government carry out the land grant program and enforce the national policy of assimilation. Most believed that assimilation was inevitable but should be done on a gradual basis without shattering traditional values. One of these was a soft-spoken 'gracious lady', who seemed to have a special affinity with the people among whom she worked.

Alice Cunningham Fletcher lived with the LaFlesche family on the Omaha Reservation in order to study their music. In 1881, she adopted one of the children, twenty-four-year old Francis, so that she could help with his education and employment opportunities. Fletcher worked with the Bureau in 1882 and Francis LaFlesche joined in 1910. He and J. N. B. Hewitt, an Iroquois, were the first Indians to be employed by the BAE as anthropologists. Fletcher and LaFlesche together wrote *The Omaha Tribe*, one of the most comprehensive anthropological studies to be produced by the BAE.

From 1889–93, Fletcher served as the official representative of the Bureau of Indian Affairs (BIA) to the Nez Perce tribe in Idaho, under the Dawes Act. During the four years required to complete the land division, she was accompanied by her friend, E. Jane Gay, who served as unofficial photographer. Although Fletcher was heavily engaged in administrative matters, she managed to collect songs and stories from the people while Gay photographed them (plates 6.25, 6.26).[29] In later years, Fletcher took her own photographs. She was invited by the Pawnee to witness and photograph their sacred Hako ceremony pertaining to the origin of fire – she was one of the few women and anthropologists to be so trusted.

JAMES MOONEY AND THE GHOST DANCE CULT

As the impact of the Dawes Act and the changing Indian way of life continued to sweep over the land, an anthropologist appeared who had a special talent to preserve, and to communicate in written words and photographs, the entire history of several Indian nations. To those people his name became a legend – even today, they still remember James Mooney.

As a child, Mooney had an insatiable curiosity about the world around him. At the age of ten he started to make lists – lists that covered topics, beginning with their origins and continuing with all the information he could discover about them; lists made with an open mind, subject to refinement as new discoveries were made. One of his lists was of Indian tribes – names, languages, boundaries, treaties. He had gathered the information in order to compile a map of who the Indians were, where they lived and what had happened to them. He wanted to know the entire history of all North American Indians. By the age of sixteen, Mooney had made his classifications. Ironically, they were very similar to those that Powell and his scientific staff had been working on for years.

In 1879 (the year in which the Bureau of Ethnology was established) Mooney joined the newspaper staff of the *Palladium* of Richmond, Indiana and began his career as a reporter. At local schools and nearby colleges, he met Indians who had come there to study. They intrigued him. He began to dream of a journey south to study the Indians of Brazil, to add to his tribal list. Lacking in resources to make his fantasy a reality, he turned to the Smithsonian Institution.

From 1882–84, Mooney bombarded Washington with letters, until finally he was brought to Powell's attention. Powell was impressed with Mooney's independent research and his list of 3,000 tribes, but he did not have sufficient funds to send Mooney on an expedition, or even to employ him on his staff. So Mooney joined the Bureau as a volunteer and somehow kept himself going for a year. Then, by a stroke of fate, C. C. Royce (who had been working on Cherokee linguistics) resigned and Powell had a slot to fill.

In 1886, Mooney became officially connected with the Bureau. The following year he began his work to reconstruct the history of an Indian nation seen through his eyes and reflected in his words and photographs.

Mooney first took a camera to the field in 1888 when he photographed the Cherokees' Corn Dance, an annual celebration of thanksgiving. He also took photographs of their Ball Game, including the 'Going to Water' rite, and reported that 'a camera was used to secure characteristic pictures of the players' (plates 6.28, 6.29).

In 1889 Mooney began to collect plants and songs used by Cherokee shamans in curing ceremonies. During his investigations, he realized that the rituals secretly transmitted between the shamans were based on an

elaborate system of knowledge. Appealing to the pride of one of the medicine men, Ayyuini (Swimmer), also called Ayasta (Spoiler) or Tsisiwa (Bird), Mooney obtained the first notebook of sacred curing formulas written in the Cherokee language. Swimmer became Mooney's chief confidant and opened up the wealth of his tribe's history to the young anthropologist (plate 6.27).[30]

During the summer of 1890, Mooney was working in the North Carolina and Tennessee Mountains with the eastern branch of the Cherokee. He was planning to visit the western branch in Indian Territory during the winter to make comparisons. But in the meantime, a messianic religion had sprung up among the tribes and had begun to attract attention. Mooney was called upon by the government to investigate it and to report on its significance. Photographs were to be taken to document the facts officially, and thereby to dispel the rumors circulated by the media. What was intended as a preliminary study lasting only a few weeks was to become for Mooney a lifelong study of the Plains Indians.

When a culture, long oppressed by the overwhelming force of another more powerful civilization, loses all hope of survival, there occurs a strange phenomenon known by many names but which always takes the same form. Faced with extinction, an unreasonable hope is stirred among the people by the appearance of a 'prophet'. This shaman has a vision in which he transcends this world and meets a higher deity who gives him a message of salvation for his people: the desperate way of life will change; the people can bring about this transformation by reforming and by following certain rituals, particularly entering a trance while participating in a circular dance.[31]

In 1890, the seizure of tribal lands, broken treaties, and the forced program of assimilation by the federal government produced one of the greatest revitalization movements of North American Indians. It came at a time when many of the Indians, especially the Plains tribes, were demoralized. It was called the Ghost Dance, after a traditional dance that united all Indians, both living and dead. The new religion promised a return to idealized former days, before the arrival of the white civilization. All Indians were urged to unite in brotherhood.

The Ghost Dance cult was first recorded in 1870 among the Paviotso, a sub-tribe of Utes at Walker Lake, Nevada, with Wodziwob as the first prophet. The cult spread from Nevada into California and back to Oregon, where similar cults had appeared in the 1850s. The first Ghost Dance only lasted five years, because Wodziwob made the two fatal mistakes which so often cause the downfall of a nativistic endeavor: first he put a fixed calendar date on the millennium, and secondly he failed to provide for his own resurrection.

In January 1889, a young Paiute was received as the returning messiah when he brought back the Ghost Dance cult. He was the natural son of Tavivo, an apostle of Wodziwob. After his father's death, he had been adopted by David Wilson, a white farmer, and named Jack Wilson (sometimes known as Jackson Wilson or John Johnson). His Indian name was Wovoka (or Wevokar, Wopokahte, Koitsaw, Cowejo or Kwohitsaug). Wovoka, recovering from a bout of scarlet fever, during a total eclipse of the sun received a series of visions giving once again the messianic message of brotherhood.[32]

In the words of ethnologist Ruth Underhill: 'a spark was struck in Nevada which started a religious blaze'.[33] Wovoka's message spread like wild fire over the plains. It traveled great distances and leapt over language and cultural barriers. It was carried to other tribes by 'apostles' who made preparations to enable the prophet to spread the movement among their own people. Wovoka's doctrine was flexible enough to allow for many interpretations. Indians who adopted it incorporated their own beliefs into the basic themes.[34] By the fall of 1890, an estimated 20,000 North American Indians were practicing the Ghost Dance religion.[35]

The most notable interpretation of Wovoka's prophecy was that of the Sioux on the Pine Ridge, Rosebud and Standing Rock Reservations of Dakota Territory. The Sioux added some new and warlike ingredients: not only would their ancestors return, but they would help rid the world of the white man; and in the event of military action, Ghost Dance shirts would protect the wearer from harm. All this was to occur by the spring of 1891.

When the Ghost Dance was taken up by the warlike Sioux, the federal government's response was the massacre of Wounded Knee (see page 48). The Sioux surrendered on January 15, 1891, the year of Wovoka's prophecy. Black Elk, an Oglala Sioux medicine man, said that it was the end of his nation. Some thought it was the end of the Ghost Dance cult as well.

But the movement continued to gain momentum among the other Plains tribes. This time the government had its own anthropologist, James Mooney, to report on the religion's evolution and write an accurate account of it. Mooney was also instructed to obtain photographic evidence of where the Dances took place and who participated in them. Four days after the Sioux surrender, Mooney wrote to the Bureau:

> Please have sent at once several dozen 5 × 8 plates. The Indians are dancing the ghost dance day and night and as a part of the doctrine, they must discard as far as possible everything white man [sic]. They are bringing out costumes not worn in years ... I have written Mr. Hillers in regard to work on Kodak before starting and a box of plates sent on from here, but have not heard from him. Please see if it can be pushed as I cannot stay here more than a few days longer.[36]

Before studying the Ghost Dance, Mooney had used, in his fieldwork, a tripod camera with glass plates. If he did take pictures with this camera, they have not yet been discovered. For this trip he reported that he also carried a Kodak used by Matilda Coxe Stevenson. Within a week, he requested a Kodak manual so that he could determine the proper exposures. He wanted to take photographs of the Dance from both without and within the circle. Considering the frenzy of the Dance, the Kodak would have been the best choice: it would take rapid, simple and relatively successful photographs. Mooney immediately abandoned his cumbersome flash unit, as the ritual was the same day and night. But campfire smoke and the pallor of winter light reflected on the snow-filled dance grounds made it difficult to photograph.[37]

Mooney valued field photographs as historic documents but he did not have the time to learn the techniques. His main means of communication was the written word. Yet his slightly out-of-focus photographs, with the shadow of his image, are haunting (plate 6.30).

In the following year Mooney continued his investigation of the Ghost Dance on his own. He left Washington in mid-November 1891 for the Pine Ridge Reservation in South Dakota. One morning he rode out to the site of the tragedy at Wounded Knee (see Chapter 3). As he walked around, he came upon a mass grave of Big Foot's band, paint-smeared with sacred clay given to the Sioux by Wovoka. The graves were marked so that the dead would be the first at the resurrection. Mooney vowed to learn more about the tragic implications of the cult from the prophet himself. He headed for Nevada.

Mooney arrived in late December and spent a lonely Christmas night

at Reno. The following morning he started south for the Walker River Reservation to meet Charly Steep, an uncle of Wovoka. After a week's discussion about Paiute culture, Mooney won Charly's trust by showing him photographs of his friends, Cheyenne and Arapaho Ghost Dancers. These photographs led him to Wovoka.

On New Year's Day, 1892, guided by Charly, Mooney approached the Paiute camp. Along the way, he took some photographs of mounds. Gazing out on the desolate snow-filled prairie, he found it hard to determine whether the mounds were sagebrush plants or the *wikiup* homes of the people (plate 6.32).

Coming over a ridge, Mooney met Wovoka who invited him to camp that evening. Wovoka wanted to tell the anthropologist sent by Washington about his sacred mission to the tribes. In subsequent interviews, Wovoka supplied very little additional information about his doctrine. Mooney showed him the photographs of the Cheyenne and Arapaho dancers, many of whom had visited Wovoka during the previous summer. Wovoka's reticence gave way to curiosity. He responded to Mooney's natural honesty and sympathy. Most of all, the pictures of the Ghost Dance actually being performed convinced him to trust Mooney.

At their last meeting, Mooney wrote: 'I had my camera and was anxious to get Wovoka's picture. When the subject was mentioned, he replied that his picture had never been made.' Mooney paid Wovoka his regular price for an informant's services and promised to send him a copy of the picture. The prophet posed in front of the lens and the photographer tripped the shutter. Mooney now possessed the first photographic image of Wovoka (plate 6.33).

In 1894, Wovoka the Messiah was appearing as a sideshow attraction at the Midwinter Fair in San Francisco.[38] By 1926 he was having his picture taken with the famous Hollywood cowboy actor, Tim McCoy, who was Governor of Wyoming at the time (plate 6.35).

Wovoka's dream died at Wounded Knee. Yet, in a lonely cemetery at Shurz, Nevada, offerings from those who honor him still mark his grave.[39] The impact of Wovoka's meeting with Mooney is still felt today. Mooney had not only seen and spoken with the Messiah but had proof of his visit in the photograph. This emphasized to Mooney's Ghost Dance informants that he was sincere in his efforts. Mooney reported: 'I had always shown a sympathy for their ideas and feelings, and had now accomplished a long journey to the Messiah himself ... the Indians were at last fully satisfied that I was really desirous of learning the truth concerning their religion.'[40]

Despite the fears created by this cult, no government representative other than Mooney was ever sent to gain first-hand evidence from the prophet himself. Mooney's written report, the songs he collected, and the photographs are all that remain. His classic publication *The Ghost Dance Religion and the Sioux Outbreak of 1890* still stands as a model for anthropological investigations.

Also in 1892, Mooney visited the Caddo, Kiowas and Comanches where he participated in Ghost Dances and witnessed for the first time a Peyote Ceremony (plate 6.36). For the next thirty years, he recorded its development and participated in delegations to Congress to have the use of this hallucinatory drug recognized as an integral part of the religion of certain tribes. Mooney used this series of photographs, taken over a thirty-year period, to support his case – and he won. The Native American Church became legally recognized as an official religion, still in existence today.

Mooney later became involved in more controversy when he photographed the Sun Dance ceremony of the Cheyenne and the Arapaho at Darlington, Oklahoma Territory. The ceremony included a section where young men had to prove their courage in a way that some saw as meaningless self-torture. Mooney, after years of studying the tribes, knew it was part of their religion. The acting Indian agent accused Mooney and another BAE ethnologist of staging the ceremony and paying participants for their photographs. After many hearings, Mooney and the BAE were cleared of charges.

As a government anthropologist, Mooney testified against many other government officials throughout his career. He continued to cause concern to Congress. It was difficult for the government to accept one of their own men's encouraging ancient beliefs and ceremonies during a time of a national policy of assimilation. It took a great deal of courage for Mooney to champion religious freedom for all.

During the winter of 1892, Mooney traveled to the Southwest with Tilly Stevenson to make collections for the impending World's Columbian Exposition in Chicago. Both witnessed and photographed the ceremonies and activities at Zuni and Hopi Pueblos (plate 6.42). Mooney also recorded nearby Navaho in Keam's Canyon (plates 6.37, 6.38, 6.40, 6.41). The government exhibits at the 1893 Exposition displayed an all-time record number of photographs.

FURTHER STUDIES IN THE SOUTHWEST

In 1894, BAE ethnologist W. J. McGee organized an expedition to the Southwest and Mexico to find the last surviving tribe of North American Indians which had never had contact with white men. William Dinwiddie, the Bureau's staff photographer, accompanied him to record evidence that they still existed. Dinwiddie and McGee went first to Arizona to make collections and take pictures of Papago Indians. They then headed south along the Californian coast to confront the Sonora Desert in Mexico and the Seri Indians who lived on Tiburon Island, considered to be 'the most primitive tribe remaining on the North American continent ... [and] ever found on the West Hemisphere'. Portraits of sixty Seris were made. It was reported that in all 500 photographs of Papago and Seri surroundings were taken that season (plate 6.50).[41]

In the following year, McGee returned with the photographer J. W. Mitchell to study the Seri in depth. Military procedures were followed: the trek across the desert and the river journey evoked memories of the Wheeler Survey and Powell's expeditions down the Grand Canyon. McGee had come to the Bureau from the US Geological Survey and saw himself following in Powell's footsteps. Unfortunately the Seri were at war with the nearby Mexican rancherias. No photographs were taken except for some showing abandoned villages. The expedition managed to make collections, and to survey and map 'Seriland', 10,000 square miles 'never trod by white man' (plate 6.52).[42]

On January 3, 1896, McGee's last day in Mexico, he made one final attempt at ethnology in an interview with a Seri outcast, Fernando Kolusio, photographed by Mitchell. McGee reported that '... he was very small when he left the tribe; he is now old, somewhat deaf, and has forgotten the language... [rendering his] information practically worthless except when corroborated'.[43]

In 1895, 1897 and 1899, Frederick Webb Hodge led expeditions to the Southwest for the BAE. Adam Clark Vroman from California accompanied him as the government's official photographer. One of the last great Western aventures of the nineteenth century was recorded by Vroman – the ascent of Katzimo, also known as Mesa Encantada (Enchanted Mesa)

in New Mexico. According to tradition, the top of this massive rock formation had once been occupied by the people from Acoma Pueblo. At harvest time, they descended a rock ladder to gather their crops from the fields in the valley below. A great storm destroyed this ladder and prevented their returning to rescue a boy and his mother who had remained to guard the pueblo. The people built a new Acoma Pueblo, which was found by the Spanish explorer, Coronado, in 1540. The legend was heavily disputed by Eastern academia. Vroman's photographs of the ancient pueblo ruins for the BAE showed that there was truth in the story: in the words of his fellow photographer of the Southwest, Charles Lummis, to the assumptions of the academic establishments, the pictures were 'deadly' (plate 6.20).[44]

In 1898, the Trans-Mississippian and International Exposition was held at Omaha. It was the most successful ever held in America up to that time. In the midst of an economic depression, before a foreign war with Spain over Cuba and the Philippines, it attracted over two-and-a-half million visitors and deposited several hundred thousand dollars into the government's treasury. The latest in art and invention and all the advantages of white man's civilization were displayed as evidence of what Manifest Destiny had accomplished in the West. In contrast there was also a group of North American Indians representing tribes which had felt the impact of Manifest Destiny – an impact so tremendous as to be almost inconceivable to those who had not experienced it.

Most nineteenth-century expositions had exhibited a few Indians as curiosities of the past. This one originally planned to show all the tribes who had advanced under the national policy of assimilation. Alice Fletcher was appointed as the government's representative in charge of the Indian Education Exhibit. And, as an added attraction at the Exposition, all the tribes were to be presented as a unified whole in an 'Indian Congress'.

The idea was conceived by Edward Rosewalter, editor-publisher of the newspaper, the *Omaha Bee*. The Department of the Interior held overall responsibility for its execution and placed Captain William A. Mercer, official agent for the nearby Omaha and Winnebago tribes, in charge. James Mooney, the government's leading expert on Indian ethnology, was appointed as a consultant. Frank A. Rinehart of Omaha was hired as official photographer.

Mooney saw the Indian Congress as a unique opportunity to educate the public about traditional Indian life on a scale never before attempted. As the project was so broad in scope, he suggested the tribes be limited to those representing each different house type of North American Indians. Over 500 Indian delegates attended.

In the course of the Exhibition, Mercer gradually shifted the emphasis of talks and demonstrations from education to entertainment. Twice weekly, sham battles were held. On September 27, Mooney reported to the Bureau that the only ethnological feature on site was a Wichita grass house. The Indian Congress had 'rapidly degenerated into a wild west show with the sole purpose of increasing gate receipts'.[45] On October 12, President William McKinley was a guest at a sham battle and enthusiastically reviewed the parade.

Mercer, unlike Mooney, was aware that his audience was not yet ready to appreciate the diversity of cultures it had so recently subjugated. Photographs of the battles by Rinehart perpetuated the popular stereotype of hostile Plains Indians. Yet most of the participants in the Wild West shows were members of Southwestern tribes (plate 6.43): only at the very end were the Comanche, Kiowa, Wichita and Sioux delegates enticed to enter the mock warfare.

Despite the circus atmosphere, it was a nostalgic reunion for veterans from both sides of the Indian Wars. General Nelson Miles met his old friend and foe, the Apache Chief Geronimo, still a prisoner of the War Department. But probably the Indians benefitted most from the opportunity to meet other Indians and to exchange intertribal communications. The festivities included a Dog Feast, a Ghost Dance, and a Fire Dance: not all the old traditions had vanished.

During the last week of the Exposition, Mooney became involved in a project to photograph the delegates to the Indian Congress. Rinehart was commissioned by the government to take the pictures, but was still occupied with recording other events. Photographs of the delegates were actually taken by his assistant, Adolph F. Muhr. Mooney arranged for Muhr to photograph what was required to mark a unique historical event and provide an ethnographic record. Over 200 photographs of seventy tribes were taken under his direction (plate 6.45).[46] The Bureau, which had paid half the photographer's fee, retained the negatives but could not hold copyright over government property. A hundred were paid for and copyrighted by the Exposition management.[47]

The year 1900 marked more than the end of a decade. It was the year in which Hillers retired and Cushing died. It was the year in which moving images arrived at the pueblos. O. P. Phillips of Armat Motion Picture Company, Washington DC, made an arrangement with the Bureau to visit New Mexico and Arizona 'for the purpose of making motion pictures representing the industries, amusements and ceremonies of the Pueblo and other tribes. The object of the work was to obtain absolutely trustworthy records of aboriginal activities for the use of future students.' It was reported that 'despite accidents that happened to the apparatus, the work was fairly successful ... yielding about a dozen kinetoscope ribbons in connection with which about 100 excellent photographs were made by Mr Phillips'. The apparatus was furnished 'in the interest of science' by the Armat Motion Picture Company.[48] The following year six films entitled *Indian Snake Dance Series in Moki (Hopi) Land* were copyrighted by the Edison Company.

Adam Clark Vroman had photographed among the Pueblo Indians both as a government and independent photographer from 1895–1904. Now he was faced with a problem his predecessors had never known: that of the American tourist. Transported by railroads to isolated places and armed with their Kodak cameras, they made life difficult for professional photographers – and even more so for the Indians. By 1902 the Hopi Indians of Oraibi Pueblo restricted photographers to a single area during the Snake Dance. Vroman reported:

This was an innovation. Hitherto every man had chosen his own field, and moved to and fro wherever he liked – in front of his neighbor or someone else, kicking down another fellow's tripod and sticking his elbow in the next fellow's lens. Half a dozen or more Indian policemen led by the acting agent kept us in line, so we had to go ahead and make the best of it.[49]

Back at Zuni Pueblo during the field season of 1902, Tilly Stevenson wrote: 'One of the rain priests sang his prayers in the Sia tongue; another sang in Pima; all thirteen of them used other languages.'[50] She lamented that the gentle nature of the Indians had been much changed by sordid gain. It was no longer possible to make pictures of spontaneous traditional life: the Indians were paid for posing, and became self-conscious and suspicious. Ancient ceremonies were adapted, partly to entertain and partly to protect the old traditions. On December 1, 1911, Stevenson photographed the

Tablita Corn Dance at Santa Clara. By the end of the year, photography had been banned from the pueblos.

The Bureau itself was also changing. John Wesley Powell had died in 1902 and an era of exploration passed with him. The Bureau's Annual Report stated:

> He gathered about him the best available men in the various departments of science assigning to them the fields for which their abilities particularly fitted them; but at all times he was the master spirit ... The BAE is peculiarly his. The lines of research initiated by him are those that must be followed as long as the Bureau lasts; in fact, as long as the human race remains a subject of study ... The world of the future, viewing Powell's career will thank the guiding star that led the farm boy to become a teacher, the teacher to become a soldier, the soldier an explorer, the explorer a geologist, and the geologist the historian of a vanishing race.[51]

During the following years (1902–17) the Bureau had three directors: William Henry Holmes, a brilliant artist, geologist and anthropologist, who brought to the BAE an international reputation; Frederick Webb Hodge, secretary, librarian and editor, best remembered for Bulletin Number 30, *Handbook of Indians North of Mexico*; and Jesse Walter Fewkes, who combined all the talents of the new Bureau leaders. Fewkes was the first to have an academic degree: a doctorate in marine biology from Harvard. He had worked among the Pueblo Indians since the 1880s. He had been initiated into the Hopi Flute and Antelope priesthood and was probably the first anthropologist to record their songs.[52] Fewkes was also the first director to do his own photography.

W. J. McGee, acting director of the Bureau during the last years of Powell's illness, became involved in political struggles over the leadership of anthropological studies. He then made an unfortunate agreement with Boas. Together they hired an ethnologist, John W. Swanton, to continue Northwest Coast studies, outside the government's authority, using museum and university funds. Both McGee and Boas left the Bureau under a cloud of controversy. McGee returned to the US Geological Survey. Boas went to Columbia University where he established the academic disciplines of modern anthropology, and emphasized the value of photography in fieldwork. Boas continued to communicate with George Hunt, his former Kwakiutl informant, through the exchange of ethnographic pictures.[53] Hunt took photographs of the Northwest Coast tribes from 1901 until the 1920s.

Universities and museums had now begun to take the lead in the field of anthropology. Early government anthropologists had, however, made a significant contribution to the heritage of North American Indians. In recording the history of another culture, they had also recorded their own. Their photographs captured the decline of native traditions before the coming of a new generation in a world forever changed by war.

6.2 RIGHT *Zunis participating in a ceremony – probably the Basket Dance – to give thanks for the earth's harvest. Taken by John K. Hillers at Zuni Pueblo, New Mexico in the winter of 1879.*

6.3 BELOW *Zuni Pueblo, New Mexico, looking east-southeast towards the Mesa of Taaiyalone (Corn Mountain). Taken by John K. Hillers in September 1879.*

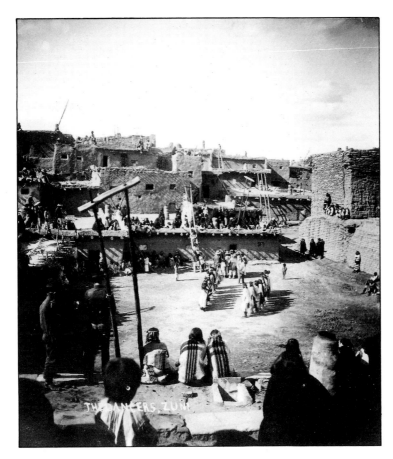

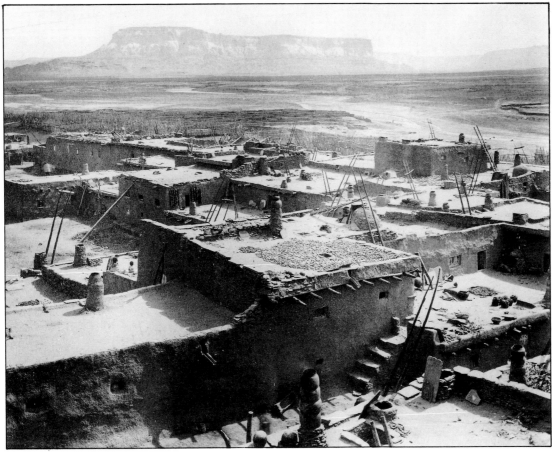

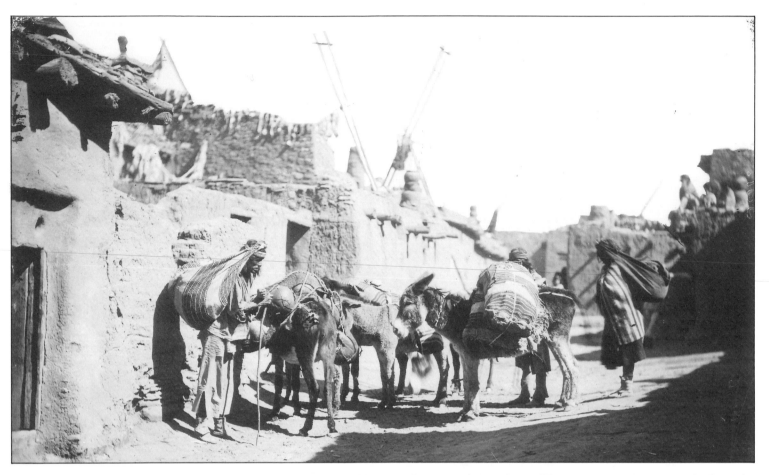

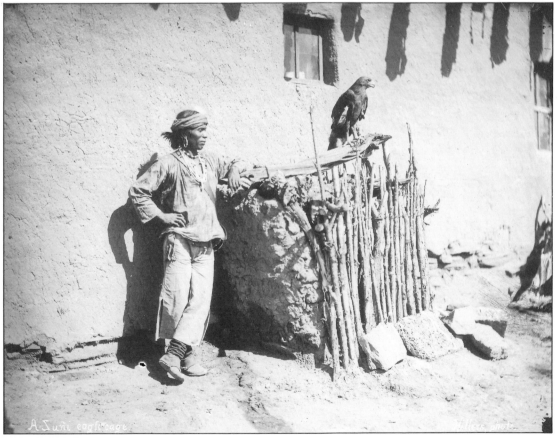

6.4 ABOVE *Two Zunis, Inihti (left) and Hota (far right), possibly leaving on a trading expedition. Taken by John K. Hillers at Zuni Pueblo, New Mexico in the winter of 1879.*

6.5 LEFT *A Zuni boy with an eagle cage. Eagles were raised for ceremonial feathers. Taken by John K. Hillers at Zuni Pueblo, New Mexico in the winter of 1879.*

6.6 RIGHT *Frank Hamilton Cushing, the Smithsonian ethnologist, in Spanish-Navaho costume. The Zuni Governor, displeased that Cushing stayed on at his pueblo when the Stevenson expedition departed, instructed him to take off his white man's clothes and blend in as much as possible. Cushing was gradually adopted by the Zuni. Taken by John K. Hillers at Zuni Pueblo, New Mexico, some time around 1881–82.*

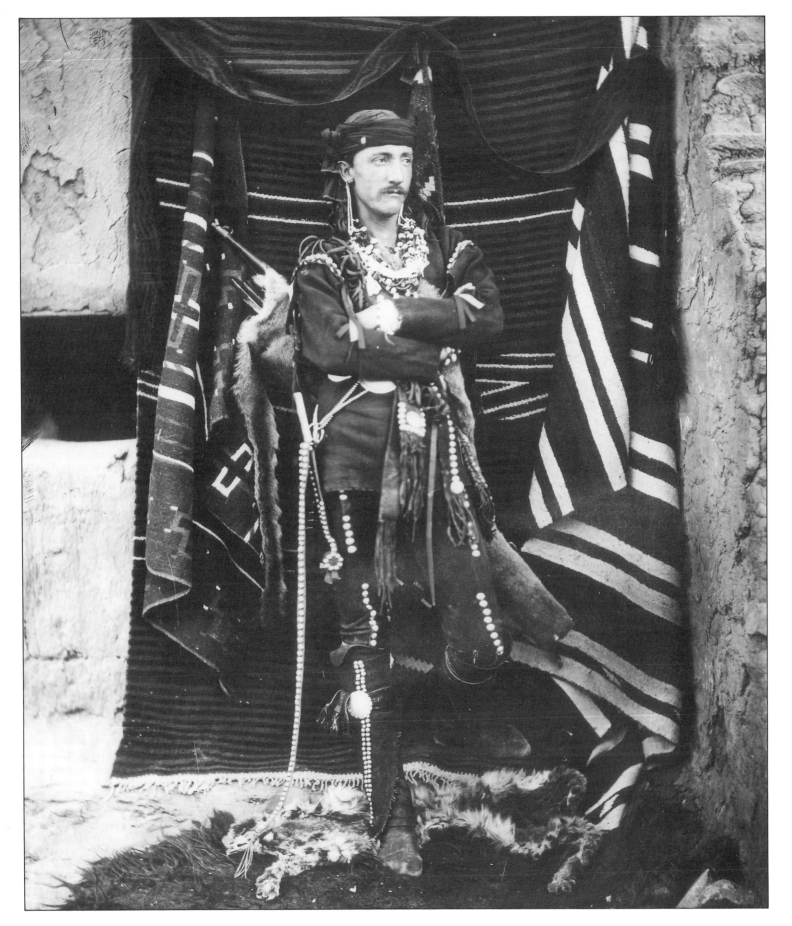

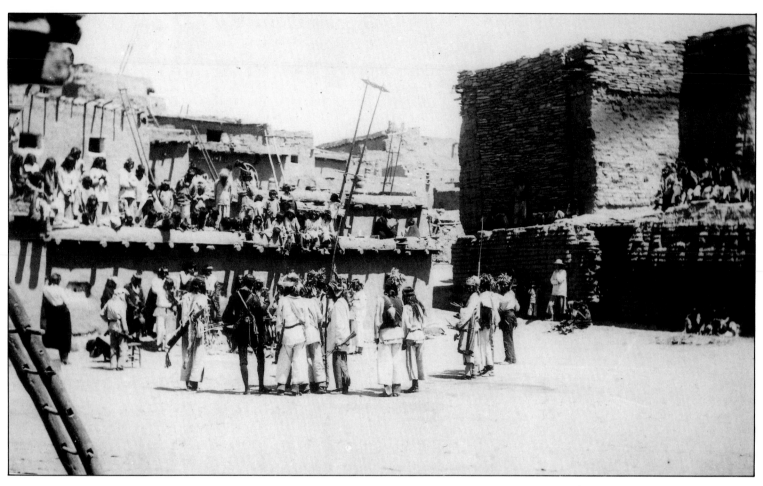

6.7 ABOVE *Frank Hamilton Cushing, the Smithsonian ethnologist, with Zuni Bow Priests, performing the War God Ceremony. Cushing became eligible for initiation into the Priesthood by obtaining the scalp of an Apache. Taken by John K. Hillers at Zuni Pueblo, New Mexico in the winter of 1881–82.*

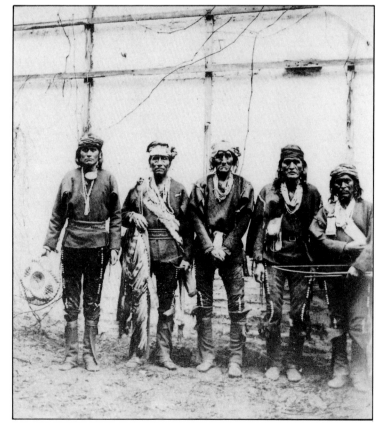

6.8 LEFT *Zuni Bow Priests who accompanied Frank Hamilton Cushing on an expedition to the East to visit their brothers, the Seneca, in 1882. Cushing was initiated into the Ka-Ka-Ka-Thia-Na-Ken (Grand Medicine Society) on the trip. Taken by the Kilburn brothers, probably in Boston.*

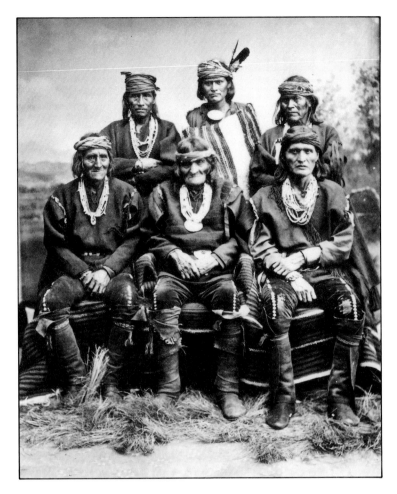

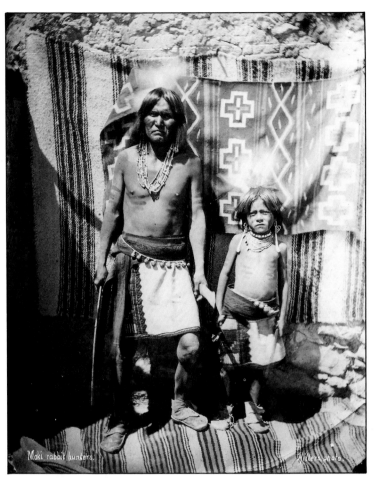

6.9 *The Zuni Bow Priests who accompanied Frank Hamilton Cushing, Smithsonian ethnologist, on an expedition to the East to visit their brothers, the Seneca. Left to right, front row: Laiyuahtsailunkya; Laiyuaitsailus, called Pedro Pino, a former Zuni Governor; and Palowahtiwa, called Patricio Pino, Governor and Cushing's adopted father. Left to right, back row: Naiyutchi, a senior member; Nanahe, a Hopi adopted by the Zuni; and Kiasiwa, a junior member. Taken by John K. Hillers for the BAE in 1882.*

6.10 *Hopi rabbit hunters posed in front of Navaho blankets at Walpi Pueblo, Arizona. Taken by John K. Hillers in October 1879.*

6.11 RIGHT *A Hopi woman brushing her husband's hair with a straw brush. Taken by John K. Hillers at Walpi Pueblo, Arizona in the winter of 1879.*

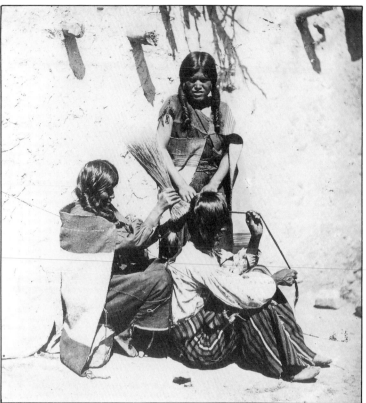

6.12 BELOW *The Dance Rock and 'kiva' (ceremonial chamber) where Hopi ceremonies were performed at Walpi Pueblo, Arizona. Taken by John K. Hillers in October 1879.*

6.13 RIGHT *Two members of the Tesuque tribe, Dio-Nisia Vijil (standing) and Katinita Susa, at Tesuque Pueblo, New Mexico. Taken by John K. Hillers some time between 1880 and 1883.*

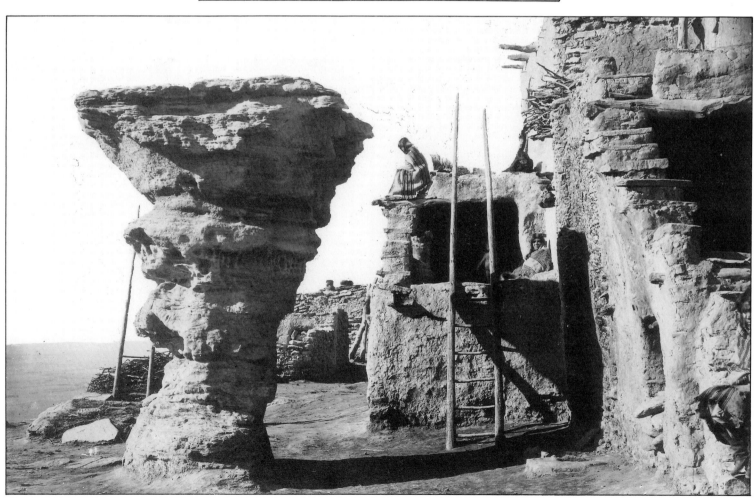

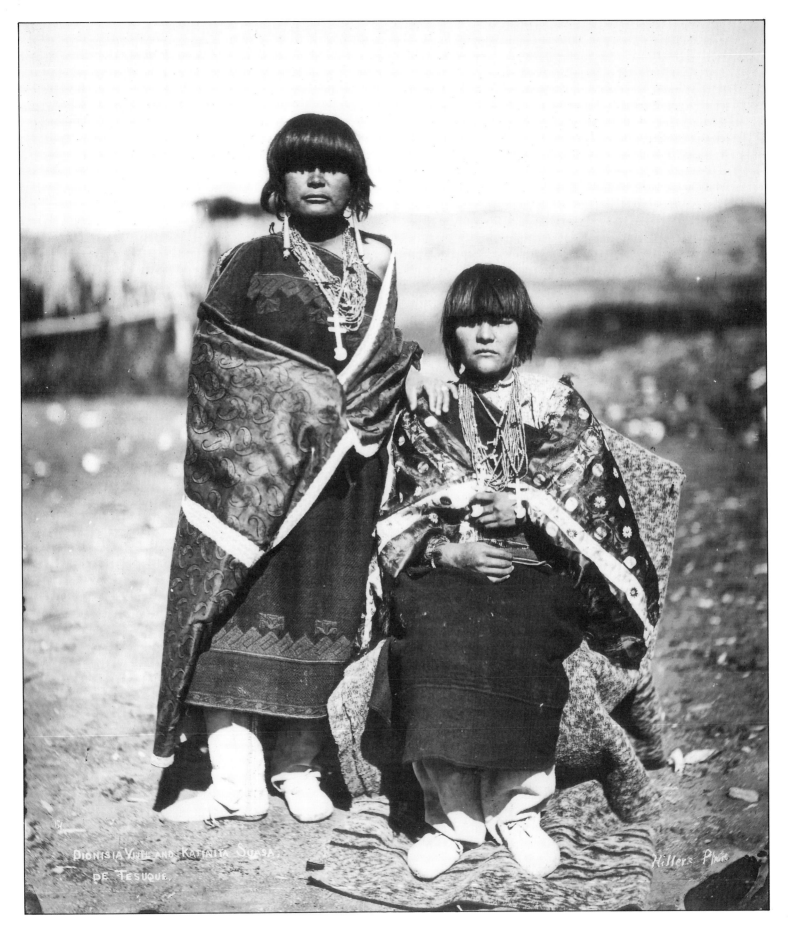

DIONISIA VIGIL AND KATINITA SUASA,
DE TESUQUE.

Hillers Photo

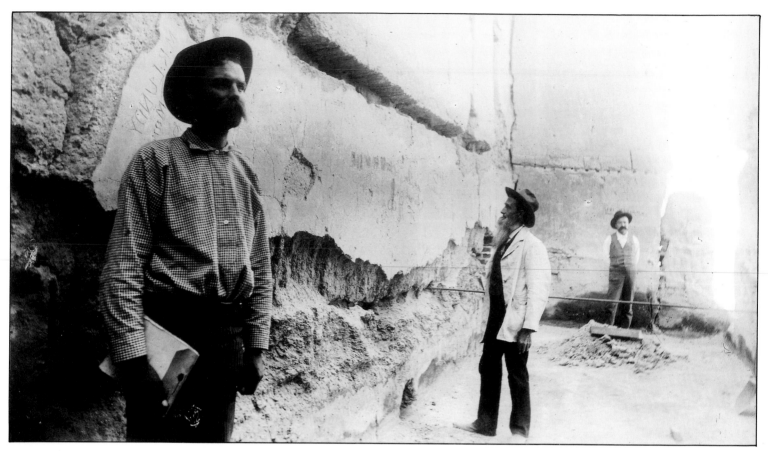

6.14 ABOVE *Archaeologists inspecting the ruined walls of Hohokam Pueblo, Casa Grande, Arizona in order to repair the south room. The ruins date from the 10th to the 13th centuries AD. By Cosmos Mindeleff, 1891.*

6.15 RIGHT *Hopi women building adobe houses in one of the first photographs ever taken of Oraibi Pueblo, Arizona. Taken, despite 'the unfriendly attitude of the natives', by John K. Hillers or the Mindeleff brothers on December 19,*

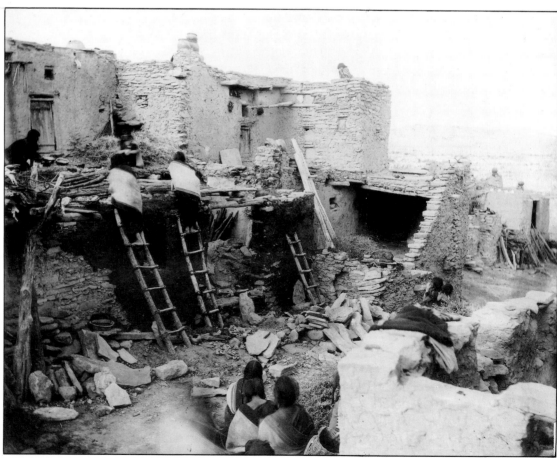

6.16 *Hopi priests performing the Antelope-Snake Dance in the plaza of Mishongnovi Pueblo, Arizona. Taken by Victor Mindeleff in August 1885.*

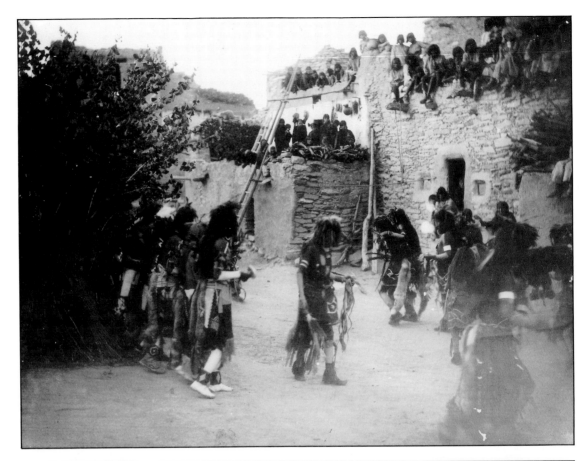

6.17 *A Navaho woman weaving on a horizontal loom. The man is possibly a member of the Stevenson expedition. Taken by Cosmos Mindeleff some time around 1893–94.*

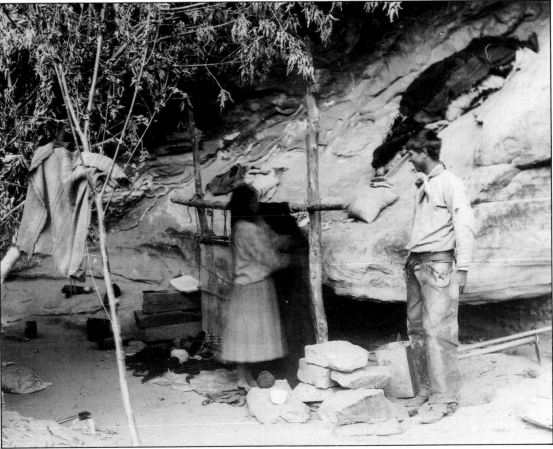

6.18 *Sia Priests of the Giant Society, Medicine Division, in their ceremonial chamber invoking the power of the bear to cure a sick boy of a sore throat. Taken under the direction of Matilda Coxe Stevenson by May Clark, a stenographer for the BAE, at Sia Pueblo, New Mexico in 1890.*

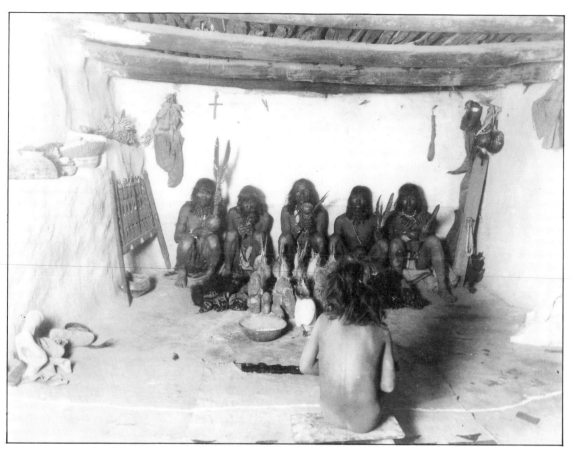

6.19 *A Shalako House Blessing Ceremony. Giant Courier Gods for the Rainmaker Priests cross a field to the ceremonial grounds at Zuni Pueblo, New Mexico. Taken by Matilda Coxe Stevenson some time around December*

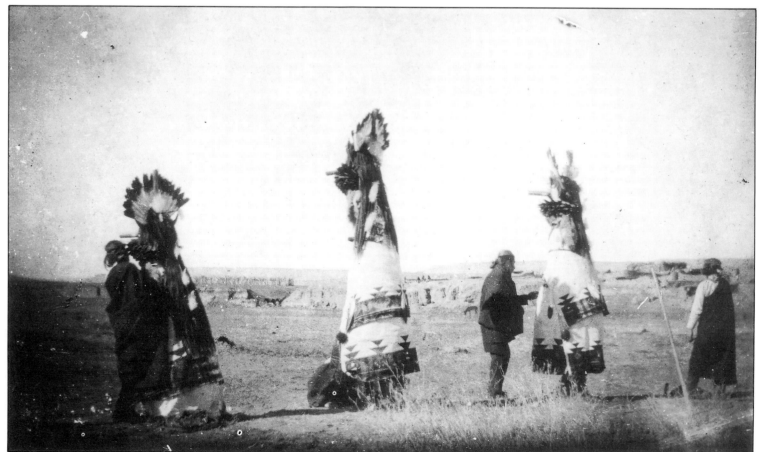

6.20 *The ascent to Old Acoma Pueblo or 'The Rock',
New Mexico. The photographer's discovery of this site
proved the truth of the story that, before the Acoma
people inhabited their existing pueblo, they lived on this
high outcrop, only able to descend to the fields by means
of a rock ladder. When the descent was destroyed in a
storm they were prevented from returning to the pueblo,
even to rescue a mother and son whom they had left
behind to guard their homes. Taken by Adam Clark
Vroman in the summer of 1899.*

6.21 RIGHT *Women prepare flour around milling bins inside an adobe house at Tewa (Hano) Pueblo, New Mexico. Kachina dolls representing gods hang on the walls. Taken by Adam Clark Vroman in the summer of 1895.*

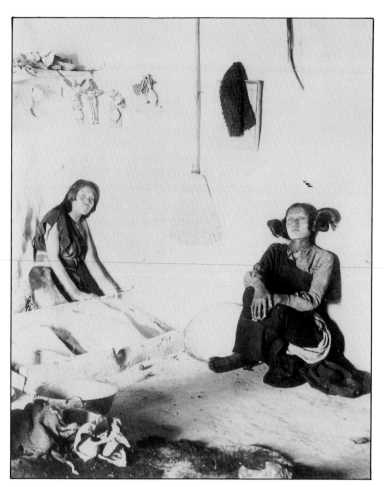

6.22 BELOW *View from the ruined church rooftop of Old Acoma Pueblo towards Katzimo (Enchanted Mesa), New Mexico. Taken by Adam Clark Vroman in the summer of 1899. See also plate 6.20.*

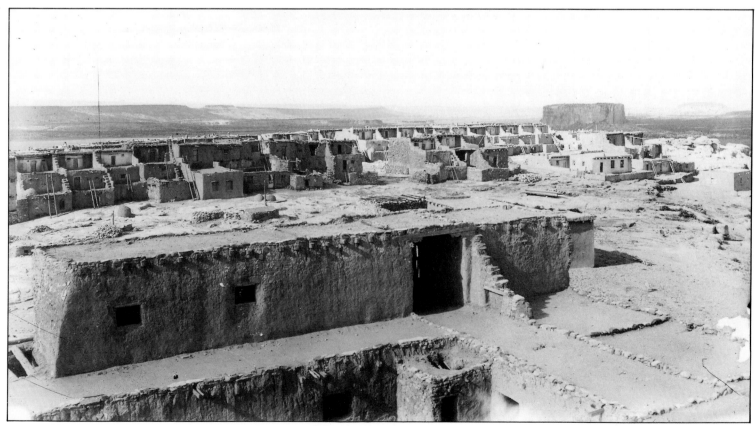

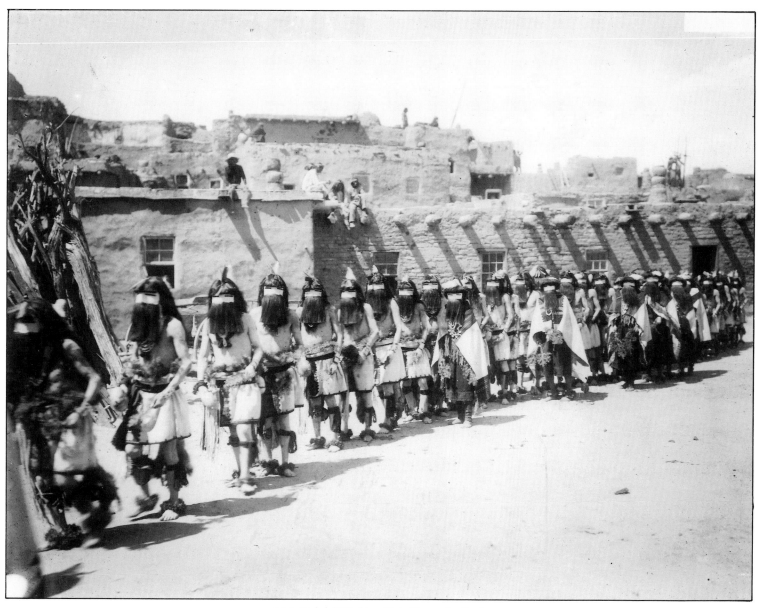

6.23 *Korkokshi Kachinas (Rain Dancers for Good)*
performing in the plaza of Zuni Pueblo, New Mexico.
Taken by Adam Clark Vroman in the summer of 1899.

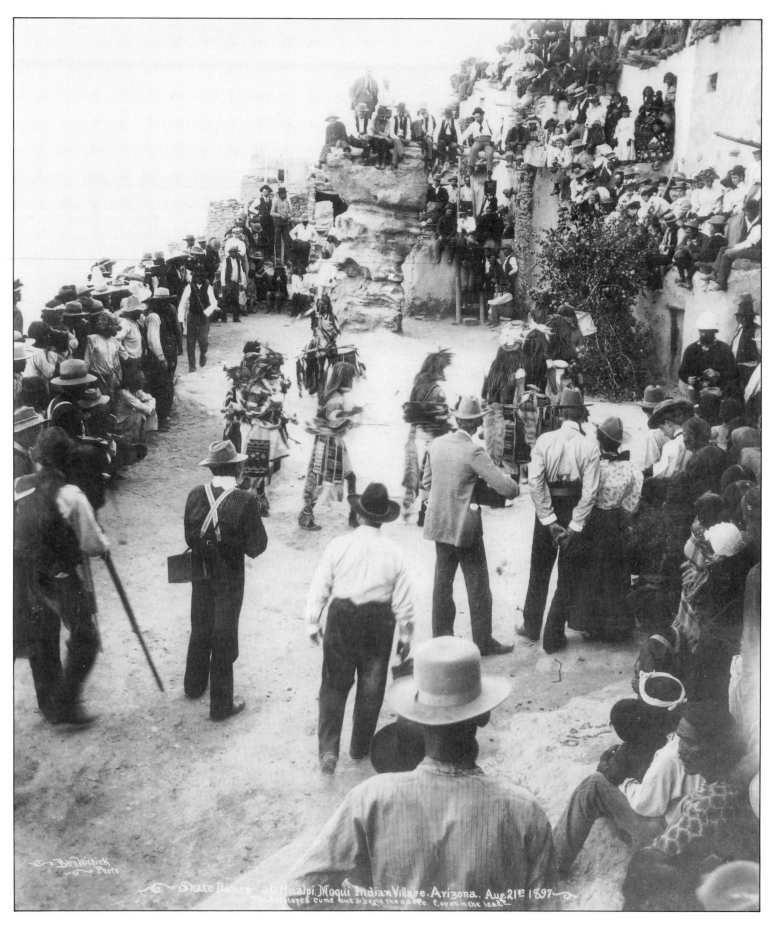

Ben Wittick Photo

Snake Dance at Hualpi, Moqui Indian Village, Arizona, Aug. 21st 1897

6.24 FAR LEFT *Hopi priests performing the Antelope-Snake Ceremony near the Dance Rock at Walpi Pueblo, Arizona. Several photographers, with their tripods and cameras, are among the throngs of tourists. Taken by Ben Wittick on August 21, 1897.*

6.25 LEFT *A northern view of the Nez Perce tribe's Yellow Dog Boom Ground camp on the Clearwater River, Old Lapwai (Spalding), Idaho. Taken by E. Jane Gay, a friend of BAE ethnologist Alice Cunningham Fletcher, in 1892.*

6.26 *Alice Cunningham Fletcher, BAE ethnologist and government representative to the Nez Perce tribe for the Dawes Commission, with her assistants in field camp in Idaho. Taken by her friend E. Jane Gay some time between 1890 and 1893.*

6.27 RIGHT *The Cherokee medicine man Ayyuini (Swimmer), also called Ayasta (Spoiler) or Tsisiwa (Bird), who gave the photographer the first notebook of sacred curing formulas written in the Cherokee language ever to be shown to a white man. Taken by James Mooney on Qualla Reservation, North Carolina in 1888.*

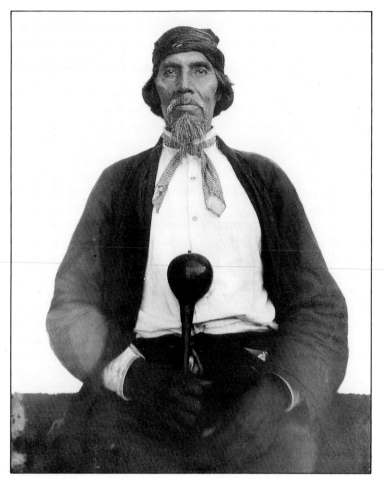

6.28 BELOW *The Cherokee Ballplayers' Dance on Qualla Reservation, North Carolina. In the ceremony before the game, the women's dance leader (left) beats a drum, the men's dance leader (right) shakes a gourd rattle, and the ballplayers, carrying ball sticks, circle counter-clockwise around the fire. By James Mooney, 1888.*

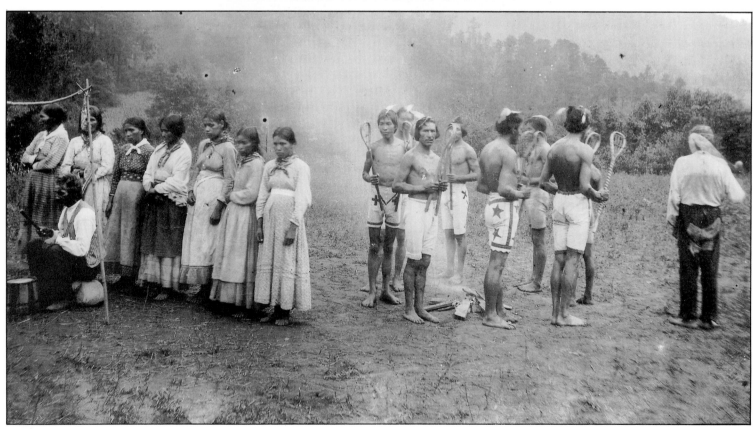

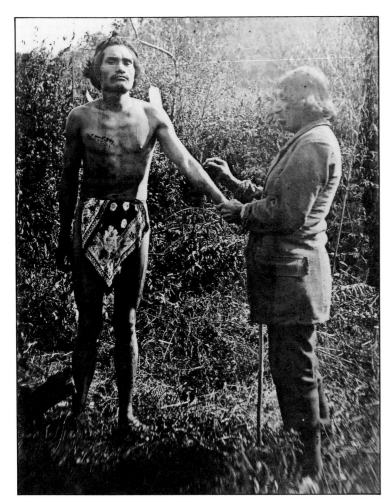

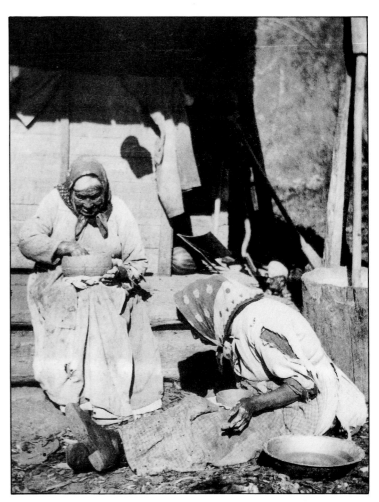

6.29 *The Cherokee Ball Game Ceremony on Qualla Reservation, North Carolina. Two or three days before the game, ballplayers were scratched with a seven-toothed turkey-bone comb. By James Mooney, 1888.*

6.30 *Cherokees Katalsta (left) and her daughter Ewi-Katalsta, making traditional pottery on Qualla Reservation, North Carolina. The photographer's shadow seems to appear in the foreground. By James Mooney, 1888.*

6.31 RIGHT *Arapaho followers of the Ghost Dance religion, some in a trance, perform the Circle Dance on the Cheyenne/Arapaho Reservation, Darlington, Oklahoma. By James*

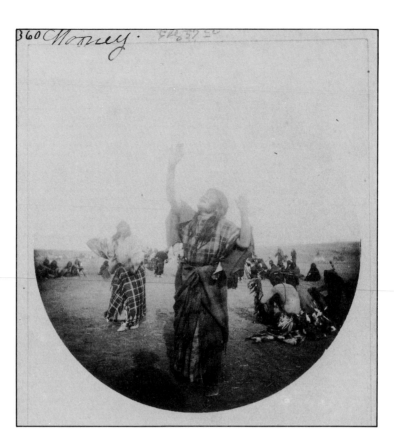

6.32 BELOW *A Paiute camp of snow-covered 'wikiup' homes, discovered by the photographer near Walker Lake Reservation, Nevada on his quest to find Wovoka, prophet of the Ghost Dance religion. Taken by James Mooney in January 1892.*

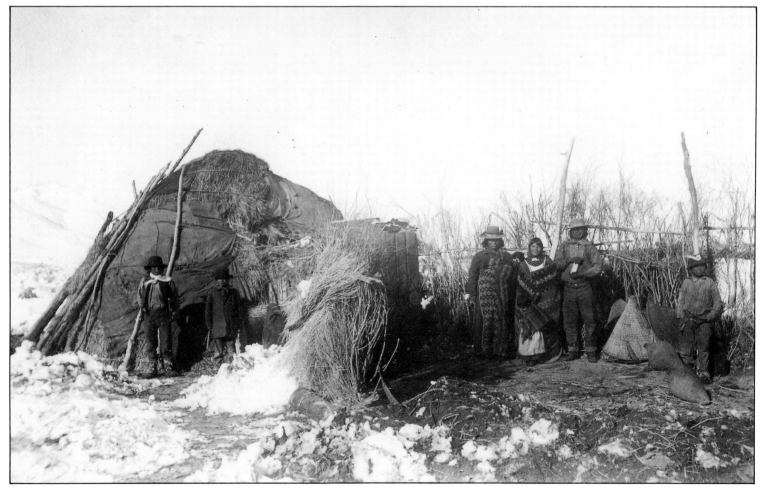

6.33 The first photographic image of Wovoka (seated), Paiute prophet of the Ghost Dance religion. Behind him stands his uncle Charly Steep, who helped the photographer to find him. Taken by James Mooney on Walker Lake Reservation, Nevada in January 1892.

6.34 Wovoka, Paiute prophet of the Ghost Dance religion. Taken by an unidentified photographer some time around 1914.

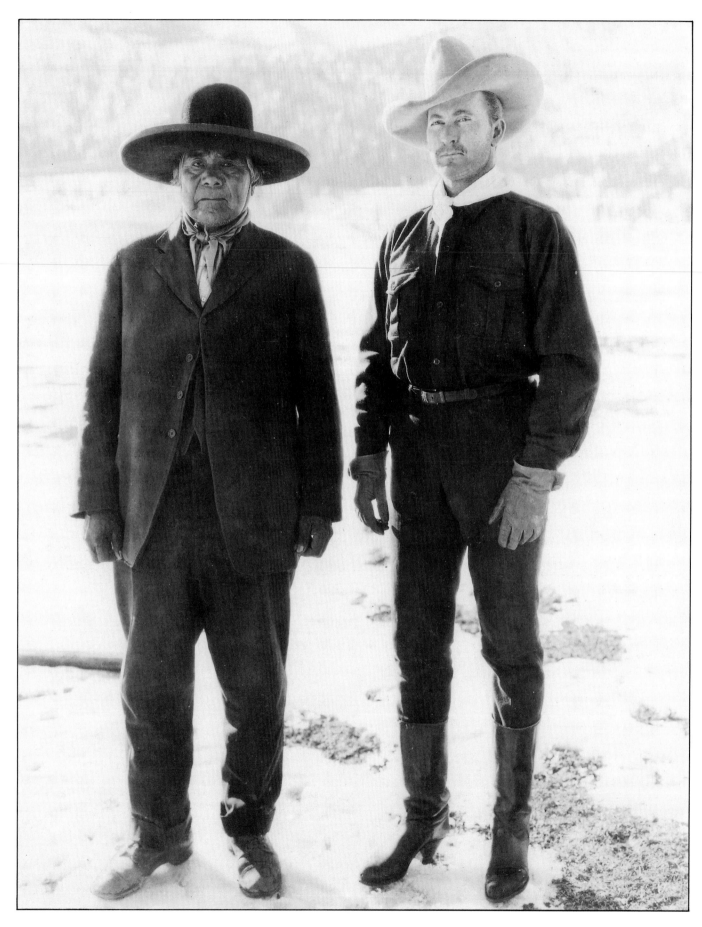

6.35 LEFT *Wovoka, Paiute prophet of the Ghost Dance religion, and General Tim McCoy, Hollywood cowboy actor and Governor of Wyoming Territory. Taken by an unidentified photographer near Walker Lake Reservation, Nevada on location for a Western film, in 1926.*

6.36 RIGHT *Kiowa participants in the Peyote Ceremony. One man holds a ceremonial rattle and wand. By James Mooney, February 1892.*

6.37 BELOW *A Navaho and James Mooney, the BAE ethnologist, at the trading post in Keam's Canyon, Arizona. Taken by an unidentified photographer in the winter of 1892–93.*

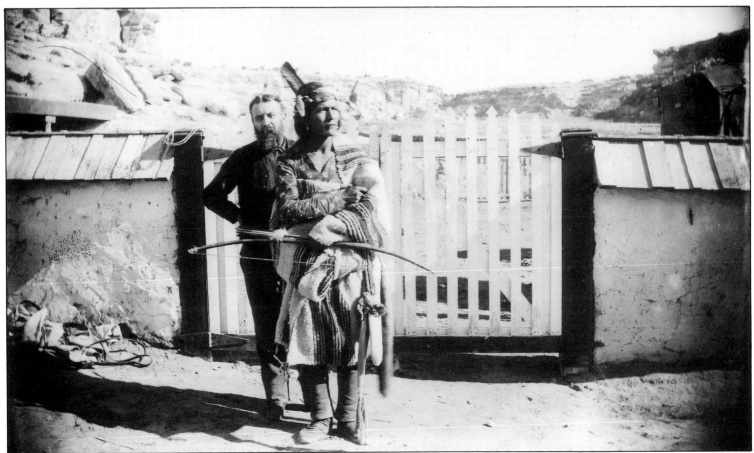

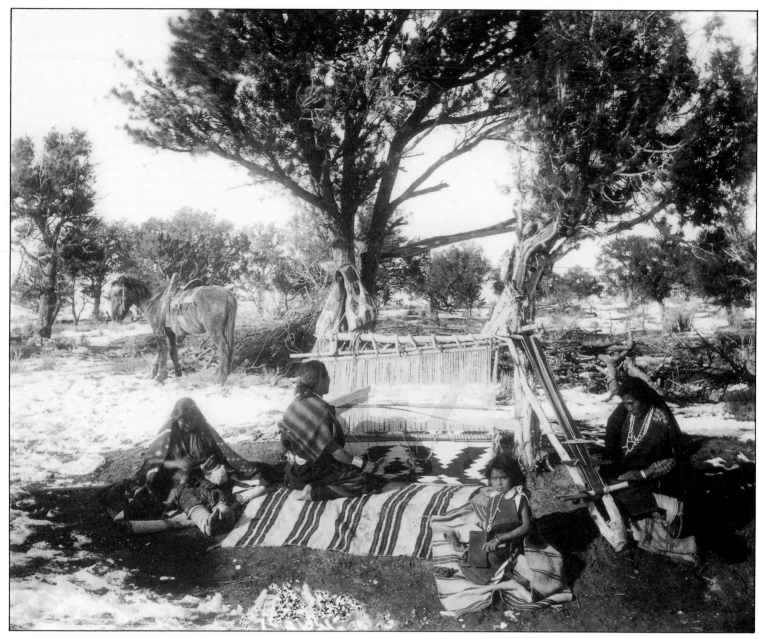

6.38 *Navaho weaving in camp at Keam's Canyon, Arizona. Charley weaves a blanket on the horizontal loom, the child, Nedespa, is carding wool, and two unidentified women are spinning wool (left) and weaving at a belt frame (right). Taken by James Mooney in the winter of 1892–93.*

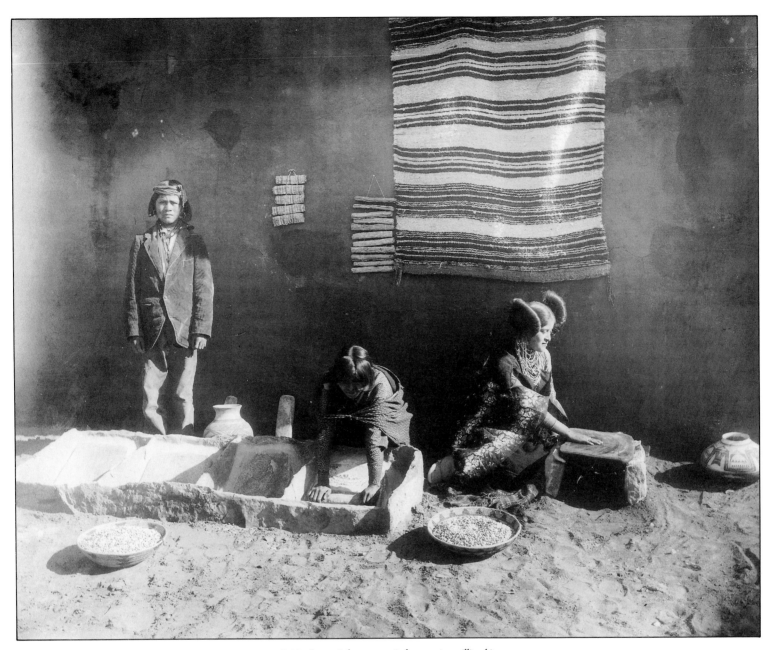

6.39 *A married woman grinds corn at a milling bin while a single woman called Betty bakes bread at Tewa (Hano) Pueblo, New Mexico. The boy is unidentified. Taken by James Mooney in the winter of 1892–93.*

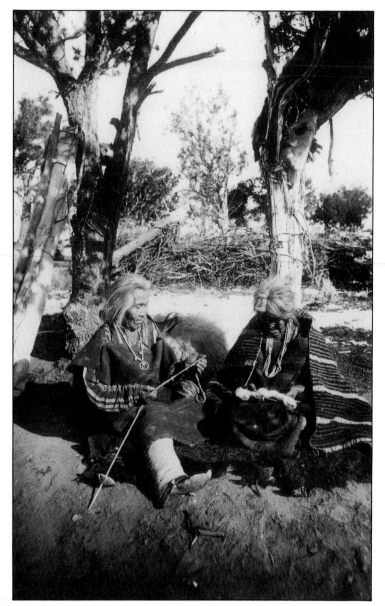

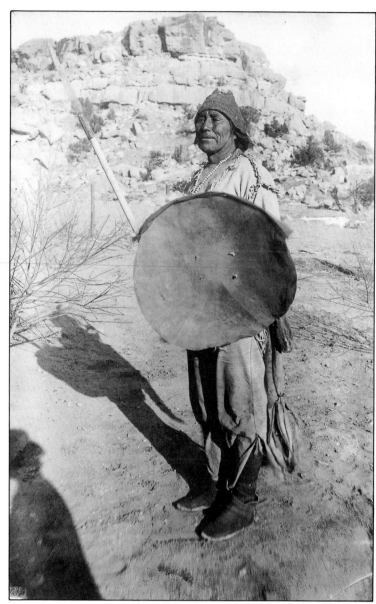

6.40 *Navaho spinning in camp at Keam's Canyon, Arizona. One woman re-spins wool on a thigh spindle (left) while the other cards a skein of wool yarn. Taken by James Mooney in the winter of 1892–93.*

6.41 *A Navaho war captain holding a lance and shield. Taken by James Mooney at Keam's Canyon, Arizona in the winter of 1892–93.*

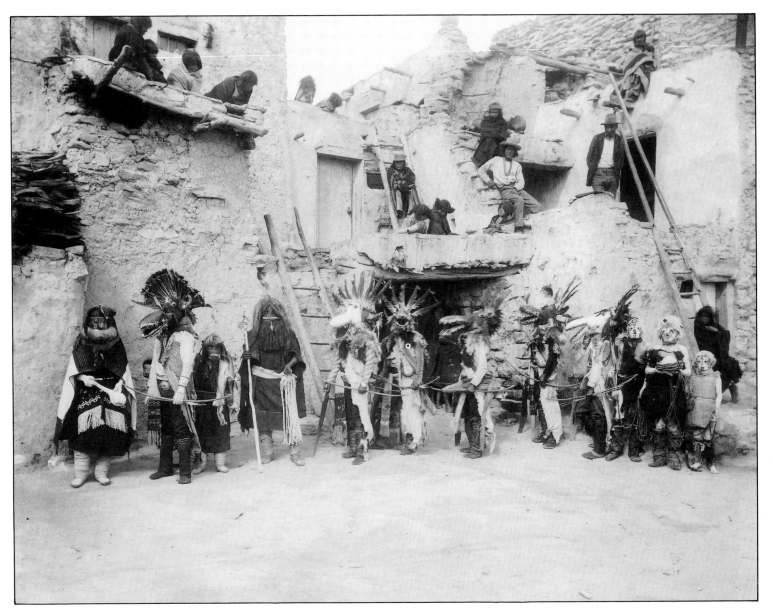

6.42 *The Hopi Powamu or Bean Planting Ceremony at Walpi Pueblo, Arizona. Ogre Kachinas (representing the gods, and used to discipline the children) stand in the plaza, left to right: Hahaiwuhti ('Mother of the Kachinas'), Black Natashka, Soyokmana ('Natashka Kachina Girl'), Soyokwihti ('Natashka Kachina Grandmother'), White Natashka, three Black Natashkas and three Heheya Kachinas (clowns). Taken by James Mooney in February 1893.*

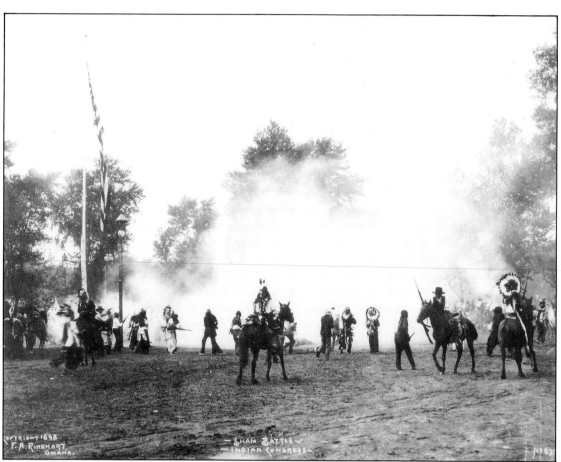

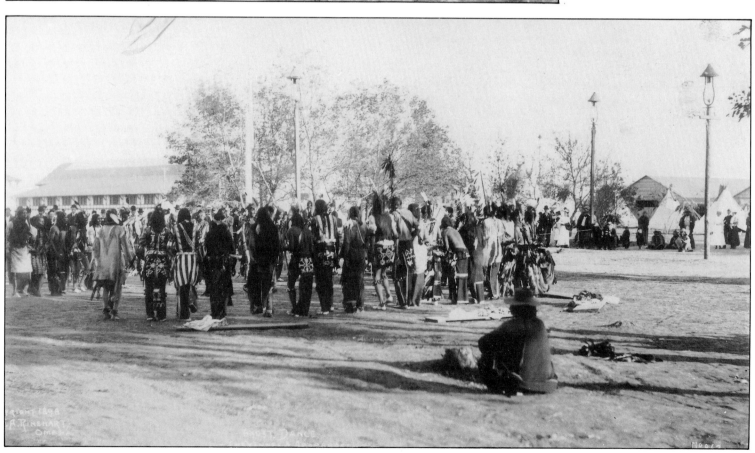

6.43 LEFT *Southwestern peoples dressed in Plains Indian costumes and performing sham battles at the Trans-Mississippian and International Exposition, Omaha, Nebraska. Taken by Frank A. Rinehart in September 1898.*

6.44 BELOW *Ghost Dancers performing under the direction of BAE ethnologist James Mooney, to educate the general public about their religion. Taken by Frank A. Rinehart at the Trans-Mississippian and International Exposition, Omaha, Nebraska on September 19, 1898.*

6.45 RIGHT *Kea-Boat (Two Hatchet), a member of the Kiowa tribe, holding a rattle and feather fan used in the Peyote Ceremony. Taken by Adolph F. Muhr at the Trans-Mississippian and International Exposition, Omaha, Nebraska in October 1898.*

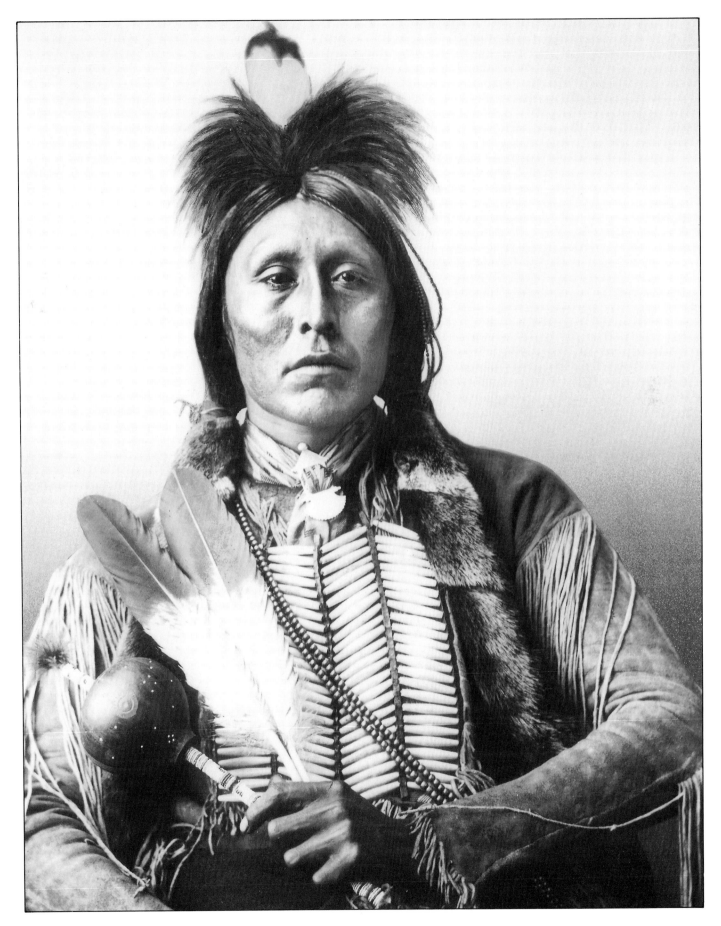

6.46 *Johnny Kit Elswa, a Haida from Skidgate Village, Queen Charlotte Islands, British Columbia and an informant of Judge James G. Swan, the BAE ethnologist and collaborator. The tattooed symbols of his clan include a brown bear on his chest and a dog fish on each arm. Taken by Ensign E.P. Niblack inside James Swan's home at Port Townsend, Washington Territory on December 4, 1886.*

6.47 *The Kwakiutl village at Alert Bay, British Columbia. On the left is the lookout cage from which the chief called out recipients' names during the Potlatch Ceremony; painted on the front of the plank house is a tally of the numbers of coppers, boats and blankets already given away. Taken by James G. Swan some time around 1879–80.*

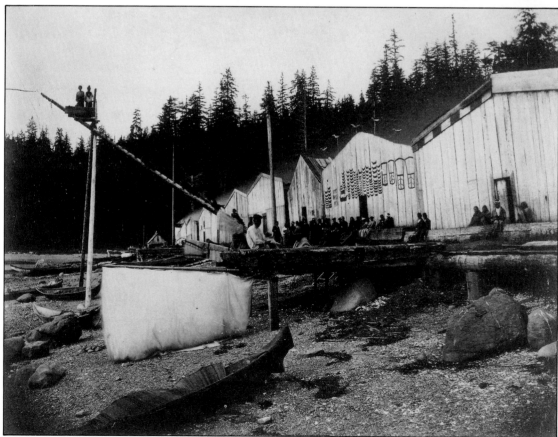

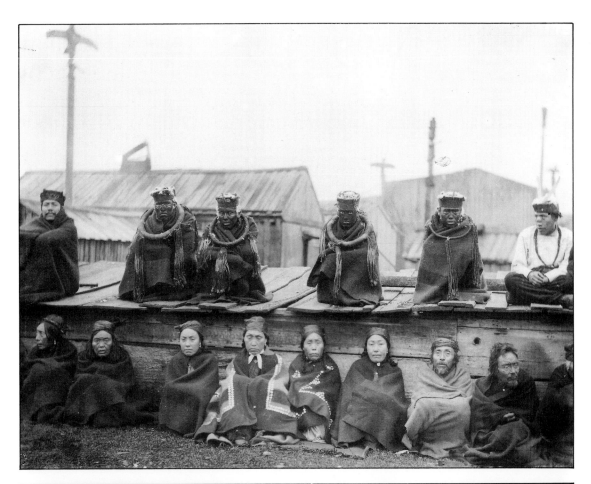

6.48 *A winter feast of the Koskimo Hamatsa on the beach at the east end of Fort Rupert, Vancouver Island, British Columbia. Some wear cedar-bark neckrings, white fur headrings and button blankets. Taken by Oregon Columbus Hastings on November 25, 1894.*

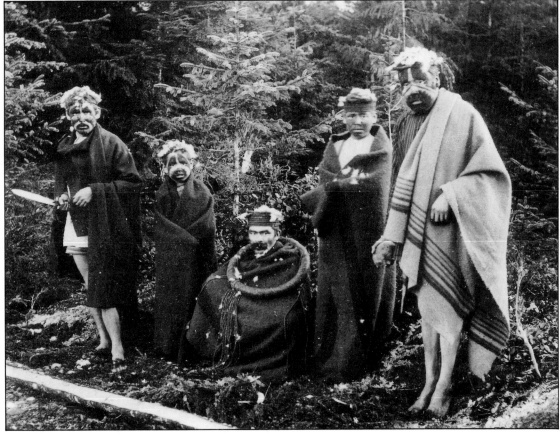

6.49 *Noo-Nlemala (Fool Dancers) of the Kwakiutl tribe participating in a winter initiation ceremony in the forest at Fort Rupert, Vancouver Island, British Columbia. They include Charlie Wilson (left) and a Frenchman, Mungo Martin (right). Taken by Oregon Columbus Hastings in November 1894.*

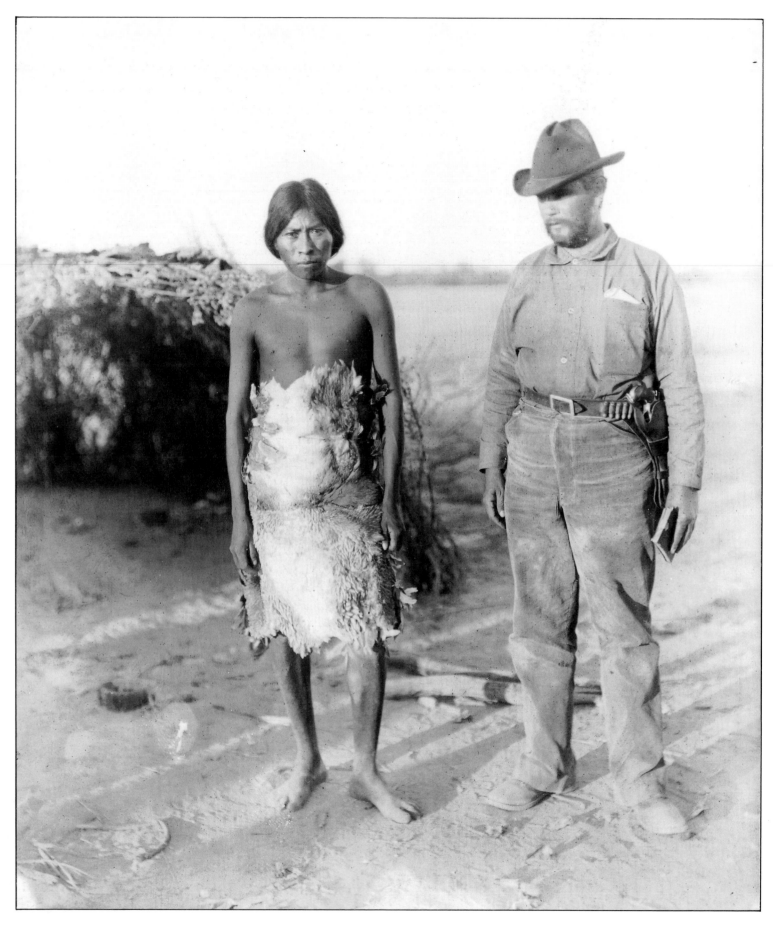

6.50 LEFT *Juan Chavez, a Seri Indian, and BAE ethnologist W. J. McGee, in camp at Encinas Rancheria Sonora, Mexico. At the time of this photograph, the Seris were considered 'the most primitive tribe remaining in the North American continent', and were the only Indian people to have had no previous contact with white men. Taken by William Dinwiddie in November 1894.*

6.51 RIGHT *W.J. McGee (left) secures a Seri vocabulary from Mashem, a Spanish-speaking sub-chief. Don Pascual Encinas, a rancheria owner (center), his son and grandson are among those who look on. Taken by William Dinwiddie at the Rancho San Francisco de Costa Rica, Sonora, Mexico in the summer of 1894.*

6.52 *Expedition members in field camp in Seriland, 'never trod by white man' until this time. Taken by J.W. Mitchell on Tiburon Island near Sonora, Mexico in the summer of 1895.*

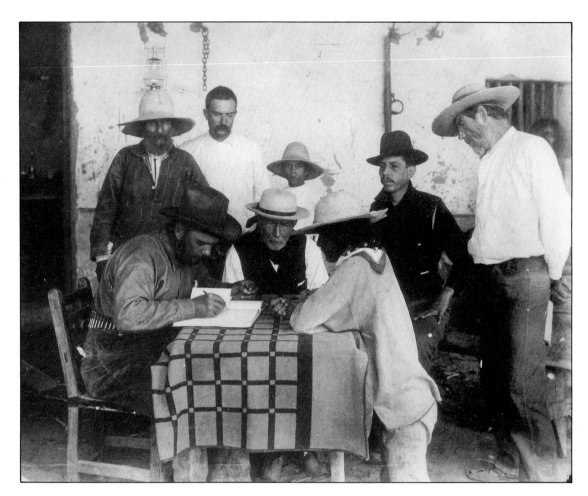

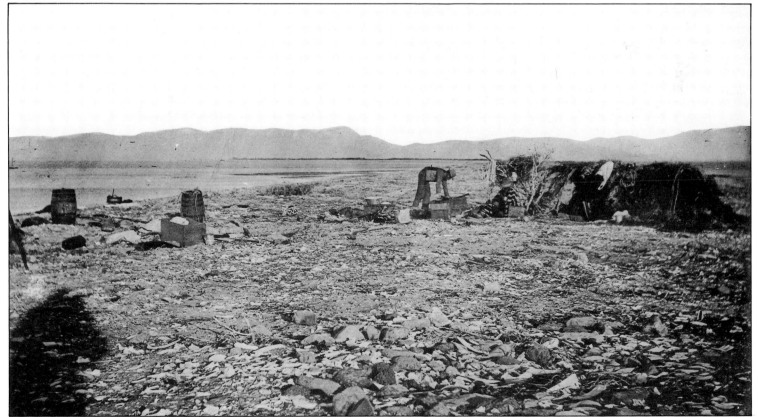

GOVERNMENT STUDIOS

IN 1870, the Smithsonian Institution built its first photographic 'apartment', and placed Thomas William Smillie in charge. The new laboratory was used to photograph specimens of archaeology and natural history, for illustrations in the Institution's publications, and distribution to other museums.[1]

Until the government had its own facilities, all delegation photography was carried out by private studios. Once a laboratory had been established at the National Museum, private help was no longer needed to record the visiting Indians. From 1870 until the turn of the century, the government and private enterprise competed for the Indian business. Then, as the older companies disappeared, the government remained the major institution interested in recording the delegates.

The government studio was moved in 1875 to a new building erected in connection with the Centennial Exposition. Still under Smillie's direction, the laboratory produced exhibit photographs for the National Museum, and did work for the various government surveys.[2] The earliest identified delegation portrait taken in the new studio was by Smillie, of a Cheyenne in either 1878 or 1879 (plate 7.2).

When the Bureau of Ethnology (later the Bureau of American Ethnology) was created in 1879, John K. Hillers came with its new director, John Wesley Powell, to be the first photographer of the new Bureau. For a time, Powell was director of both the Bureau and the US Geological Survey, and staff members were used interchangeably by both organizations, although paid by one or the other. Thus when Hillers returned to the payroll of the US Geological Survey in 1881, he still continued to photograph Indians for the Bureau.[3]

The new Bureau was placed under the control of the Smithsonian, and assumed the responsibility of recording Indian delegations. In 1881, when a new, up-to-date laboratory was built in the National Museum, space was offered to the Bureau for its photographic work.[4] From this arrangement, two studios developed, each complementing the other.

Like the Smithsonian, the Bureau and the Survey both had illustration sections to produce images for their publications. The Bureau's section was headed by William Dinwiddie, who held the title of 'Ethno-photographer'.[5] Dinwiddie not only accompanied field expeditions but also recorded delegations.

In 1894, the Bureau leased space a short distance from the Smithsonian. Although the space was limited, there was room for a small photographic laboratory for in-house processing.[6] Aided by Henry Walther, Dinwiddie continued to photograph delegations.[7] Miss Linconia Russell helped to catalog images[8] using the same number series that Jackson had used when he organized the negatives of the old United States Geological Survey of the Territory.

When Dinwiddie retired in 1897, he was replaced by Wells M. Sawyer.[9] Sawyer resigned in 1898 and was replaced by De Lancey W. Gill.[10] De Lancey Gill was first employed at the US Geological Survey. He

was taken on as a draftsman by head illustrator, William Henry Holmes.[11] When Holmes left in 1889 to direct field archaeology for the BAE, Gill succeeded him.[12] Gill is credited with a few Indian portraits during the early 1890s. These may represent the beginnings of his Indian photography, or they may have been taken by John K. Hillers, who routinely made the delegation portraits.

At the time when Gill joined the Bureau, delegation visits were increasing, especially during the winter months when Congress was in session.[13] The work of the field parties was also unprecedented, because of the development of the Kodak box camera. Gill was obliged to increase his photographic skills in order to keep pace with the delegations, and to develop field negatives. He was also responsible for cataloging and classifying the negatives.

The Bureau considered that it was important to take photographs of the delegates for historical as well as anthropometric reasons. Anthropology was a growing science, and the Bureau used photography as a means to further its growth. Such photography was thus useful 'in dealing with the wilder tribes, who would resist ordinary physical measurements on fiducial or other grounds'.[14] The field collaborators made it a point to 'obtain group photos with figures so placed as to permit measurement of stature and other physical elements in terms of a known unit figure introduced for the purpose'.[15]

In the laboratory, visiting Indians were photographed against artificial backdrops or other known objects to permit physical measurements of sufficient accuracy for practical purposes',[16] and special attention was given to recording the subjects in exact portrait, profile and full-face, 'with the view of permitting the extension of measurement to the facial angle, form of cranium, and other anthropometric elements' (plates 7.6, 7.7).[17] Casts were made of the few who would submit to the experience of having their face encased in plaster.[18]

In 1903 and 1904, the Bureau hired Andrew John, an Iroquois and local resident, to meet delegates, interview them and take them to have their portraits made (plate 7.9).[19] As the Bureau's photographic studio was a production laboratory rather than a portrait studio, delegates were taken to the Smithsonian's National Museum laboratory to be recorded by Smillie.[20] Gill did, however, record delegates, eventually producing more studio portraits than any other photographer in the Institution. Sometimes he took photographs in the field – for example, on his trip to Jamestown, Virginia in 1900 (plate 7.5).

When the Indians visited Gill's studio, they were naturally curious. He had to contend with their peeking into desks and cabinets, and striking all the matches they could find. His patience was further tried as he waited for them to finish preparing themselves for his camera. When ready, they allowed profile images to be made, but preferred full-length views, with both eyes and ears showing.[21]

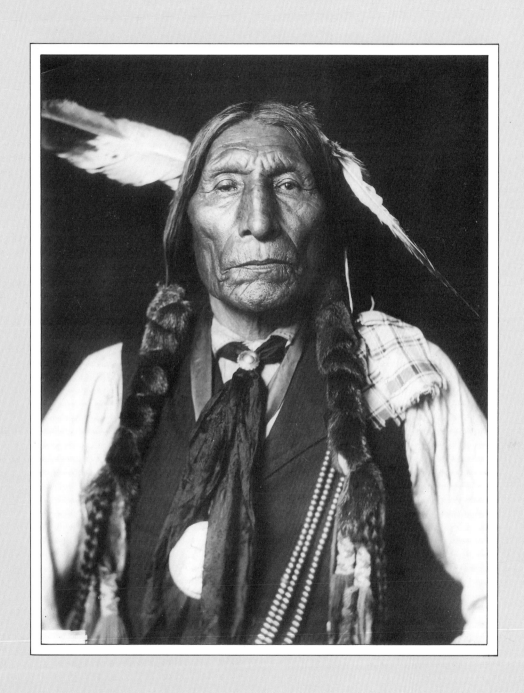

7.1 *Wolf Robe, a Southern Cheyenne. Taken by
De Lancey Gill in June 1909.*

As delegations were composed of the most prominent Indians, Gill recorded many famous individuals. In 1900, and again in 1903, he photographed the great Nez Perce leader, Chief Joseph (plate 7.18). After the 1903 portrait had been made, Gill asked Joseph to autograph a print. He obliged, signing 'Chf. Joseef, 1900'. When Gill attempted to correct the date, Joseph refused to alter it on the grounds that that was how he had learned to sign his name.[22]

In 1905, Gill took a portrait of Hollow Horn Bear that was later used on a fourteen-cent postage stamp issued in 1922 (plates 7.16, 7.17). This was not the only time an Indian portrait was used for official government purposes. In 1899 Smillie had photographed an Indian headdress, which was then retouched on to Alexander Gardner's 1872 portrait of Running Antelope (plate 7.3). The resulting image was used on a United States five-dollar silver certificate (plate 7.4).[23]

In 1905, Gill also met the great Apache Chief Geronimo (plate 7.19), who was in the capital for President Theodore Roosevelt's inauguration. Until that time, Gill had never paid for the privilege of photographing an Indian. Because of his fame, however, Geronimo was able to charge photographers who wished to take his portrait. The rate was based on Geronimo's own, self-imposed scale of fees: a portrait made with a hand-held camera cost ten cents; if a tripod was used, the price rose to twenty-

five cents; and for a studio portrait, 'the sky was the limit'. Geronimo demanded two dollars from Gill, exactly the amount Gill had on him. After being paid, Geronimo demanded another twenty-five cents, forcing Gill to borrow the money. To even the score, however, Gill made two portraits while appearing to take only one.[24]

Both Gill and Smillie worked for their respective organizations for most of their careers. On March 7, 1917, Smillie died, and was replaced by Loring Beeson.[25] Beeson resigned in 1920, and was succeeded by Arthur Olmsted.[26]

The Indian delegations flocked to Washington in record numbers until World War I; thereafter, numbers declined. De Lancey Gill continued to take their photographs until his failing eyesight caused him to transfer what little work there was to Olmsted.[27] One of Gill's last recorded Indian portraits was of Sitting Bull's grandson (plate 7.20).

In 1932, Gill was forced to retire due to a Congressional economy drive. His retirement brought an abrupt end to the most prolific period of government studio photography of the American Indian. During his career he had created a vast library of hundreds, perhaps thousands, of portraits. His portraits record not only the physical characteristics of American Indians, but, perhaps more importantly, they depict the leading chiefs at a time when the Indian Wars had given way to life on the reservations.

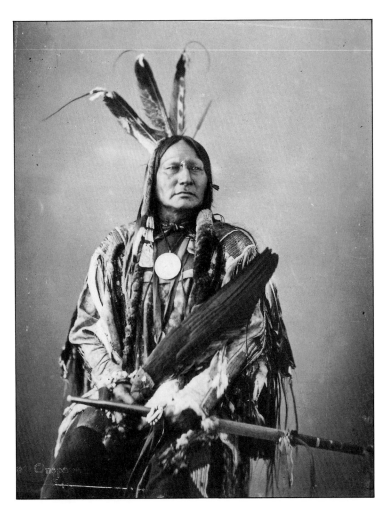

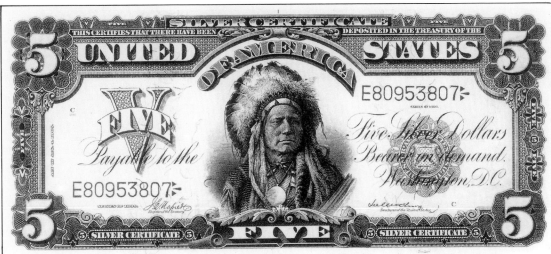

7.2 LEFT ABOVE *Squint Eye, a Cheyenne who was previously a prisoner at Fort Marion. This was the first delegation photograph at the new studio (opened in 1875) of the Smithsonian Institution. Taken by Thomas W. Smillie some time around 1878–79.*

7.3 RIGHT ABOVE *Running Antelope, a Hunkpapa Dakota. This image, slightly changed, was used on an 1899 United States five-dollar silver certificate (plate 7.4). By Alexander Gardner, 1872.*

7.4 ABOVE *The 1899 United States five-dollar silver certificate which combined the image in plate 7.3 with a photograph of an Indian headdress taken by Thomas W. Smillie in 1899.*

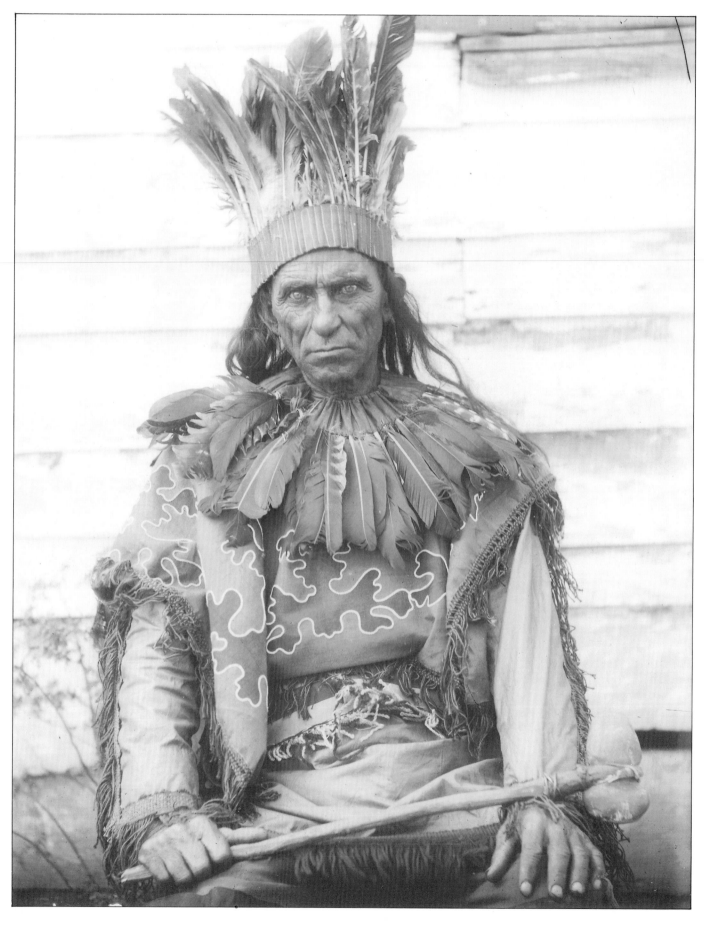

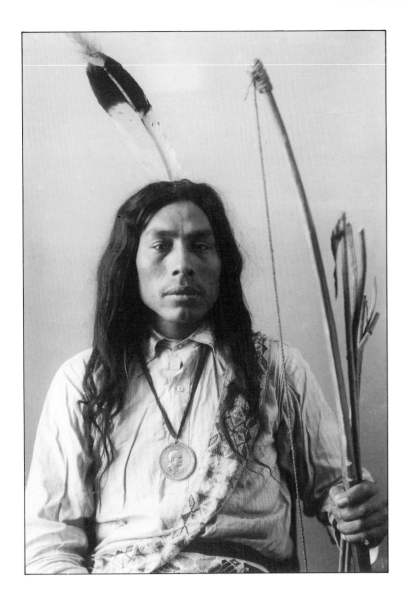

7.5 FAR LEFT *William Terrill Bradby, a Pamunkey Indian. Taken by De Lancey Gill in October 1899 on Pamunkey Reservation during a trip to Jamestown, Virginia to photograph Indians in conjunction with the work of anthropologist James Mooney.*

7.6 and **7.7** LEFT and BELOW *No Liver, also known as James Arketah Jr, an Oto. Such full-face and profile portraits of delegates were used to allow later measurements of anthropometric elements. Taken by De Lancey Gill in December 1899.*

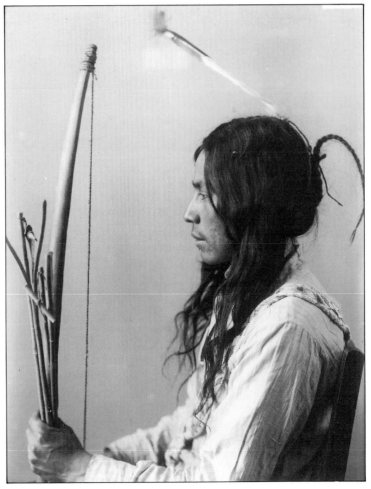

7.8 RIGHT *The Rev. John Eastman, a Santee Dakota. Taken by Thomas W. Smillie on January 4, 1904.*

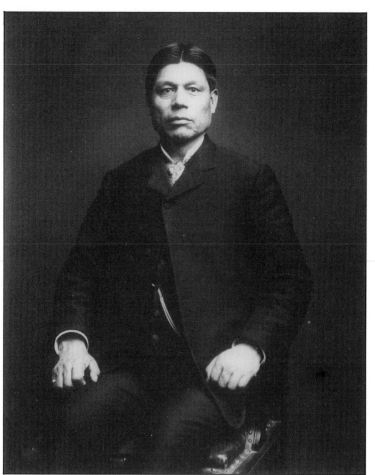

7.9 BELOW *A Yankton Dakota delegation on the roof of the Arts and Industries building of the Smithsonian Institution. They had been met and conducted there by Andrew John, an Iroquois hired by the BAE. Taken by Thomas W. Smillie on March 24, 1904.*

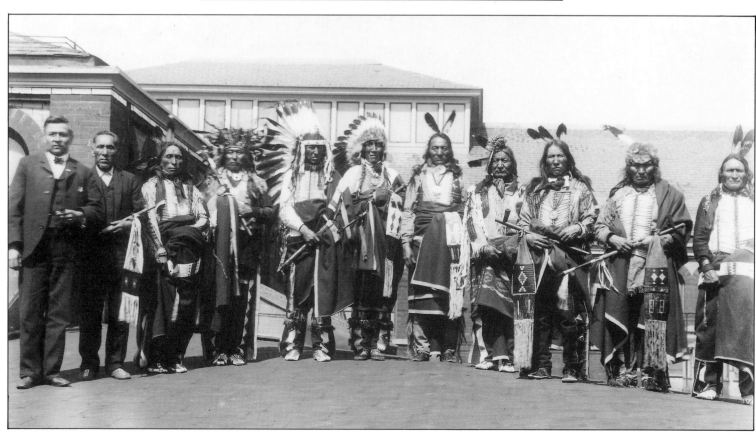

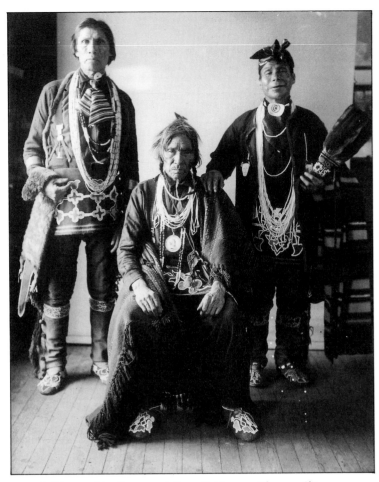

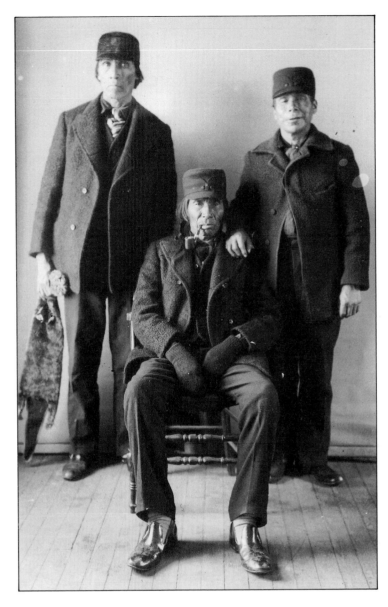

7.10 *A Chippewa delegation group. Left to right: Someone Traveling, Sound Of Eating, wearing the President James Buchanan Peace Medal issued in 1857, and High Up In The Sky or Charles Sucker. Taken by De Lancey Gill in Washington DC, February 1901.*

7.11 RIGHT *The same Chippewa delegation group shown in plate 7.10. Left to right: Someone Traveling, Sound Of Eating and High Up In The Sky or Charles Sucker. Taken by De Lancey Gill in Washington DC, February 1901.*

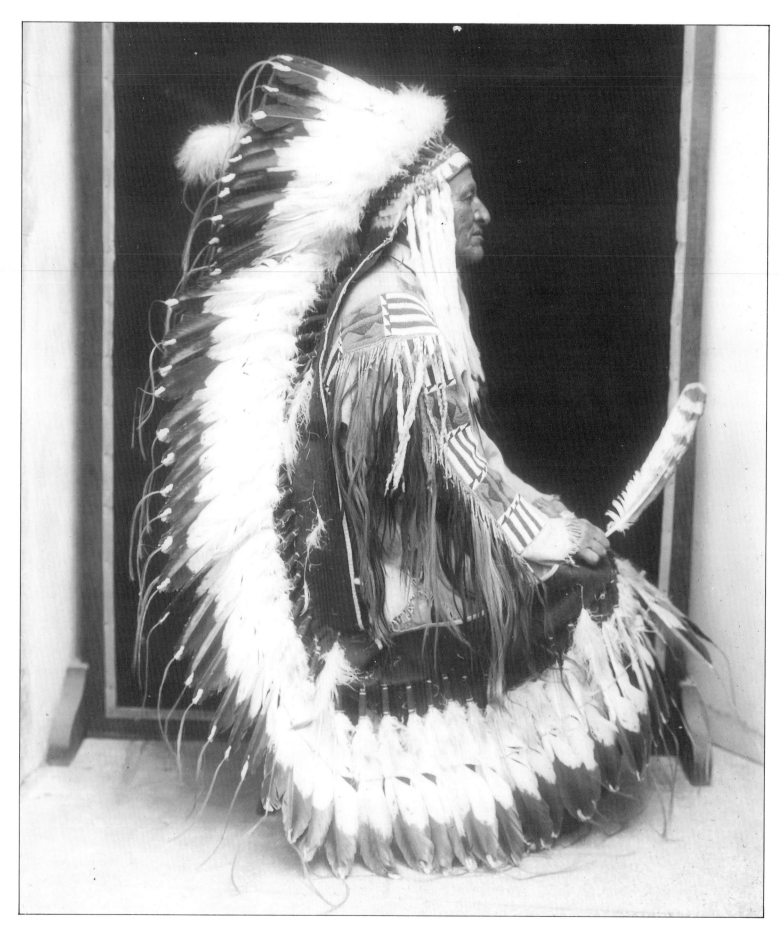

7.12 LEFT *Chief John Grass, also called Charging Bear, a Blackfoot Dakota. By De Lancey Gill, 1912.*

7.13 LEFT *Members of a Winnebago delegation holding what seem to be treaties. Left to right: Jacob Russell, Etchica, Cat or Jim Burt and Red Eagle or Henry French. Taken by De Lancey Gill in Washington DC, March 1912.*

7.14 BELOW *Nez Perce delegates. Left to right: Pile of Clouds, Yellow Bull, Aleck Morse and Tom Hill. Taken by De Lancey Gill in the BAE studio on January 2, 1912.*

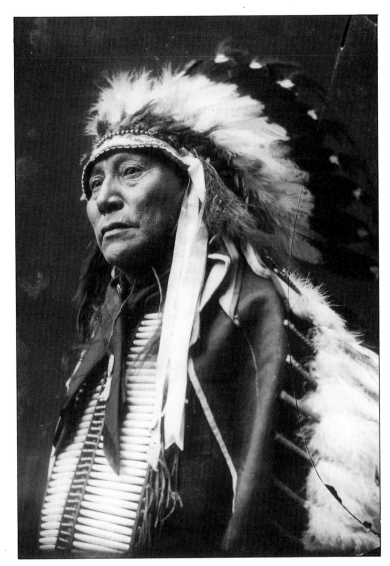

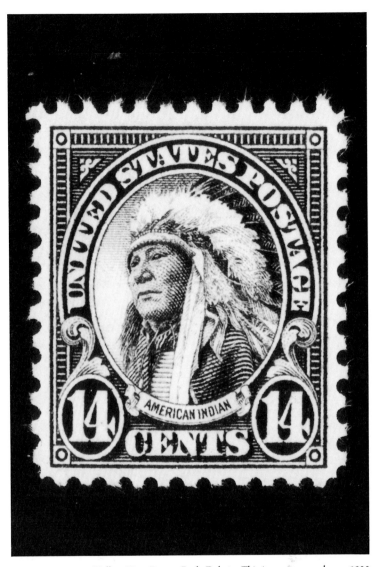

7.15 LEFT *Hair Hanging Down, a Comanche, against a plain, uninterrupted backdrop very different from the cluttered sets of the photographer's earlier portraits. By De Lancey Gill, 1930.*

7.16 LEFT ABOVE *Hollow Horn Bear, a Brule Dakota. This image was used on a 1922 United States fourteen-cent postal stamp (plate 7.17). Taken by De Lancey Gill on March 8, 1905.*

7.17 ABOVE *The 1922 fourteen-cent postal stamp based on Gill's portrait of 1905 (plate 7.16).*

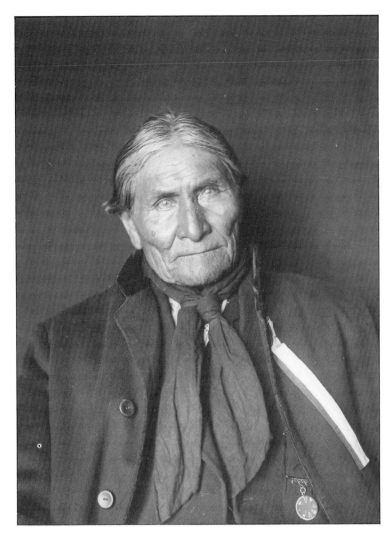

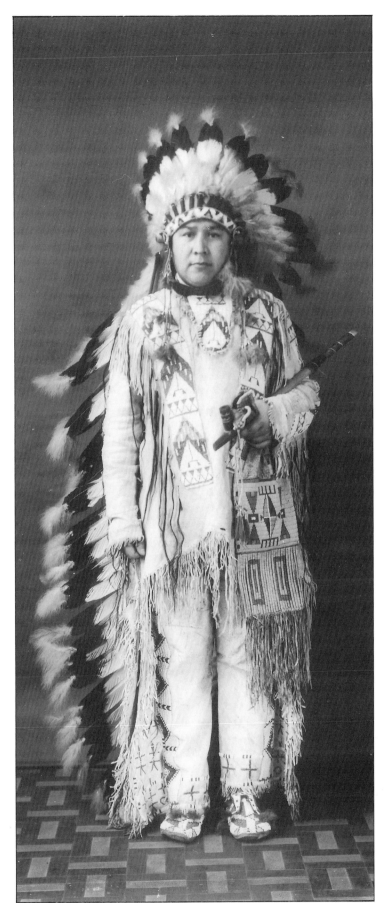

7.18 LEFT *Chief Joseph, the Nez Perce leader. When the photographer asked him to autograph a copy of this image he signed, 'Chf. Joseef, 1900.' Gill attempted to correct the date but was rebuffed on the grounds that this was how Joseph had learned to sign his name. Taken by De Lancey Gill in February 1903.*

7.19 ABOVE *The famous Chiricahua Apache Chief Geronimo. He charged the photographer two dollars for taking this portrait, then demanded another twenty-five cents, which Gill was obliged to borrow. To even the score, Gill made a second portrait while appearing to make only one. Taken by De Lancey Gill in the BAE studio, March 1905.*

7.20 RIGHT *Crazy Bull, a Hunkpapa Dakota and Sitting Bull's grandson, in one of the last delegate portraits made by the photographer. Taken by De Lancey Gill in October 1931.*

CHAPTER EIGHT

INDEPENDENT FRONTIER PHOTOGRAPHERS

THE PERILOUS LIFE

IN THE early 1800s, the American West was composed of a core of Indian country surrounded by an outer margin of white settlements in the Southwest, California, Oregon country and the Great Basin. In 1829 the eastern boundary was the Mississippi River; but by 1859, settlements had pushed this border to the eastern edge of the present states of Oklahoma, Kansas and Nebraska.

The public demand for views of Western scenery and of the Indians was almost insatiable: images were avidly purchased and sometimes redrawn for publication. The photographers who chose to fill this demand had to leave the relative comfort of the studio for the difficult arena of the frontier. Traveling from one outpost to another, they used their complex and cumbersome equipment to record the West and the Indians. William Henry Jackson's inventory in 1875 is typical of the period:

- Stereoscopic camera with one or more pairs of lenses
- 5″ × 8″ camera box plus lens
- 11″ × 14″ camera box plus lenses
- Dark tent
- 2 tripods
- 10 lbs collodion
- 36 oz silver nitrate
- 2 quarts alcohol
- 10 lbs iron sulfate
- Package of filters
- 1½ lbs potassium cyanide
- 3 yards canton flannel
- 1 box rottenstone
- 3 negative boxes
- 6 oz nitric acid
- 1 quart varnish
- Developing and fixing trays
- Dozen and half bottles of various sizes
- Scales and weights
- Glass for negatives, 400 pieces[1]

Added to this was the requisite personal gear of bedroll, clothes, firearms and ammunition, axe and shovel, cooking utensils and food. The resulting several hundred pounds of baggage were transported by mule or wagon, or in inaccessible regions, were carried by hand. This material had to be packed and unpacked several times a day, frequently after an arduous trip, whenever the photographer wanted to record a new view.

Once a subject had been selected, a wet-plate negative was made and exposed, a tricky business at best. Clarence Jackson, William Henry's son, recalled how his father coated a glass plate with collodion:

The process of preparing a wet-plate and developing it called for great skill and art. I recall, as a small boy, seeing my father coat an 18 × 22 inch plate. He balanced it carefully on the thumb and fingers of his left hand, poured a pool of collodion in the far, left-hand corner of the plate, and then slowly worked the thick fluid about the edges and all over the plate until it reached the near, right-hand corner. So sure and careful was his hand that never a drop was spilled, nor was there any fluid left to be returned to the collodion bottle. This was hard enough to do in the studio, let alone on the top of a mountain in driving gales, after lugging cameras, plates and plate-holders up over ledges slippery with ice and across treacherous fields of snow.[2]

Once a photograph had been taken, the equipment was loaded back on to the mule, and the photographer was on his way. The entire process usually took half-an-hour, however, Jackson, 'when hard pressed for time', could make a negative in fifteen minutes, 'from the time the first rope was thrown from the pack to the final repacking'.[3] Given the dangers of the field, and the disastrous results should a mule or its pack slip, it is a wonder that so many negatives made it back to the studio for printing.

In addition to technical problems, the frontier photographer, whether on a government expedition or self-employed, had to contend with nature. During the 1866 Fiske expedition through Minnesota, photographer Wilson B. Harlan recorded the hardships caused by drought, heat, mosquitoes, high winds, and drenching rains, as well as a stampede by several thousand buffalo that narrowly missed them.[4]

The various processes of early photography also required large amounts of water, a commodity that could be in scarce supply in desert areas, or on frozen mountain tops. If the water were muddy or alkaline (a common occurrence), the negative could be damaged.[5]

The bitter cold of winter in the mountains caused collodions to thicken so that they would not flow evenly, and water had to be made by heating snow. It took the dedication of a photographer like Solomon Carvalho to overcome such handicaps. In his biography he described his experiences of January 1854 with the Frémont expedition:

To make daguerreotypes in the open air, in a temperature varying from freezing point to thirty degrees below zero, requires a different manipulation from the processes by which pictures are made in a warm room. My professional friends were all of the opinion that the elements would be against my success. Buffing and coating plates, and mercurializing them, on the summit of the Rocky Mountains, standing at times up to one's middle in snow, with no covering above save the arched vault of heaven, seemed to our city friends one of the impossibilities …

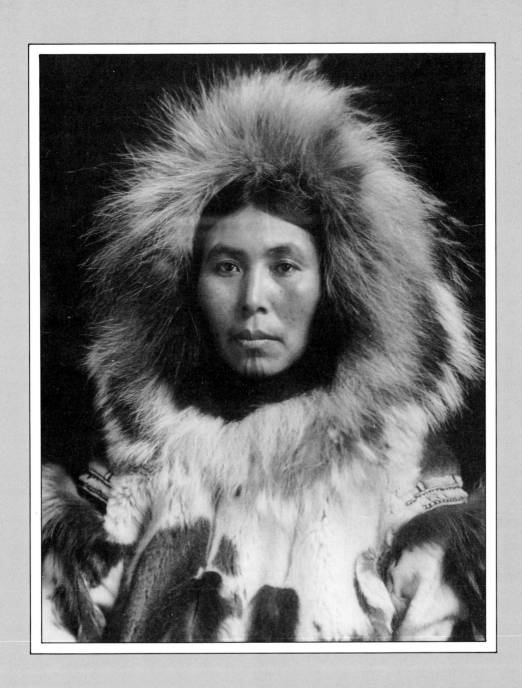

8.1 *An Eskimo woman with a tattooed chin. Taken by F.H. Nowell in Nome, Alaska on December 22, 1908.*

I shall not appear egotistical if I say that I encountered many difficulties, but was well prepared to meet them.

While suffering from frozen feet and hands, without food for twenty-four hours, traveling on foot over mountains of snow, I have stopped on the trail, made pictures of the country, repacked my materials, and found myself ... frequently some five or six miles behind camp, which was only reached with great expense of bodily as well as mental suffering.[6]

Carvalho's difficulties continued. Fifty of the pack animals fell several hundred feet down a ravine, killing two and smashing tent poles. This meant that the men had to sleep out in the snow. Provisions got so low that twenty-seven of the horses were slaughtered for food. To save the group, Frémont ordered that excess baggage be abandoned, including Carvalho's daguerreotype equipment.[7]

Photographers in the searing heat of deserts had to contend with different problems. The dry air shrank the negative holders causing their joints to separate and admit light, or to fall apart completely.[8] The dark tents were infernally hot as they had to be tightly closed to keep out the blowing sand. Consequently, photographers nearly suffocated from the fumes given off by the chemicals.[9] William Henry Jackson found that 'the perspiration would run from my face in such streams that great care was needed to keep the briny fluid from spoiling my plates'.[10]

O'Sullivan noted that although the mountain scenery could be lovely, his group was driven out of the country by the 'unlimited number of voracious and particularly poisonous mosquitoes', as well as the 'entire impossibility to save one's precious body from frequent attacks of that most enervating of all fevers, known as the "mountain ail"'.[11]

Ridgway Glover had problems with larger creatures – namely bears. He described one incident in the *Philadelphia Photographer*, when he temporarily parted company with a companion:

... He had not been gone long, before I came across a large grizzly bear. I was about to firing [sic] a ball into his rump, but, fortunately, thought what he was in time; had I fired, you would have received no more letters from me. He showed fight, but at last concluded to let me alone, and I had no disposition to attack him; he was as tall as an elk, and I guess, would weigh 1500 at least. One lick with his paw would have settled my coffee for me instantly.[12]

Photographers were threatened not only by environmental dangers, but also by the Indians themselves. At first they were generally amiable towards photographers, but with the encroachment of advancing settlers, hostilities grew, making the photographers' task even more perilous.

Ridgway Glover described his experiences through a series of letters in the *Philadelphia Photographer* entitled 'Photography Among the Indians'. In his first letter, dated June 30 1866, he noted that Mr Laramie [Larimer], an ambrotypist, had been killed by the Indians and his wife taken captive.[13] Glover notes that at first he had difficulty in making pictures of the Indians, but 'now that I am able to talk to them, I get pretty much all I want' (presumably he had learned some of their language).

Glover photographed the Brule and Oglala Sioux around Fort Laramie until he left with a group led by Colonel Carrington. A few days later they were overtaken by Indians, and he noted that, 'They looked very wild and savage-like while galloping around us; and I desired to make some instantaneous views, but our commander ordered me not to, as he expected an attack at any time.'[14]

Glover missed a second opportunity when some Cheyennes came into camp as 'my collodion was too hot, and my bath too full of alcohol, to get any pictures of them, though I tried hard. They attacked our train in the rear, killed two of the privates, and lost two of their number.'[15]

His last letter was dated August 29, 1866. At that time he was waiting for additional supplies. The next notice of Glover's activities in the *Philadelphia Photographer* was in an editorial note: 'Mr Ridgway Glover was killed near Fort Phil Kearney on the 14th of September by the Sioux Indians. He and a companion had left the Fort to take some views. They were found scalped, killed, and horribly mutilated.'[16] Even though Glover paid with his life for his attempts to photograph the Indians, none of his images has been positively identified.

In 1871, George Kirkland traveled around Colorado with William Chamberlain and other photographers. The adventure started out 'with a loving good-bye kiss to my other half and accumulated wealth, I bade good-bye to care and toil and gave myself full away to enjoyment and all appurtenances thereunto belonging'.[17] However they soon came to Indian country, which made Kirkland very nervous. He recorded the ensuing adventure:

Well, with the Indians in my mind, and my extreme dislike for them was not a pleasant feeling for one to carry along with him when looking after the ponies; nevertheless I had been looking after them and had just entered the tall willow, along the bank of the Grand, when suddenly I heard the bushes crack and an UNEARTHLY yell of 'ah-eh ah! eh-ah! eh-ah ooooh!!' In an instant my hand was on my revolver, and a whole posse of 'wild live inguns' [sic] I fancied ready to 'whip' me; but after the first prolonged 'ah-eh' I knew the gentle voice [his donkey!], and immediately grew brave and laughed at myself, and wondered what earthly use a revolver was in my hands ... for my reputation as a marksman would save the side of a mountain at twenty paces ... and after that I felt ashamed to look a donkey in the face.[18]

Danger aside, however, many Indians were photographed, though not many by Kirkland (plate 8.2). The photographers' ability to capture images impressed the Indians. They were awed by these individuals who seemed to use the sun's power for themselves. The Dakota Indians (as we have seen) called them 'Shadow Catchers'. To catch a shadow was tantamount to catching and potentially controlling a person, and for this reason the Indians sometimes feared being photographed (plate 8.3). Photographers often misunderstood this fear[19] – to them, a photograph was simply an image on a piece of paper.

Frequently the Indians' response to the photographers was simply based upon their past experiences of white men. Carl Wimar made several attempts to photograph the Mandan in 1858, even though he knew they were afraid. '... But so soon as I had planted the camera they became so incensed that they aimed their arrows at my person, which you may imagine caused me to immediately desist from further effort.'[20] He then learned that the Indians feared that they would die of smallpox if photographed – their village had once been ravaged by the disease. He finally obtained images, but had to stand behind a curtain with a small opening for the camera lens.[21]

Wimar was also confused by the varying social customs of the different tribes. While in Sioux territory he noted:

We had scarcely reached the shore when some three hundred savages galloped towards us in a furious manner, until they were within about

one hundred paces of our party when they suddenly came to a halt and fired their flintlocks over our heads. You may imagine our fright when we heard the whistling balls passing over us, but we were informed that such proceedings were intended as a sign of friendship.[22]

Dr William Abraham Bell experienced a different problem in recording the Indians. In 1867, while he was photographing a group of women, one of them indicated that she would like to look at her friends through the camera. Bell's camera did not correct the image, so everything appeared upside down. When the women saw her friends with their legs in the air, she was incensed: Bell was forbidden to take the photograph.[23]

Circumstances favored the photographic efforts of Lloyd Winter and Percy Pond in Alaska. One day while relaxing on a hillside, they unwittingly observed a secret Chilkat Ceremony not meant for uninitiated eyes. When the Indians saw them, the dance ceased in confusion and consternation. Winter understood the native language, so he was able to converse with them about the unfortunate incident. Finally they agreed on a solution: Winter and Pond were initiated into membership of the tribe. Pond was named 'Crow Man', while Winter's name was simply translated into their native language.[24]

Winter and Pond took an active interest in the Northwest Coast Indians, and made frequent photographic trips to their villages. One of their most striking interior photographs was of a Tlingit house (plate 8.4).

Many different stories such as these underline the fact that the native response to photography was as varied as were the beliefs, experiences and unique personalities of the people. In addition, the individual personality and proclivities of each photographer played an important part in the encounters.

William Prettyman must have had the perfect personality for the profession. In 1891, during a land rush into the territory of the Sauk and Fox, he was not only welcomed by the Indians, but even given a feast while they sat together watching the settlers spreading throughout Indian land. When he was not able to visit his Indian friends, they sought him out at his Arkansas City gallery.[25]

As Prettyman found, once photographers had gained the confidence of the Indians, the desired pictures could usually be obtained (plate 8.28). Major Lee Moorhouse noted that sometimes years of close friendship and association were necessary to dispel the mistrust each group held for the other.[26]

Some encounters between the photographers and the Indians proved beneficial, as in the case of Wassajah, a Yavapai Indian. He was captured as a child in 1871 by Pima Indians. Soon afterwards they sold him for $30 to Mr Carlos Gentilé, an Italian photographer, who wanted to save the boy. He returned to the East with him, and he was baptized 'Carlos Montezuma' (after Gentilé and the Montezuma ruins in Arizona).[27] Wanting the best for the boy, Gentilé, who could no longer support him, transferred custody to a Baptist minister in Illinois. Gentilé later committed suicide, but Montezuma was given a good education, ultimately graduating from the Chicago Medical School. He worked in the Indian service, and wrote about his people.[28]

As businessmen, the photographers also had to contend with financial realities. Failure to make a profit meant the end of a photographic career. Successful Western photographers realized that although frontier and Indian views were popular, their major profit came from the steady income of day-to-day studio portraiture. When they went out in the field, therefore, their studios were left in the hands of wives and partners. Many women

in this way became talented, albeit anonymous, photographers.

Photographers also had to contend with the vagaries of fashion to stay in business. During the Civil War, small $2\frac{1}{2} \times 4\frac{1}{2}$ inch *carte de visite* photographs were in fashion. Everyone rushed to have his portrait made, then traded images with friends and collected portraits of famous personalities, including Indians. These images were then assembled in specially-designed albums. As fashion changed, these were soon replaced by a larger image called a 'cabinet' card. Similarly when stereographs began to decline in popularity in the late 1870s, independent photographers were gradually driven out of business by larger firms with more efficient production methods and more advanced marketing schemes.[29]

The general prevailing economic conditions also affected studios. The severe depression of 1873 caused many photographers to seek other ways of supplementing their income.[30] Additionally, during and immediately after the Civil War, specific taxes were levied on photographers: license fees were imposed, and tax also had to be paid on individual images.

The circle of professional frontier photographers was relatively small, and many knew each other. Images were easily available, and as competition increased, photographers had to contend with piracy by their peers. Copying another photographer's work was such a commonplace practice that many images cannot now be credited to their original creators.

Even though images could be copyrighted, the only legal requirement was that the titles be registered by the clerk of the District Court of Washington DC.[31] A. Zeno Shindler was thus able to copyright Indian photographs that he knew were by William Henry Jackson and Joel E. Whitney.[32]

David F. Barry was so bothered by the practice of 'stealing' images that, around 1882, he wrote the following notice: 'This Catalogue contains Indians of note all taken from life and are not copies. Photographs of Indians advertised by Haynes of Fargo are copies taken from my photos.'[33] (It must be noted that Frank. Jay Haynes also made many original photographs of the Indians, and established an important studio at Yellowstone National Park.) Other photographers posted rewards for information concerning illegal copies, but regardless of their efforts, piracy still ran rampant.

PHOTOGRAPHERS OF THE FRONTIER TOWNS

Frontier photography was not restricted to traveling field photographers. Towns sprang up as the white population spread westward. Towns big enough to have a saloon usually also had a photographer. To supplement his income, the photographer may also have been a dentist, jeweler or watchmaker. These photographers are often listed by profession in the census records, along with the farmers, railroad workers, prospectors, gamblers and even prostitutes. Many of these photographers also made trips into the wilderness to photograph the Indians, while others photographed them in the comfort of their studios.

Thomas M. Easterly made some of the earliest portraits of Iowa, and Sauk and Fox Indians while he was an itinerant daguerreotypist around Liberty, Missouri in about 1846–47. The use of controlled lighting indicates that his portraits were made in a studio (plates 8.7, 8.8), but its exact location has never been determined. Perhaps it was an early portable tent, or possibly the portraits were made later in 1847 when he opened a studio in St Louis, Missouri. John H. Fitzgibbon, another early photographer, also had a studio in St Louis and made portraits of the Indians.

Salt Lake City had many photographers. Charles R. Savage and George

M. Ottinger had a studio there in the 1860s, and photographed the local Indians. One of their employees, Charles W. Carter, eventually opened his own studio, Carter's View Emporium, which did an even brisker business recording the Indians.

Carter took a photograph of Paiute Jim and his wife (plate 8.9). In a rare, surviving studio log, Carter referred to the event:

> I expect that this is the first time that the loving Jim ever had his arm around the neck of his lady love. As a general thing the Indians are not very loving ... But I got Jim to sit for his 'pigter' as they call it. He looked so amiable sitting by the side of his spouse, that I could not resist the inclination of putting his arm around her neck. The picture was taken before he was aware he looked so loving.[34]

Although some of Carter's photographs were produced for the Indians, many were clearly made for white consumption. Several of his portraits carry patronizing or demeaning captions such as the title 'Venus and Adonis' for a portrait of a man and his wife, or, under a portrait of three women, 'The Three Graces'. Although meant to be humorous, they reveal the superiority felt by whites at the time.

Omaha, Nebraska also had many studios that specialized in Indian photography, such as those of Edric Eaton, Mr Hamilton and William Henry Jackson (who formed Jackson Brothers), and Daniel S. Mitchell. St Paul, Minnesota had James Martin, M. Tuttle, Benjamin Franklin Upton, Joel Emmons Whitney and Charles Zimmerman, to name but a few. The list goes on: to mention all the photographers who made images of Indians would seem an endless task. But their works live on in the photographs stored in attics, antique shops and archives.

By the turn of the century, photography had become technically so easy that it was no longer restricted to dedicated professionals. Amateurs and professionals alike formed camera clubs. These clubs made photographic trips to appealing areas such as the Indian pueblos of the Southwest. Their journeys were no longer hindered by hostile Indians, and they were still admitted to some of the ceremonies.

One such camera club was based in Pasadena, California at the home of Adam Clark Vroman, an important Indian photographer (plate 8.10). Other members of the club included H. E. Hoopes and Peter G. Gates. When recording the Indians, it was not unusual for one tripod to be set up and for each photographer then to take his turn snapping the shutter on the same scene. If the subject happened to be a person, only the changed position of the hands establishes that two separate photographs had been taken (plate 8.11). These outings were viewed as a source of fun as well as an opportunity to record a different culture.

Sometimes, however, the camera clubs caused problems, especially in relation to ceremonies such as the Hopi Snake Dance. The Indians feared that if these ceremonies were recorded, the resulting images might be used against them as proof of their continuing religious activities — activities that the Bureau of Indian Affairs was trying to stamp out in pursuit of its goal of assimilation. Eventually all whites were banned from viewing the Snake Dance.

Some of these later photographers, however, began to understand the plight of the Indians and to campaign on their behalf. Such was the case with Charles Lummis. Lummis, who had traveled on foot from Cincinnati, Ohio to Los Angeles, California in 1884–85, became enamored of the Southwest and the Indians in particular. From 1888–92 he lived at Isleta Pueblo and recorded it. On returning to Los Angeles, he published several books revealing the beauty of the country and its people. In 1899 he became even more involved with the Indian cause and published a series of articles entitled 'My Brother's Keeper', in reaction to Richard Henry Pratt and his school for 'civilizing' the Indians (see page 74).

Lummis was typical of a new breed of photographer, not only sensitive to the plight of the Indian, but also interested in helping out, either by raising public awareness of the wrongs that had been done to the Indians, or by simply recording them for posterity.

Photography itself had evolved: the interested amateur could photograph anything with ease, while the more serious professional could use more artistic types of photography to express his views. Ultimately, the growing awareness of the Indians' situation and the development of artistic photography were to combine to produce the great photographic endeavors of the early twentieth century.

8.2 RIGHT *Ute Jack, also known as Green Leaf. Because of a lack of opportunities and his fear of Indians, the photographer made few Indian images. Taken by George Kirkland some time around 1871.*

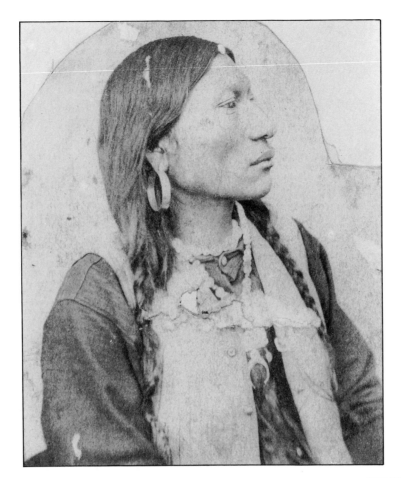

8.3 BELOW *A group of Mohave Indians on the Colorado River Reservation, Arizona. Some cover their faces through fear of the camera. By an unidentified photographer.*

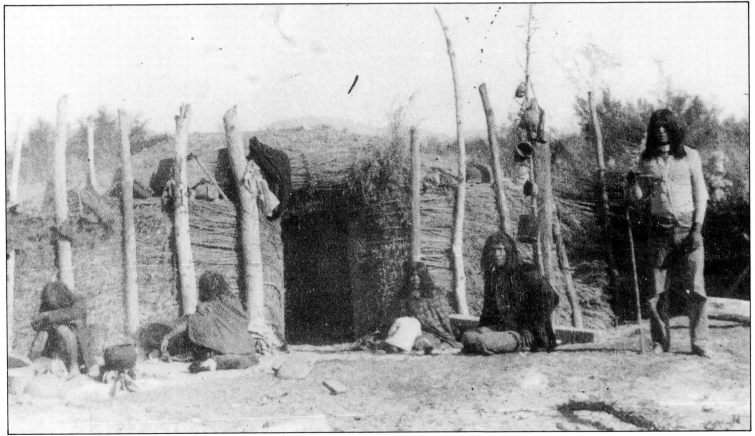

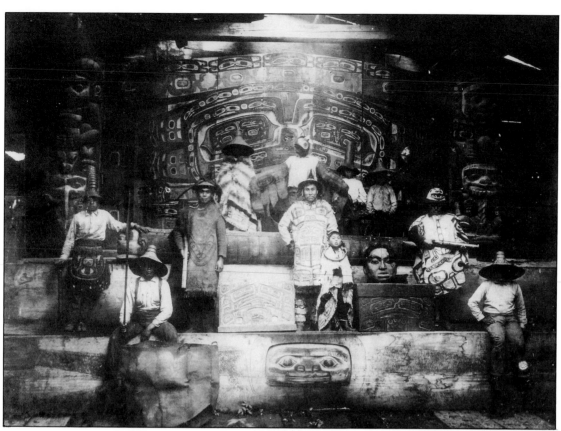

8.4 LEFT *The interior of the home of Tlingit Chief Klart-Reech. By Lloyd Winter and Percy Pond, copyright 1895.*

8.5 BELOW *Tlingit dancers at a Potlatch Ceremony in Alaska. The photographers inadvertently witnessed a secret Chilkat Ceremony. When discovered by the Indians, they were initiated into the tribe to avoid problems: Pond was named 'Crow Man', and Winter's name was translated into the language. By Lloyd Winter and Percy Pond, copyright 1895.*

8.6 RIGHT *Chief Joseph, the Nez Perce leader. Probably taken some time around 1877, and circulated by Frank Jay Haynes, David F. Barry and Orlando Scott Goff (the photographer has not been conclusively identified).*

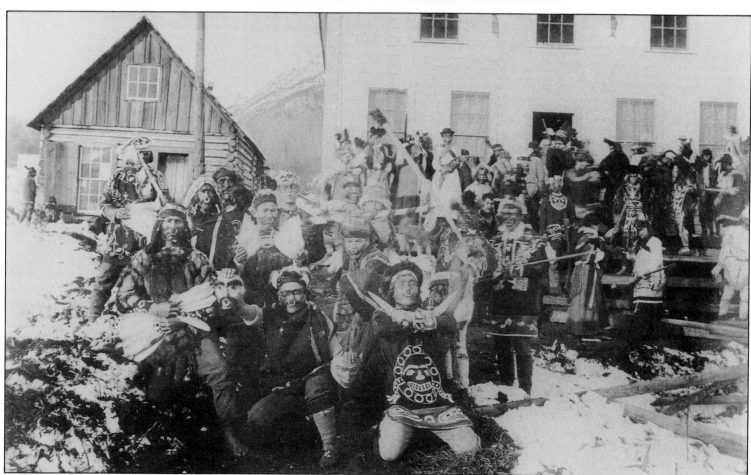

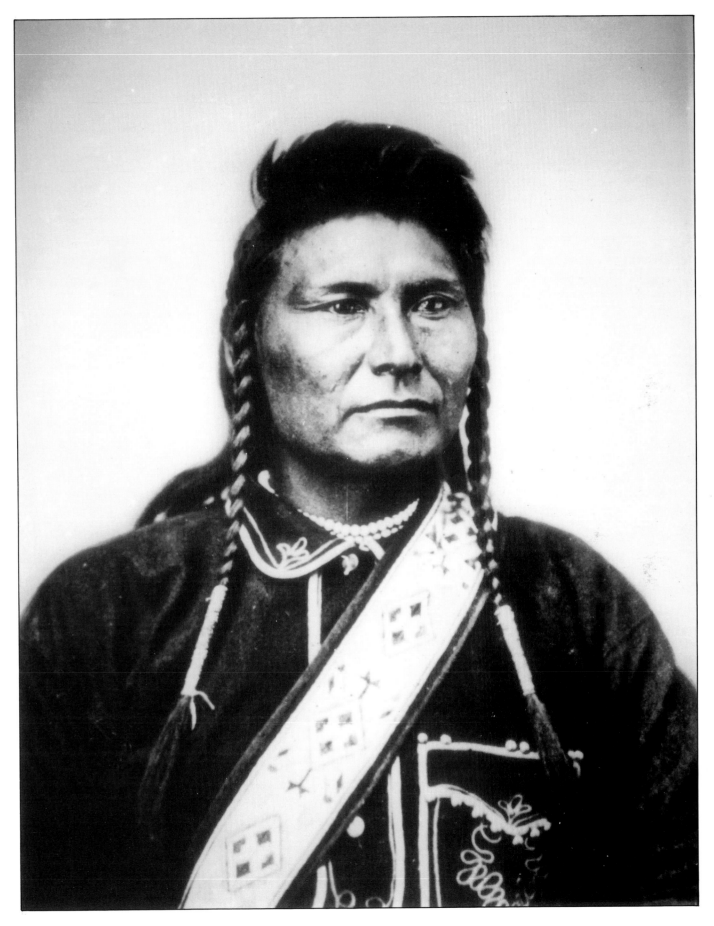

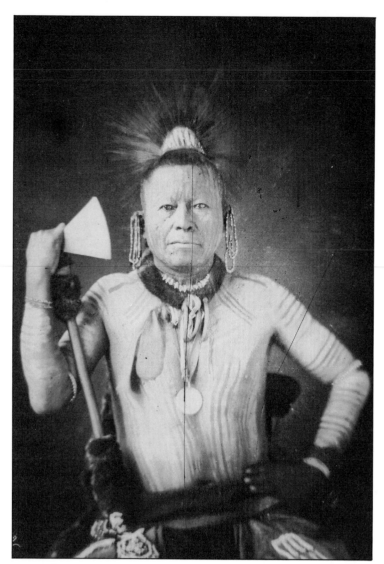

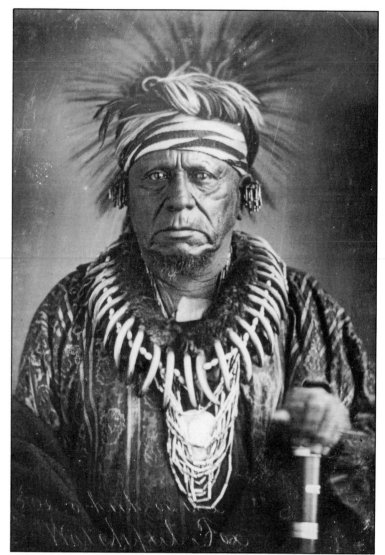

8.7 *Longhorn, a Sauk and Fox. A daguerreotype taken by Thomas M. Easterly some time around 1846–47; the wet-plate copy negative was made by A. Zeno Shindler in 1869.*

8.8 *Keokuk, a noted Sauk and Fox leader. A daguerreotype taken by Thomas M. Easterly some time around 1846–47; the wet-plate copy negative was made by A. Zeno Shindler in 1868, twenty years after Keokuk's death.*

8.9 RIGHT *Paiute Jim and his wife. The photographer commented: 'I expect that this is the first time that the loving Jim ever had his arm around the neck of his lady love ... I could not resist the inclination of putting his arm around her neck.' Taken by Charles W. Carter of C.W. Carter's View Emporium, Salt Lake City, Utah some time around 1879.*

8.10 BELOW *One of the many camera clubs which began to spring up around the turn of the century. The membership of this club, which was based at Pasadena, California, included H.E. Hoopes (standing, on the far left), Adam Clark Vroman (seated), and Peter G. Gates. Taken by an unidentified photographer during a trip to the San Juan Capistrano Mission in 1900.*

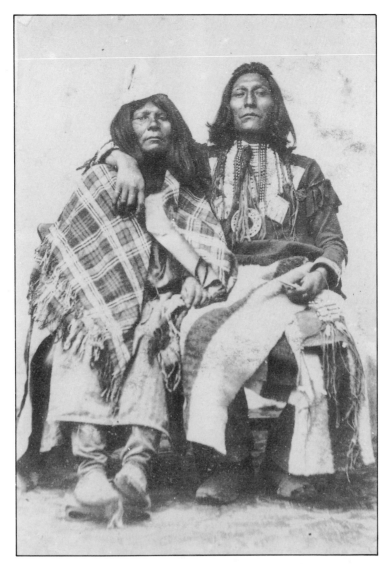

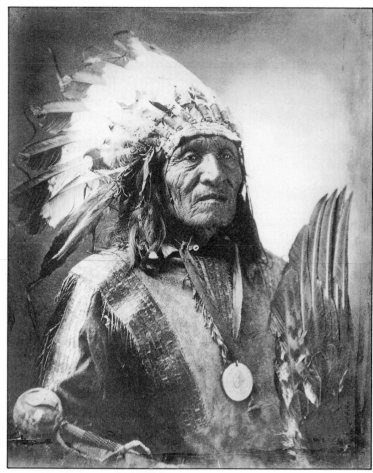

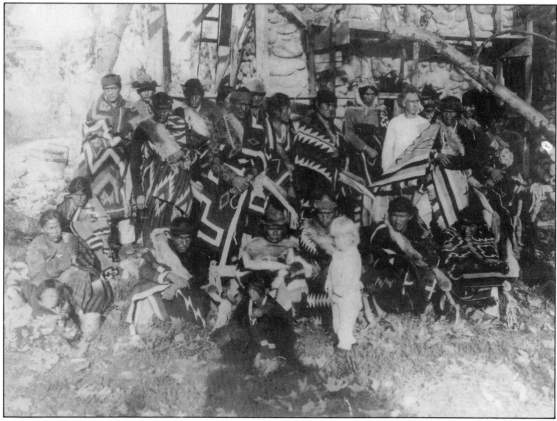

8.11 LEFT ABOVE *A Hopi weaver. Taken by H.E. Hoopes, a member of Pasadena camera club (see plate 8.10), on a visit to Oraibi Pueblo in 1902. His photograph can be distinguished from those taken on the same camera stand by his colleagues only by the change of hand positions.*

8.12 ABOVE *He Dog, a Brule Dakota. Taken by John Alvin Anderson on the Rosebud Reservation, South Dakota, probably some time between 1895 and 1915.*

8.13 LEFT *A group of Navahos visit the photographer and writer Charles F. Lummis at his home in Los Angeles, California. By an unidentified photographer.*

8.14 ABOVE *A street scene in a Bellacoola village, British Columbia. Taken by an unidentified photographer some time before the turn of the century.*

8.15 LEFT *The camp of Hunkpapa Dakota Chief Sitting Bull at Qu'Appelle, Canada. By Frank Jay Haynes, 1881.*

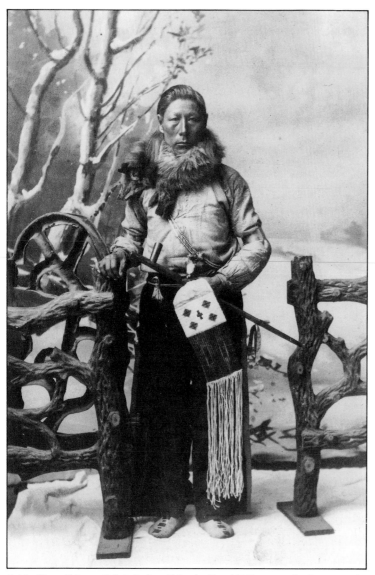

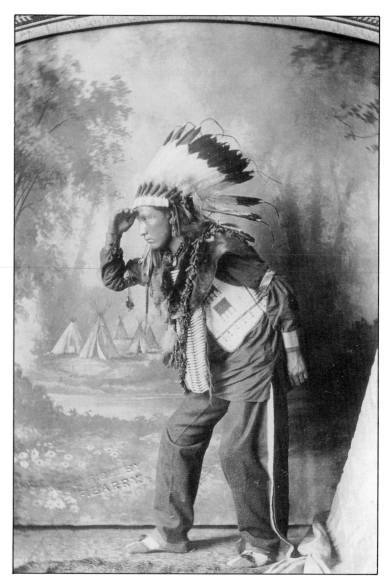

8.16 *Harry Eaton, a Dakota Indian. Taken by David F. Barry in either his Bismarck or his Standing Rock studio, Dakota Territory, probably in the 1880s.*

8.17 *An unidentified Dakota Indian posed against one of the photographer's many backdrops and beside a tipi also used as a prop. By David F. Barry.*

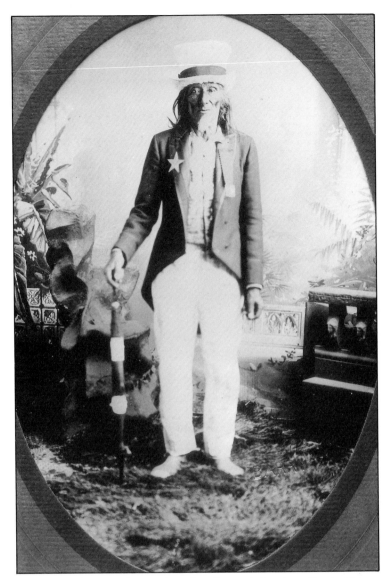

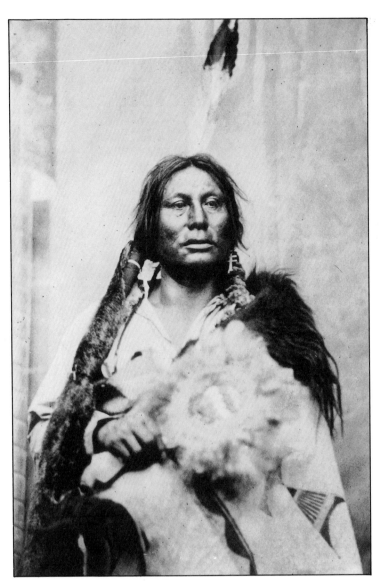

8.18 *Hairy Chin, a Hunkpapa Dakota, dressed as Uncle Sam during Fourth of July celebrations. Other guests from the Standing Rock Reservation included noted chiefs. Hairy Chin was invited to lead the parade. He died two days after returning to the reservation. Afterwards other Indians vowed never to wear the costume. Taken by David F. Barry some time around July 4, 1889.*

8.19 *Chief Gall, a Hunkpapa Dakota who, early in his acquaintance with the photographer, threatened him with a weapon. They later became friends, and Barry photographed him many times. By David F. Barry.*

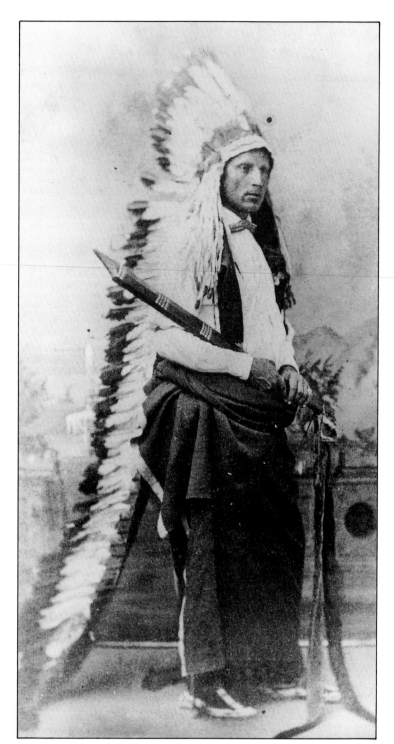

8.20 LEFT *Red Shirt, an Oglala Dakota, against the backdrop of a garden with fountain and balustrade. On some Indian photographs the balustrade is touched out and the fountain changed to a tipi. Circulated by many photographers but probably taken by Daniel S. Mitchell or his company, Mitchell and McGowan, Omaha, Nebraska, in the late 1870s or the 1880s.*

8.21 ABOVE *Unidentified Paiute children. Taken by Charles W. Carter at Salt Lake City, Utah.*

8.22 RIGHT *Ute Indians, Wa-Rets and Shavano. Taken by William Gunnison Chamberlain in his studio at Denver, Colorado, possibly in 1868.*

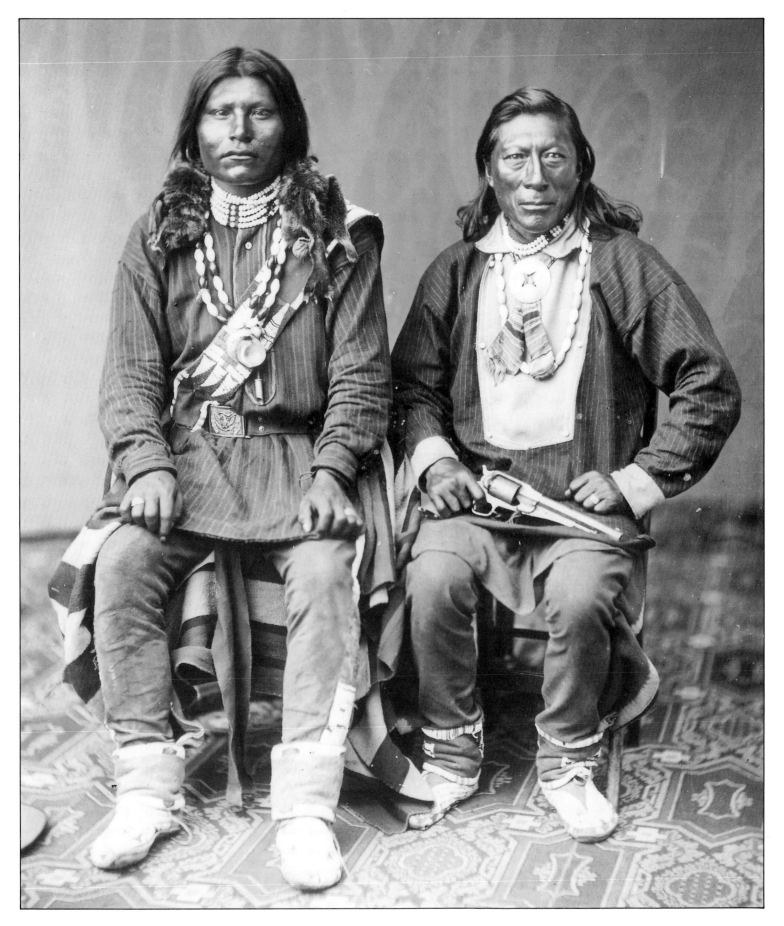

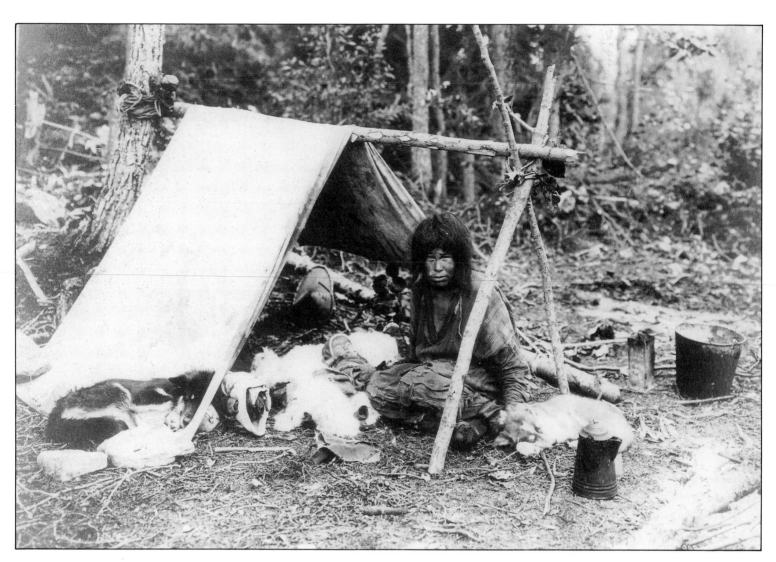

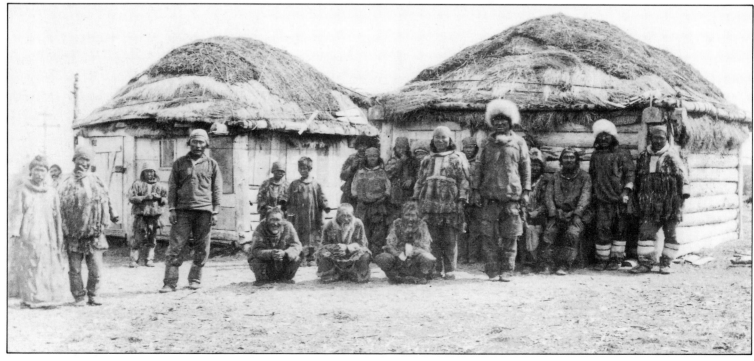

8.23 LEFT ABOVE *An Ahtena Toral woman and child. Taken by Miles Brothers of New York and San Francisco in 1902, on their trip to photograph the line of a potential railroad down from Valdez, Alaska on behalf of the Valdez, Copper River and Yukon Railroad Company.*

8.24 LEFT BELOW *An Eskimo group in front of storehouses at Togiak, Alaska. Taken by Hartmann and Weinland before 1887.*

8.25 RIGHT *The White Deerskin Dance of the Hupa Indians. Taken by A.W. Ericson some time around 1890–1900.*

8.26 RIGHT BELOW *The historic tipi of Hunkpapa Dakota Chief Old Bull. Taken by Frank Fiske some time around 1900.*

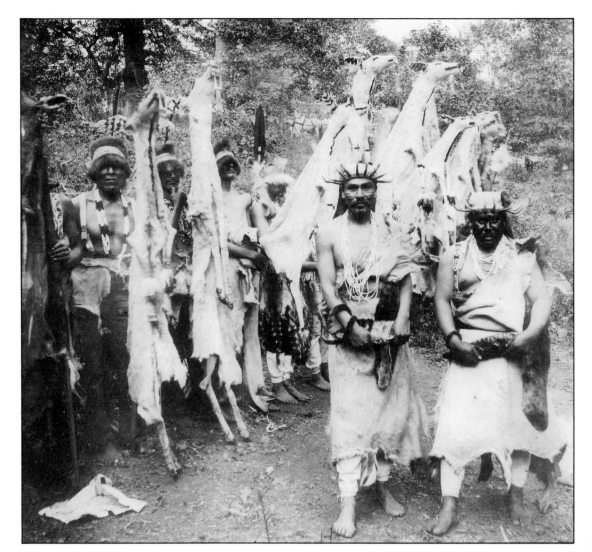

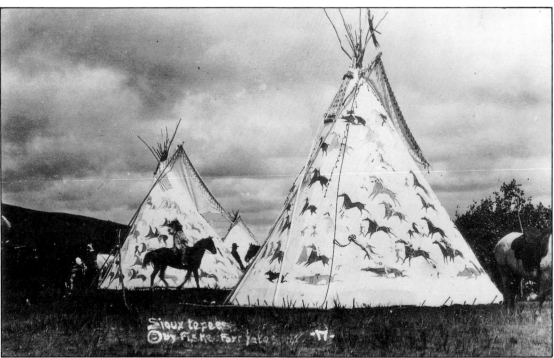

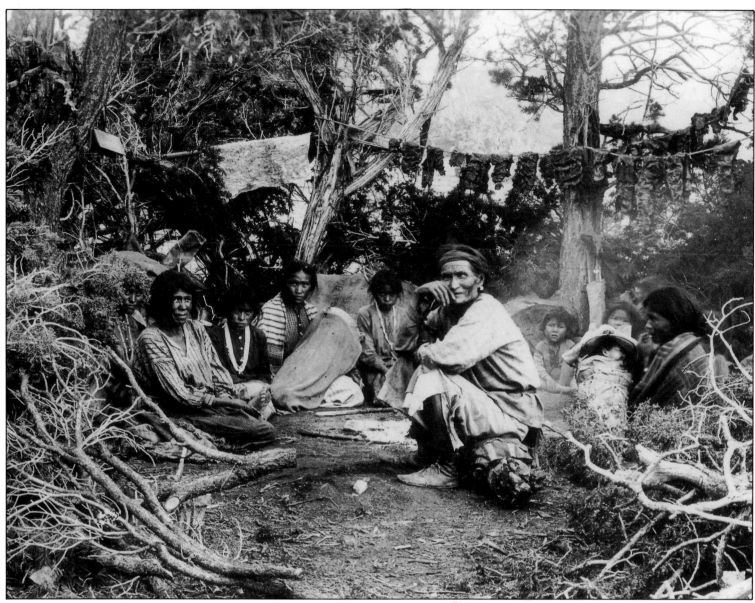

8.27 ABOVE *A Navaho camp. Probably taken by George Ben Wittick, copyright January 21, 1897.*

8.28 RIGHT ABOVE *A group of Pawnees eat watermelon, possibly while on tour with Pawnee Bill's Wild West Show. Taken by William Prettyman some time around 1890.*

8.29 RIGHT BELOW *The Feast of San Geronimo at Taos Pueblo, New Mexico. Taken on September 30, 1871 by Orloff Westmann of Elizabethtown, New Mexico, while under contract to English entrepreneur and collector William Henry Blackmore to photograph the people for his collection.*

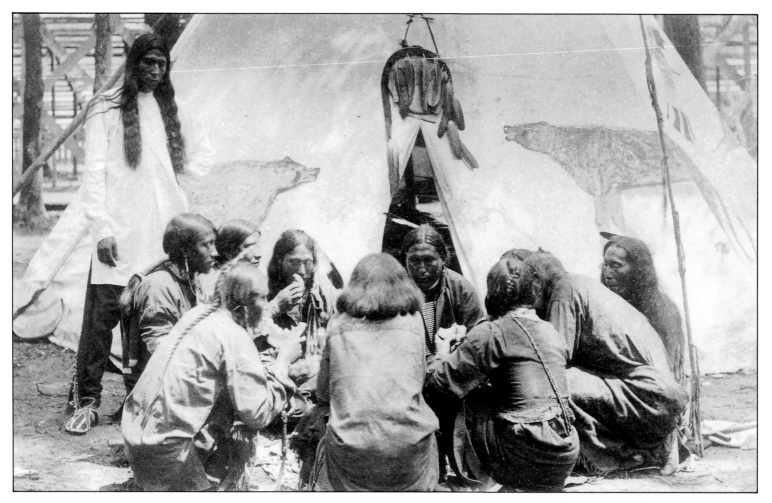

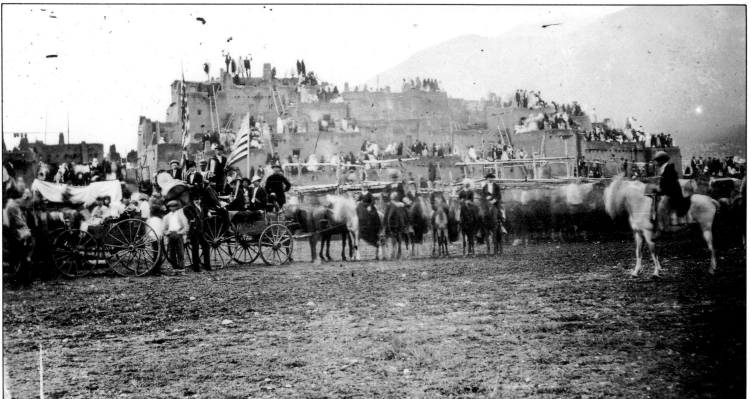

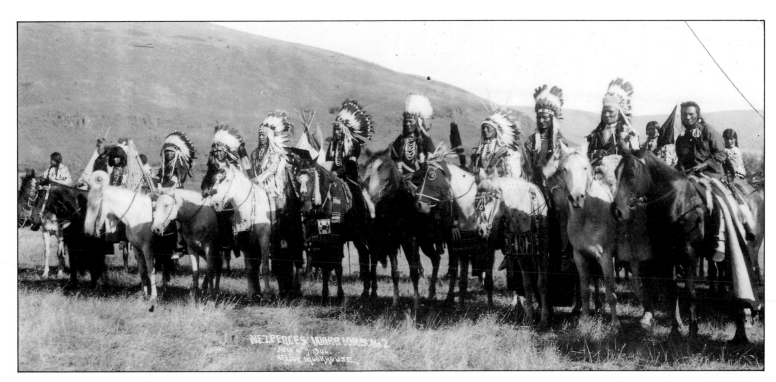

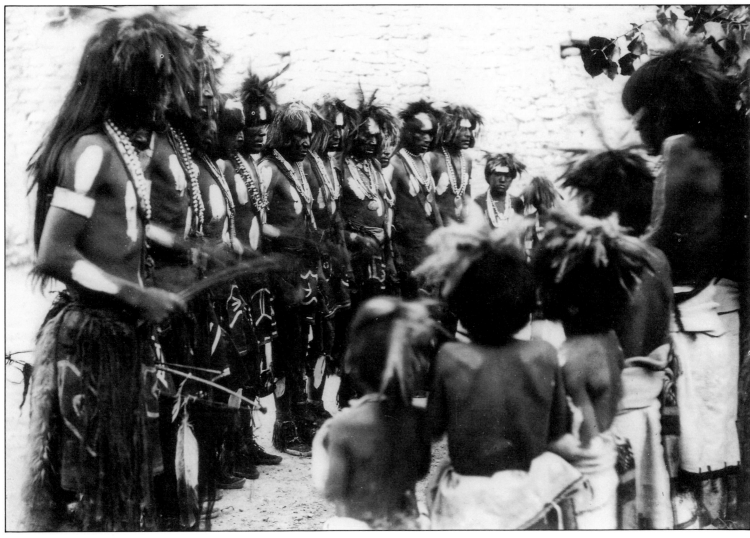

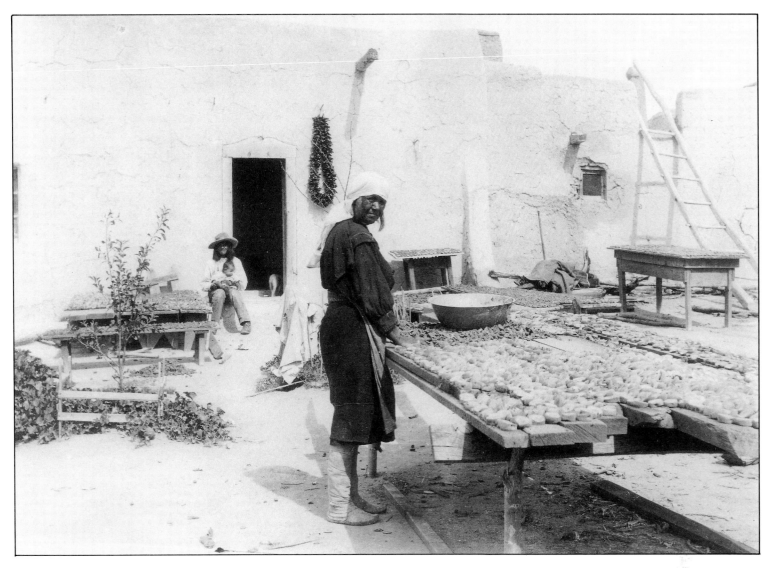

8.30 LEFT ABOVE *Nez Perce warriors. Taken by Major Lee Moorhouse on July 4, 1906.*

8.31 LEFT *Hopi Snake Dancers. Such photographs of ceremonies eventually caused many tribes to forbid the use of cameras and even the presence of non-Indian spectators. Taken by Sumner W. Matteson on August 21, 1900.*

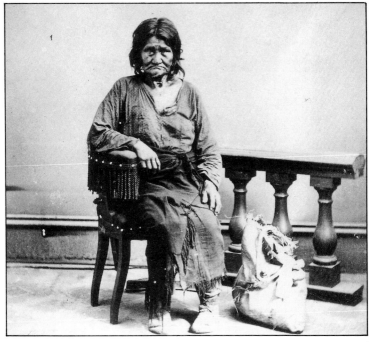

8.32 ABOVE *An Isleta woman drying peaches. The photographer took his photographs of life in the West while traveling on a bicycle. Taken by Sumner W. Matteson on September 30, 1900.*

8.33 LEFT *Old Bets, a Santee Dakota woman who helped many whites during the Sioux Revolt of 1862. Taken by William Henry Illingworth of St Paul, Minnesota.*

GRAND ENDEAVORS

THE impact of industry and technology during the nineteenth century caused dramatic changes in the history of North America. Out of this grew a generation of photographers who felt a strong social responsibility to preserve, document and communicate the course of some of these changes. They began this Herculean task by taking photographs of the aboriginal population of North American Indians. They devoted their fortunes and their lives to this grand endeavor.

After 1890, new processes and techniques were needed to insure the survival of the professional photographer. Art salons or clubs were organized which were devoted to a more interpretative and aesthetic style of photography. Their members were called 'Pictorialists'. These photographers attempted to create in their pictures the atmospheric effects of Impressionist paintings. They began to experiment with new techniques – novel angles in composition; dramatic close-ups and lighting; soft-focus lenses; abstract or non-existent backgrounds; added or omitted details; hand-tints or other coloring – all possible means of manipulating the final result to make their images look more like other art forms and less like photographs.[1]

A leader in this movement was Gertrude Kasebier, a trained artist who had a New York portrait studio. Kasebier photographed Sioux Indians from the William F. Cody Wild West Show, in about 1900 or 1901. The portraits illustrate not only her highly-developed technical skills – the command of light and tone combined with perfect composition – but are intuitive, sensitive pictures which reflect the compassion she felt for her subjects (plate 9.1). In 1902, Kasebier and other professional photographers formed the Photosession Club with Alfred Stieglitz, father of modern American photography, as their mentor. The Club's purpose was to exhibit, publish and promote studio photography as art. It also greatly influenced photographers out in the field.[2]

The Pictorialists of the West followed the old trails but with a new freedom to photograph in a relatively peaceful atmosphere. They were free from wars, that is, but instead were surrounded by throngs of anthropologists, university researchers and tourists who flocked on the railroads to the Indian sites. Like the expeditionary and other frontier photographers, the Pictorialists carried large glass-plate view cameras and not the Kodak box camera of the amateur.

They were professional photographers with a serious purpose in mind. They thought of themselves as visual historians, belonging both to the scientific and artistic communities. As a scientific pursuit, they wanted to conduct enthnological studies and record the traditional Indian ways of life before they completely vanished. They idealistically ventured out to discover the noble savage. Instead, they found disheartened people living in despair. Realism made bad photographs – but their artistic skills could beautify what they had found. As artists they must have imagination and a respect for their subjects. Then the camera could be used as an instrument of creative expression just as a painter uses his paintbrush. The Pictorialists painted with the camera.

Photography is also a story-telling medium. Each picture automatically implies a time before and after its taking: the world depicted in the photograph may never actually have been, and we may never know the real story. But we know that reality existed before the picture was taken and will go on after.

The making of a photograph is as much a decision about what to leave out as it is a selection of what to include. In this way the photographer edits the world around him. The Pictorialists did not intend to delude the viewers by leaving out or changing elements of the image – rather, they intended to take the viewers back to a vanished world and remind them of what had been destroyed. They wanted to give back to the Indians what had been taken away. They looked to their subjects for those ethnographical and artistic elements which would lend themselves to the photographic medium in order to recreate this history.

And so began a complex conspiracy between photographers and North American Indians. Together they produced an idealized vision, which satisfied both their needs, of what life used to be and should be like. Both parties participated in recreating the history of an entire nation. The West became the symbol of America's youth; the North American Indians, the symbol of ancient wisdom.

EDWARD SHERIFF CURTIS

Edward Sheriff Curtis was born in Wisconsin in 1869, the very year of John Wesley Powell's epic voyage down the Colorado River in the Grand Canyon. He grew up in a region steeped in Indian lore. The Chippewa (Ojibwa), Menominee and Winnebago were his neighbors. He was in his twenties at the time of the tragedy at Wounded Knee. Although most of the frontier wars were over, massacres of both Indians and whites were still reported in his daily newspaper. He had seen the effects of Manifest Destiny.

Curtis journeyed West. He gained fame with romantic portraits and landscapes taken around Seattle, Washington. As official photographer on the Harriman expedition to Alaska in 1899, Curtis developed an interest in the many different ethnic groups he encountered. His relationship with the wealthy Harrimans and other scientific members of the party led to influential contacts back East.

From 1900–1906, Curtis photographed Northwest, Southwest and Plains Indians (plates 9.3–9.9). During that time he hired Adolph F. Muhr (photographer of the 1898 Indian Congress delegates in Omaha) as his darkroom assistant. Apparently, Muhr did not take photographs of Indians with Curtis – he handled the laboratory work.

In 1905 Curtis presented a lecture series in Washington DC, using

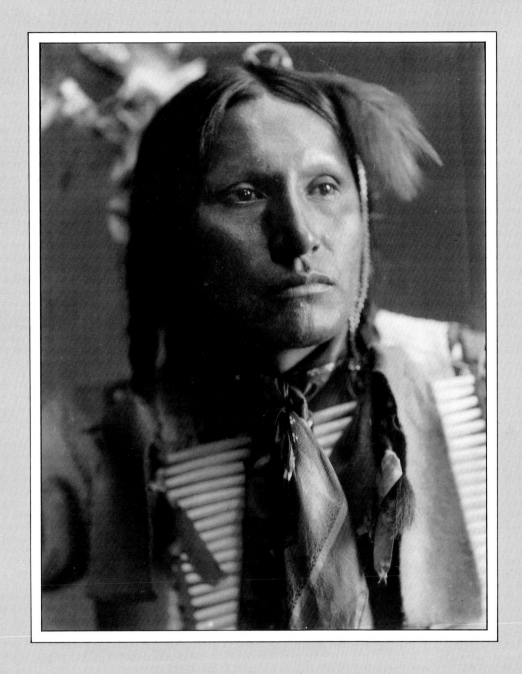

9.1 *American Horse, a Sioux participant in the William F. Cody Wild West Show in New York City. Taken by Gertrude Kasebier some time around 1900–1901.*

lantern slides made from his photographs. It was highly successful and won the attention of President Theodore Roosevelt. Roosevelt saw himself as one of the last frontiersmen. The West (including the Indians) was part of the American image he wanted to perpetuate. As a young man, he had fought there; great Indian chiefs like the Apache Geronimo, and Comanche Quannah Parker, had ridden in his inaugural parade. Roosevelt declared Curtis's photographs of North American Indians to be 'works of art', and became one of his most ardent supporters.

On January 23, 1906, Curtis sent to the wealthy railroad entrepreneur, J. Pierpont Morgan, a proposal to have his photographs published under the title 'The North American Indian, twenty volumes containing fifteen hundred pictures … going fully into their history, life, manners, ceremony, legends and mythology'. He requested and received an interest-free capital loan of $75,000 to cover expenses for about fifteen years, including payments to Indians for having their pictures taken. Curtis also won the support of the scientific community at the Smithsonian Institution for his project. Frederick Webb Hodge, BAE ethnologist, served as his general editor. Curtis's work for the volumes spanned thirty years, covered eighty tribes and produced approximately 40,000 photographs (plate 9.10).

In addition to still photographs, Curtis and his staff produced a silent film, In the Land of the Headhunters, recreating Indian life on the Northwest Coast. The story was filmed between 1910 and 1914. George Hunt, Franz Boas's Kwakiutl informant and photographer, provided the ethnographical information. The story was based on legends and oral history but it was dramatically presented, with added violence and romance. The actors wore costumes designed for the film. Curtis directed. It was a box office failure but had tremendous impact on future ethnographic films, including Robert Flaherty's classic, Nanook of the North. Photographers and Indians had entered the world of fantasy.[3]

ROLAND REED

Another photographer of Indians during this period was Roland Reed. He was born in 1864 in Wisconsin, less than one hundred miles from Curtis' birthplace. In 1890, Reed headed West to make his fortune. He began his career making sketches of the Indians along the Great Northern Railroad. Many of his portraits were of the Blackfeet living along the Missouri River. Dissatisfied with his artwork, Reed wrote about photography: 'If I could master this seemingly easy way of making pictures, I would have no trouble in getting all the Indian pictures I wanted.'

In 1893, Reed joined the studio of Daniel Dutro in Havre, Montana. He and Dutro worked together for several years, taking Indian portraits which they sold to the railroad news department for use in publicity material to attract passengers to the West. Reed left Dutro to join the Associated Press news service in Seattle. He ventured north to photograph the Alaskan gold rush and the native populations. He found what remained totally uninspiring.

In 1900, Reed settled in Bemidji, Minnesota. He used his studio portrait photography to finance his field trips among the local Chippewa (Ojibwa) Indians. At first, he had difficulty in obtaining pictures. Their leader, King Bird, threw him out of the Red Lake village. Finally, at the Cross Lake Indian School, he had success. Like James Mooney before him, Reed used a photograph to gain an entrance. Patiently waiting for several days at Ponemah village, Reed answered the request of two small girls to photograph their sick brother. When Reed returned to the village several months later with the print in hand, the father of the sick boy asked to see the

picture. He turned his back, walked away and stood staring at the image for some time. Finally, he asked Reed what the photograph cost. Reed inquired after the boy. He learned then that the child had died. He told the father how glad he was that he had made the picture and gave it to him. Reed remembered: 'That fine, old man gave me his hand, and from that time on, I was welcomed.'

By 1907, Reed has gained enough fame and fortune to close his studio and concentrate entirely on making a photographic record of Indian life. In 1915, he and fiction writer James Willard Schultz created an illustrated book entitled Blackfeet Tales of Glacier National Park. They took a group of Indians, with costumes and studio paraphernalia, into the romantic setting of the Park. The Blackfeet had never lived there, but they and the imagemakers recreated the stories and photographs as if they were true (plates 9.12–9.16).

Reed was not a prolific photographer. He viewed his work with North American Indians as an art form which took patient years of refinement to produce the few pictures he wanted to create. Reed did not sell his pictures commercially and even turned down an offer from an advertiser of $15,000 for 200 of his negatives. The only publication rights he granted were to the National Geographic Magazine. On his death in 1934, a collection of about seventy negatives of Chippewa, Cheyenne and Blackfeet Indians was inherited by a cousin, Roy E. Williams, who used them in lectures to school children about Indians.[4]

THE PRINCE ROLAND BONAPARTE EXPEDITIONS

Foreigners from distant lands also attempted to combine anthropology and art in photographs of North American Indians. One of these was Prince Roland Bonaparte, grandson of Lucien, second brother of Emperor Napoleon I. Forbidden by French law to follow the military career he wanted, the prince turned to geography and other sciences. He was a trained ethnologist and had taken anthropometric pictures at the 1883 Colonial Exposition in Amsterdam. Four years later he traveled to the New World to study Indians. He photographed them both there and when they journeyed to his studio in France. His portraits are reminiscent of the early photographs of delegations to Washington. Faces of proud Omaha chiefs attired in ceremonial splendor appear once more. By 1906, Bonaparte had amassed a collection of over 7,000 negatives, some of which were printed and distributed in portfolios. The North American Indians album was entitled Peaux Rouges, and was presented to the Smithsonian Institution (plates 9.17–9.19).[5]

THE WANAMAKER EXPEDITIONS

During the years 1908–17, when patriotic feelings ran high, a group of Americans attempted to alleviate the despair of life on the reservations. Expeditions to the West were conducted once again – this time, not by the government but by private enterprise. Their purpose was not discovery or scientific study but an attempt to save the Indians from cultural extinction. Photographs taken on these expeditions were used to publicize Indian history in order to give impetus to a campaign to make them citizens, which many believed to be their only chance of survival.

The financial patron of this movement was Rodman Wanamaker, heir to the Philadelphia department store dynasty. Joseph Kossuth Dixon, Doctor of Law, served as expedition leader. Dixon was a highly-skilled

photographer in the best tradition of the Pictorialists. His son, Rollin Lester Dixon, led the motion picture unit.

The first expedition went in 1908 to the Valley of the Little Bighorn in Montana. Its main purpose was to shoot a movie version of *Hiawatha*, with Indians playing the roles. A thousand still photographs, mainly of landscapes and daily life, were also taken.

The second expedition in 1909 returned to the Valley for the meeting of what was expected to be the Last Great Indian Council. Wanamaker and Dixon believed, like so many of their contemporaries, that the traditional Indian was destined to disappear. The BAE reported an alarming 65 per cent decrease in their population that year. The old chiefs, by then fifty or sixty years old, were dying and their history was disappearing with them. It was time to gather the last generation to tell their stories and be photographed for Dixon's book, *The Vanishing Race*. He wrote: 'the camera, the brush and the chisel have made us familiar with his plumed and hairy crests, but what of the deep fountains of his inner life ... what did he think ... feel?'

Representatives from nearly every reservation – Crow, Blackfeet, Gros Ventre, Cayuse, Umatilla, Creek, Kiowa, Apache, Comanche, Cheyenne and Sioux – were assembled. Portraits were made of the chiefs, as well as scenes of camp life and battle. Dixon also re-enacted General George Armstrong Custer's Battle of the Little Bighorn for both film and still photographs. Surviving Custer scouts, Curly, Goes-Ahead, Hairy Moccasin and White-Man-Runs-Him of the Crow tribe, and the opposing Cheyenne Chief Two-Moons and Sioux Chief Runs-The-Enemy, played themselves in their version of history, thirty-three years after the actual event of June 26, 1876.

To quell the fears of those who believed that the gathering would evoke the days of glory in such a way as to incite further disastrous warfare, Dixon responded that the expedition's purpose was to record authentic Indian customs and show the 'highest ideals of peace'. Warriors who had once loved battle now loved peace and sought the education of their children for the future.

Dixon promised the Indians that the pictures would be preserved in Washington for future generations. For those that attended, it was a nostalgic meeting of many nations. As one of the chiefs, Pretty-Voice-Eagle, reported:

> The meeting of the chiefs is to me a great thing in many ways. First: I was glad to come here and meet the chiefs from all over the country, and see many whom I have never seen before, and talk to them by sign language. It is a great sign to me that we have all met here, met in peace ... Second: it is a great idea that has been thought to send a man here to take our speeches and make our pictures, and think over and talk over the old times, and make a record of them ... I hope that my grandchildren and their grandchildren will read the speeches I have made here, and will see my pictures.[6]

On May 12, 1909, Wanamaker proposed a National Monument to the Indian. It was to be made of bronze, like the Statue of Liberty, only larger, and was to be erected in New York harbor. An Act of Congress for the monument was signed by President William Howard Taft on December 8, 1911. Ground-breaking ceremonies took place on Washington's Birthday, February 22, 1913, on a hilltop at Fort Wadsworth, Staten Island. Thirty-two chiefs from eleven tribes signed a Declaration of Allegiance to the US Government and hoisted the American flag. For many, it was the first time they had felt part of the country. Sadly, the monument was never built: World War I put an end to it.

During the 1913 inauguration of President Woodrow Wilson, an Indian delegation attended a luncheon in Wanamaker's office in the Philadelphia store. Mountain Chief, a Blackfoot, gave Wanamaker a necklace of buffalo teeth and named him 'High Crow', an honor never bestowed on a white man by this tribe.

The same year, Wanamaker sponsored the Expedition of Citizenship. Its purpose was to take the American flag, as a symbol of citizenship, from Fort Wadsworth to every one of the 189 Indian tribes. A flag was also given to each tribe to raise over their homes, as a re-enactment of the 1913 ceremony in New York. The new portable recording machine invented by Thomas Edison's company played a speech by President Woodrow Wilson at each stop. 20,000 miles were covered, primarily by a private railroad car which also served as a darkroom. Joseph Dixon led the four-member photographic unit: himself; Rollin, his son; John D. Scott, a New York photographer; and W. B. Cline, on loan from George Eastman of Rochester. There is still a controversy over who actually took the photographs. It does not matter who did so; only that they were taken.

On the three expeditions sponsored by Wanamaker, Kodak 3A and Graflex cameras were used. The expeditions produced 11,000 negatives on glass plate and nitrate film and fifty miles of motion picture film. The film has deteriorated; the prints remain.[7]

A negative contains only the original conception of the artist who created it. It is left to others to interpret. This is what remains in our minds: Indian images showing the strength and dignity of a wonderful variety of cultures, images which reflect the universal values of family, tribe and nation. The Pictorialists attempted to give Wovoka's dream back to the Indians: the photographs unite them at last in brotherhood, present them with a heritage, and make them part of American history. They are a haunting record of Indian life; they are contrived, idealistic and at times romantic; but they give a sense of an Indian world unaffected by white civilization. They are echoes of a time when man and nature had an understanding: 'They symbolize the survival of human values in a universe gone mad with materialistic greed.'[8]

Curtis; Reed; Bonaparte; Dixon – photographers at the turn of the century when recording gave way to recreating – photographers with a story to tell in alluring, artistic imagery – photographers of North American Indians.

9.2 RIGHT *Tatanka Ptieela, a Dakota. Taken by Heyn and Matzen some time around 1900.*

9.3 BELOW *Navaho Indians in the Canyon de Chelly, Arizona. By Edward Sheriff Curtis, 1904.*

9.4 RIGHT *Chief Joseph, the Nez Perce leader. By Edward Sheriff Curtis, 1903.*

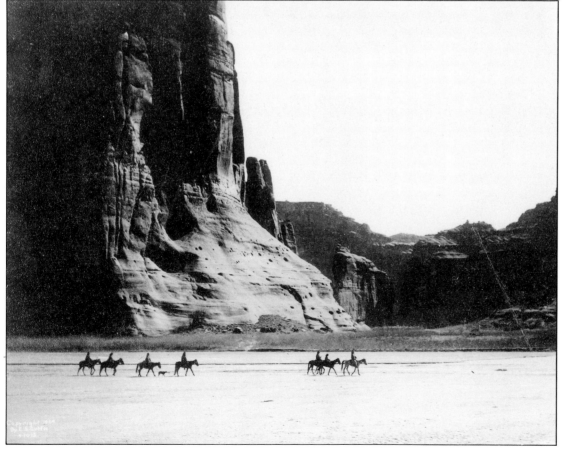

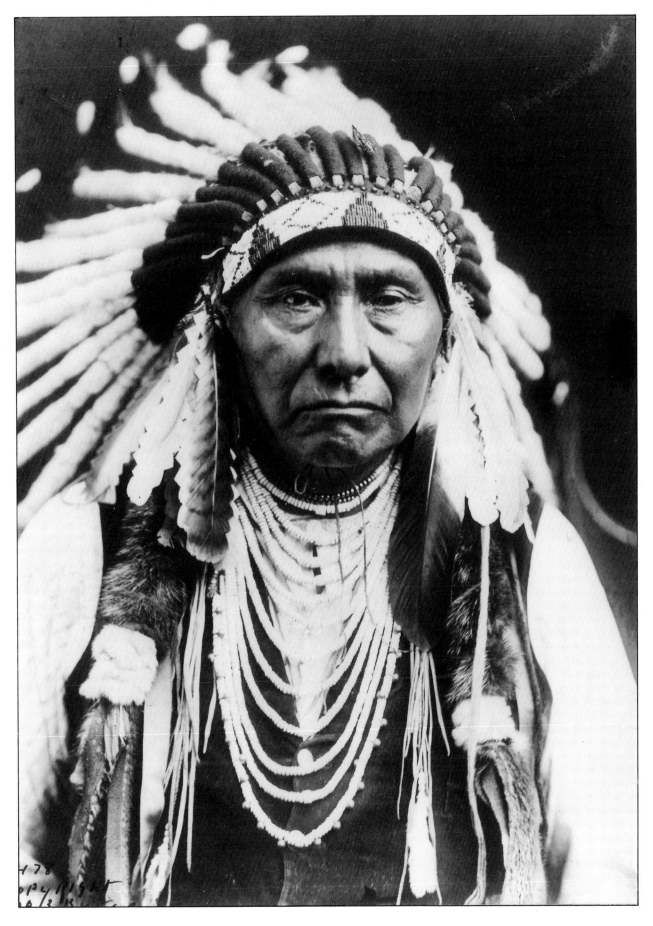

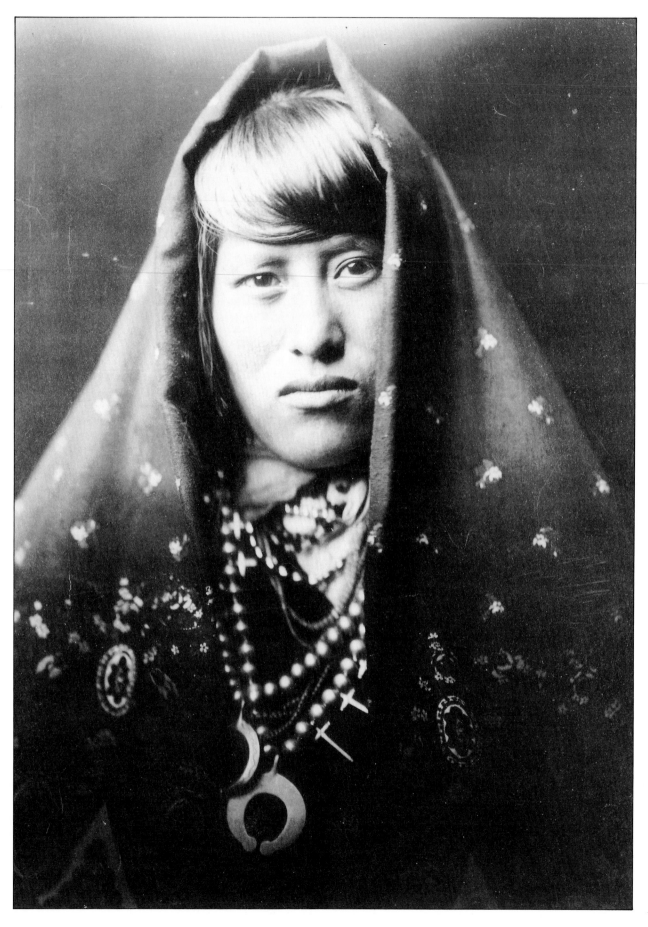

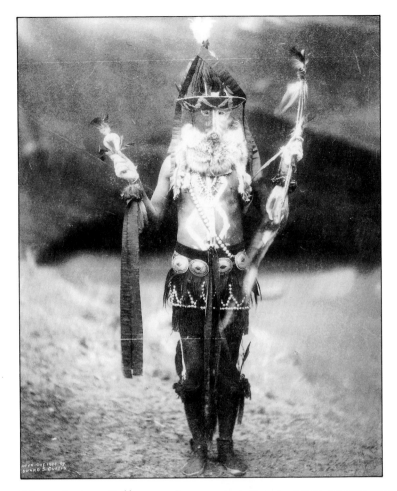

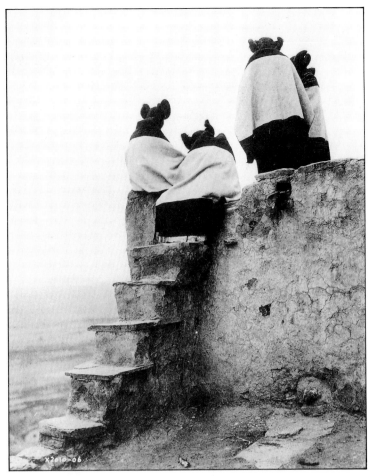

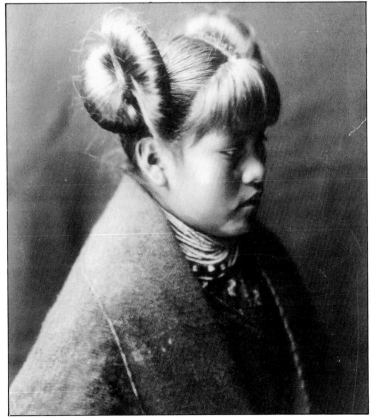

9.5 LEFT *An Acoma Pueblo woman. By Edward Sheriff Curtis, 1905.*

9.6 ABOVE *The Yeibichai (Night Chant Ceremony) of the Navaho Indians. By Edward Sheriff Curtis, 1904.*

9.7 ABOVE *Maidens watching ceremonial dances at Hopi Pueblo, Arizona. By Edward Sheriff Curtis, 1906.*

9.8 LEFT *A Hopi child. By Edward Sheriff Curtis.*

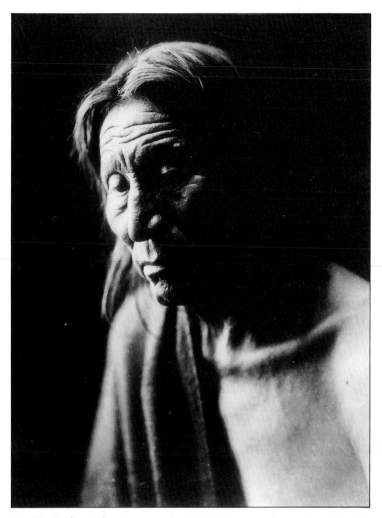

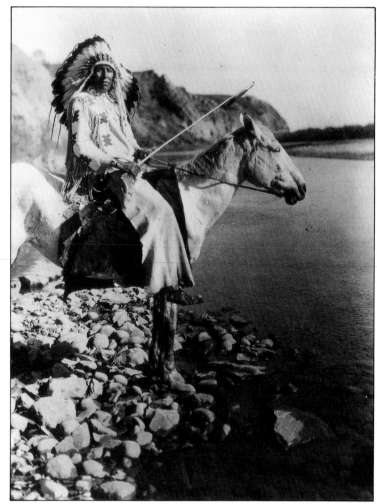

9.9 *Big Head, an Indian from an unidentified Southwestern tribe. By Edward Sheriff Curtis, 1905.*

9.10 *A Blackfoot in Glacier National Park, Montana: one of the photographer's images for his twenty-volume work on some eighty Indian tribes. By Edward Sheriff Curtis, 1927.*

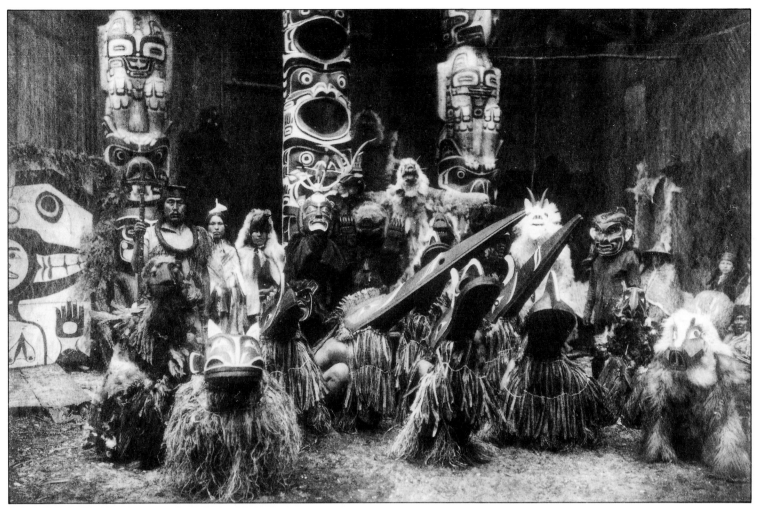

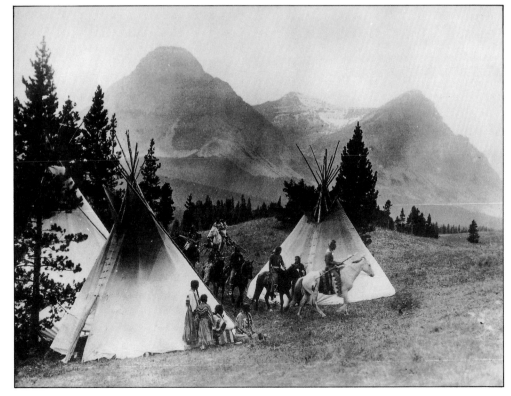

9.11 ABOVE *Masked Kwakiutl dancers wearing costumes from the photographer's silent film 'In the Land of the Headhunters,' which recreated Indian life on the Northwest Coast. By Edward Sheriff Curtis, 1914.*

9.12 LEFT *Blackfoot Indians in Glacier National Park, Montana, including Daisy Norris Gilham (standing on the left, near the tipi) and Two Guns White Calf (standing at the entrance to the tipi on the right). Such images – taking the Blackfeet into a setting they had never inhabited, along with props and costumes – were used in the photographer's book 'Blackfeet Tales of Glacier National Park,' co-written with James Willard Schultz (see also plates 9.13–9.16). By Roland Reed, 1915.*

9.13 *Blackfoot Indians in Glacier National Park, Montana, including Lazy Boy, Fish Wolf Robe and Two Guns White Calf. By Roland Reed, 1915.*

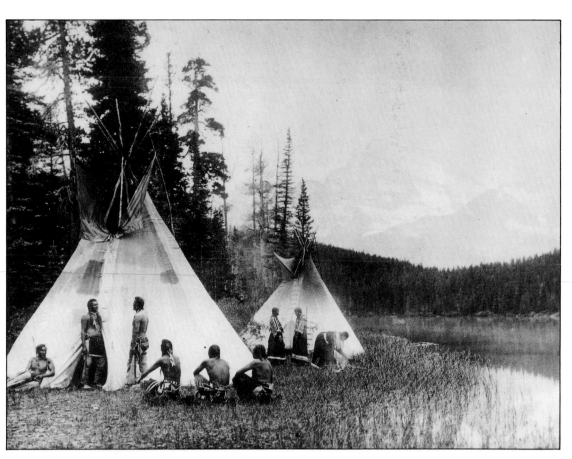

9.14 *Blackfoot Indians Not A Real Woman and Three Bears (also called Frog Mouth) in Glacier National Park, Montana. By Roland Reed, 1915.*

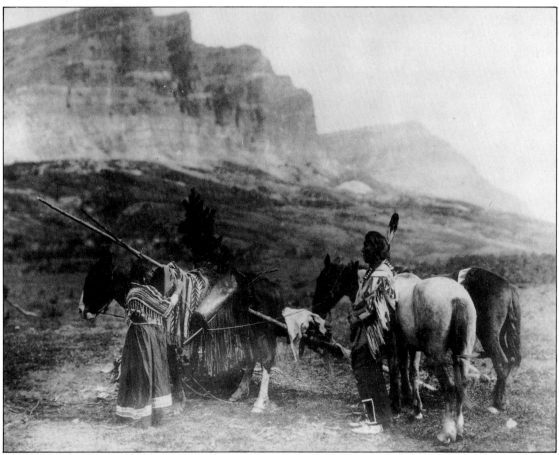

9.15 *Blackfoot Indians in Glacier National Park, Montana. Left to right: Stabs By Mistake, Eagle Child, Two Guns White Calf, Black Bull and an unidentified Indian. By Roland Reed, 1915.*

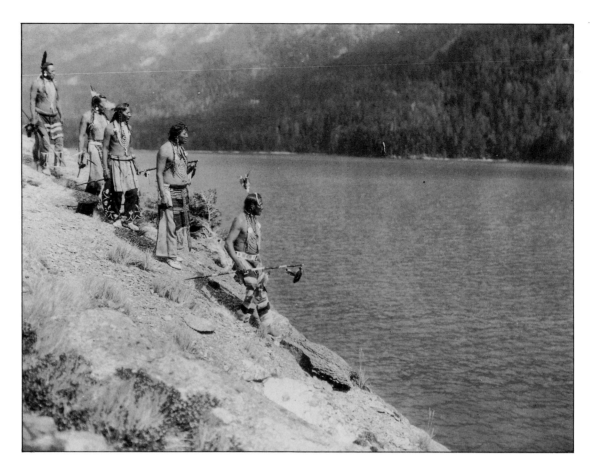

9.16 *Blackfoot Indians including Bill Shoot (left) and Eagle Child (center) in Glacier National Park, Montana. By Roland Reed, 1915.*

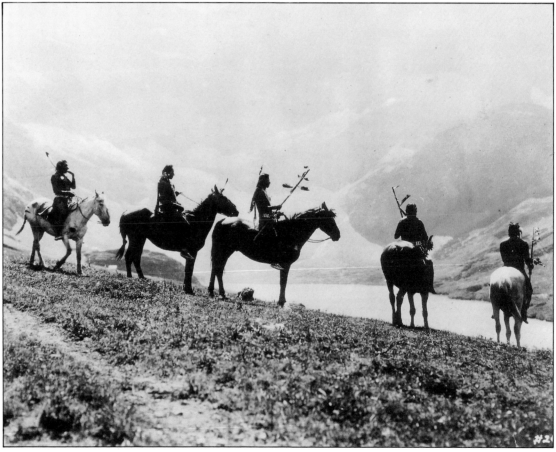

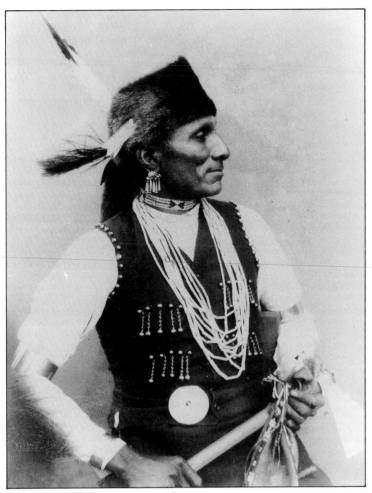

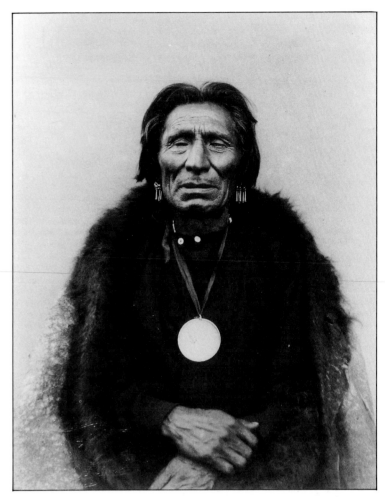

9.17 *Omaha sub-chief Standing Bear, a representative of the Indian peoples, at the Colonial Exposition, Amsterdam. By Prince Roland Bonaparte, 1883.*

9.18 *Omaha Chief Yellow Smoke, a representative of the Indian peoples, at the Colonial Exposition, Amsterdam. By Prince Roland Bonaparte, 1883.*

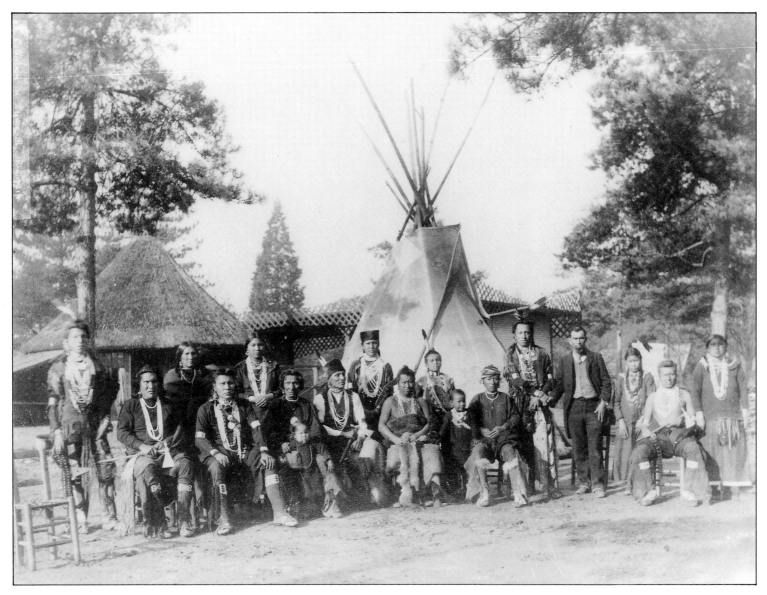

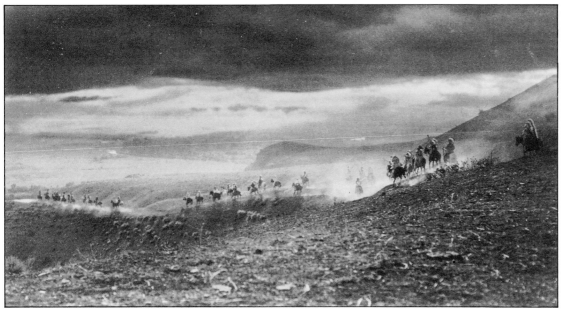

9.19 ABOVE *An Omaha group representing the North American Indians at the Colonial Exposition, Amsterdam. Left to right: White Swan, Inside Man, Cook, Chef Du Bande, Mnigh-Di-Tai, Yellow Smoke (with a child), Standing Bear (holding a pipe-tomahawk), Cat, Bright Eye, Traveler, Village Maker, Homme Connu, John Pilcher (their leader), an unidentified man, Lunne Dure, Hard Chief and White Crow. By Prince Roland Bonaparte, 1883.*

9.20 LEFT *'Into the Valley' (the Valley of the Little Bighorn). Taken by Joseph Kossuth Dixon on a Wanamaker expedition.*

9.21 ABOVE *'Skirting the Skyline'.*
Taken by Joseph Kossuth Dixon on a
Wanamaker expedition.

9.22 LEFT *'Lighting the Smoke Signal'.*
Taken by Joseph Kossuth Dixon on a
Wanamaker expedition.

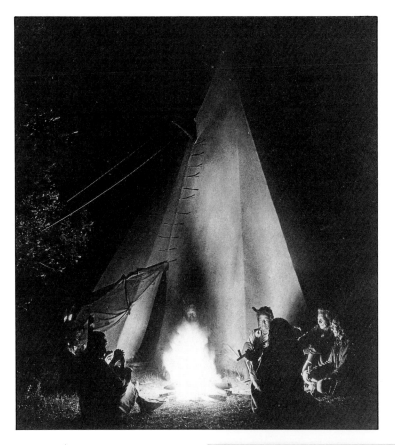

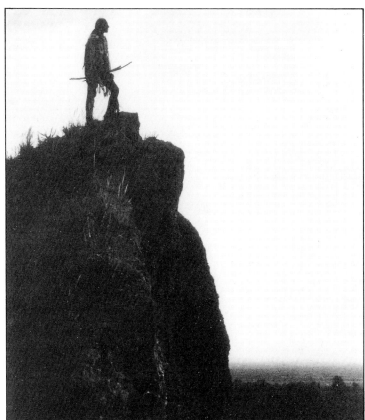

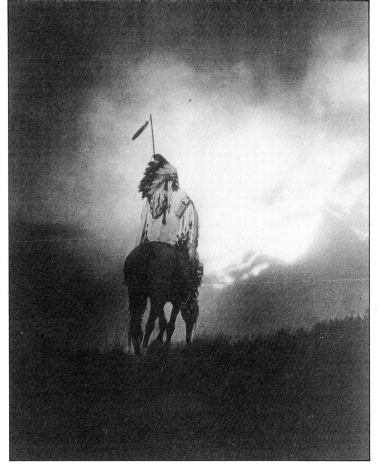

9.23 ABOVE *'War Memories'. Taken by Joseph Kossuth Dixon on a Wanamaker expedition.*

9.24 ABOVE *'The Last Outpost'. Taken by Joseph Kossuth Dixon on a Wanamaker expedition.*

9.25 LEFT *'Sunset of a Dying Race'. Taken by Joseph Kossuth Dixon on a Wanamaker expedition.*

NOTES TO APPENDIX 1

1 References for sources of information on delegation photographers are listed in the right-hand column. City directory, business directory and census data is self-referencing. Most other references appear in the Bibliography (pages 248–53).

2 Professions listed in city and business directories have not been noted; entries have been included only if an individual was with the photographic trade.

3 Only studio addresses are listed, although these may also have been home addresses.

4 Studio number changes may or may not be significant. A studio (Bell's or Ulke's, for example) gained additional street numbers as the business expanded. These changes are not always shown in city directories or on photographic mounts.

5 Breaks in dates may reflect the location change of a photographer, or simply a lack of directories.

6 Years given for city and business directories are years of publication or issue, and may reflect information gathered in the preceding year.

7 Dates are given in the format month/day/year or month/year.

ABBREVIATIONS

Ad. advertisement
b. born (**d.** died)
BD business directory
CD city directory
cdv carte de visite
dag. daguerreotype

DNI *Daily National Intelligencer*
Ltr. admin. letter of administration for estate (after death)
NAG no business address given (although listed as a photographer in relevant city)
NebSHS Nebraska State Historical Society
NOG no occupation given
nr. near
P & FAJ *Photographic and Fine Art Journal* (volume numbers listed are old series)
Post *Washington Post*
Star *Washington Evening Star*
† further listings suspected or known but either not relevant to Indian photography, past dates covered by this appendix, or information unavailable

APPENDIX 1 DELEGATION PHOTOGRAPHERS *c.* 1840–*c.* 1900

All references are to Washington DC, except as noted. References are made only to non-government studio operators. Buildings in Washington DC were renumbered along Pennsylvania Avenue in 1870; an asterisk indicates only the number change of a studio, not a physical move. Common abbreviations are used for the American states, and bold type is used to indicate important photographers, whether or not included in these listings.

Addis Photographic Gallery (Robert W. Addis)
(*See also:* John **Addis**, P. B. **Marvin**, A. Z. **Shindler**)

1862–69	308 Penna. Ave.	Ad./CD

Addis, John

1863	308 Penna. Ave. (Addis Photog. Gallery)	CD

Addis, Robert W. (b.?–d. Nov. 1873: Washington DC)

1862–64	308 Penna. Ave. (Addis Photog. Gallery)	BD
1869–70	NAG	CD
1871	416 B St., S.E.	CD
1872–73	1227 Penna. Ave., N.W.	BD
11/15/1873	Ltr. admin. filed Washington DC Court	

Beck, T. J. Dorsey

1860	308 Penna. Ave. (McClees & Beck)	CD

Bell & Brother(s); Bell Bro. (partnership varies)
(*See also:* individual brothers; **Bell & Hall; Turner & Co.**)

1860	(Turner & Co.)	
1862	480 Penna. Ave. (Thomas, Nephi & Francis?)	BD/CD
1863	480 Penna. Ave. (Thomas, Jackson & Francis?)	BD/CD
1864–65	480 Penna. Ave. (Thomas & Francis?)	BD/CD
(1866)	(Bell & Hall)	
1867–69	480 Penna. Ave. (Francis & William)	BD/CD
1870	317* and 319* Penna. Ave., N.W. (Francis & Charles)	CD
1871–73	319 Penna. Ave., N.W. (Francis & Charles)	CD/BD
1874	317 Penna. Ave., N.W. (Francis & Charles)	CD/BD
1875 †	319 Penna. Ave., N.W. (Francis & Charles)	CD/BD
1884–85	466 C St., N.W. (Charles, James & Jackson)	CD/BD
1886	461 C St., N.W. (Charles, James & Jackson)	CD/BD

Bell & Hall (William Hamilton Bell & Allen F. Hall)

1866	480 Penna. Ave.	BD

Bell, Charles Milton (b. 1848: Va. – d.*c.* 5/16/1893: Washington DC)

1860	Census: Washington DC as age 12 from Va.	
1868–69	NAG (probably Bell Bro.)	CD
1870	(317 and 319 Penna. Ave., N.W.) Bell & Bro.	CD
1871–73	(319 Penna. Ave., N.W.) Bell & Bro.	CD
1874–76	459 Penna. Ave., N.W.	CD/BD
1877	459 and 461 Penna. Ave., N.W.	CD/BD
1878	459 Penna. Ave., N.W.	BD
1879–80	459, 461 and 465 Penna. Ave., N.W.	BD
1881	459, 461, 463 and 465 Penna. Ave., N.W.	BD
1882	459 and 461 Penna. Ave., N.W.	CD/BD
1883	459, 461, 463 and 465 Penna. Ave., N.W.	CD/BD
1884	462 Penna. Ave., N.W. and 330 C St., N.W.	CD/BD
1885–86†	463 Penna. Ave., N.W.	CD/BD
5/16/1893	Will probated Washington DC Court	
1893–*c.* 1909	Studio continues under wife, Annie Bell	

Bell, Francis Hamilton (b.*c.* 1810: N.Y.–d.*c.* 12/1880; Washington DC) (Father of Bell family of photographers)

1860	Census: Washington DC as age 50 from N.Y.	
1862	480 Penna. Ave.	CD
1863–66	NAG (probably Bell & Bro.)	CD
1867–69	(480 Penna. Ave., N.W.) Bell & Bro.	CD
1870	(317* Penna. Ave., N.W.) Bell & Bro.	CD
1871–72	319 Penna. Ave., N.W.	CD
1872–75	NAG (probably Bell & Bro.)	CD/BD
1876	319 Penna. Ave., N.W.	CD
1877	459 and 461 Penna. Ave., N.W.	CD
1878–80	NAG	CD
12/1880	Ltr. admin. filed Washington DC Court	

Bell, Jackson Ward (b.*c.* 1839: Va.–d.?)

1860	Census: Washington DC as age 21 from Va.	
1863	480 Penna. Ave. (Bell & Bro.)	CD
1880–86	NAG	CD

Bell, James E. (b.*c.* 1845: Va.–d.?)

1860	Census: Washington DC as age 15 from Va.	
1862	NAG	CD
1884–85	466 C St., N.W. (Bell & Bro.)	CD/BD
1886	461 C St., N.W. (Bell Bro.)	CD/BD

Bell, Nephi (b.*c.* 1844: Va.–d.?)

1860	480 Penna. Ave. (Turner & Co.)	CD
1860	Census: Washington DC as age 16 from Va.	
1862	480 Penna. Ave. (Bell & Bro.)	CD

Bell, Thomas H. (b.*c.* 1842: Va.–d.?)

1862–65	480 Penna. Ave. (Bell & Bro.)	CD

Bell, William Hamilton (b.*c.* 1834: Va.–?)
(*See also:* Bell & Hall)
Not to be confused with Dr William Abraham Bell of the Kansas Pacific Survey, or William Bell of the Wheeler Survey.

1860	Census: Washington DC: age 26 from Va.	
1862–65	NAG (probably Bell & Bro.)	CD
1866	480 Penna. Ave. (Bell & Hall)	CD
1867	480 Penna. Ave. (Bell & Bro.)	CD

Brady, Mathew B. (b.1823: N.Y.–d.1/16/1896: N.Y.C.) (National Photographic Art Gallery)
(*See also:* Alexander **Gardner**; James F. **Gibson**)
One of America's most important photographers, with studios in New York and Washington DC. Learned daguerreotypy from Samuel F. B. **Morse**, J. W. **Draper**, and Professor **Doremus.** Trained large corps of photographers who in turn became successful, and trained others. For more information on his life, studios and partners, consult *Cobb, 1955; Kunhardt, 1977* etc. Photographed not only visiting Indian delegates but also Indians visiting or connected with Phineas T. Barnum's circus in N.Y. Photographed major delegations in 1857–58, 1867, 1868, 1872.

1849	Opens studio on 4 1/2 St; studio fails	
c. 1858–69	Studio at 625–27 Penna. Ave.	CD/BD
1870–81 †	Studio at 350–51* Penna. Ave.	CD/BD

Clarke, John Hawley (b.*c.* 1811: Del.–d.7/16/1914: La.?) (also, 'Clark John' and commonly, 'John H. Clark') *Smith and Tucker, 1982*

1851–53	Penna. Ave., nr. 7th (M. A. Root & Co.)	Ibid./CD

†	To New Orleans to open studio	Ibid.

Cohner, Samuel A.
1857–58	308 Penna. Ave. (McClees Studio)	*P & FAJ,* vol. 10, p. 380/CD
1859	Goes to Havana (Cuba?)	*P & FAJ,* vol. 12, p. 30

Fountaine, Louis (Probably Shindler's brother- or father-in-law)
1867	308 Penna. Ave. (Shindler & Co. at Addis Studio)	CD

Gardner, Alexander (b.1821: Paisley, Scotland–d.12/10/1882: Washington DC) (also, 'Gardiner') (Gardner Photog. Art Gallery) — *Cobb, 1958*
pre-1858	New York City (Brady Studio)	*Cobb, 1958*
1858–62	350–52 Penna. Ave. (Brady Studio)	*Cobb, 1958*
8/1862	Partnership with James F. Gibson	*Cobb, 1958*
Fall 1862	332 Penna. Ave. (Gardner Bros.)	*Cobb, 1955*
1863–69	511 7th St., N.W.	CD/BD
9/25/1865	Fire damages much of studio 511 7th St.	DNI, 9/25/1865
1870	412 7th St., N.W.	CD/BD
1871–82	921 Penna. Ave., N.W.	CD/BD
12/10/1882	Dies Washington DC	*N.Y. Times,* 12/11/1882

Gardner, James (b.c. 1832: Scotland–d.?)
1860	Census: Washington DC as age 28 from Scotland	
pre-1862	350–52 Penna. Ave. (Brady Studio)	*Cobb, 1955*
1862	332 Penna. Ave. (Gardner Bros.)	*Cobb, 1955*
1863–?	511 7th St., N.W. (Gardner Bros.)	*Cobb, 1955*/CD

Gardner, John
1862–?	332 Penna. Ave. (Gardner Bros.)	*Cobb, 1955*

Gardner, Lawrence (b.c. 1848: Scotland–d.9/19/1899: Washington DC) (Son of Alexander Gardner)
1860	Census: Washington DC as age 12 from Scotland	
1869–70	NAG (probably Gardner's)	CD
1871–83	921 Penna. Ave., N.W. (Gardner Studio)	CD
1884–86	911 F St., N.W.	CD
†		
9/19/1899	Dies Washington DC	*Star,* 9/20/1899

Gardner Brothers (Alexander, James & John Gardner)
Fall 1862–63	332 Penna. Ave.	*Cobb, 1955*
1863-69	511 7th St. (Intelligencer Building)	CD/BD
†		

Gardner's Photographic Art Gallery *see* Alexander **Gardner**

Gibson, James F. (b.c. 1829: Scotland–d.?)
1860	Census: Washington DC as age 31 from Scotland	
1862–?	350–52 Penna. Ave. (Brady Studio)	*Cobb, 1958*
1864–67/1868	350–52 Penna. Ave. (partner with Brady)	*Cobb, 1955*
†	Goes to Kansas	*Cobb, 1955*

Gurney, Jeremiah (& Son)
Important, very early, New York photographer. Recorded Cheyenne and Arapaho delegates traveling through New York, June 1871, on contract with William Blackmore. Spotted carpet, shown in 1871 Cheyenne & Arapaho portraits, is similar to Gardner's; however it appears to occur only in this Indian series by Gurney.

Hall, Allen F.
1860	NAG	CD
1866	480 Penna. Ave. (Bell & Hall)	CD

Marvin, P. B.
1864	NAG	CD
1865–67	308 Penna. Ave. (Addis Gallery)	CD

McClees Studio
(*See also:* James **Earle McClees,** Samuel **Cohner,** Julian **Vannerson, McClees & Beck**)
Fall 1857–59	308 Penna. Ave.	*P & FAJ,* vol. 10, p. 380/CD
1860	308 Penna. Ave. (McClees & Beck)	CD

McClees & Beck (James Earle McClees & T. J. Dorsey Beck)
1860	308 Penna. Ave.	CD

McClees, James Earle (b.1821; Phila., Penna.–1887) — *Finkel, 1980*
pre-1857	Phila. (& also there through 1860s)	Phila. CD/BD
1857–59	308 Penna. Ave. (McClees Studio)	CD
1860	308 Penna. Ave. (McClees & Beck)	CD
†	Back to Phila.	*Finkel, 1980*/Phila. CD

National Daguerreotype Gallery *See* Marcus Aurelius **Root**

National Photographic Art Gallery *See* Mathew B. **Brady**

Powers, Marcellus J. (Operator for Whitehurst's Gallery)
1863	288 Penna. Ave.	CD
1864–65	434 Penna. Ave. (Whitehurst's)	CD
1866	NAG (Whitehurst's)	NbSHS cdv

Root & Company, Root & Clark *See* Marcus Aurelius **Root**

Root, Marcus Aurelius (b.1808: Ohio–d.1888: Phila.) — *Newhall, 1976*
pre-1852	Phila., Penna.	*Finkel, 1980*
1852–53	Penna. Ave., nr. 7th St. (National Daguerreotype Gallery)	*DNI Ads.*
1853	352 Penna. Ave., nr. 7th St. (Root & Company; Root & Clark)	CD
1856	(352 Penna. Ave.?) Root & Co.	*P & FAJ,* vol. 9, p. 318

Shindler & Company (Antonio(n) Zeno Shindler & Louis Fountaine)
1867	308 Penna. Ave. (Addis Gallery)	BD

Shindler, Antonio(n) Zeno (b.1823: area of present-day Bulgaria–d.8/8/1899: Washington DC) Primarily an artist. Did not take 1857–58 series of Indian delegation portraits credited to him, which were by McClees studio.
†	Antonio(n) Zeno flees homeland, goes to France, and possibly Germany	
†	In France reportedly stays with Dr Shindler and adopts his name. Studies painting.	
†	Emigrates to U.S.; by 1850s is in Phila., Penna.	
1867	To Washington DC from Phila., Penna.	Phila. CD
1867–69	308 Penna. Ave. (Shindler & Co. at Addis Gallery)	BD/CD
1870?–71	308 Penna. Ave.	CD
1870–71	Unsubstantiated report of trip west	
1871–76	N.Y.C. and Phila., Penna.	
1876	To Washington DC as artist for U.S. National Museum	
8/8/1899	Dies Washington DC, aged 76	*Post,* 8/9/1899

Turner & Company (Henry W. Turner & Nephi Bell)
1860	480 Penna. Ave.	CD

Turner, Henry W. *See* Turner & Company

Ulke & Brother (Henry, Julius & Leo Ulke)
1870–74	1111 Penna. Ave., N.W. (listed as such, but known to share studio longer)	BD/CD

Ulke, Henry (b.1/29/1821: Germany–d.2/17/1910: Washington DC)
A photographer, but did more work as a painter.
c. 1860	To Washington DC from N.Y.	N.Y. CD
1860	434 Penna. Ave.	CD
1862–63	278 Penna. Ave.	CD
1864	278 1/2 Penna. Ave.	CD/BD
1865–69	278 Penna. Ave.	CD/BD
1870–75†	1111 (& 1109) Penna. Ave. (Ulke & Bro.)	CD/BD
2/17/1910	Dies Washington DC	*Post,* 2/20/1910

Ulke, Julius (b.c. 1833: Germany–d.7/31/1910: Washington DC)
c. 1860	To Washington DC from N.Y.	N.Y. CD
1860	Census: Washington DC as age 27 from Prussia	
1863	278 Penna. Ave.	CD
1865–68	NAG (278 Penna. Ave.?)	CD
1869	278 Penna. Ave.	CD
1870–79	1111 (& sometimes 1109) Penna. Ave.	CD/BD/*DNI* Ads.
1880–82†	1109 Penna. Ave.	CD/BD
7/31/1910	Dies Washington DC	*Post,* 8/1/1910

Ulke, Leo (b.?: Germany?–d.?)
c. 1863	To Washington DC from N.Y.	N.Y. CD
1863	278 Penna. Ave.	CD

Vannerson, Julian (b.c. 1827: Va.–d.?) (also, wrongly, 'Julius' and 'Vammerson')
c. 1852	To Washington DC from Richmond, Va.	Richmond CD
1852–53	Penna. Ave. nr. 4 1/2 Sts.	*Glenn, 1981*/DNI Ads.

1855–57	426 and 428 Penna. Ave. (Vannerson Studio)	CD/*DNI* Ad.
Fall 1857–59	308 Penna. Ave. (McClees Studio)	CD
1860	308 Penna. Ave. (McClees & Beck)	CD
1860	Census: Washington DC as age 33 from Va.	
†	To Richmond, Va.	Richmond BD

Whitehurst, Jesse H. (b.*c.* 1820: Va.–d.1875: Baltimore, Md.)
Important early photographer and owner of chain of studios in Norfolk, Lynchburg, Petersburg and Richmond Va., Baltimore, Md., and N.Y.C., in addition to Washington DC studio. These were run by other operators. There were several operators at Washington DC studio including

Julian **Vannerson** in 1853. Marcellus J. **Powers** took delegation photographs *c.* 1863–65.

1851	Penna. Ave. between 4 1/2 and 6th Sts.	*DNI* Ad.
1853	Listed without address	CD
1855	Penna. Ave. nr. 4 1/2 Sts.	*DNI* Ad.
1857	Listed without address	*P & FAJ*, vol. 5, no. 9
1858	434 Penna. Ave.	CD
1863	Listed without address	BD
1864–65	434 Penna. Ave.	BD Ad.
1866	NAG	NbSHS cdv
1867–68	424 Penna. Ave.	BD
1870	424 and 426 Penna. Ave., N.W.	BD/CD

NOTES TO APPENDIX 2

This appendix is given as a preliminary guide to studio locations. It can be used for dating photographs, but consideration must be given to those points made at the beginning of Appendix 1. No attempt has been made to list every known Indian photographer, or all places visited on photographic trips or non-photographic endeavors. Local newspaper accounts can sometimes be useful in illuminating careers of specific photographers, but much of this research still needs to be done.

Tribes are listed by cultural areas, but are restricted to frontier areas only. Specific tribes are noted when a photographer's work is restricted to a limited region. Tribal identifications are based largely on the Smithsonian Institution National Anthropological Archive collections. Cultural areas represent either the area of fieldwork, or the affiliation of those Indians posing for studio portraits.

Early paper photographs were placed on cardboard mounts. These mounts changed size with fashion; they are known by their popular names, and can be useful in dating images. The more popular styles are the carte de visite abbreviated here to 'cdv', $2^{1}/_{2}'' \times 4''$, popular during the Civil War but used until about 1888; the cabinet card, $6^{1}/_{2}'' \times 4^{1}/_{4}''$, popular after the Civil War until the 1880s; and the boudoir card, $8^{1}/_{4}'' \times 5''$, popular in the later 1800s.

References to sources of information on frontier photographers are located at the end of each entry and appear in full in the Bibliography (pages 248–53). Unless otherwise noted, all references to photographs supporting photographer names, dates, locations, etc. are located in the Smithsonian Institution National Anthropological Archives, Washington DC. Dates are given in the format month/day/year or month/year. Common abbreviations for American states are used.

ABBREVIATIONS
Ariz.T. Arizona Territory (pre-1912)

BAE Bureau of American Ethnology
BD business directory
BM British Museum
CD city directory
cdv carte de visite
dag daguerreotype
D.T. Dakota Territory (pre-1889)
Ft. Fort
I.T. Indian Territory (1820–11/16/1907)
NAG no business address given
O.T. Oklahoma Territory (1890–11/16/1907, the western half of I.T.)
Res. Reservation
St. Street
T. Territory
† Further listings suspected or known but either not relevant, past dates covered by this appendix, or information unavailable

APPENDIX 2 SELECTED FRONTIER INDIAN PHOTOGRAPHERS *c.* 1840–*c.* 1900

Adams & Thomson's
†	Cdv studio portrait of Sauk & Fox	
	Studio listed at 135 Mass. St., Laurence, Ks.	
Reference	BM A9/1228	

Addis, Alfred S. (Stephenson & Addis; Addis & Noel)
1859	56 Main St., Leavenworth, Ks.
	Photographs Cheyenne and Arapaho delegates
1860	**Stephenson** & Addis, 40 Delaware St., Leavenworth, Ks.
	Stephenson apparently retains Addis negatives which are later purchased by William Blackmore
1863	Addis & **Noel**
Tribes	Southern Plains
References	Roberts to Fleming: BM Album 12, title page

Addison, George A. (b.9/1853: Mississippi)
Active around Ft. Sill, O.T., both field and studio photographs; pirated some images.
Tribes	Southern Plains (Comanche, Kiowa); Southwest (Apache)

Anderson, George Edward (1860–1928)
Important Mormon photographer, reported to have photographed Indians in Utah. In 1870s apprenticed to Charles R. **Savage.**
Tribes	Basin?
Reference	*Francis,* 1978

Anderson, John Alvin (b.3/25/1869: Stockholm, Sweden–d.6/26/1948: Atascadero, Calif.)
1884	Comes to Neb., Cherry County, near Ft. Niobrara
	Learns photography, buys 8 × 10 primo camera
1885	Census: Neb.: Seven Creeks as age 16 from Sweden
	Commissioned as civilian photographer for army at Ft. Niobrara
	Starts to photograph Rosebud Res., D.T.
1886	Goes to work for W. R. **Cross**
†	Studio at Ft. Niobrara, probably late 1880s
1886–87	Neb. Directory as having studio at Valentine
5/1889	Photographs Crook Treaty Commission with Dakota at Rosebud Agency
	Discontinues Ft. Niobrara studio and army work
1890–95	Three trips to Penna.
	Photographic work in Valentine, Neb. and at Rosebud Agency
1896	Copyrights work, *Among The Sioux*

c. 1895–1915	Makes most significant photos of Rosebud (Brule) Dakota
1936	Moves to Rapid City, S.D.
	Develops & manages Dakota Indian Museum
1939	Moves to Atascadero, Calif., where dies
	Negatives at Neb. State Historical Society
Tribes	Northern Plains (Brule Dakota)
References	'John Alvin Anderson . . .,' 1970; *Doll and Alinder,* 1976; *Dyck,* 1971

Andrews, Dr Enos E. & Co.
Dentist, jeweler and photographer.
1/–11/1871	N.M.: Santa Fe with McKenzie
	Operates Nicholas **Brown** studio in Brown's absence
Tribes	Southwest
References	*Rudisill,* 1973; BM A9/1224

Archer *See* Baker, Archer & Co.

Bailey, Dix & Mead
Field photographs, mostly around Ft. Randall, D.T., 1880s, especially Sitting Bull and band while in Ft. Randall.
Tribes	Northern Plains (Hunkpapa Dakota)

Baker & Johnston (Charles S. Baker & Eli? Johnson)
1880s	Evanston, Wyoming
1880	Census: Wyo. Terr. as Eli Johnson, age 20 from Sweden (possibly this is Johnson of partnership)
Tribes	Basin (Shoshoni); Plains (Arapaho); Southwest (Apache)

Baker, Archer & Co. (Charles S. Baker & ? Archer)
†	Probably 1870s or 1880s, possibly in Evanston, Wyo.
Tribes	Southwest (Apache)

Baker, Charles S. (b.?: N.Y.–d.10/28/1924) (Baker & Johnston; Baker, Archer & Co.)
†	Established Union Pacific Photographic Railroad Car
1878	To Evanston, Wyo.; opens studio, helped by daughter, Attie
1880s	Baker & **Johnston** studio, Evanston, Wyo.
†	Undated studio, Baker, **Archer** & Co.
Tribes	Basin (Shoshoni); Plains (Arapaho); Southwest (Apache, Mohave, Yavapai)
References	*Stone* (1924?) personal communication, J. Carter, Neb. State Historical Society, to author (Fleming)

Balster, Frank S.
Optician, jeweler and photographer.
† Undated field and studio portraits of Utes
 Studio listed at Durango, Colo.

Barker, A. W.
† Cdv studio/field views of Sauk and Fox and unidentified tribe
 Studio listed at Ottawa, Ks.

Barry, David F. (b.3/6/1854: Honeoy Falls, N.Y.–d.3/6/1934: Superior, Wisc.)
One of the most important frontier Indian photographers. Many of his photographs have been copied and circulated by other photographers. In Barry's catalog of photographs, he noted that F. J. **Haynes** was circulating images of Barry's without permission. Barry, in turn, circulated images by other photographers, such as O. S. **Goff** and **Notman.**

1861	Family goes west to Osego, Wisc.
†	As a child, meets O. S. **Goff,** an itinerant, in Wisc.
6/8/1870	Census: Wisc.: Columbus as age 16 from N.Y.
Fall 1878	Becomes protégé of O. S. **Goff,** Bismarck, D.T. Generally, Barry does studio work; Goff travels.
9/12/1879	In charge of studio while Goff travels to Ft. Meade; eventually takes over studio
1880s	Spends some time at Ft. Yates (Standing Rock Agency)
5/8/1880	Sets up mobile, branch studio at Ft. Buford
1881 and 1882	Goes to Ft. McGinnis and Ft. Buford
Summer 1883	At Ft. Custer, Mont.
6/25/1886	Visits Custer battlefield for 20th anniversary (continues to make periodic trips to battlefield)
1890	Sells Bismarck studio to William **DeGraff;** destroys many negatives (probably local portraits)
	H. G. **Klenze** also claims to be successor to gallery
5/15/1890	Moves to Superior, Wisc., and sets up studio
1891	Establishes studio at 522 Tower Ave., W. Superior
1892	Moves to 1715 Broadway, W. Superior
c. 1/15/1897	Closes Superior studio and moves to N.Y.C.
	Studio established at 1300 Broadway, N.Y.
Summer 1898	Returns to Superior, Wisc.
	Studio at 1312 Tower Ave.
1913	Moves to 1316 Tower Ave.
1925	Attends 50th anniversary of Custer battle
3/6/1934	Dies
	Collections at Douglas County Historical Society, Superior, Wisconsin; Buffalo Bill Historical Center, Cody, Wyoming; Denver Public Library
Tribes	Northern Plains
Reference	*Heski, 1978*

Barthelmess, Christian (b.4/11/1854: Klingenberg, Germany–d.4/10/1906: Ft. Keogh, Mont.)

11/15/1881	Military musician; arrives at Ft. Wingate, N.M.
	Begins taking photographs
c. 1883	Company of Barthelmess & **Schofield** formed, of unknown duration
1883–84	Aids Dr Washington Matthews with Zuni research
11/14/1886	Leaves Ft. Wingate
12/2/1886	Arrives Ft. Bayard, N.M.
?–4/12/1888	At Ft. Lewis, Colo.
6/6/1888–*c.* 1898	Ft. Keogh, Mont.; photographs formation of Casey's scouts, 1889
1898–1903	Overseas postings
c. 7/1903–4/10/1906	Back to Ft. Keogh, where dies
Tribes	Northern Plains (Cheyenne, Crow); Southwest (Apache, Hopi, Navaho, Zuni)
Reference	*Frink & Barthelmess, 1965*

Beneke, R. (also listed as 'F.' Beneke)

1875	New evidence suggests he accompanied Newton-Jenney Expedition to Black Hills (and not Dr V. T. McGillycuddy as suggested by *Taft,* 1938), taking photographs of Dakota Indians. Possibly was also a studio photographer.
Tribes	Northern Plains (Dakota)
Reference	*Watson, 1948*

Bennett & Brown (George C. Bennett & William Henry Brown)

1880–*c.* 83	Studio in Santa Fe, N.M.
	Bennett does most of the traveling work
	Stereo and view cards marked 'G. C. Bennett', 'Bennett & Brown', and 'W. Henry Brown'
	Bennett works with Adolph Bandelier at Acoma, Cochiti, and Frijoles Canyon

6/28/1888–6/6/1893	Address in Santa Fe, N.M. papers at West Side Plaza
Tribes	Southwest
Reference	*Rudisill, 1973*

Bennett, George C. (Bennett & Burrall; Bennett & Brown) (Same images can be marked 'G. C. Bennett', 'Bennett & Brown', and 'W. Henry Brown')

1878	Partnership with **Burrall,** Santa Fe, N.M.
1880–82	Partnership with William Henry **Brown**
1880–83	While with Brown, does field-work with Adolph Bandelier at Acoma, Cochiti and Frijoles Canyon
†	Undated stereo of Tesuque; studio at Santa Fe, N.M.
Tribes	Southwest
Reference	*Rudisill, 1973*

Bennett, Henry Hamilton (b.?–d.1908?)

1865	Buys studio of Leroy **Gates** in Kilbourne, Wisc. (Kilbourne later known as Wisconsin Dells)
	Active until 1908 (when dies?)
Tribes	Winnebago
References	*Bennett, 1959;* M. Bennett to Smithsonian Institution, 11/6/1963, Smithsonian Institution National Anthropological Archives

Benzinger, Fred

1892	At Taos and other pueblos
Reference	*Rudisill, 1973*

Bibo, Emil (2/10/1862: Brackl, Prussia–d.3/23/1925)

c. 1898–1912	Active in N.M., also operates trading post at Cubero
Tribes	Southwest (Acoma, Laguna)
Reference	*Rudisill, 1973*

Blanchard, J. B. & Co.

c. 1890s	Studio addresses listed at Plaza Gallery, Los Angeles, and 513 N. Main St., Los Angeles
	Photographs Calif. Indians
Tribes	California

Bliss, W. P. (Wittick & Bliss)

c. 1878/1879	Active Santa Fe, N.M., and Ft. Sill, I.T.
†	Partnership with George Ben **Wittick,** who photographs Indians
Tribes	Southwest
Reference	*Rudisill, 1973*

Bonine, E. A.

c. 1870s	Studios listed at Pasadena, Calif., and Lamanda Park, Los Angeles
Tribes	Southwest (Apache, Maricopa, Pima, Quechan [Yuma])

Boston, J. A.

10/22/1880	Field photography of Utes; studio listed at Durango, Colo.

Bowman, Walter S.

c. 1899	Field photograph of Cayuse copyrighted this year

Bretz, George W.
Some confusion as to authorship of some images: the same backdrop is also credited to **Irwin & Mankins,** also of Ft. Sill area.

1894	Studio at Ft. Sill, O.T.
7/1895	Photographs Apache prisoners at Ft. Sill
Tribes	Southern Plains (Caddo, Comanche and Kiowa); Southwest (Apache)

Brewster, ?

c. 1870–80	Studio portraits of Cahuilla Indians
	Studios listed in Ventura and Santa Paula, Calif.
Tribes	California (Cahuilla)

Brown, John O. (N. Brown & Son[s])

1866	Mo.: St Louis CD at 41 N. 4th
8/1866	Probably goes to Santa Fe, N.M., with father, Nicholas
Tribes	Southwest?

Brown, N. & Son(s) (N. Brown E. Hijo) (Nicholas Brown, and sons, William Henry & John O.)

1866	Mo.: St Louis BD at 41 N. 4th
8/1866	St Louis studio closed
	Santa Fe, N.M. and Chihuahua, Mex. studios opened; Chihuahua studio open until at least 11/1871; Santa Fe studio open until at least 1869
Tribes	Southwest
Reference	*Rudisill, 1973*

Brown, Nicholas (b.c. 1830: Vt.–d.?) (N. Brown & Son(s); N. Brown E. Hijo)

1857–58	Mo.: St Louis BD at 43 N. 4th
4/1858	*P & FAJ*, vol. 11, p. 108, ref. notes a Mr Brown is painting photographs for **Fitzgibbon** in St Louis, possibly Nicholas; also suggests Brown worked for Brady in the east
1859–66	Mo.: St Louis BD at 41 N. 4th (N. Brown & Sons)
8/1866	Leaves St Louis and opens studio in Santa Fe, N.M., next door to Santa Fe Hotel
9/1866	At Fort Union, N.M.
10/–12/1866	In 'Rio Abajo' area (Albuquerque)
1/–4/1867	Back in Santa Fe studio
1/1867–2/1868	In 'Rio Abajo' and goes to Chihuahua, Mex., where opens studio
2/1868	Returns to Santa Fe; continues travels around US while sons operate Santa Fe and Chihuahua studios
1870	Census: N.M.: Santa Fe County as age 50 from Vt.
1/11/1871	Travels back to Chihuahua; Santa Fe studio operated by Dr Enos **Andrews**
11/1871– c. 1/1872	Back to Santa Fe studio
2/1872	To St Louis
July 1872	Back to Santa Fe
Tribes	Southwest (Jemez, Navaho and Taos); possibly Plains
Reference	*Rudisill, 1973*

Brown, W. Calvin (Lieutenant in Territorial Militia)

c. 1882	To Albuquerque, N.M.; opens studio?
1880s	Travels in N.M. and Ariz. (Hopi area in 1885) Sells photographs of Charles F. **Lummis** and others Late 1880s E. Gregg becomes studio manager
1888–89	Partnership with George H. **Wonfor** on Gold Ave., Albuquerque
1889	Sells studio to William Henry **Cobb** Goes to Farmville, Va., and opens studio
Tribes	Southwest (Hopi, Laguna, Mohave)
Reference	*Rudisill, 1973*

Brown, William Henry (b.1884–d.12/19/1886) (N. Brown & Son(s); N. Brown E. Hijo) (Son of Nicholas Brown)

1866	Mo.: St Louis CD at 41 N. 4th (note: a second William Brown in St Louis, 1857–75, is apparently not related)
8/1866	To Santa Fe, N.M.; N. Brown & Sons studio
1867	To Chihuahua; remains there at studio, N. Brown E. Hijo, while father returns to Santa Fe
7/1869	Returns to Santa Fe studio; possibly leaves area (note: possibly the William Brown located in Minneapolis 1872–79, or could be the other William Brown)
1880–c. 83	Forms partnership, (George C.) Bennett & Brown
1884	Opens studio in Parral, Mexico
1885	To El Paso, Texas; opens studio; dies there
Tribes	Southwest
Reference	*Rudisill, 1973*

Brubaker, C. B.
Photographer and published works by R. A. **Brotherton,** B. F. **Childs,** and probably others.

c. 1876	Field photographs of Ojibwa
†	Studios listed at Marquette & Houghton, Mich.
†	Partnership with **Whitesides**
Tribes	Midwest Woodlands (Ojibwa)

Buehman & Hartwell (Henry Buehman & F. A. Hartwell)
Some confusion over authorship: the same backdrop is also credited to **Mitchell & Baer.**

1881–83	**Hartwell** assists Buehman in Tucson, Ariz.T. studio
1883	Hartwell buys half-interest in studio, forms partnership
1889	Partnership lasts until Hartwell opens studio in Phoenix, Ariz.T.
Tribes	Southwest (Apache, Mohave, Papago, Pima)

Buehman, Henry (b.5/14/1851: Bremen, Germany–d.12/20/1912: Tucson, Ariz.) (Buehman & Hartwell) Skilled as both photographer and dentist.

1868	To San Francisco, Calif.; at unidentified photographic studio
1869	Opens studio at Visalia (also 'Versaile'), Calif.
1871–74	Itinerant work in Ariz., Calif., Nev. and Utah
2/20/1875	Buys studio of Juan **Rodrigo,** corner of House and Maiden Lane, Tucson, Ariz.T.; after four months, moves to Congress St.
1879	Assisted by Charles **Sladky** & F. J. **Partridge** at Tucson studio
1881–83	Assisted by F. A. **Hartwell**
1882	Builds new studio on Congress St.
1883	M. J. **Brundage** starts assisting at Tucson studio Forms partnership with F. A. **Hartwell,** who buys half-interest in studio
1884	Brundage stops assisting

1889	End of partnership with Hartwell
Tribes	Southwest (Apache, Cocopa, Pima and Papago)
Reference	*Evans, 1981*

Burfield, Thomas J.

†	Cabinet studio portrait of Dakota Studio listed at Norwood, Minn.
Tribes	Northern Plains (Dakota)

Burnette, B. W.

?	Undated studio portrait of Ponca Studios listed at Tyndall and Springfield, Ill.

Bushnell, C. A.

c. 1898	Photographs Sinkiuse Salish

Butterfield, ?

†	Cabinet studio portrait of Brule Dakota Studio listed at 'corner of Main Ave. and 9th, Sioux Falls, Dak.'

Carbutt, John
Active as photographer, publisher and photo-lithographer. Published the work of **Bill & Illingworth** and probably others. Possibly pirated photographs.

10/1866	On Union Pacific excursion to end of rail
1866–70	Active in Chicago; 131 Lake St.
1870	In Phila.
10/9/1887	Takes first photo by flashlight at Franklin Institute
Tribes	Plains
Reference	*Taft, 1942*

Carpenter, H. C.

pre-1890	Cabinet studio portraits of Pomo Indians (and paintings) Studios listed at Ukiah and Fort Bragg, Calif.

Carter, Charles William (b.8/4/1832; London–d.1/27/1918; Midvale Utah)
Important Indian photographer, but also known to have copied other photographers' works, such as that of C. R. **Savage.**

1853–56	As soldier in the British Army, develops interest in photography
1859	To Salt Lake City, Utah
c. 1863	Opens Carter's View Emporium on E. side E. Temple St., between 1st and 2nd South Sts.
1867	Salt Lake City CD at Savage and Ottinger (W. side E. Temple between 1st and 2nd S. Sts.)
1869	Salt Lake City CD at E. side E. Temple between 1st and 2nd (not Savage & Ottinger's address)
8/16/1870	Census: Utah: Salt Lake City as age 38, 'laborer' from England
1874	Salt Lake City BD at 89 East Temple, W. side
1879–80	Salt Lake City BD at N. side 5th S. between 3rd and 4th E.
1884–85	Salt Lake City CD at Mammoth Photo Gallery, 2nd and 4th E. 3rd S.
1888	Salt Lake City BD at 4 1/2 E. 3rd S.
3/13/1906	Sells negative collection, equipment, copyright to Mormon Church for $400
Tribes	Basin
References	*Wadsworth, 1975; Slaughter and Dixon, 1977*

Caswell, William M. (b.c. 1843: Vt.–d.?) (Caswell & Davy)

6/18/1880	Census: D.T.: Billings County as age 37 from Vt.
†	Partnership, Caswell & **Davy,** Duluth, Minn.
Tribes	Midwest Woodlands (Ojibwa)

Chamberlain, Walter A. (Son of William G. Chamberlain)

1878–79	Colo.: Denver CDs at Larimer, N.W. corner of 15th (William G. **Chamberlain**'s)
1881	Colo.: Denver BD at Chamberlain & Son
1882	Colo.: Denver CDs at 359 Larimer
1883–1892&†?	Colo.: Denver CDs with W. H. **Jackson** & Co.
Tribes	Basin?

Chamberlain, Walter A. (Son of William G. Chamberlain) (b.9/1859: Iowa)

1878–79	Colo.: Denver CDs at Larimer, N.W. corner of 15th (William G. **Cham-**

Took summer photographic trips around Denver, Colo., with his son, Walter A., and George Kirkland, brother of Charles **Kirkland.** Some confusion over studio locations – the BDs do not always support the changes suggested by biographers; all are listed below.

1847	Develops interest in daguerreotypy and buys outfit in Lima, Peru
1852–55	Ill.: Chicago CD at 131 Lake St.
6/1861	Moves to Denver, Colo. and opens studio
1861	Colo.: Denver BD: corner of Larimer and F Sts.
8/1862	Moves studio to Larimer St., between 14th and 15th
1/1864	Leaves studio in charge of Frank M. **Danielson** and opens branch studio in Central City to be run by Danielson

11/1864	Returns to Denver and opens studio in Graham's block at N.W. corner of Larimer and 15th; remains there until retires
	Gallery assistants include Francis D. **Storm**, Charles D. **Kirkland**, and his son Walter A. **Chamberlain**
6/1872	Studio enlarged
1881	Denver BD at Chamberlain & Son, Larimer, N.W. corner of 15th
2/1881	Retires, selling business to Francis D. Storm; still comes to studio
1882	Colo.: Denver CD: 359 Larimer
	Some of Chamberlain's negatives sold to Charles Weitfle, but destroyed in fire; other negatives reported to have been walled up in basement of building at 1633–35 Larimer St.
Tribes	Basin
References	*Andrews, 1964; Harber, 1975; Mangan, 1975*

Chase, A. W. Connected with US Coast Survey; possibly photographed Indians, or simply collected images. Related images are studio views.

pre-1874	Photographs of Tolowa
pre-1876	Photographs of Maidu
Tribes	California

Chesley (also **Chesley & Tanner; Chesley Bros.**)

| † | Undated boudoir prints showing Dakotas quarrying pipestone |

Childs, B. F. (Childs' Art Gallery)
His photographs were published by **Brubaker**, and by **Brubaker & Whiteside**, Houghton, Mich.

†	Undated stereographs of Ojibwa
	Childs' Art Gallery listed at Marquette, Mich.
Tribes	Midwest Woodlands (Ojibwa)

Clark, R. H.

| † | Cabinet studio portrait of Apache |
| | Studio listed at Whiteriver, Ariz. |

Clinton, J. L.

1878	Sells photograph copyrighted by B. H. **Gurnsey** of Taos
	Studio listed at 18 S. Tejon St., Colo. Springs
1888–96	Colorado Springs, Colo.
	Publishes views by Ira **Rudy** and sells views (bought or pirated?) made by J. R. **Riddle**
Tribes	Southwest?

Cobb, William Henry (b.1860: N.Y.?–d.3/6/1909: Albuquerque, N.M.)
Worked in civil engineering and taxidermy as well as photography. Some confusion over authorship: images are also credited to Charles **Sanders** (also 'Saunders') and Calvin W. **Brown**.

c. 1880–81	Goes to Albuquerque
†	Returns east
1889	Returns to Albuquerque and buys out studio of W. Calvin **Brown**
Tribes	Southwest
Reference	*Rudisill, 1973*

Concannon, Tom M.

| c. 1876 | Field photographs of Osage Indians, I.T. |
| | Studios listed at Cainey and Baxter Springs, Ks. |

Connolley

| † | Stereographic studio portrait of Comanches |
| | Studio listed at Ft. Sill, I.T. |

Cornish, George Barcroft

1880s	Partnership with William S. **Prettyman**, Arkansas City, Ks.
1906	Copyright photographs in partnership with (?) **Baker**, Kansas City, Ks.
1907	Copyright photographs alone
Tribes	Southern Plains

Cosand & Moser

| c. 1870s | Cdv studio portrait of Cheyenne |
| | Studio listed at Ft. Reno, I.T. |

Cross, William R. (b.c. 1843: Vermont–d.?)
There is some confusion as to the authorship of some images with **Mitchell & McGowan**, who also had studio in Omaha, Neb.; did field-work at Dakota reserves.

1868	Neb.: Omaha BD at studio at Caldwell Block
1870	Neb.: Omaha BD at studio on S.W. corner of Dodge and 15th St.
1878	Studio at Niobrara, Neb.
†	Studios at Norfolk, Neb. and Hot Springs, S.D.
6/18/1880	Census: D.T.: Billings Co. as age 37 from Vt.
Tribes	Plains

Currier, Frank F.
Appears to have been connected with Julius Meyer, dealer in Indian artifacts, Omaha, Neb.

1872	Opens studio in Omaha, Neb.
1873	Omaha BD at 232 Douglas St.
1874–76	Omaha BDs at 235 Douglas St. (and notes 1872 opening)
1878	Omaha BD at 559 & 561 15th, cor. Dodge
1879	Omaha BD at 113 N. 15th
1880	Omaha BD at 1316 Farnam
1883–85	Omaha BD at 1212 Farnam
1886	Omaha BD at 1720 St Mary's Ave.
Tribes	Plains

Dally, Frederick (b.1838: England–d.1914: Wolverhampton?, England)

9/1862	Arrives Victoria, Canada; opens dry goods store
1860s	Opens photographic studio on S. side of Fort St.
1867	Makes trip to Bakerville; possibly opens studio
1868	Makes second trip to Bakerville
9/16/1868	Fire destroys studio
11/1868	Returns to Victoria
9/1870	Sells Victoria studio to Green Brothers; goes to Phila., and then back to England
1870s–80s	Many of his negatives acquired by Richard and Hannah **Maynard**, circulating them under their imprint
Tribes	Northwest Coast
Reference	*Mattison, 1985*

Davidson, I. G.

c. 1890s	Boudoir field views of Haida
	Studio listed at 181 First corner of Yamhill St., Portland, Ore.
Tribes	Northwest Coast

D'Heureuse, R.

c. 1862	Field views of Mohave and Quechan (Yuma) Indians
	Studio listed at Ft. Yuma, Calif.
Tribes	Southwest (Mohave, Quechan)

Dodge, Katherine T.

1/1899	Copyrights Apache photos
	Studio listed at San Carlos, Ariz.T.
Tribes	Southwest (Apache)

Doerr, H. A.

| † | Stereographic field view of Apache |
| | Studio listed at San Antonio, Tex. |

Dossetter, Edward

6/–7/1881	Accompanied Dr I. W. Powell on inspection tour of Indian res's.
1880s?	Active in Victoria, Canada and Northwest Coast, British Columbia
Tribes	Northwest Coast
Reference	*Mattison, 1985*

Drum, O.

| 1890s? | Field view of Osage |
| | Studio listed at Pawhuska, O.T. |

Drusle (Drasle?)

| 1890s? | Studio portrait of Osage |
| | Studio listed at Ponca City, O.T. |

Dutro, Daniel (b.1850?–d.1918)
Union army drummer boy; fought with vigilantes in Missouri.

1867	Goes to Montana, working in Helena in non-photographic job
†	Health forces him to work at Ft. Benton as geologist; takes up photography
1893–97	Havre, Mont.; Roland **Reed** becomes apprentice, later partner
	Itinerant work among Indians, with Reed, and either sells images or works on contract for News Department of the Great North Railroad
†	Leaves photographic, goes into mining
Tribes	Plains
Reference	*Andrews, 1964*

Easterly, Thomas M. (b.1809: Brattleboro, Vt.–d.3/11/1882: St Louis)
Probably the first to photograph Sauk and Fox and Iowa Indians; preferred the technique of daguerreotypy after no longer fashionable. His address variations are probably only number changes.

1846–47	Itinerant daguerreotypist with F. F. **Webb** at Liberty, Missouri; during this time he appears to have photographed Iowa and Sauk and Fox Indians, such as Keokuk, who died 6/1/1848
c. late 1847	Moves to St Louis, Missouri
c. 2/23/1848	Starts to operate John E. **Ostrander**'s 'Miniature Gallery', 103 4th St., S.E. corner of 4th and Olive

11/1848	Takes over Ostrander's gallery
1851–54	St Louis CDs at S.E. corner of 4th and Olive
1857–59	St Louis BDs at 71 N. 4th, S.E. corner of Olive
1860	St Louis CD at Easterly and Brown (Thomas B. Brown), 'Farming implements' (possibly the Brown related to the Nicholas Brown family in St Louis at this time?)
1864–65	St Louis CD as having studio, NAG, possibly at home address, 60 Jefferson
1866	St Louis BD at 65 4th
1867	St Louis CD at 218 1/2 N. 4th, with Martin Easterly
1868	St Louis CD at 218 1/2 N. 4th, with Mrs Philomena Easterly also listed as photographer
1869–71	St Louis CD at 218 1/2 N. 4th with Martin Easterly
1872	St Louis CD at studio, NAG
1873	St Louis CD at 218 1/2 N. 4th; Martin Easterly
1874–78	St Louis CD at 218 1/2 N. 4th
1880–82	No CDs located; presumably at same address or operating from home
Tribes	Sauk and Fox, Iowa
References	*Van Ravenswaay, 1953; Ewers, 1968; Newhall, 1976*

Eaton, Edric L. (b.c. 1835–7: Vt., or Neb.?)
There is some confusion as to which photographs are his. Copied, and had his images copied by, C. W. **Carter, Savage & Ottinger,** and probably others. Mrs Anna Eaton is occasionally listed as artist.

c. mid-1860s	Undated cdv imprints: '234 Farnham Street, Branch, corner 15th and Douglas' and '234 Farnham Street, formerly of 15th and Douglas'
Late 1860s	Possibly sells studio (15th and Douglas?) to W. H. **Jackson**
6/6 and 6/8 1870	Census: Omaha: two entries as age 34 and 35 from Vt.
1870–73	Omaha BDs at 234 Farnam
1876–78	Omaha BDs at 238 Farnam
1879	Omaha BD at 1320 Farnam; 212 N. 16th
1880	Omaha BD at 1320 Farnam; 212 N. 16th; 613 S. 13th
6/5/1880	Census: Omaha as age 43 from Neb.
1881–85	Omaha BD at 1320 Farnam
1886	Omaha BD at 1320 Farnam; 1402 S. 13th
1887	Omaha BD at 1320 Farnam
1888	Omaha BD at 1320 Farnam; 1518 Douglas
1889–92	Omaha BD at 1320 Farnam
†	Undated imprints, '425 Broadway, Council Bluffs, Iowa'
Tribes	Plains (Omaha, Pawnee); Basin (copies ?)

Eberhart, H. C.

1860s?	Cdv studio portrait of Sauk and Fox
	Studio listed at Tama City, Iowa; same backdrop credited to **Hudson**

Elrod, J. C.

†	Cdvs of Kiowa
	Studio listed at Elrod's Galleries, Ft. Sill, I.T.

Ericson, Augustus William

1893	Photographs Hupa or Karok Deer Dance
	Studio listed at Arcata, Calif.
1890s	Photographs other Calif. tribes

Falkenshield, Dr Andrew (b.12/1/1821: Copenhagen, Denmark–d.10/1896: St Paul, Minn.) (Falkenkhold) Originally from the Danish nobility. Also active as artist and photograph painter. Reported to have taken early photographs of Dakotas, as well as the missionary, Rev. S. Riggs.

†	Possibly works for Alexander **Hesler** in Chicago, where may have met J. E. **Whitney**
c. 1856	To St Paul; it has been suggested he works with Moses C. **Tuttle,** however Tuttle's rooms are at **Whitney**'s gallery at corner of 3rd and Cedar
1858	St Paul CD as having boards at Whitney's, corner of 3rd and Cedar
1860	Census: St Paul as age 30 from Denmark; lives with J. E. Whitney
1863	St Paul CD at corner of 3rd and Cedar
1864–65	St Paul CDs at 136 3rd
1869–70	St Paul CDs at 134 3rd
1870	Census: St Paul as age 45 from Denmark
1871	St Paul CD at 136 3rd
1873	Reported to have abandoned photography to concentrate on painting
1879	Apparently works with C. A. **Zimmerman**
Tribes	Northern Plains
Reference	*White, 1981*

Fansler, S. T. ('Dick') (Fuller & Fansler)

c. 1889 or †	Photographs Dakota
	Studio at Fort Yates, N.D. (same studio previously occupied by O. S. **Goff**

	& D. S. **Barry**)
	Second studio listed at Mound City, S.D.
c. 1897–99	Frank B. **Fiske** is his apprentice
1903	Fiske takes over Ft. Yates studio
Tribes	Plains
Reference	*Vyzralek, 1983*

Fennemore, James (b.9/7/1849: London, England–d.1/25/1941: Phoenix, Ariz.)
Studio as well as survey photographer with Powell's US Topographical and Geological Survey of the Colorado of the West.

1870	Salt Lake City, with **Savage & Ottinger**
1872	Leaves with Powell on survey
1874	Salt Lake City at 5 South between 11 and 12 East

Fiske, Frank Bennett (b.6/11/1883: Ft. Bennett, S.D.–d.7/18/1952: Bismarck, N.D.)

c. 1897–99	Apprenticed to S. T. 'Dick' **Fansler,** Ft. Yates, N.D.
Spring 1899–1903	Takes over Ft. Yates studio until Fort closed as military post
1903–05	Opens and closes studio at Bismarck, N.D., nr. Standing Rock Agency
3/1905–c. 1918	Returns to Ft. Yates studio
1919	Marries and settles at Ft. Yates; non-photographic work
1925	Moves to McLaughlin, S.D.
Tribes	Plains (Dakota at Standing Rock)
Reference	*Vyzralek, 1983*

Fitzgibbon, John H. (b.1816?: London–d.1882: en route to Photographic Association convention)
Important early studio photographer of the Indians.

1841	Begins making daguerreotypes
1846	Opens St Louis, Missouri gallery
1848–52	St Louis CDs at N.E. corner of 4th and Market [also listed as no. 1 4th]
1852–53	No St Louis listings; exhibits at N.Y.C.
1853	Purchases R. H. Vance collection of dags. of Pacific Coast from Jeremiah Gurney of N.Y.
1854–59	St Louis CB/BD at no. 1 4th, corner of Market
1858	*P & FAJ*, vol. 11, p. 108 notes Fitzgibbon's artist is a Mr **Brown** (possibly Nicholas Brown or William Brown [not Nicholas's son])
1860	St Louis CD at 65 N. 5th
1861	Moves to Vicksburg, Miss.; captured by Union Army; prisoner in Cuba
1866	Returns to St Louis
1867–71	St Louis BDs at 116 N. 4th
1872	St Louis CD at 116 N. 4th; and S.W. corner of 4th and Olive
1873–76	St Louis BDs at 116 N. 4th
1876	Retires from active studio work
	Publishes and edits *St. Louis Practical Photographer* (first issue, 1877)
1878–79†	St Louis BDs; Mrs J. H. Fitzgibbon photographs at 415 Franklin St., while John edits from home address
Tribes	Sauk and Fox
Reference	*Newhall, 1976*

Fly, Camillus S. (b.1849–d.1901: Tombstone, Ariz.T.) Most famous for his presence at the gunfight at the OK Corral and photographic documentation of meeting between General Crook and Geronimo.

1879	To Tombstone, Ariz.T.; opens studio on Fremont St. with entrance to OK Corral
	Mrs M. E. Fly, also photographer, operates studio in his absences
3/1886	Photographs meeting between Geronimo and Crook
†	Tombstone studio fails; separates from wife
†	Studio at Bisbee, Ariz.T., but fails
6/6/1892–?	Santa Fe, N.M.: San Francisco Street
1894	Opens studio at Phoenix, Ariz.T., but fails
†	Becomes sheriff of Cochise County
†	Returns to Tombstone
1901	Dies in Tombstone
	Wife, Mrs M. E. Fly, posthumously publishes his photographs
1910s	Fly negative collection purchased by Phelps, Dodge Mercantile Co., but warehouse soon burns down destroying negatives
Tribes	Southwest (Apache)
References	*Andrews, 1965; Daniels, 1968; Rudisill, 1973; Current and Current, 1978*

Fouch, John H.

†	Possibly runs studio at Ft. Buford, D.T. (founded 1866)
5/22/1877	To Cantonment Tongue River (later, 'Ft. Keogh'), Mont.
6–7/1877	Makes photographic trip to Custer battlefield; first to record it photographically

11/1877	Sells photographs of Chief Joseph who has just surrendered at Ft. Keogh
11/11/1878	Leaves Ft. Keogh studio and goes east
	Ft. Keogh studio taken over by S. J. **Morrow**
1882–83	Minn.: Minneapolis BD at 107 Washington Ave. N.
By 1889	Excelsior, Minn. (suburb Minneapolis) operating Minnetonka Art Gallery
Tribes	Plains; Plateau (Chief Joseph in captivity)
References	*Gray, 1978*; Smithsonian Institution National Anthropological Archives SPC 004590.00 – cdv with imprint, 'Fort Buford military gallery,' overstamped with 'John H. Fouch, … Ft. Keogh, Montana'

Fuller & Fansler (Fuller and S. T. 'Dick' Fansler)
Undated partnership at Ft. Yates, N.D. Photographed Hunkpapa Dakota.

Gaige, J. G. (b.?–d.7/1869: Camp Godwin, Ariz.T.) (Wrongly, 'Gage')

†	Studio in Santa Fe, N.M.; leaves to unknown place
11/1862	Returns to Santa Fe
8/1865	Signs contract with N.M. Military District Chief Quartermaster to photograph all posts in district
2/–3/1866	Active at Fort Sumner ('Bosque Redondo') during Navaho captivity
7/1866	El Paso, Texas, on way to Chihuahua, Mexico
5/1869	Tucson, Ariz.T.
Tribes	Southwest (Navaho and Apache at Bosque Redondo)
Reference	*Rudisill, 1973*

Gates, Peter G. *See* Adam Clark **Vroman**

Godkin, W. R.

1888	Studio portrait of Dakota
	Studio listed at Pine Ridge
Tribes	Northern Plains (Dakota)

Goff, Orlando Scott (b.9/10/1843: Moodus, Conn.–d.1917: Idaho)

10/1/1861–8/25/1865	Soldier during Civil War
†	To Lyons, N.Y.; probably learns photography
c. 1870	To Portage, Wisc.
	Meets young David F. **Barry** in Columbus, Wisc., who carries water for Goff as itinerant photographer
1871	To Yankton, D.T., possibly with Northern Pacific Railroad *c.* 11/1/1872
	Hired by Stanley J. Morrow in Yankton, D.T.
Summer 1872	Trip up Missouri River; visits Ft. Buford and Ft. Stevenson
10/15–	Opens studio at Bismarck, D.T., Main St.
c. 11/1873	Visits Fts. McKeen and Lincoln
11/5/1873	Opens Ft. Lincoln studio of Goff **& Ford** (Judge Ford, financial partner)
8/1875	To Chesterton, N.Y.; marries Annie Eaton
10/1875	To Ft. Lincoln, D.T. (there with Custer)
5/1876	Ford leaves Ft. Lincoln studio
Late 1870s	Opens branch studio at Ft. Custer, Mont.
1877?	Circulates photograph of Chief Joseph said to have been taken this year; image also credited to **Haynes**, who can be placed near Joseph at this time
c. 6/26/1878	Opens Bismarck, D.T. studio
	Hires David F. **Barry** and teaches him photography so that Goff can make photographic trips
1879	Barry goes to Ft. Lincoln studio for winter
6/2/1880	Census: D.T.: Bismarck as age 32 from Conn.
8/1/1881	Takes photograph of Sitting Bull (possibly the first)
Spring 1884	Rents Bismarck studio to Barry
6/27–10/1884	Goes to Ft. Assiniboin
10/1884	Returns to Bismarck
1886	Re-establishes Ft. Custer studio
c. 1886	Spends 1½ years in Chicago hospital
1896	Is in and around Dickinson, N.D.
1898	Opens studio at Havre, Mont.
	Opens branch studio at Ft. Assiniboin, but closes when troops leave for Spanish–American War, re-concentrating effort on Havre
5/1903–1906	Fire destroys Havre studio and negatives; presumably Barry had negatives from Bismarck studio
1906	Retires from photography; moves to Idaho, where dies
Tribes	Plains; Plateau
References	*Watson, 1949; Gray, 1978*

Grabill, John C. H.

Mid-Oct. 1886	Sets up studio in McIntyre building, Sturgis, D.T.
	Takes photographs of soldiers at Ft. Meade, D.T.
1886–91	Works in and around Black Hills
After 1887	At various D.T. locations such as Deadwood, Lead, and Hot Springs (Mont.?)
Jan. 1891	Records aftermath of Wounded Knee at Pine Ridge

Tribes	Plains (Dakota, and aftermath of Wounded Knee)
Reference	'John C. H. Grabill …', 1984

Gurnsey & Illingworth (B. H. Gurnsey & William H. Illingworth)
Exact dates of partnership unknown, probably *c.* 1870 when the Gurnsey family lived next door to the Illingworth family in Sioux City, Iowa. Undated cdv imprints, 'Gurnsey & Illingworth, 3rd St., one door west of Post Office, Sioux City, Iowa'.

Tribes	Northern Plains

Gurnsey, B. H. (b.c. 1844: N.Y.–d.c. 4/21/1890) (also, 'Guernsey')
Some confusion exists as to photographic credits. The same studio shown in mounts is credited to Gurnsey, Gurnsey & **Illingworth, Hamilton & Hoyt**, and **Hamilton & Kodylek**. Known to have published images.

1860	To Indiana? (has child born there)
1864	To D.T.? (has child born there)
1866	To Iowa? (has child born there)
1870	Photographs Winnebago Agency, near Sioux City, Iowa
7/27/1870	Census: Iowa: Sioux City as age 36 from N.Y.; enumerated children suggest previous whereabouts
	Census shows lives next door to William H. **Illingworth** and family
†	Cdv imprint, 'Gurnsey, 3rd St., one door west of Post Office, Sioux City, Iowa'
c. 1870?	Cdv imprint, 'Gurnsey & Illingworth, 3rd St., one door west of Post Office, Sioux City, Iowa'
c. 4/2/1980	William H. Jackson notes death, and that his negatives were scattered. (Franklin A.) **Nims** of Colorado Springs, Colo. got a large number; as did another unknown photographer (possibly **Illingworth** or **Hamilton**?) who then went out of business.
Tribes	Northern Plains (Dakota); Midwest Woodlands (Winnebago)
Reference	Smithsonian Institution National Anthropological Archives MS 4881 Jackson to Holmes, 4/2/1890

Hall, E. E.
There is confusion over credit with George Wharton **James & Maude.**

1897	Copyrights Hopi photo; James listed as photographer
†	Undated views copyrighted by Hall but credited to Maude & Co.
Tribes	Southwest

Hamacher, ?

†	Undated portrait of Smohalla, the Sokulk priest
	Studio listed at N. Yakima, Washington

Hamilton, ?
Several individuals named 'Hamilton' photographed Indians at the same time. No doubt they were related, but that relationship has not been clarified. All notations have been listed below.

8/5/1867	William H. **Jackson** meets with a Hamilton in Omaha, Neb.; on 8/7/1867 is hired by him to do photographic work. (Later in fall of same year, buys Hamilton's studio to establish **Jackson Bros.** studio.)
1870	Census: Iowa: Sioux City as **James H. Hamilton**, age 37 from Ky.
1879	Iowa BD as J. H. Hamilton at Sioux City, Iowa
6/1/1880	Census: D.T.: Deadwood as **Grant Hamilton**, age 36 from Ky. (is married, but listed as boarder – probably on a trip)
6/12/1880	Census: Iowa: Sioux City as G. C. Hamilton, age 36 from Ky. (living with family)
†	Stereograph imprint, 'C. L. **Hamilton**, Sioux City'
†	Stereograph imprint, '**Hamilton & Kodylek**, Sioux City, Iowa'
†	Stereograph imprint, '**Hamilton & Hoyt**, Pearl St., Sioux City, Iowa'. Also listed as publisher of some images
Tribes	Midwest Woodlands (Winnebago); Plains (Dakota, Omaha)
Reference	*Jackson, 1940*

Hastings, Oregon Columbus (b.4/26/1846: Pontoosuc, Ill.–d.8/5/1912) ([Stephen Allen] Spencer & Hastings; Robertson & Hastings)

1873	Partnership **Robertson & Hastings** listed at Port Townsend, Wash. T.
8/1879	Goes with I. W. Powell to Metlakatla
1874	Manages **Spencer**'s studio, Victoria, Canada
1881–82	Leaves Victoria
c. 1882	Returns to Victoria; partner in Spencer & Hastings
c. 1883	Buys out Spencer
1/1889	Sells studio
1894	Takes photographs at Ft. Rupert for Franz **Boas**
Tribes	Northwest Coast (Kwakiutl)
Reference	*Mattison, 1985*

Haynes, Frank Jay (b.10/28/1853: Saline, Mich.–d.3/10/1921: St Paul, Minn.)
Important Yellowstone photographer. Some confusion over details of his early life.

c. 1874	Apprentice to S. C. **Graham**, Beaver Dam, Wisc.
c. 1875	(alternatively) Apprentice to sister and brother-in-law, Ripon, Wisc.

9/7/1876	Opens studio in Moorhead, Minn.
1876	Begins travel for Northern Pacific Railroad
1877	Reported to have taken portrait of Chief Joseph, probably correctly, as was in same area as Joseph; image also circulated by O. S. **Goff**
pre-1879	Teaches L. A. **Huffman** photography
1879	To Fargo, D.T.; opens studio
	Wife Lily runs studio while he travels on Northern Pacific Railroad
6/19/1880	Census: D.T.: Fargo as age 26 from Mich.; (lives with brother Fred, also a photographer)
1881	Photographic trip to Yellowstone
By 1885	Has Haynes Palace Studio (railroad) Car
1889	Minn.: St Paul BD at 394 Jackson, corner of 6th
	Palace Car operated by assistants
1890–94	Minn.: St Paul BDs at 392 Jackson, corner of 6th (**Haynes & Bro.** [Fred])
1895–1901 &†?	Minn.: St Paul BDs: at Selby Ave., N.E. corner of Va.
1905	Palace Car ceases operation
	Son **Jack Haynes** becomes involved in business
	Haynes collection donated to Mont. Historical Society
Tribes	Plains; Plateau
References	*Galusha, 1959; F. Jay Haynes (1981?)*

Heister, Henry T. (Also 'Hiester')

Summer 1871?	To Santa Fe at invitation of Dr Enos **Andrews** to replace Nicholas **Brown**
1874	Trip down Rio Grande with John D. Howland
	Opens studio in Mesilla, N.M.
Tribes	Southwest (Hopi, Navaho)
Reference	*Rudisill, 1973*

Heller, Louis (b.8/11/1839: Darmstadt, Germany–d.6/25/1928: San Francisco, Calif.)

c. 1855	To N.Y.C.
Early 1860s	Joins N.Y. studio
c. 1862	Moves to Calif.
1864	Moves to Yreka, Calif. and opens studio
1860s	Travels to Fort Jones, Etna and Scott Valley
1869	Sells Yreka studio to assistant, Jacob **Hansen**
	Opens studio in Fort Jones
4/–5/1873	Photographs Modoc War; photographs later produced by **Watkins** Gallery, San Francisco
8/1900	Sells Fort Jones studio
	Moves to San Francisco
Tribes	Modoc
Reference	*Palmquist, 1977*

Heyn & Matzen (? Heyn & [James] Matzen)

The Heyn family of photographers are important in Omaha at the turn of the century. Most important Indian photographic work was done by Heyn & Matzen who copyrighted many Indian portraits c. 1900. These portraits may have been taken at the 1898 Trans-Mississippi and International Exposition. Heyns involved in photography are: George (active c. 1881–92); Mrs George (active 1893–95); Herman (b.6/1852 in Germany and active in Omaha 1885–1915 and †?); Lewis (active 1883–85); Sabina (later Sabina Heyn Unverzagt, active 1893–1901 and †?); and Siegfried (active 1889–95, running S. Heyn & Co. 1893–94). Heyn companies include: Heyn The Photographer; Heyn Photo Supply Co.; S. Heyn & Co.; and Heyn & Matzen.

Tribes	Northern Plains
References	Omaha BDs

Hoer, F. A.

1896	Studio portrait of Apache
	Studio listed at Lumberton, N.M.

Hook, William E. Sr and Jr

Both father and soon took photographs; there is some confusion as to authorship.

c. 1875–85	Field views of Chippewa
	Studio listed at Chippewa Falls, Wisc.
1889–90	At Manitou Springs, Colo.
1891–97	At Colorado Springs, Colo.
	Photographs Tesuque

Hoopes, H. E. (of Media, Penna.) *See* Adam Clark **Vroman**

Houseworth, Thomas

Best known as a publisher of photographs, but may also have taken Indian photographs in San Francisco, Calif. studio, variously listed at 317 and 319 Montgomery St., and at 12 Montgomery St. Published a series of Indian photographs taken by an unidentified photographer with the US Fish commission at the Alaska-Yukon-Pacific Exposition

Howard, ?

†	Cdv studio portrait of Shoshoni

	Studio listed at Fort Sanders, Wyo.T.

Hudson, J. L. (Hudson's Gallery)
Same backdrop is credited to **Eberhart**; correct authorship unknown.

1860s?	Cdvs field and studio portraits of Sauk and Fox
	Studio listed at Tama City, Iowa

Huffman, Laton Alton (b.1854: Iowa–d.12/28/1931: Billings, Mont.)

†	Learns photography from F. J. **Haynes**
1879	Takes over Ft. Keogh, Mont. studio from S. J. **Morrow**; presumably obtaining negatives as in 1883, publishes list including Morrow (& **Fouch**) photos from this period
1880	Census: Mont.: Ft. Keogh as age 25 from Iowa
1880	Opens Miles City, Mont. studio
1890	Closes Miles City studio and goes to Chicago
1896	Studio at Billings Mont.
†	Reopens a studio at Miles City
1905	Closes Miles City to casual trade specializing in production work
Tribes	Northern Plains
References	*Brown and Felton, 1955; Brown and Felton, 1956; Gray, 1978*

Hull, Arundel C. (b.1846: Indiana–d.1908)

1867	Travels on train westward from Omaha taking photographs through Colo., Utah and Wyo. Claims to have made portrait of Sitting Bull.
1868	Employed by **Jackson Bros.** studio in Omaha
1869	Travels with William H. Jackson taking photographs
Summer 1871	Travels with William H. Jackson taking photographs
c. 1872	Sets up studio in Fremont, Neb.
1880	Census: Neb.: Fremont as age 34 from Indiana
1902	Dies
1920	Negatives stored in leased studio taken to city dump
Tribes	Plains?
Reference	*Miller, 1962*

Huntington Bros.

pre-1889	Cabinet studio portrait of Twana Indian
	Studio listed at Olympia, Wash.

Hutchins (Hutchins & Lenney/Lanney)

1892	Views of Comanche; studio near Ft. Sill, O.T.
c. 1890s	Undated partnership with **Lanney**, studio listed at Anadarko, O.T.

Illingworth, William H. (b.9/20/1842; England–d.3/16/1893; St Paul, Minn.)
Son, William H. Jr, helps in studio 1881–85, as does third wife, Flora. ([Frank J.] Gilmartin & Illingworth)

1840s	To US
1850	To St Paul, Minn.
Summer 1862	To Chicago to learn photography
Fall 1862	Back to St Paul, working with photography as sideline
1864–66	Minn.: St Paul BD at Jackson between 5th and 6th
5/31/–8/3/1866	Goes on Fiske Expedition with George [de] **Bill**
1866 or 1867	Sells Fiske Expedition negatives and rights to John **Carbutt**
1867	Minn.: St Paul BD at corner of 7th and Sibley
1869–70	Minn.: St Paul BDs at 27 E. 7th
7/27/1870	Census: Iowa: Sioux City as age 28 from England
1868–71	Has views published by Burrett & Pease
1872–75	Has views published by Huntington & Winne
1873–76	Minn.: St Paul BDs at 7th N.E. corner of Jackson (International Block)
7/2–8/30/1874	With Custer Expedition to Black Hills
1877–80	Minn.: St Paul BDs at 79 E. 7th
1881	Minn.: St Paul BD at 127 (old 79) E. 7th
1882–84	Minn.: St Paul BDs at 517 North St.
1885	Minn.: St Paul BD at 517 North St., and 424 E. 7th
1886–87	Minn.: St Paul BDs at 517 North St.
1888	Minn.: St Paul BD at **Gilmartin** & Illingworth, 412 E. Wabasha
†	
3/16/1893	Commits suicide
1900	Negative collection sold to Ed. A. Bromley
1914	Part of Bromley collection sold to Minneapolis Public Library
1920	Black Hills negatives of Bromley collection to S.D. Historical Society
†	After Bromley death, rest of collection to Minn. Historical Society
Tribes	Northern Plains
Reference	*Grosscup, 1975*

Ingersoll, Truman Ward (b.2/1862: St Paul, Minn.–d.6/9/1922: St Paul, Minn.)

1881	After surveying for Northern Pacific Railroad, returns to St Paul; does some photographic work
1884	St Paul studio at 160 W. 3rd

1885–88	St Paul BDs at 40 E. 3rd
1889–92	St Paul BDs at 27 E. 3rd
1893	St Paul BD at 27 and 29 E. 3rd
1894	St Paul BD at 27 E. 3rd
1895–99	St Paul BDs at 56 E. 6th
1900–01&†?	St Paul BDs at 52 E. 6th
1900	Census: Minn.: St Paul as born 2/1862
1906	To San Francisco to photograph earthquake damage
1906	St Paul, new studio at 88–92 W. 4th
11/28/1909	Retires; sells studio to **Buckbee-Mears** (negatives now lost) Moves to Buffalo, Minn.
Tribes	Ojibwa of Minn.
Reference	*Johnston, 1980*

Irwin & Mankins (William 'Ed' Irwin & ?, Mankins)
Same studio backdrop is credited to **Bretz.**

c. 1895	Partnership formed at Chickasha & Duncan, I.T.
?	Mankins killed by Mexicans
Tribes	Southern Plains (Kiowa, Comanche); I.T.

Irwin, William 'Ed' (b.1871: Red Oak, Missouri–d.1935: Douglas, Ariz.)

c. 1892 or 1983	Moves to Chickasaw, I.T.
c. 1893	Learns photography and opens studio
c. 1895	Forms partnership with **Mankins;** Clara March Ducker helps in studio; studio also known as **Blue Tent Gallery**
†	Mankins killed by Mexicans
1896–1901	Travels to Texas and Ft. Sill, taking photos
Early 1900s	Has studio in Goldthwaite, Texas
1904	Moves to Bisbee, Ariz.T.
1908	Leaves Bisbee on trip; Ruf **Carson** operates studio in absence
†	Studio in Silver City, N.M. (sources differ, one suggesting he is there before Bisbee; another suggests he moves back after his wife dies in Bisbee)
1922	Sells Bisbee studio, possibly to Ruf Carson Travels and photographs; moves to Douglas, Ariz.
Tribes	Southern Plains (Kiowa); I.T.; Southwest (Apache)
Reference	Personal communication, Carol Roark to author (Fleming) 1984

Jackson Brothers (William Henry & Edward C.)
There is some confusion over the studio carpet: the same one appears in images by **Eaton,** Jackson Bros. and Parker & Johnson, all of Omaha. Parker & Johnson claim to be successors to Jackson Bros. Thus the problem exists over the Eaton images. Jackson also acquired either Eaton's studio, or his negatives, or image copying has occurred.

8/7/1867	William hired by Hamilton, Omaha, Neb.
Fall 1867	Buys Hamilton's studio Possibly buys second studio from E. L. **Eaton**
1868	Joined by brother, Edward Assistants include John **Jarvis** (who later comes east to Washington DC with Jackson, establishing an important photography business), Arundel **Hull,** and Ira T. **Johnson**
1868–70	Omaha BD at corner of 15th and Douglas
1869	William goes with Arundel Hull to Cheyenne, Wyo. where sets up business, 6/23
Summer 1871	William travels with Hull
Fall 1871	William returns to Omaha and sells equipment to photographer named **Silver,** while studio apparently goes to (Charles) **Parker** & (Ira T.) **Johnson**
Tribes	Plains (Oto, Omaha, Osage, Pawnee, Ponca, and Winnebago)
References	*Jackson, 1940; Jackson to Taft, 1933, Ks. Historical Society; Newhall, 1974*

Jackson, Fred (Son of William Henry Jackson) (b.c. 1851)

1880	Denver CD as with W. H. **Jackson,** 413 Larimer
1881	Denver CD as with A.E. **Rinehart,** 326 13th St. (also lives with Frank **Rinehart**)
1884–86	Denver CDs as with W. H. Jackson, 414 Larimer
1887	Denver CD as with Jackson & Co., 1609, 1611, 1613 and 1615 Arapahoe St.
1888–92 &†?	Denver CD as with Jackson & Co., 1615 Arapahoe St.

Jackson, William Henry (b.4/4/1843: Keesville, N.Y.–d.6/30/1942: N.Y.C.)
One of America's premier photographers. Due to his publication of catalogs listing holdings of the US Geological Survey, many images are credited to him that he did not take. Many of his images were also pirated by other photographers. Some doubt remains about authorship of photos relating to Omaha studio. Many biographies have been written – dates for various events differ. Jackson's dates from his autobiography have been used in preference to others until contradictory primary evidence surfaces. Occasionally Jackson's own notes differ some from CD and BD listings.

1857	First photographic job with unidentified studio
1858	Works with C. C. **Schoonmaker,** Troy, N.Y.
1860	Works with Frank **Mowry,** Rutland, Vt.
1862–63	Military service
1863	Works with Mowry
1864	Works with F. **Styles,** Burlington, Vt.
1866	Starts travels in west
8/7/1867	Hired by **Hamilton,** Omaha, Neb.
Fall 1867	Buys Hamilton's studio, and possibly one from E. L. **Eaton**
1868	Joined by brother Edward, forming **Jackson Bros.** Assistants include John **Jarvis** (who later comes to Washington DC at the same time as Jackson, and sets up studio there), Arundel **Hull,** and Ira T. **Johnson**
1868–70	Omaha BD at corner of 15th and Douglas
1869	Travels with Hull for railroad Co. and to Cheyenne, Wyo., where sets up business, June 23
1870	Becomes official Hayden Survey photographer
Fall 1871	Sells equipment in Omaha studio to photographer named **Silver,** while studio possibly goes to (Charles) **Parker** & (Ira T.) **Johnson** Goes to Washington DC to work at Survey headquarters
1874	Publishes US Geological Survey Miscellaneous Publication no. 5 – *Catalog of Indian Photographs* (first edition only)
1877	Publishes expanded version of US Geological Survey
1879	Various US surveys consolidated Jackson opens studio in Denver, 413 Larimer; is aided by Frank **Smart,** son of a Washington DC photographer
1881–84	Partnership, Jackson & (Alfred E.) **Rinehart** in Denver Son Fred **Jackson** works in studio
1881	Begins work with Denver and Rio Grande Railroad
c. 1884	Becomes partner with Chain & Hardy, Booksellers Is assisted by Louis Charles **McClure**
1885	Moves studio to Arapahoe Street
1892	Incorporates as W. H. Jackson Photography & Publishing Co., with Walter F. **Crosby** as silent partner
1893	His is official photographic company for World's Columbian Exposition
1894–99	Jackson takes world tour for World Transportation Commission
Fall 1897	Becomes part owner in Detroit Publishing Co. and a director of Photochrome Co. Goes to Detroit Jackson is quoted as saying Denver negatives went to Detroit Publishing Co., and also that they went to his successor. It is likely that the Denver general studio portrait negatives stayed with his unnamed successor, and the scenic western views went to Detroit.
1898	Does pictorial on Trans-Mississippi and International Exposition Omaha, Neb. Continues to travel for railroads
1924	Photochrome Co. collapses and Jackson sells out; retires from Detroit Publishing Co.
1938	Technical advisor for filming of *Gone With The Wind*
1942	Dies in New York City
Tribes	Northern and Southern Plains; Plateau; Basin; Southwest
References	*Jackson, 1940; Newhall and Edkins, 1974; Andrews, 1964*

James & Pierce (George Wharton James & C. C. Pierce)

1901	Copyrights images of Southwest Indians

James, George Wharton (b.1858–d.1923)
Anthropologist and traveler who also photographed Southwest Indians, especially the Hopi Snake Dance. Two thousand of his glass plate negatives were obtained by C. C. **Pierce,** and are part of the Title Insurance and Trust Co.'s Historical Collection at the Calif. Historical Society. A second collection of negatives is at the Southwest Museum, Los Angeles, Calif.

Tribes	Southwest (Hopi)
References	*Rudisill, 1973; Kurutz, 1978*

Jarvis, John (b.c. 1850: England–d.?)

1868	Hired by William H. **Jackson** in Omaha, Neb. studio as printer
6/8/1870	Census: Neb.: Omaha as age 20 from England (lives close to W. H. Jackson family)
c. 1871	Goes east to Washington DC at the same time as Jackson; opens up a studio in Washington DC; especially active as publisher
Tribes	Plains?

Johnson, Charles G.
Made some of the earliest photographs in Ariz., including the Cocopa Indians

1868	Moves to San Francisco, Calif. Publishes a book with tipped-in photographs, originally scheduled to be serialized in twenty-five parts, but only three parts issued.

1897	Still living, in Tombstone, Ariz.T.
Tribes	Southwest (Cocopa)
Reference	William Reese & Co., Cat. no. 19, entry no. 30

Kaadt, Christian G. (b.3/1868: Denmark–d.5/10/1905) (Santa Fe Art Studio)
Possibly took photographs of Indians, but made excellent copies of other photographers' works, such as those by Hillers.

c. 1885	To Clinton, Iowa, where learns photography
1893	Moves to Santa Fe; opens studio
1903	Official photographer of Santa Fe Central Railroad

Keen, G. E.

| 1890s | Photographed Dakota; studio at Mankato, D.T. |

Kelly, R. L.
Photographed Indians, and copied works by Barry, Gardner, etc.

| 1880s–90s | Photographed Dakota; studio at Pierre, D.T. |
| Tribes | Northern (Dakota) |

Kelly, W. F.

| c. 12/1892 | Photographs Nisqually |
| | Studio at 1111 E. St., Tacoma, Wash. |

Kirkland, Charles D. (Brother of George Kirkland)

c. 1868	Goes to Denver and works for W. G. **Chamberlain**
1868–71?	Runs Chamberlain studio during Chamberlain's travels
Tribes	Northern Plains?; Basin?
Reference	*Mangan, 1975*

Kirkland, George (Brother of Charles Kirkland)

Summer 1871	Joins W. G. **Chamberlain** on summer photographic trip; encounters Indians
†	Other possible summer trips with Chamberlain
1876	Denver BD at 377 Larimer St.
1877	Denver CD as 'expressman', NAG
Tribes	Basin (Ute)
Reference	*Mangan, 1975*

Klenze, H. G.
Work known only from mount imprints at the Amon Carter Museum, 'H. G. Klenze, successor to **Barry** (c. 1890?), Bismarck and Standing Rock, D.T.' and 'H. G. Kenze, successor to D. F. Barry, photographer, Bismarck, D.T. and Fort Assiniboine, M.T. Photographs of Noted Indian Chiefs ...' and 'H. G. Klenze, photographer, Fort Assiniboin, M.T. ...' (Barry leaves Bismarck in 1890).

| Tribes | Plains |

Lamon, W. H.

| c. 1860s | Cdv studio portraits of Arapaho |
| | Studio listed at Lawrence, Ks. |

Lenney, ? (Also '**Lanney**') (Lenney & Sawyers; Hutchins & Lanney)
In 1890s, in Oklahoma area, was possibly working with, printing for, or selling photographs to James Mooney of the Bureau of American Ethnology, who was also in the area. Undated partnerships with **Sawyers** in Purcell, I.T. and with **Hutchins** in area of Ft. Sill

| Tribes | Southern Plains (Arapaho, Comanche and Kiowa); Southwest (Apache) |

Loock, ?

| 1890s | Undated stereographic field view of Dakotas |
| | Studio listed at Rapid City, S.D. |

Lummis, Charles Fletcher (b.3/1/1859; Lynn, Mass.–d.11/25/1928: Calif.?)

1877–78	Goes to Harvard and works as printer in N.H.; possibly learns photography
1881	To Chillicothe, Ohio
9/12/1884	Starts 'Tramp Across Continent' from Cincinnati, Ohio
2/1885	Arrives Los Angeles
	Becomes City Editor of *Los Angeles Times*, developing active interest in photography
1886	Covers Apache Wars in Ariz.T.
12/1887	Suffers paralyzing stroke
Fall, 1888	To N.M.
	Moves into Isleta Pueblo and takes photos
1891 and 1892	Publishes several books, some with illustrations
1892	Leaves Isleta and goes on Peruvian expedition as photographer with A. Bandelier
1893	Returns to Los Angeles. Takes other trips and photographs Indians, etc.
1/1895	Becomes editor of *Land of Sunshine*, an illustrated magazine, using his photographs and those of Adam Clark **Vroman**
1899	Publishes series of articles, 'My Brother's Keeper', as reaction against convention of Indian educators held in Los Angeles and directly against Pratt and the Indian School

1901	Founds Sequoya League, an organization to aid Cupeno Indians
Tribes	Southwest (Isleta)
References	*Williams, 1981; Moneta, 1985*

Markey, D. A. (Also 'C. A.' Markey)
Some studio props appear to be the same as in the **Randall/Wittick** studio.

| 1887 | Field views of Apache |

Martin, James E. (b.c. 1824: N.Y.–d.?) ([Benjamin Franklin] Upton & Martin)

1858	Minn.: St Paul BD: 3rd between Washington and Franklin
1862	Makes photographs relative to Sioux Revolt
1863	St Paul BD at 3rd between Washington & Franklin
1864–66	St Paul BDs at 315 3rd (Greenleaf's Block)
1867–69	St Paul BDs at 264 3rd
1870–71	St Paul CDs at 264 3rd; John **Morrison** is proprietor of Martin's gallery, but Martin not listed
†	Undated partnership with B. F. **Upton** in St Paul
Tribes	Northern Plains (Dakota)

Matteson, Sumner W. (b.9/15/1867: Decorah, Iowa–d.1920)

1896	In Denver, Colo. selling bicycles and Kodak equipment
1898–99	Travels on bicycle around US taking photographs, especially in Southwest
Spring 1900	Travels again to Southwest around Taos; photographs Snake Dance
1901	Returns to Hopi villages with McCormick Hopi Expedition of Field Museum
1902	Photographs Hopi Pueblo at same time as **Vroman** and others
1904	Starts giving illustrated lectures
1905 and 1906	Photographs 4th of July celebrations at Ft. Belknap with Gros Ventre and Assiniboin Indians
1909	More or less stops taking photographs and travelling around
Tribes	Southwest; Northern Plains
Reference	*Casagrande and Bourns, 1983*

Matzen, James (also 'Matsen')

1895	Omaha CD lists but NAG
1896	Omaha BD at 912 N. 24th
1897–98	Omaha BD at 1406 Farnam
c. 1900	Partnership formed, **Heyn & Matzen**, possibly active during the Trans-Mississippi and International Exposition in Omaha in 1898 due to the large number of Indian portraits, many copyrighted c. 1900
Tribes	Plains (Dakota)

Maude, Frederic Hamer
Important photographer of Southwest Indians at the turn of the century. Undated studio at 101 1/2 Broadway, Los Angeles, Calif. Undated partnership, Maude & (George Wharton) **James.** Confusion over attributions with E. E. **Hall**, James, and G. B. **Wittick**.

Maynard, Hannah Hatherly (b.1/17/1834: Bude, England–d.5/15/1918: Victoria, Canada)
Work intertwined with that of her husband, Richard **Maynard**; made experiments with novel techniques. Along with Richard, acquired **Dally** negatives and printed them.

1852	Marries Richard Maynard
1862	Moves to Vancouver Is, Canada, possibly opening Mrs R. Maynard's Photographic Gallery
1862?–74	Victoria, Vancouver Is. lists at Johnston St., corner of Douglas
1875	Trip with husband to San Francisco
1874–92	Victoria, Vancouver Is. lists at Douglas St., corner of Johnson St.
1879	Trip with husband around Vancouver Is.
1887 or 1889	Trip with husband to Queen Charlotte Is.
1892–1900†	Victoria, Vancouver Is. lists at 41 Pandora Ave.
1910	Disposes of photographic equipment to Chinese photographer named 'Peter', on Government St., Victoria
Tribes	Northwest Coast
Reference	*Mattison, 1985*

Maynard, Richard (b.2/22/1832: Straton, England–d.1/10/1907: Victoria, Canada) Work intertwined with that of wife, Hannah **Maynard.** Takes trips with her (see above). Acquired negatives of **Dally,** and printed them with self-credit lines.

1852	Marries Hannah Hatherly
1858–59	Goes to Bowmanville to mine gold in Fraser River
3/1862	Returns to Victoria, leaves again, and returns
5/1864	Takes earliest known photograph of city of Victoria
1864–74	Victoria, Vancouver Is.: Fort Street
1873	Goes on inspection tour along east coast of Vancouver Is. and Northwest Coast of mainland with Indian Affairs Commissioner, I. W. Powell; takes photographs
1874	Makes second trip with I. W. Powell around Vancouver Is., but weather prevents taking photographs
1874–1892	Victoria, Vancouver Is. lists at Douglas St., corner of Johnson St.

1879	Photographic trip to Alaska
1882	Photographic trip to Alaska
1884	Trip to Queen Charlotte Is. with Captain Newton H. Crittenden
1887	Photographic trip to Alaska
1888	Trip with Hannah to Queen Charlotte Is.
1892	Photographs seal rookeries at Pribilof Is.
1892–1900†	Victoria, Vancouver Is.: Pandora Ave.
Tribes	Northwest Coast
References	*Weissman, 1980; Mattison, 1985*

McEvoy, ?

†	Cabinet studio portraits of Shoshoni
	Studios at Blackfoot, Idaho Falls, Pocatello, and Montpelier, Idaho

McGowan, Joseph H. (Mitchell & McGowan)

1878	Neb.: Omaha BD at S.W. corner of 12th and Harney (**Mitchell & McGowan**)
†	Stereograph imprint, 'Mitchell, McGowan & Co., 513 12th St., Omaha, Neb.'
Tribes	Plains

Meddaugh, J. E. (Possibly related to O. E. Meddaugh who records Pomo *c.* 1912)

1888	Field views of Dakota at Pine Ridge
	Studio listed at Rushville, Neb.

Miller, ?

1891	Studio portrait of Osage; studio at Arkansas City, Ks.

Miller, ?

c. 1880s	Portraits of Sitting Bull and family circulated
	Studio listed at Aberdeen, S.D.

Miller, A.

Appears to have pirated many of **Randall/Wittick** portraits; possibly does own field work. Studio listed as Ft. Apache.

Tribes	Southwest?

Miller, Fred E. (b.8/25/1868: Chicago, Ill.–d.4/1936)

1896	Learns photography in Bloomfield, Iowa.
pre-1896	Undated studios in McCook and Pauline, Neb. and Clarksville, Iowa
1896	Moves to Helena, Mont., works for newspaper, becomes assistant clerk and records for the Bureau of Indian Affairs on the Crow Res.
c. 3/1898	Accepts position as land clerk at Crow Agency, Mont. (through years acts as clerk, chief clerk and occasionally as acting agent)
	Active photographing Crow Indians at the Agency
	During stay gives tours to artists, Joseph H. **Sharpe**, Edgar S. **Paxon** and Frederic **Remington**
1905	Adopted into Crow nation
1910	Resigns job at Crow Agency, and stops taking Indian photographs. Moves to Hardin, Mont.
†	In later years starts to write history of his years with the Crow; however notes disappear shortly before his death in 1936
†	Collection of five hundred glass plates sold to photographer in Billings, Mont., and later purchased by druggist who has known Miller. Druggist dies and store bought out, negatives remaining in basement until taken to dump. Copies of photographs in Smithsonian Institution National Anthropological Archives and University of Mont.
Tribes	Plains (Crow)
Reference	*Castles, 1971*

Mitchell & Baer (Capitol Art Gallery)

The same backdrop appears as in the **Buehman & Hartwell** photographs.

1890s	Studio portraits of Southwest Indians
	Studio listed at Prescott, Ariz.
Tribes	Southwest

Mitchell & McGowan (Daniel S. Mitchell & Joseph H. McGowan)

1878	Neb.: Omaha BD: Mitchell & McGowan S.W. corner of 12th and Harney

Mitchell, Daniel S. (b.*c.* 1837: Maine–d.?) (Mitchell & [Joseph H.] McGowan)

1876	Cdv imprints, 'D. S. Mitchell, Eddy St., Cheyenne, Wyo.'
1878	Neb.: Omaha BD at Mitchell & McGowan S.W. corner of 12th and Harney
†	Undated stereograph, 'Mitchell, McGowan & Co., 513 12th St., Omaha, Neb.'
1879	Omaha BD as Manager Bee Hive Photo Gallery 211 N. 16th
1880	Omaha BD as Manager Bee Hive Photo Gallery 213 N. 16th
6/1/1880	Census: Omaha as age 43 from Maine (lives with sister, May Connell, a retoucher named Davenport, and a printer, McLugin?)
1881	Omaha BD as Manager Bee Hive Gallery 213 N. 16th; May 'Cannell' is proprietor

1883	Manager Beehive Photographic Studio, and proprietor Pioneer Photographic House, 213, 215 N. 16th
1884	Omaha BD: Manager Bee Hive Studio, 213 N. 16th
1884–85	Neb. BD at studio in Norfolk
10/8/1885	Sells Norfolk., Neb. studio to I. M. **Macy** and C. E. **Doughty**
	Opens up a poultry yard
1886	Omaha CD lists only house address (Bee Hive Gallery listed at 213 N. 16th with H. E. **Gray** as proprietor)
Tribes	Plains
Reference	Personal communication, John Carter, NebSHS, to author (Fleming), 11/1985

Monsen, Frederick I. (b.1865: Bergen, Norway–d.1929)

1868	Comes to Utah T., father describes himself as photographer
†	Works as photojournalist on assignment with photographers such as W. H. **Jackson**
1886	Unofficially travels with US Geological Survey to fix boundary between US and Mexico
	Works for Generals Crook and Miles at end of Apache campaign
1889–90	Substitutes for Frank **Nims** on Brown-Stanton Survey
1893	Spends six months in Death Valley taking photos
1894–95	Works among the Southwest Indians
1896	Joins Yosemite National Park Boundary Survey as topographer and artist
1897 &†	To Southwest Indians, returning several times, sometimes with A. C. **Vroman**
	Begins preference for Kodak camera
†	Establishes studio in San Francisco, and compiles collection of Southwest Indian photographs
1906	San Francisco earthquake destroys studio, and most of photograph collection. Is able to partially reconstruct collection by copying his circulated prints, as well as those lent to him by Vroman
	Turns almost exclusively to illustrated lectures
1923	Huntington Library purchases 373 large Southwest Indian prints
Tribes	Southwest
Reference	*Current and Current, 1978*

Morledge, Clarence Grant (b.?–d.7/9/1948) (also Clarence Morledge Grant)
Active in photography from the 1880s, especially in the area of S.D. and Neb. Recorded the aftermath of Wounded Knee in 1891. Images usually marked with initials 'C.G.M.'

Tribes	Northern Plains (especially Dakota)

Morris, J. L.

†	Cabinet studio portrait of Kansa Indian
	Studio listed at 829 Mass. St., Lawrence, Ks.

Morrow, Stanley J. (b.5/3/1843: Richland Co., Ohio–d.1921: Dallas, Texas) Took frequent summer photographic tours of D.T. and Mont.

Late 1860?	Family probably moves to Wisc.
9/19/1861	Enlists with 7th Wisc. Infantry
4/6–9/1/1864	Transferred to Volunteer Reserves, serving at Point Lookout Prison, Md., where learns photography under M. B. **Brady**
c. 1864	Returns to Columbia County, Wisc. as photographer; marries
1886	Moves to Yankton, D.T.
1/30/1869	Establishes studio in Yankton, Fuller's Block, which remains his home base for fifteen years
3/15–4/24/1869	Trip to Sioux Falls, D.T.
1869–70	Works in Yankton studio during winter
Spring 1870	Begins trip up Missouri River with wife, stopping at Ft. Rice, Ft. Buford, Ft. Stevenson, Ft. Totten, Ft. Abercrombie, Ft. Wadsworth, Minneapolis, and Sioux City; *c.* July photographs signers of treaty between Yanktonai Dakota, Arikara, Hidatsa and Mandan at Ft. Berthold
1/7/1871	Returns to Yankton
?–8/8/1871	Trip to Fts. Rice and Buford
1/5/1872	Does illustrated travelog and takes it on tour
3/1872	Returns to Yankton
4/1/1872	Takes another trip
1/1873	Builds new studio in Yankton
c. 5/1873	Trip with family to Mont. and Fort Benton
7/–9/1876	Takes trip to Black Hills, meets with Crook Expedition and photographs; continues with them to Red Cloud Agency
12/20/1876	Returns to Yankton
6/22/1877	Another trip, but not Sheridan's Custer exhumation
Fall 1878	Takes over Ft. Keogh studio as branch operation
4/1/1879	Accompanies Captain Sanderson's Custer reburial expedition
8/16/1879	Becomes Ft. Custer post photographer

5/5/1879	End of Ft. Custer studio work
12/1879	Sells Ft. Keogh studio to L. A. **Huffman** and returns to Yankton
6/4/1880	Census, D.T.: Yankton as age 38 from Ohio (also living with family is L. M. **Johnson**, a 24-year-old photographer from Iowa; living nearby is Morrow's brother-in-law, **Ketchum**, 29 from Iowa, who also has a studio)
Summer 1880	Builds new studio in Yankton
8/1882–4/1883	Trip to Fla., Yankton studio operated by L. W. **Marble**
1883	Retires, devoting life to travel and photography in east and south
Tribes	Plains
References	*Hurt and Lass*, 1956; *Gray*, 1978

Mudge, The Misses

†	Undated boudoir prints of Shoshoni
	Studio listed at Blackfoot, Idaho

Muybridge, Eadweard James (b.4/9/1830: Kingston-on-Thames, England–d.5/8/1904: Kingston-on-Thames) (Born 'James Edward Muggeridge')
Very famous photographer; only his basic developmental and Indian-related dates are listed.

1852	To America; takes up photography
1860	Photographs for US Geological Survey on Pacific coast and later director of photographic surveys in that region
c. 1867	Works with Silas **Selleck** in San Francisco
1868	To Alaska with government military force, visits Ft. Wrangell and photographs Tlingit Indians
1869	Moves from Selleck's to **Nahl**'s Gallery at 121 Montgomery St.
c. 1870	Has own gallery in San Jose, Calif.
†	Studio known as 'Helios' and 'Helios' Flying Studio,' 111 and 121 Montgomery St., San Francisco
1871	With **Houseworth**'s Gallery in San Francisco, Calif.
1872	With **Bradley & Rulofson**, San Francisco, who publish many of his images
5/1872	Begins experiments to record motion photographically
c. 5/3–5/11/1873	Records Modoc War for government
10/1874	Kills Major Larkyns, but acquitted; spends two years in S. America, and then returns to N. America, continuing motion studies
Tribes	Northwest Coast (Tlingit); Plateau (Modoc)
References	*Andrews*, 1964; *Palmquist*, 1977; *Mattison*, 1985

Nast, C. A.

c. 1880–1901	Studio portraits of Ute
	Studio listed at 1604 and 1694 Curtis St., Denver, Colo.
10/12–11/7/1882	To Santa Fe, San Francisco St.
Tribes	Basin; Southwest?
Reference	*Rudisill*, 1973

Newcombe, C. H. (also 'G. H. Newcombe')

6/16–17/1884	Field photographs of Dakota
1903	Field photographs of Nootka
	Studios listed at Dakota Ave., Huron, Dakota and Oak Street, Watertown, Dakota

Northwestern Photo Company (George E. Trager)
Company apparently formed in Chadron, Neb. to circulate images taken by Trager who made first photographs of the aftermath of Wounded Knee, 1/1890.

Notman, William (b.1826: Renfrewshire, Scotland–d.1891)
Emigrated to Montreal, Canada, in 1856 and set up a studio. A leading Canadian photographer, and the first Canadian photographer to produce extensive stereograph series; obtained royal appointment in 1865. Main studio was in Montreal. Used props to simulate outdoor scenes. Photographed Huron Indians with these same props. Had other studios at Halifax, Toronto, Ottawa, New York, Boston, Albany and Newport. His sons, Charles F., George W., and William McFarland (sometimes confused with his father, William Sr), accompanied him on trips. William McFarlane and Charles took over the work when William Sr died.

Tribes	Canadian Ojibwa and Huron
References	*Beaton*, 1975; *Colnaghi*, 1976

Ottinger, George Martin. See **Savage & Ottinger.**

Palmer, Albert A.

1880s?	Field? photographs of Chippewa
	Studio listed at Minnehaha Falls, Minneapolis, Minn.

Parker & Johnson (Charles Parker & Ira T. Johnson) There is confusion over the studio carpet: it is also credited to **Jackson Bros.** as well as Edric **Eaton.**

1868	Johnson works in **Jackson Bros.** studio, Omaha
1870	Parker & Johnson forms; claims to be 'successor to Jackson Bros., corner of Douglas and 15th St., Omaha'
	Omaha BD as at 228 Farnham

Parker & Parker ([Francis?] Parker & ? Parker)

†	Cdv studio portraits of Calif. Indians
	Studio listed at corner of F & 6th, San Diego, Calif.

Parsons, George W. (b.3/1845: Arkansas)

1890s	Field views of Osage
	Studio listed at Pawhuska, O.T.

Perry, H. B.

1888	Field view of Dakota meeting commission at Lower Brule Agency, D.T.
	Studio listed at Chamberlain, D.T.

Pierce, C. C. (b.1853–d.1946)

1886	Comes to Los Angeles, Calif., and establishes himself as a photographer
†	Amasses large collection of photographs relating to Los Angeles, etc. Obtains other photographers' work, especially George Wharton **James**'s Indian negatives May also have taken own photographs of Indians
Tribes	California?; Southwest?
Reference	*Kurutz*, 1978

Prettyman, William S. (b.11/12/1858: Delaware–d.?)

1879	To Ks. Apprenticed to I. H. Bonsall in Arkansas City, Ks.
†	Opens own gallery in Arkansas City, Ks.
1883	Makes photographic trip to I.T.; thereafter makes approximately one trip a year for the next ten years During absences from studio, had a partner to cover. These included Prettyman and **Miller;** Prettyman and **McFarland;** and Prettyman and (George B.) **Cornish.**
1891	Photographs land rush into Iowa Indian and Sauk and Fox areas
9/16/1893	Photographs Cherokee outlet land rush
†	Leaves Arkansas City, negatives stay with Cornish Moves to Blackwell, I.T./O.T.? and opens studio
1895	Photographs last run into Kickapoo country east of Oklahoma City
1905	Sells business, leaving negatives behind, and goes west Negatives preserved from Arkansas studio by Cornish. As Cornish moves his studio, takes Prettyman and Bonsall negatives with him. Makes safety copy negatives and although he copyrights the images, does credit Prettyman. Negatives then to Cunningham (Prettyman's biographer) collection
Tribes	Southern Plains; Indian Territory
Reference	*Cunningham*, 1957

Randall, A. Frank
Further research is needed on this important Indian photographer. Confusion exists as to correct authorship of many negatives, especially Apache, where George Ben **Wittick** negatives exist of images copyrighted by Randall, and Randall prints captioned by Wittick. Also, he copyrighted photographs copyrighted by **Buehman,** or vice versa. Some images were apparently also pirated from him by A. **Miller.** Was mostly itinerant in 1882–86, with center of operation at Wilcox, Ariz.T. Did have studio at Montezuma Block, Las Cruces, N.M. from c. 12/1885–5/1886. Some prints for 1886 identify studio in Deming, N.M. Made an expedition with General Crook into Mexico.

Tribes	Southwest (Apache)
Reference	*Rudisill*, 1973

Reed, Roland W. (b.1864: Fox River Valley, Wisc.–d.1934)

1890	Makes Indian sketches but turns to photography
1893	Apprenticed to Daniel **Dutro**, Havre, Mont. Begins itinerant work with Dutro photographing Indians, etc. Sells images to, or works on contract with, News Department of the Great Northern Railroad
1897	Reed leaves Dutro to photograph Alaskan gold rush and Alaskan Indians (does not do so – finds them 'uninteresting')
1890	Opens studio in Bemidji, Minn.
†	Studios in Ft. Benton and Great Falls, Mont. and Ortonville, Minn.
1907	Closes studio and starts great endeavor to record Indians
1934	Dies. Negatives go to cousin; later sold to Kramer Gallery, St Paul
Tribes	Plains; Southwest
Reference	*Johnston*, 1978

Rinehart, Frank A. (b.1862: Illinois–d.?) Son of Alfred Evan **Rinehart**, who was also a photographer, and one-time partner with W. H. **Jackson** in Denver, Colo.

1881–85	Colo.: Denver CDs at 413 (and 1883, also at 415 1/2) Larimer St. (Alfred E. **Rinehart**'s studio; lives with Fred **Jackson**, William Henry's son)
1886–90	Neb.: Omaha BDs at 1520 Douglas St.
1891–92	Neb.: Omaha BD at 1524 Douglas St.

1893–1901	Neb.: Omaha BDs at 1520 Douglas St.
	Adolph **Muhr** with him in 1901 and †?
1898	Photographs Indians with A. Muhr at Trans-Mississippi and International Exposition, Omaha, Neb.; makes one set on contract for Bureau of American Ethnology, copyrights second set
1900	Census: Neb.: Omaha as born 1862 from Ill.
1902–15 &†?	Neb. Gazetteers: studio in Omaha

Reynolds Photo Company
A photographic wholesale and retail dealer, circulated photographs of D. F. **Barry**, and George E. **Spencer** (who is also known to have copied Barry images), and probably many others. Possibly also took photographs of Indians on its own. Studio c. 1890s listed at 201 S. Clark St., Chicago, Illinois.

Robertson & Co.

†	Undated cabinet studio portraits of Creek Indians
	Studio listed at Muskogee, I.T.

Robertson & Hastings (Robertson & [Oregon Columbus] Hastings)

1873	Photographs Haida objects; also Indians?
	Studio listed at Port Townsend, Wash. Terr.

Robinson, H. P.

1890s	Field and studio photographs of Arapaho and Comanche, O.T.
	Studio listed at Ft. Sill, O.T.

Rodocker, D. (b.10/1840: Ohio)

c. 1890s	Studio portraits of Comanche and Apache or Kiowa-Apache
	Studio listed at Winfield, Ks.

Rose & Hopkins (John K. Rose and Benjamin S. Hopkins)

1896–1901	In Denver, Colo.
1899	Photographs and copyrights many Indian studio portraits
Tribes	Basin; Plains; Plateau

Rothrock, G. H. (Rothrock & Barnett)

†	Undated stereographic studio photographs of Southwest Indians
	Studio listed at Phoenix, Ariz.
†	Undated partnership with **Barnett**
Tribes	Southwest

Russell

†	Cabinet studio portrait of Kiowa
	Studio listed at Anadarko, O.T.

Russell, R. W. (Wittick & Russell)

c. 1880	Partner with George Ben **Wittick** in Santa Fe, N.M.
	Russell apparently runs studio while Wittick travels
1881–84	N.M.: Albuquerque BD: Gold Ave., between 1st and 2nd Sts.
Tribes	Southwest
Reference	*Rudisill, 1973*

Sanders, Charles (also 'Saunders')

1880s	Photographs Acoma and Hopi
	Some images credit Sanders in plate but on William H. **Cobb** mounts
Tribes	Southwest

Savage & Ottinger (Charles Roscoe Savage & George Martin Ottinger)

1862	Partnership formed, Salt Lake City, Utah
1867 and 1869	Salt Lake City BDs at W. side E. Temple between 1 and 2
1870	James **Fennemore** works at studio
c. 1870	Partnership dissolves; Ottinger resumes career as artist; both remain friends

Savage, Charles Roscoe (b.8/16/1832: Southampton, England–d.1909: Salt Lake City, Utah)

1858	Arrives in US with Mormons
	Works in N.Y. with photographer Elder **Stenhouse**, also a Mormon
1859	Leaves N.Y. for Neb.
1860	Sets up studio in Council Bluffs, Iowa
6/7/1860	Leaves for Salt Lake City, Utah
6/20/1860	Census: Neb.: Platte Co.: El Dorado as age 29 from England
8/28/1860	Arrives Salt Lake City
c. 8/30/1860	Becomes partner with Marsena **Cannon**, Salt Lake City
	Studio is called Pioneer Art Gallery
c. 1861	Cannon leaves partnership
1862	Forms partnership **Savage** & (George Martin) **Ottinger**
c. 1862	Charles W. **Carter** works with Savage
c. 3/1866	Trip to Calif. for railroads, then to N.Y. and back to Utah
	Purchases photo supplies and photographic wagon; much lost on return trip

1867 and 1869	Salt Lake City BD as Savage and Ottinger, W. side E. Temple between 1st and 2nd
1869	Photographs joining rails at Promontory Point for Union Pacific
1870	Photographic tour with Brigham Young through upper Rio Virgin country and Zion Canyon area
	Partnership Savage & Ottinger dissolves
	James **Fennemore** is employee
	Census: Utah: Salt Lake City as age 37 from England
1870s	George E. **Anderson** is apprentice
1874	Salt Lake City BD: Savage Pioneer Art Gallery (also 'Bazar'), E. Temple W. side between S. Temple and 1 S.
8/5–10/1879	Trip to England with George Ottinger
1880	Census: Utah: Salt Lake City as age 47 from England
6/21/1883	Pioneer Art Bazar burns, all destroyed
Fall 1883	Studio rebuilt
	Is using dry plate negatives
1884 and 1888	Salt Lake BDs at Savage's Art Bazar, 12 and 14 S. Main
1885	George L. **Savage** is assistant
1890	Salt Lake BD at 12 S. Main
	Assisted by Roscoe E. **Savage** and Ralph Savage
1906	Sells company to his sons
Tribes	Basin
Reference	*Wadsworth, 1975*

Schwemberger, Brother Simeon
Franciscan monk with studio in Gallup, N.M. and Window Rock, Ariz.

Tribes	Southwest
Reference	*Rudisill, 1973*

Scott, George W.

c. 1880s	Photographs Dakota; studio listed at Ft. Yates

Severn, Thomas

†	Undated cabinet portrait of Pawnee
	Studio listed at 215 Jefferson St., Joliet, Ill.

Shuster

c. 1880s	Makes Tillamook studio portraits
	Studio listed at Tillamook, Oregon

Sipple's Art Studio

1880s	Makes studio portraits of Osage
	Studio listed at Parsons, Ks.

Slocum, J. E.

1880s	Operates studio in San Diego, Calif.
†	Undated views of Laguna Pueblo
Tribes	Laguna
Reference	*Rudisill, 1973*

Smith & Hassell Co.

1889	Copyrights Ute field and studio photographs
	Studio listed at Denver, Colo.

Smith, William A. (Wertz & Smith)

Summer 1866	Partner with **Wertz**
1867	Photographic assistant with Indian Commissioner Graves investigating Navaho at Bosque Redondo.
	Takes photographs of Bosque, but unlocated
Tribes	Navaho
Reference	*Rudisill, 1973*

Snell, E. B. (Elite Gallery)

†	Undated cabinet portraits of Cheyenne
	Studio listed as Elite Gallery, Wellington, Ks.

Soule Art Company & Soule Photograph Company (John P. and William Stinson Soule)
Mainly publisher of Indian views at the turn of the century. Some images marked on plate 'F.D.G.' Studios at various addresses in Boston, Mass. Field photographs of Indians taken earlier by William.

Soule, William Stinson (b.8/28/1836: Turner, Maine–d.?)

1861	Listed as photographer in Army; wounded in action
1865	Studio in Chambersburg, Pa.
1866 or 1867	Chambersburg studio burns; sells equipment
1867	Goes to Ft. Dodge, Ks., via St Louis and Ft. Leavenworth; works in store and begins taking Indian photographs (most Indian photographs probably made at this time)
Late 1868	To Ft. Sill and Camp Supply, O.T.; probably continues some Indian photography

1874 or 1875	Leaves Ft. Sill and goes to Boston to work with brother, John P. **Soule**, who later publishes some of William's Indian photos
Tribes	Southern Plains
References	*Nye, 1968; Belous and Weinstein, 1969*

Spencer, George E.
Confusion exists over authorship of some of Spencer's photographs. Some are copies of works by D. F. **Barry**, and some are also credited to **Reynolds** Photo Company (also of Chicago), and to **Stilwill**.

| *c.* 1890s | Images (many copies) of Plains Indians |
| | Studio listed at 7520 Ellis Ave., Chicago, Ill. |

Spencer, Stephen Allen (b.1829?: near London, Conn.–d.8/15/1911; Victoria, Vancouver Is.) (Spencer & Hastings)
Early pioneer photographer in Canada. See *Mattison*, 1985, for extensive studio information. Married Annie Hunt, a Kwakiutl, and sister of George Hunt, Franz Boas's chief informant. Took many undated stereographic views of Northwest Coast Indians.

Standiford, ?. F.

| † | Undated cabinet portrait of Creek |
| | Studios noted at Muskogee, Creek Nation; Wagoner, Eufaula, Tahlequa and Uineta, I.T. |

Stephenson, Richard (Stephenson & Addis)

1859	Studio at Leavenworth, Ks. at 40 Delaware St.
1860	Partner with Alfred S. **Addis** at 40 Delaware St.
1862	Addis leaves; Stephenson at 40 Delaware St.
	Apparently acquires Addis negatives of 1859 Cheyenne and Arapaho delegation
1870	Studio at 48 Delaware St.
	Meets William Blackmore, who acquires Addis negatives
Tribes	Southern Plains
Reference	Roberts to Fleming; British Museum Album 12, title page

Stevenson, ?

| *c.* 1890s | Studio portraits of Cheyenne |
| | Studio listed at El Reno, O.T. |

Stillwell, L. W.
Probably took photographs of Indians, but also copies from others, such as D. F. **Barry**. Duplicate images are also credited to George E. **Spencer**. Studio listed at Deadwood, S.D.

Stobie, C. S.

1867	Takes photograph of Big Rib, Dakota
	Studio listed at 71 Hanover St., Chicago, Ill.
1868	William Blackmore purchases image from him for his collection
Tribes	Plains
Reference	Blackmore collection, Museum of N.M.

Stotz, C. C.

c. 1890–1907	Makes studio and field portraits of local Indians
	Studio listed at El Reno, O.T.
Tribes	Southern Plains; Indian Territory

Taber, Isaiah West (b.1830–d.after 1906)
Important studio operator in San Francisco 1864–1905, with connections in Boston. Wholesale dealer who probably contracted photographers. It is uncertain if he photographed Indians himself. Tribes represented are mostly from the Southwest.

| Reference | *Rudisill, 1973* |

Templeman, J. N.

| *c.* 1880s | Undated cabinet studio portrait of Dakota |
| | Studio listed at Miller, D.T. |

Toplegy (Topley?)

| pre-1891 | Chippewa studio portrait |
| | Studio listed at Ottawa, Canada |

Trager, George E. (b.?; Germany?–d.?) (also 'Traeger')

1876	Comes to America from Germany
Fall 1889	Arrives in Chadron, Neb.
11/1889	Purchases Miss A. **Luce**'s Bon Ton Gallery with his partner, Fred **Kuhn**
	Begins to photograph surrounding area and Indians
Fall 1890	Makes several photographic trips to Pine Ridge; thus is aware of location of Indians and military, both on the move. Travels with General Miles to scene of Wounded Knee
12/30/1890–1/1891	First to photograph the aftermath of Wounded Knee
1891	Forms Northwestern Photographic Company to circulate Wounded Knee photographs

Summer 1892	Sells Chadron Gallery and goes to Yellowstone Park
†	Goes to Fremont, Neb. and forms partnership, **Steadman** & Trager
†	Location after Fremont unknown
Tribes	Northern Plains (especially Wounded Knee)
Reference	*Mitchell* (1984?)

Trueman, Robert H.

1889–94	Partnership with Norman **Caple**
1895	Goes into business for himself
1895–99	Takes photographs of Blackfoot on Bow River
1900	Restricts activities to British Columbia
Reference	Dempsey to Blaker, 1966, Smithsonian Institution National Anthropological Archives

Tuttle, Moses C. (b.*c.* 1831: Maine–d.?)

1856	Ad. in St Paul BD, 'ambrotype and daguerreotype views of Indian Chiefs, rooms at **Whitney**'s Gallery corner of 3rd and Cedar'
1858	St Paul BD as at 3rd between Wabashaw and St Peter
†	Studio continues at St Paul; no evidence of further Indian work
Tribes	Northern Plains?

Upton & Martin *See* Benjamin Franklin **Upton** & James E. **Martin**

Upton, Benjamin Franklin (b.1818–living 1901) (Upton & [James E.] Martin)

1860s	Apparently takes field photographs of Ojibwa while has studios in St Anthony and Minneapolis, Minn. (studios may date as early as 1856)
1871	Minneapolis BD at 4th between Spruce and Cedar
1875	Minneapolis CD at 17 Johnston's Block
†	Undated partnership with James E. **Martin**
Tribes	Northern Plains (Plains Ojibwa)
Reference	Smith to Blaker, 1959, Smithsonian Institution National Anthropological Archives

Vroman, Adam Clark (1856: La Salle, Ill.–7/24/1916; Altadena, Calif.) Originally worked for the railroad. Made amateur photographic trips with the Camera Club, of which H. E. **Hoopes** was a member. Clubs such as these traveled together to photograph scenes, such as Hopi Snake Dances, etc., and therefore almost duplicate images were taken by several different photographers. Peter G. **Gates** took photographs at the same dance as Hoopes and Vroman. Sumner **Matteson** was also at Hopi during 1901 photographic trip, although not connected with the club. Vroman was a friend of C. **Lummis**. Another photographic traveling companion was W. R. **Harned**.

1892	Moves with wife to Pasadena, Calif.
1894	Returns with wife to Media, Penna., where wife dies
11/14/1894	After returning to Pasadena, opens book store; is also a Kodak dealer
1895	Makes first trip to Hopi in Ariz.; photos used by C. Lummis to illustrate his magazine, *The Land of Sunshine*.
1895–1905	Visits all Calif. missions and photographs them and the Indians
1897	Official member of BAE's expedition to Katzimo under Dr Hodge
1898	Begins 'The Club', a camera club that met in his home in Pasadena
1899	Again accompanies BAE under Hodge to Southwest pueblos and ruins; writes of his experiences in *Photo Era* between January and October, 1901
1901	To Southwest to photograph area and Indians
1902	With Camera Club to Hopi Pueblos etc.
1904	Last trip to Southwest to Canon De Chelly & Hopi
†	Continues with photography; travels to Orient
	Negatives at the Los Angeles County Museum of Natural History
Tribes	Southwest
References	*Mahood, 1961; Webb and Weinstein, 1973*

Wagner, James

Dec. 1890	Photographs Rosebud Agency
	Studio listed at Valentine, Neb.
Tribes	Northern Plains (Dakota)

Warnky & Abbott (F. C. Warnky and C. L. Abbott)

1878	In Garland, Colo.
1879	Photographs Indians at Abiquiu
	Studio listed at Alamosa, Colo.
Tribes	Southwest
Reference	*Rudisill, 1973*

Watkins, Carleton E. (b.1829–d.1916)
One of the most important American scenic photographers. Known to have published and bought Heller's views of Modoc War. May not have produced his own Indian photographs.

1854	Learns daguerreotypy from Robert **Vance** in Calif.
	Becomes operator for Vance
c. 1858	Opens own gallery in San Francisco
1861	Visits Yosemite Valley and starts scenic photography
1874	Buys Heller's views of Modoc War, producing them on his mount

1906	Studio and negatives destroyed by San Francisco earthquake
References	*Palmquist, 1977; Witkin and London, 1979*

Westmann, Orloff

9/30/1871	Works on contract for William Blackmore photographing Apache and Taos Indians at Taos, N.M.
	Studio listed at Elizabethtown, N.M.

Whitney & Zimmerman (Joel Emmons Whitney & Chas. A. Zimmerman)
Circulated large numbers of Indian photographs, many originally taken by Whitney.

Whitney, Joel Emmons (b.1822: Phillips, Maine–d.1886: St Paul, Minn.)

1850	To St Paul; learns daguerreotypy from Alexander **Hesler**
	Possibly meets Andrew **Falkenshield**
1856	M. C. **Tuttle** has rooms in his gallery
1856–66	St Paul BDs at corner of 3rd and Cedar
1860	Census: Minn.: St Paul as age 38 from Maine (lives with Andrew Falkenshield)
1862	Photographs participants in Sioux Revolt
1864 and 1867	Is aided in studio by E. L. Whitney, probably his wife, Elsie
1867	St Paul BD at 174 3rd corner of Cedar
	Chas A. **Zimmerman** works with Whitney, 174 3rd corner of Cedar
1869	St Paul BD as (Wm S.) **Combs** and Whitney, 174 3rd corner of Cedar
c. 2/25/1871	Whitney retires; and Zimmerman takes over studio and continues to circulate Whitney negatives under his name
Tribes	Northern Plains (Dakota and Plains Ojibwa)
References	Zimmerman to Powell, 2/23/1871, National Archives M156

Winter & Pond (Lloyd Winter & Percy Pond)

	Active in Alaska taking photographs of Northwest Coast Indians. In 1894 accidentally viewed secret Tlingit dance and initiated into tribe to solve dilemma. This started a long and fruitful relationship between the photographers and the Tlingit. They made many trips to visit them, photographing potlatches etc.
Tribes	Northwest Coast (Tlingit)
Reference	*Cunkle (Calmenson), 1973*

Wittick & Russell (George Ben Wittick & R. W. Russell)

c. 1880	Partnership formed in Santa Fe
	Russell does studio work; Wittick travels
3/1881	Partnership moves to Albuquerque, Gold Ave. between 1st and 2nd Sts.
1884	Partnership dissolves
Tribes	Southwest
Reference	*Rudisill, 1973*

Wittick, George Ben (b.1/1/1845: Huntingdon, Penna.–d.8/30/1903: Ft. Wingate)

1861	Stationed at Ft. Snelling, Minn. in Army
	If photographer at this time, could have been there to record participants in Sioux Revolt, 1862
Late 1870	Studio in Moline, Ill.
c. 1878–79	Goes to Santa Fe for railroad work
	Partnership with W. P. **Bliss**
c. 1880	Partnership with R. W. **Russell**

3/1881	Partnership moves to Albuquerque, Gold Ave. between 1st and 2nd Sts.
1884	Wittick & Russell partnership dissolved
1884–7/1900	Studio in Gallup
	Sells out to Imperial Photograph Gallery
1900	Studio at Fort Wingate
	Assisted by son, Archie **Wittick**
1903	Dies; Archie continues business
Tribes	Southwest
Reference	*Rudisill, 1973*

Wolfenstein, Valentine (b.?: Sweden–d.?)

1860s	Served in American Civil War
†	Goes to Ft. Union, N.M. via Junction City, Ks.
†	Learns photography from Mr **Booth,** in Las Vegas, Nev. studio
1868	Photographs at Bosque Redondo, Ft. Sumner
1870	To Los Angeles, Calif.
c. 1872	Buys **Godfrey**'s Sunbeam Gallery, Los Angeles
Tribes	Navaho and Apache
Reference	*Rudisill, 1973*

Zimmerman Bros. (Charles A. & Edward O. Zimmerman & others, sons?)
Important both as photographers and as a photographic supply company.

1873	Minn.: St Paul BD at 216 3rd
1874–80	Minn.: St Paul BDs at 8 W. 3rd
1881–86	Minn.: St Paul BDs at 9(8) W. 3rd
1891–93	Minn.: St Paul BDs at 9 W. 3rd
12/1/1894–1901 and †?	Minn.: St Paul BDs at 99 and 101 E. 6th

Zimmerman, Charles A. (b.*c.* 1844; France–d.1909)
Probably learned photography from his father, also named Charles, who was a photographer. Circulated Joel E. Whitney negatives of Indians under his imprint after take-over of studio. Also apparently photographed Ojibwa Indians on his own. Went into business with brother, and later, with his sons? Also, was in partnership with Fred H. Whitestruk.

1866	St Paul CD lists but NAG
1867–70	St Paul CDs as with **Whitney,** 174 3rd
1870	Census: St Paul as age 26 from France (lives with father)
c. 2/25/1871	Takes over Whitney's studio
1873	St Paul BD at **Zimmerman Bros.,** 216 3rd
1874–80	St Paul BDs at Zimmerman Bros., 8 W. 3rd
1880	Census: Minn.: St Paul as age 35 from France (brother, Edward O., also listed as age 36 from Germany)
1881–86	St Paul BDs at Zimmerman Bros., 9(8) W. 3rd
1887–90	St Paul BDs at **Zimmerman & Whitestruk,** 9 W. 3rd
1891–93	St Paul BDs at Zimmerman Bros., 9 W. 3rd
12/1/1894–1901 & †?	St Paul BDs at 99 and 101 E. 6th
Tribes	Northern (Dakota and Plains Ojibwa)
References	Zimmerman to Powell, 2/23/1871, National Archives M156; Smithsonian Institution National Anthropological Archives file print 45, 479–A

REFERENCES

REFERENCES

ABBREVIATIONS

acc. accession
AR Annual Report
BAE Bureau of American Ethnology
DNI *Daily National Intelligencer*
encl. enclosed
IA Office of Indian Affairs
LR letters received
LS letters sent
misc. miscellaneous collection
MS manuscript
NARA National Archives and Records Administration, Washington DC (formerly NARS, National Archives and Records Service)
n.d. no date
n.s. new series
P & FAJ *Photographic and Fine Art Journal*
RG Record Group
SI Smithsonian Institution
SIA Smithsonian Institution Archives, Washington DC
SINAA Smithsonian Institution National Anthropological Archives, Washington DC
SPC Source Print Collection
USNM United States National Museum, Washington DC

NOTE

Full details of most publications cited in these References are contained in the Bibliography on pages 248–53. SI and USNM Annual Reports are referenced by the year they report, not the year of publication; BAE Annual Reports are referenced by number. Square brackets denote supplied information.

ONE THE BACKGROUND

1 *Taft*, 1938, p. 3
2 *Hagan*, 1976, p. 157
3 *Heski*, 1978, p. 25
4 *Taft*, 1938, n.p.
5 *Cobb*, 1958, p. 136

TWO PEACEFUL ENCOUNTERS

1 *Donaldson*, 1887, pp. 328–30
2 Ibid., p. 331
3 Ibid.
4 *Viola*, 1976, pp. 21, 145
5 *DNI*, December 13, 1851, p. 2
6 Allen and Hillary Weiner, *Photographic Sales Catalogue*, New York, 1981, p. 25
7 McIlvain to Fillmore, February 5, 1852, IA, RG 75, LR (misc.), NARA
8 *DNI*, January 10, 1852
9 Personal communication, Gary Roberts to author (Fleming). May 15, 1980; and in *Powell*, 1981, vol. 1, p. 113
10 William Little Chief to Commissioner of Indian Affairs, October 27, 1880, IA, RG 75, microfilm M234, roll 126, letter 1542, NARA
11 Report of Lower Sioux meeting, May 25, 1858, IA, RG 75, microfilm T494, roll 6, microfilm M234, roll 125, letter 1542, NARA
12 *P & FAJ*, vol. 10, n.s., vol. 4, October 1857, pp. 306–07
13 McClees circular in W.W. Turner papers, acc. 76–112, SINAA
14 *DNI*, December 16, 1857
15 *P & FAJ*, vol. 11, n.s., vol. 5, April 1858, pp. 98–99
16 Ibid.
17 *Weinstein*, Robert, 1978, pp. 1–8
18 Collection 4286, SINAA
19 Joseph Henry to James Denver, February 21, 1859, IA, RG 75, LR (misc.), NARA
20 Joseph Henry to Lewis V. Bogy, February 20, 1867, IA, RG 75, LR (misc), NARA

21 J.R. Hanson to Faulk, July 6, 1867, encl. with letter from Faulk to Commissioner for Indian Affairs, July 18, 1867, IA, RG 75, LR, Upper Missouri Agency (D–458), NARA; in *Viola*, 1981, pp. 70–71
22 *McElroy's Philadelphia City Directory*, 1867, under 'McClees' (no listings located in Washington DC city directory or newspapers)
23 *Richmond City Directory*, 1866, under 'Vannerson, Julian'
24 *P & FAJ*, vol. 12, n.s., vol. 6, June 1859, p. 130
25 *Boyd's Directory of Washington*, 1867, under 'Shindler, A. Zeno', 'Marvin, P.B.', 'Fountaine, Louis'
26 Clipping from *Washington Chronicle*, n.d., submitted with bill for advertisement, June 12, 1867, IA, RG 75, LR (misc.) (C–267), NARA: in *Viola*, 1981, p. 163
27 *Viola*, 1981, p. 164
28 *DeMallie*, 1981, p. 43
29 Ibid.
30 *Kappler*, 1904, vol. 2, p. 1011
31 *DeMallie*, 1981, p. 59
32 Ibid., p. 48
33 Circular to Superintendents and Agents, October 16, 1868, IA, RG 75, LS, vol. 88, pp. 150–52, NARA; in *Viola*, 1981, p. 47
34 Ibid., pp. 47–49
35 William Blackmore collection, box 8, item 0070, Blackmore diary 16, 1868, p. 17, History Library, Museum of New Mexico
36 [*Shindler*], 1867 [1869] (title page misdated '1867')
37 *Cobb*, 1958, p. 134
38 *Scherer*, 1975b, p. 73
39 Blackmore collection of photograph albums, British Museum, Museum of Mankind, London
40 *Jackson*, 1874
41 *Jackson*, 1877
42 Example: Collection SPC, Dakota: 4877, SPC 005947.00, SINAA
43 *Brayer*, 1949, vol. 1, p. 318
44 Shindler to Baird, September 19, 1876, RG 52, vol. 204, p. 327, SIA
45 *Cobb*, 1958, p. 136

THREE THE INDIAN WARS

1 *Utley and Washburn*, 1977, p. 178
2 *Brown*, 1970, p. 9
3 *Utley and Washburn*, 1977, p. 2
4 Ibid., p. 212
5 Personal communication, John C. Ewers to author (Fleming), 12/85
6 Ibid., p. 195
7 Ibid., p. 223
8 *Capps*, 1973, pp. 176–77
9 *Carley*, 1976, p. 19
10 *Prucha*, 1984, vol. 1, pp. 458–59
11 *Watson*, 1948, p. 62
12 Ibid.
13 *Utley and Washburn*, 1977, p. 258
14 *Prucha*, 1984, vol. 1, pp. 537–38
15 *Palmquist*, 1978, p. 193
16 Ibid., pp. 197–98
17 Example: SPC 015295.00, SINAA
18 *Mozley*, 1972, p. 46
19 *Palmquist*, 1978, pp. 45–46
20 *Gray*, 1978, p. 4
21 *Grosscup*, 1975, pp. 45–46
22 Ibid.
23 Ibid.
24 *Utley and Washburn*, 1977, p. 269
25 MS 2367–A, SINAA
26 *Watson*, 1948, p. 61
27 *Gray*, 1978, p. 8
28 Ibid., p. 9
29 Ibid., p. 7
30 Ibid., p. 10
31 *Utley and Washburn*, 1977, p. 302

32 *MacEwan*, 1973, opposite p. 96
33 *Gray*, 1978, p. 13
34 Personal communication, Gary Roberts to author (Fleming), 1985
35 *Prucha*, 1984, vol. 1, p. 539
36 *Bourke*, 1891, p. 476
37 *Mitchell* (1984?), p. 3
38 Ibid., pp. 4–5
39 *Niehardt*, 1972, p. 230

FOUR PLANNING FOR THE FUTURE

1 *Utley and Washburn*, 1977, p. 193
2 Ibid.
3 *Prucha*, 1984, vol. 1, pp. 449–50
4 Carleton to Chavez, June 23, 1863; in *Prucha*, 1984, vol. 1, p. 451
5 *Prucha*, 1984, vol. 1, p. 451
6 Carleton to Lorenzo Thomas, September 6, 1863; in *Prucha*, 1984, vol. 1, p. 452
7 *Prucha*, 1984, vol. 1, p. 455
8 *Hagan*, 1976, p. 157
9 Harlan to Dole, June 22, 1865, Indian Office, LS, 5:262, RG 48, NARA; in *Hagan*, 1976, p. 157
10 *Rudisill*, 1973, p. 55
11 Ibid., p. 28
12 Ibid., p. 63
13 *Hagan*, 1976, p. 158
14 *Prucha*, 1976, p. 194
15 *Hagan*, 1976, p. 159
16 Ibid.
17 *Utley and Washburn*, 1977, p. 330
18 *Hagan*, 1976, p. 160
19 Ibid., p. 161
20 SPC Apache 020614.00, SINAA
21 *Hagan*, 1976, p. 162
22 *Prucha*, 1964, p. 82
23 *Frink and Barthelmess*, 1965, p. 90
24 *Gray*, 1976, p. 10
25 *Frink and Barthelmess*, 1965, p. 90
26 Ibid., p. 134
27 *Utley and Washburn*, 1977, pp. 250–51
28 *Hagan*, 1976, p. 162
29 *Prucha*, 1976, p. 206
30 Ibid., pp. 202; 206
31 *Hagan*, 1976, p. 165
32 *Utley and Washburn*, 1977, p. 333
33 *Scott*, 1984, p. 26
34 *Prucha*, 1977, p. 202
35 *Hagan*, 1976, p. 159
36 *Prucha*, 1977, pp. 207–21
37 Personal communication, Cesare Marino to author (Fleming), 1985
38 File print 3421–B–2, SINAA
39 File print 3421–B–10, SINAA
40 *Flecky and Moore*, 1976, p. 27
41 *Rudisill*, 1973, p. 52
42 *Peterson*, 1971, p. 3
43 *Utley and Washburn*, 1977, pp. 238–39
44 *Center of The American Indian*, 1984, p. 2
45 *Prucha*, 1976, p. 272
46 Ibid., p. 274
47 Ibid., p. 276
48 Ibid., p. 282
49 *Malmsheimer* to Viola, 1982, SINAA
50 USNM, AR 1889, p. 110
51 *Prucha*, 1976, p. 288
52 *McBride*, 1970, p. 78
53 Ibid., p. 82
54 *Dolan*, 1977, pp. 17–20
55 *Prucha*, 1976, p. 318
56 Personal communication, John C. Ewers to author (Fleming), January 13, 1986

FIVE CAPTURING THE GOLDEN MOMENT

1 *Ostroff*, 1981, p. 8
2 *Goetzmann*, 1959, pp. 4–5
3 Ibid., pp. 4–21
4 *Goetzmann*, 1959, p. 22
5 *Marder and Marder*, 1982, pp. 18–19
6 *Preuss*, 1958, pp. 32–38
7 *Goetzmann*, 1966, pp. 244–48
8 *Goetzmann*, 1959, pp. 109–11
9 *Taft*, 1938, p. 261
10 *Goetzmann*, 1966, p. 289, pp. 326–28
11 *Taft*, 1938, p. 263
12 *Ostroff*, 1981, p. 12
13 MS 4285, SINAA
14 *Darrah*, 1977, p. 92
15 *Hayden*, 1863, p. 457
16 *Goetzmann*, 1959, p. 427
17 *Sampson*, 1869, p. 466
18 *Horan*, 1966, pp. 33–54
19 *Jackson*, 1940, pp. 44–69
20 MS 4410, SINAA
21 *Bartlett*, 1962, p. xiv
22 *Naef, Wood and Heyman*, 1975, pp. 5–52
23 *Bartlett*, 1962, pp. 127–28
24 *Sampson*, 1869, p. 285
25 *Bailey*, 1884, pp. 151–54
26 *Darrah*, 1977, p. 93
27 *Bartlett*, 1962, pp. 338–67
28 *Wheeler*, 1874, pp. 167–77
29 *Bartlett*, 1962, pp. 333–49
30 *Horan*, 1966, pp. 252–53
31 *Darrah*, 1977, p. 93
32 *Naef, Wood and Heyman*, 1975, p. 131
33 Ibid., p. 131
34 Ibid., p. 53
35 *Darrah*, 1977, p. 93
36 *Bartlett*, 1962, pp. 3–34
37 *Brayer*, 1949, vol. 1, pp. 196–97
38 *Jackson*, 1877, p. 76
39 Jackson to Fewkes, April 28, 1921, BAE LR, SINAA
40 Jackson to Holmes, April 21, 1890, BAE LR, SINAA
41 *Jackson*, 1940, pp. 186–251
42 *Bartlett*, 1962, pp. 285–96
43 *Porter*, 1969, p. 9
44 Zimmerman to Powell, December 16, 1870; February 23, 1871, LR Powell Geographical & Geological Survey Rocky Mountains, 1869–72, microfilm M156, Roll 11, NARA
45 *Darrah*, 1949, p. 491
46 *Powell, W. C.*, 1949, p. 273
47 Ibid., p. 496
48 *Dellenbaugh*, 1908, n.d.
49 *Powell, W. C.*, 1949, p. 396
50 *Jones*, 1949, p. 54
51 *Steward*, 1949, p. 206
52 *Bishop*, 1947, p. 184
53 MS 4410, SINAA
54 *Powell, W. C.*, 1949, p. 292
55 *Beaman*, 1874, p. 516
56 MS 4410, SINAA
57 *Powell, W. C.*, 1949, pp. 472–73
58 Ibid., p. 385
59 Ibid., p. 492
60 MS 4410, SINAA
61 *Darrah*, 1949, pp. 492–95
62 Wheeler, O. D. to Stevenson, M. C., September 16, 1903, LR BAE, SINAA
63 *Fowler*, 1962, p. 6
64 *Jackson*, 1874; 1877
65 MS 4410, SINAA
66 Ibid.
67 *Noelke*, 1974, pp. 28–32

68 *Horan*, 1966, p. 318
69 *Darrah*, 1949, p. 496
70 *Bartlett*, 1962, pp. 370–71
71 Ibid., p. 119
72 *Jones and Jones*, 1975, p. 2
73 *Bartlett*, 1962, pp. 14–15
74 *Jackson*, 1940, p. 215

SIX 'THE CULTURE OF IMAGINING'

1 *Benedict*, 1934, p. 1
2 *White*, 1949, pp. 15–16
3 *Sontag*, 1977, p. 93
4 *Blackman*, 1981, p. 45
5 *Moses*, 1984b, pp. 8–9
6 *Daniel*, 1967, pp. 216–17
7 *Hinsley*, 1981, p. 20
8 *Judd*, 1967, p. 12
9 Ibid., pp. 133–34
10 *Coe and Gates*, 1977, pp. 6–7
11 BAE, First AR
12 BAE, Second AR
13 BAE, Third AR
14 *Hinsley*, 1981, p. 196
15 BAE, Fourth AR
16 *Hinsley*, 1981, pp. 200–201
17 BAE, Eleventh AR
18 Ibid.
19 *Noelke*, 1974, p. 136
20 SI, AR 1879
21 SI, AR 1882
22 *Jacknis*, 1984, p. 4
23 *Mattison*, 1985
24 *Jacknis*, 1984, p. 5
25 *Mattison*, 1985
26 *Jacknis*, 1984, p. 6
27 *Mattison*, 1985
28 *McNickel*, 1972, p. 86
29 *Jacox*, 1985, pp. 18–23
30 *Moses*, 1984b, pp. 23–24
31 *Greenway*, 1969, pp. 152–53
32 Ibid.
33 *Underhill*, 1963, p. 257
34 *Moses*, 1984b, p. 53
35 *Moses and Szasz*, 1984a, p. 12
36 Mooney to Henshaw, LR BAE, January 19, 1891
37 Mooney to Henshaw, LR BAE, June 8, 1891
38 *Greenway*, 1969, p. 156
39 *Moses and Szasz*, 1984a, p. 13
40 *Colby*, 1978, p. 230
41 SI, AR 1894
42 SI, AR 1895
43 Ibid.
44 *Mahood*, 1961, p. 31
45 *Bigart and Woodcock*, 1979, p. 17
46 Ibid., p. 16
47 Mooney to Powell, LR BAE, October 20, 1898
48 BAE, Twenty-second AR; BAE, Twenty-third R AR
49 *Mahood*, 1961, p. 10
50 BAE, Twenty-fourth AR
51 Ibid.
52 *Judd*, 1967, pp. 26–29
53 *Jacknis*, 1984, p. 6

SEVEN GOVERNMENT STUDIOS

1 SI, AR 1873, p. 56
2 SI, AR 1875, p. 42
3 *Glenn*, 1983, p. 8
4 SI, AR 1882, p. 7
5 MS 4733, Dinwiddie to Powell, November 11, 1895, SINAA

6 SI, AR 1894, p. 55
7 Walther affidavit, 1903, NAA
8 MS 4733, Dinwiddie to Powell, November 11, 1895, SINAA
9 SI, AR 1897, p. 45
10 SI, AR 1898, p. 48
11 Gill autobiography, Artists File, National Portrait Gallery Library, Washington DC
12 *Glenn*, 1983, p. 8
13 BAE, Fifteenth AR, p. xxi
14 SI, AR 1902, p. 44
15 BAE, Twenty-sixth AR, p. xxviii
16 Ibid.
17 SI, AR 1902, p. 44
18 BAE, Twenty-sixth AR, p. xxviii
19 BAE, Twenty-fifth AR, p. xxi
20 Ibid.
21 *The Detroit Free Press*, August 22, 1915
22 Ibid.
23 *Daniel*, 1969, p. 4
24 *The Detroit Free Press*, August 22, 1915
25 USNM, AR 1917, p. 26
26 USNM, AR 1920, p. 63
27 *Glenn*, 1983, p. 21

EIGHT INDEPENDENT FRONTIER PHOTOGRAPHERS

1 *Taft*, 1938, p. 309
2 *Jackson*, 1947, p. vi
3 *Taft*, 1938, p. 309
4 *Grosscup*, 1975, p. 39
5 Ibid., p. 40
6 *Carvalho*, 1860, pp. 20–21
7 *Newhall*, 1976, p. 90
8 *Ostroff*, 1981, p. 19
9 *Daniels*, 1968, p. 177
10 *Jackson*, 1917, p. 177
11 *Taft*, 1938, p. 286
12 *Philadelphia Photographer*, vol. 3, no. 36, pp. 367–69
13 Ibid., vol. 3, no. 32, pp. 239–40
14 Ibid., vol. 3, no. 35, p. 339
15 Ibid.
16 Ibid., vol. 3, no. 36, p. 371
17 George Kirkland scrapbook, Library of State Historical Society of Colorado; in Mangan, 1975, pp. 39–41
18 Ibid., p. 46
19 *Webb and Weinstein*, 1973, p. 11
20 *Rathbone*, 1946, pp. 22–23
21 Ibid.
22 Ibid., p. 21
23 *Nye*, 1968, p. xi
24 *Cunkle*, 1979, p. 71
25 *Cunningham*, 1957, p. 55
26 *Moorhouse*, 1906
27 Montezuma to Holmes, July 10, 1905, LR BAE, SINAA
28 Kelly, Bernard, 'The Strange Story of Dr. Montezuma', *The Denver Post*, February 27, 1972
29 *Grosscup*, 1975, p. 49
30 Ibid., p. 45
31 *Cobb*, 1958, p. 130
32 Vintage Duplicates, under 'Shindler', SINAA
33 *Barry* (1882?)
34 *Wadsworth*, 1975, p. 122

NINE GRAND ENDEAVORS

1 *Witkin and London*, 1979, pp. 213–14
2 *Holm*, 1973, pp. 39–41
3 *Lyman*, 1982, pp. 37–60
4 *Johnston*, 1978, pp. 45–57
5 Bonaparte, SINAA Vertical File
6 *Dixon*, 1913, p. 206
7 *Reynolds*, 1966, pp. 1–30
8 *Deloria*, p. 12; in Lyman, 1982

BIBLIOGRAPHY

Adam, Chuck
1967 *C. C. Stotz, Photographer of Indians. Central States Archaeological Journal* 14(4): 154–57

Alinder, Jim and Don Doll
1976 *Crying for a Vision: A Rosebud Sioux Trilogy 1886–1976, Photographs by John A. Anderson, Eugene Buechel, S. J. and Don Doll, S. J.* Dobbs Ferry, N.Y.: Morgan & Morgan

Anderson, John Alvin
1896 *Among the Sioux.* Rosebud Agency, South Dakota: J. A. Anderson

Andrews, Ralph W.
1963 *Indians as the Westerners Saw Them.* Seattle: Superior Pub. Co.

Andrews, Ralph W.
1964 *Picture Gallery Pioneers 1850 to 1875.* Seattle: Superior Pub. Co.

Andrews, Ralph W.
1965 *Photographers of the Frontier West: Their Lives and Works 1875 to 1915.* NY: Bonanza Books

Bailey, W. Whitman
1884 'Recollections of the W. Humboldt Mountains.' *Appalachia* 4: Vol. 12

Barbre, Joy and Louis B. Casagrande
1982 *Side Trips: The Illustrated Adventures of Sumner Matteson. The Science Museum of Minnesota Encounters* 5(6): 7–9

Barry, David F.
[1882?] *D. F. Barry's Catalogue of Noted Indian Chiefs.* Bismarck, Dakota: David F. Barry

Barthelmess, Casey E. and Maurice Frink
1965 *Photographer on an Army Mule.* Norman: Univ. of Okla. Press

Bartlett, Richard A.
1962 *Great Surveys of the American West.* Norman: Univ. of Okla. Press

Beaman, E. O.
1874 'The Canon of the Colorado, and the Moquis Pueblos.' *Appleton's Journal* 11 (266–271): 513–16; 545–48; 591–93; 623–26; 641–44; 686–88

Beaton, Sir Cecil W.H. and Gail Buckland
1975 *Magic Image: The Genius of Photography from 1839 to the Present.* Boston: Little, Brown

Bell, William Abraham
1869 *New Tracks in North America.* N.Y.: Scribner, Welford & Co.

Belous, Russell E., and Robert A. Weinstein
1969 *Will Soule: Indian Photographer at Ft. Sill, Oklahoma 1869–74.* Los Angeles: Ward Ritchie Press

Bender, Norman J., ed.
1984 *Missionaries, Outlaws, and Indians: Taylor E. Ealy at Lincoln and Zuni, 1878–1881.* Albuquerque: Univ. of New Mexico Press

Benedict, Ruth
1934 *Patterns of Culture.* Boston: Houghton Mifflin, Co.

Bennett, H. H. Studio
1959 *The Beautiful Dells of the Wisconsin.* Wisconsin: H. H. Bennett Studio

Bigart, Robert, and Clarence Woodcock
1979 'The Trans-Mississippi Exposition of the Flathead Delegation.' *Montana, The Magazine of Western History* 29(4): 16–17

Bishop, Francis Marion
1947 'Capt. Francis Marion Bishop's Journal. Edited by Charles Kelly.' *Utah Historical Quarterly* 15(1–4): 159–238

Blackman, Margaret B.
1980 'Posing the American Indian: Early Photographers Often Clothed Reality in Their Own Stereotypes.' *Natural History,* 89(10): 68–74

Blackman, Margaret B.
1981 *Window on the Past: The Photographic Ethnohistory of the Northern and Kaigani Haida.* Ottawa: National Museums of Canada. (Revision of author's thesis, Ohio State Univ.)

Bourke, John Gregory
1891 *On the Border with Crook.* Chicago: Rio Grande Press

Bourns, Phillips M.
1982 'Matteson as Photographer.' *The Science Museum of Minnesota Encounters* 5(6): 12–13

Bourns, Phillips M. and Louis B. Casagrande
1983 *Side Trips: The Photography of Sumner W. Matteson 1898–1908.* Milwaukee: Milwaukee Public Museum and Science Museum of Minnesota

Bratley, Jesse Hastings
1962 *Teaching Indians of the Plains. Compiled by Winifred Reutter. Dakota Days.* Stickney, S. D.: Argus Printers

Brayer, Herbert Oliver
1949 *William Blackmore: The Spanish-Mexican Land Grants of New Mexico and Colorado 1863–1878,* vol. 1 of 2 vols. Denver: Bradford-Robinson

Brown, Dee Alexander
1970 *Bury My Heart at Wounded Knee.* N.Y.: Holt, Rinehart & Winston

Brown, Mark Herbert, and W. R. Felton
1955 *The Frontier Years: L. A. Huffman, Photographer of the Plains.* N.Y.: Henry Holt & Co.

Brown, Mark Herbert, and W. R. Felton
1956 *Before Barbed Wire, L. A. Huffman, Photographer on Horseback.* N.Y.: Henry Holt & Co.

Buckland, Gail and Sir Cecil W. H. Beaton
1975 *Magic Image: The Genius of Photography from 1839 to the Present.* Boston: Little, Brown

Bushnell, David I., Jr.
1925 'John Mix Stanley, Artist-Explorer.' *Smithsonian Report For 1924,* pp. 507–12. Washington: G.P.O.

Capps, Benjamin and the Editors of Time-Life Books
1973 *The Indians. The Old West Series.* N.Y.: Time-Life Books

Carley, Kenneth
1976 *The Sioux Uprising of 1862.* St Paul: Minn. Hist. Society

Carter, John E.
[1983?] *Photographers Listed in Nebraska Business Gazeteers 1879 Through 1917.* Lincoln: Neb. State Hist. Society

Carvalho, Solomon N.
1860 *Incidents of Travel and Adventure in the Far West with Col. Fremont's Last Expedition.* N.Y.: Derby & Jackson

Casagrande, Louis B., and Joy Barbre
1982 *Side Trips: The Illustrated Adventures of Sumner Matteson. The Science Museum of Minnesota Encounters* 5(6): 7–9

Casagrande, Louis B., and Phillips Bourns
1983 *Side Trips: The Photography of Sumner W. Matteson 1898–1908.* Milwaukee: Milwaukee Public Museum and Science Museum of Minnesota

Castles, Jean L.
1971 '"Boxpotapesh" of Crow Agency.' *Montana, The Magazine of Western History* 21(3): 84–93

Center of The American Indian
1984 *Making Medicine: Ledger Drawing Art from Fort Marion.* [Exhibition Sept. 16–Nov. 26, 1984] Okla. City: Center of the American Indian

Cobb, Josephine
1955 'Mathew B. Brady's Photographic Gallery in Washington.' Speech reprinted in *The Columbia Historical Society Records* (53–56): 3–44

Cobb, Josephine
1958 *Alexander Gardner. Image* 7(6): 124–36

Coe, Brian and Paul Gates
1977 *The Snapshot Photograph: The Rise of Popular Photography 1888–1939.* London: Ash & Grant

Colby, William Munn
1977 *Routes to Rainy Mountain: A Biography of James Mooney, Ethnologist.* Ph.D. diss., Univ. Wisconsin at Madison

Colnaghi, P. & D. & Co., Ltd.
1976 *Photography: The First Eighty Years.* London: P. & D. Colnaghi & Co.

Cosentino, Andrew J. and Henry H. Glassie
1983 *The Capital Image: Painters in Washington, 1800–1915.* Washington DC: Smithsonian Institution Press

Crawford, William
1979 *The Keepers of Light: A History and Working Guide to Early Photographic Processes.* Dobbs Ferry, N.Y.: Morgan & Morgan

Cunkle, Wendy
1979 *Winter & Pond: Pioneer Photographers in Alaska.* M.A. Thesis, San Francisco State Univ.

Cunningham, Robert E.
1957 *Indian Territory: A Frontier Photographic Record by W. S. Prettyman.* Norman: Univ. of Okla. Press

Current, Karen and William R. Current
1978 *Photography and the Old West.* N.Y.: Harry N. Abrams, in assoc. with the Amon Carter Museum of Western Art

Daniel, Forrest W.
1969 'Running Antelope – Misnamed Onepapa.' *Paper Money* 8(1): 4–9

Daniel, Glyn
1967 *The Origins and Growth of Archaeology.* N.Y.: Galahad Books: 216–17

Daniels, David
1968 'Photography's Wet-plate Interlude in Arizona Territory 1864–1880.' *The Journal of Arizona History* 9(4): 171–94

Darnell, Regna Diebold
1969 *The Development of American Anthropology 1879–1920: From the Bureau of American Ethnology to Franz Boas.* Ph.D. diss., Univ. of Pennsylvania. Ann Arbor: Univ. Microfilms

Darrah, William Culp
1949 'Beaman, Fennemore, Hillers, Dellenbaugh, Johnson, and Hattan.' *Utah Historical Quarterly* 17(1–4): 491–503

Darrah, William C.
1977 *The World of Stereographs.* Gettysburg: W. C. Darrah

Davidson, Carla
1979 'The View from Fourth and Olive.' *American Heritage* 31(1): 76–93

Dellenbaugh, Frederick S.
1908 *A Canyon Voyage.* N.Y.: G. P. Putnam's Sons

Deloria, Vine, Jr.
1982 Introduction. Christopher Lyman: *The Vanishing Race and Other Illusions: Photographs of Indians by Edward S. Curtis.* Washington, D.C.: Smithsonian Institution Press, 1982

DeMallie, Raymond
1981 'Scenes in the Indian Country: A Portfolio of Alexander Gardner's Stereographic Views of the 1968 Fort Laramie Treaty Council.' *Montana, The Magazine of Western History* 31(3): 42–59

Dinwiddie, William
1895–96 *Monthly Reports, November, December and January.* (MS 4733 SINAA, Washington DC)

Dixon, Joseph Kossuth
1913 *The Vanishing Race: The Last Great Indian Council.* Garden City, N.Y.: Doubleday, Page & Company

Dockstader, Frederick J.
1977 *Great North American Indians: Profiles in Life and Leadership.* N.Y.: Van Nostrand Reinhold Company

Dolan, Veronica
1977 'Life on the Reservation.' *The Denver Post.* Nov. 6, 1977, pp. 17–22

Doll, Don and Jim Alinder
1976 *Crying for a Vision: A Rosebud Sioux Trilogy 1886–1976, Photographs by John A. Anderson, Eugene Buechel, S. J. and Don Doll, S. J.* Dobbs Ferry, N.Y.: Morgan & Morgan

Donaldson, Thomas
1887 *The George Catlin Indian Gallery in the U.S. National Museum (Smithsonian Institution) with Memoir and Statistics* (from SI, AR 1885). Washington DC: GPO

Driggs, Howard R. and William Henry Jackson
1929 *The Pioneer Photographer.* Yankers on Hudson, N.Y.: World Book Co.

Dyck, Paul
1971 *Brulé: The Sioux People of the Rosebud.* Flastaff, Ariz.: Northland Press

Edkins, Diana E.
1974 *William H. Jackson.* Dobbs Ferry, N.Y.: Morgan & Morgan in association with Amon Carter Museum, Fort Worth, Texas

Evans, Susan
1981 'Henry Buehman: Tucson Photographer 1874–1912.' *History of Photography* 5(1): 59–81

Ewers, John Canfield
1949 'An Anthropologist Looks at Early Pictures of North American Indians.' *New York Historical Society Quarterly Bulletin* 32(4): 223–34

Ewers, John Canfield
1968 'Thomas M. Easterly's Pioneer Daguerreotypes of Plains Indians.' *Bulletin of the Missouri Historical Society* 24(4, pt 1): 329–39

Ewers, John Canfield
1976 'Artifacts and Pictures as Documents in the History of Indian-White Relations.' In *Indian-White Relations: A Persistent Paradox,* edited by Jame F. Smith and Robert M. Kvasnicka. Washington DC: Howard Univ. Press

F. Jay Haynes: *Fifty Views* [exhibition brochure]
[1981?] Helena, Mont.: Montana Hist. Society

Farr, William E.
1984 *The Reservation Blackfeet, 1882–1945: A Photographic History of Cultural Survival.* Seattle: Univ. of Wash. Press.

Felton, W. R. and Mark Herbert Brown
1955 *The Frontier Years: L. A. Huffman, Photographer of the Plains.* N.Y.: Henry Holt & Co.

Felton, W. R. and Mark Herbert Brown
1956 *Before Barbed Wire, L. A. Huffman, Photographer on Horseback.* N.Y.: Henry Holt & Co.

Fiske, Turbese Lummis and Keith Lummis
1975 *Charles F. Lummis, the Man and His West.* Norman: Univ. of Okla. Press

Flecky, Michael S. J. and Harold Moore
1976 *Photo Album: St Francis Mission, School, and Community 1886–1976.* St Francis, South Dakota: Rosebud Educational Society

Fowler, Don D., ed.
1972 *'Photographed All the Best Scenery': Jack Hiller's Diary of the Powell Expeditions, 1871–1875.* Salt Lake City: Univ. of Utah Press

Francis, Rell G.
1978 'Views of Mormon Country: The Life and Photographs of George Edward Anderson.' *The American West* 15(6): 14–29

Frink, Maurice and Casey E. Barthelmess
1965 *Photographer on an Army Mule.* Norman: Univ. of Okla. Press

Fryxell, Fritiof Melvin
1939 'William H. Jackson, Photographer, Artist, Explorer.' *American Annual of Photography,* Reprinted 1940 by U.S. Dept. of Interior

Galusha, Hugh D., Jr
1959 'Yellowstone Years, a Story of the Great National Park as Chronicled in Pictures, Words and Deeds by the Venerable House of Haynes.' *Montana, the Magazine of Western History* 9(3): 2–21

Gates, Paul and Brian Coe
1977 *The Snapshot Photograph: The Rise of Popular Photography 1888–1939.* London: Ash & Grant

Gilbert, George
1980 *Photography, The Early Years: A Historical Guide for Collectors.* N.Y.: Harper & Row

Glassie, Henry H. and Andrew J. Cosentino
1983 *The Capital Image: Painters in Washington, 1800–1915.* Washington DC: SI Press

Glenn, James R.
1981 'The "Curious Gallery": The Indian Photographs of the McClees Studio in Washington, 1857–1858.' *History of Photography* 5(3): 249–62

Glenn, James R.
1983 'De Lancey W. Gill: Photographer for the Bureau of American Ethnology.' *History of Photography* 7(1): 7–22

Glover, Ridgway
1866 'Photography Among the Indians.' *Philadelphia Photographer* 3(32): 239–40; 3(35): 339; 3(36): 367–69

Goetzmann, William H.
1959 *Army Exploration in the American West 1803–1863.* New Haven: Yale Univ. Press

Goetzmann, William H.
1966 *Exploration and Empire.* N.Y.: Knopf

Goodman, Theodosia Teel
1948 'Early Oregon Daguerreotypes and Portrait Photographers.' *Oregon Historical Quarterly* 49(1): 30–49

Gray, John S.
1978 *Itinerant Frontier Photographers and Images Lost, Strayed or Stolen. Montana, the Magazine of Western History* 28(2): 2–15

Griswold, Gillett
1959 *William S. Soule Photographs: A Preliminary Survey.* Ft. Sill, Okla.: U.S. Army Artillery and Missile Center Museum

Greenway, John
1978 *Folklore of the Great West.* Palo Alto, California: 152–56: American West Publishing Co.

Grosscup, Jeffrey P.
1975 'Stereoscopic Eye on the Frontier West.' *Montana, The Magazine of Western History* 25(2): 36–50

Grossmont College Development Foundation
1974 *Eugene Buechel, S.J.: Rosebud and Pine Ridge Photographs, 1922–1942.* (An exhibition prepared by Grossmont College Summer Photography Workshop in co-operation with the Buechel Memorial Lakota Museum in St Francis, S.D.) National City, Calif.: Crest Offset

Hagan, William T.
1976 'The Reservation Policy: Too Little and Too Late.' In *Indian-White Relations: A Persistent Paradox,* Jame F. Smith and Robert M. Kvasnicka, eds. Washington DC: Howard Univ. Press

Hamp, Sidford
1872 'Exploring the Yellowstone with Hayden, 1872: Diary of Sidford Hamp.' Edited by Herbert O. Brayer. *Annals of Wyoming* 14(4): 253–98

Harber, Opel
[1975] *Directory of Early Photographers 1853 through 1900.* In Mangan, 1975, *Colorado On Glass.* Denver: Sundance

Hayden, Ferdinand Vandiveer
1863 'Contributions to the Ethnography and Philology of the Indian Tribes of the Missouri Valley.' *Transactions of the American Philosophical Society* 12 n.s.: 231–461

Heski, Thomas M.
1978 *'Icastinyanka Cikala Hanzi': The Little Shadow Catcher, D. F. Barry, Celebrated Photographer of Famous Indians.* Seattle: Superior Pub. Co.

Heyman, Therese Thau, Weston J. Naef and James N. Wood
1975 *Era of Exploration: The Rise of Landscape Photography in the American West, 1860–1885.* Buffalo, N.Y.: Albright-Knox Art Gallery and the Metropolitan Museum of Art; distributed by New York Graphic Society, Boston

Hillers, John K.
1972 *'Photographed All the Best Scenery': Jack Hiller's Diary of the Powell Expeditions, 1871–1875.* Edited by Don D. Fowler. Salt Lake City: Univ. of Utah Press. [Orig. Hillers, diary is MS 4410, SINAA]

Hime, Humphrey Lloyd
1857–8 *Photographs taken at Lord Selkirk's Settlement (the Red River of the North.* MS. 4285, SINAA

Hinsley, Curtis M., Jr
1981 *Savages and Scientists: The Smithsonian Institution and the Development of American Anthropology 1846–1910.* Washington D.C.: Smithsonian Institution Press

Horan, James D.
1966 *Timothy O'Sullivan, America's Forgotten Photographer.* Garden City, N.Y.: Doubleday

Horse Capture, George
1977 *The Camera Eye of Sumner Matteson. Montana, The Magazine of Western History* 27(3): 48–61

Hurt, Wesley R., and William E. Lass
1956 *Frontier Photographer, Stanley J. Morrow's Dakota Years.* Vermillion: Univ. South Dakota

Huyda, R.
1973–4 *Exploration Photographer: Humphrey Lloyd Hime and the Assiniboine and Saskatchewan Exploring Expedition of 1858.* Transactions of the History and Science Society of Manitoba [Canada], Vol. 11 (30): 45–59

Jacknis, Ira
1984 *Franz Boas and Photographs. Studies in Visual Communication* 10(1): 2–60

Jacox, Elizabeth
1985 '"Cook, Photographer, and Friend": Jane Gay's Photographs, 1889–1892.' *Idaho Yesterdays* 28(1): 18–23

Jackson, Clarence S.
1947 *Picture Maker of the Old West: William H. Jackson.* N.Y.: Charles Scribner's Sons

Jackson, William Henry
1874 *Descriptive Catalogue of the Photographs of the United States Geological Survey of the Territories for the Years 1869 to 1873, Inclusive.* U.S. Department of Interior Miscellaneous Publication No. 5, 1st ed. only. Washington DC: G.P.O.

Jackson, William Henry
1877 *Descriptive Catalogue of Photographs of North American Indians.* U.S. Department of Interior Miscellaneous Publications No. 9. Washington DC: G.P.O.

Jackson, William Henry
1917 [Autobiography.] (Manuscript and Pamphlet file no. 394 of the USNM National Anthropological Archives, Smithsonian Institution, Washington DC)

Jackson, William Henry and Howard R. Driggs
1929 *The Pioneer Photographer.* Yonkers on Hudson, N.Y.: World Book Co.

Jackson, William Henry
1940 *Time Exposure: The Autobiography of William Henry Jackson.* N.Y.: G. P. Putnam's Sons

Jackson, William Henry
1959 *The Diaries of William Henry Jackson Frontier Photographer to California and Return, 1866–67; and With the Hayden Surveys to the Central Rockies, 1873, and to the Utes and Cliff Dwellings, 1874.* Edited by LeRoy Reuben Hafen and Ann W. Hafen. *Far West and Rockies Series*, vol. 10. Glendale, Calif.: Arthur H. Clark Co.

'John C. H. Grabill's Photographs of the Last Conflict
1984 Between the Sioux and the United States Military, 1890–1891.' *South Dakota History* 14(3): 222–37

'John Alvin Anderson, Frontier Photographer.'
1970 *Nebraska History* 51(4): 469–80

Johnston, Patricia Condon
1978 'The Indian Photographs of Roland Reed.' *The American West* 15(2): 44–57

Johnston, Patricia Condon
1980 'Truman Ingersoll: St. Paul Photographer Pictured the World.' *Minnesota History*, 47(4): 122–32

Jones, Stephen Vandiver
1949 'Journal of John F. Steward. Edited by William Culp Darrah.' *Utah Historical Quarterly* 16(1–4): 19–174

Jones, William C. and Elizabeth B. Jones
1975 *William Henry Jackson's Colorado.* Boulder, Colorado: Pruett Publishing Co.

Jones, William A.
1984 'A Naturalist's Vision: The Landscape Photography of Henry Wetherbey Henshaw.' *History of Photography* 8(3): 169–74

Judd, Neil
1967 *The Bureau of American Ethnology: A Partial History.* Norman: Univ. of Okla. Press

Kappler, Charles J., comp. & ed.
1904 *Indian Affairs, Laws and Treaties.* vol. 2, *Treaties.* Washington, DC: G.P.O.

Kelly, Fanny
1871 *Narrative of My Captivity Among the Sioux Indians.* Cincinnati: Wilstach, Baldwin & Co.

Kunhardt, Dorothy Meserve and Philip B. Kunhardt, Jr.
1977 *Mathew Brady and His World.* Alexandria, Va.: Time-Life Books

Kurutz, Gary F.
1978 '"Courtesy of Title Insurance and Trust Company": The Historical Collection at California Historical Society's Los Angeles History Center.' *California History* 57(2): 186–94

Kvasnicka, Robert M. and Jane F. Smith, eds.
1976 *Indian-White Relations: A Persistent Paradox.* Washington DC: Howard Univ. Press. (Papers and Proceedings of the National Archives Conference as Research in the History of Indian-White Relations, sponsored by National Archive and Records Service, June 15, 1972)

Kvasnicka, Robert M. and Herman J. Viola, eds.
1979 *The Commissioners of Indian Affairs, 1824–1977.* Lincoln: Univ. of Neb. Press

Lass, William E. and Wesley R. Hurt
1956 *Frontier Photographer, Stanley J. Morrow's Dakota Years.* Vermillion: Univ. South Dakota

London, Barbara and Lee D. Witkin
1979 *The Photograph Collector's Guide.* Boston: New York Graphic Society

Lyman, Christopher
1982 *The Vanishing Race and Other Illusions: Photographs of Indians by Edward S. Curtis.* Introduction by Vine Deloria, Jr. N.Y.: Pantheon Books; Washington DC: SI Press

MacEwan, Grant
1973 *Sitting Bull: The Years In Canada.* Edmonton, Alberta: Hurtig Pub.

Mahood, Ruth I.
1961 *Photographer of the Southwest: Adam Clark Vroman, 1856–1916.* Los Angeles: Ward Ritchie Press

Mangan, Terry William
1975 *Colorado On Glass: Colorado's First Half Century as Seen by the Camera.* Denver: Sundance

Marder, William, and Estelle Marder
1982 *Anthony: The Man, the Company, the Cameras.* [Plantation, Fla.]: Pine Ridge Pub. Company

Matteson, Sumner W.
1906 'The Fourth of July Celebration at Fort Belknap.' *Pacific Monthly* 16(1): 93–103

Mattison, David
1985 *Camera Workers: The British Columbia Photographers Directory 1858–1900.* Victoria, B.C.: Camera Workers Press

Mauer, Stephen G.
1985 'Frederick Hamer Maude: Photographer of the Southwest.' *Masterkey* 59(1): 12–17

McBride, Dorothy McFatridge
1970 'Hoosier Schoolmaster Among the Sioux.' *Montana, The Magazine of Western History* 20(4): 78–97

McClees, James E.
[1858] *Indian Catalogue: McClees' Photograph Gallery.* (In MS. 76–112, W. W. Turner papers, National Anthropological Archives, Smithsonian Institution, Washington DC)

McClintock, Walter
1949 'How It Was Possible to Make the Blackfoot Indian Collection.' *Yale University Library Gazette* 23(4): 159–74

McNickle, D'Arcy
1972 *The Emergent Native Americans.* Edited by Deward Walker, Jr. Boston: Little, Brown & Co.

Miller, Nina Hull
1962 *Shutters West.* Denver: Sage Books

Mitchell, Lee Clark
1982 *Witnesses to a Vanishing America: The Nineteenth-century Response.* Princeton: Princeton Univ. Press

Mitchell, Lynn
[1984?] 'George E. Trager: Frontier Photographer at Wounded Knee' (Unpublished papers of Dec. 1984; typescript in SINAA)

Moneta, Daniela P., ed.
1985 *Charles F. Lummis: The Centennial Exhibition, Commemorating His Tramp Across the Continent.* Los Angeles: Southwest Museum

Moore, Harold and Michael Flecky, S. J.
1976 *Photo Album: St Francis Mission, School, and Community 1886–1976.* St Francis, South Dakota: Rosebud Educational Society

Moorehouse, Lee (Maj.)
1906 *Souvenir Album of Noted Indian Photographs.* Pendleton, Oregon: Lee Moorhouse

Mora, Joseph Jacinto
1979 *The Year of the Hopi: Paintings and Photographs by Joseph Mora, 1904–06.* (An exhibition organized and circulated by Smithsonian Institution Traveling Exhibition Service, 1979–1981) N.Y.: Rizzoli

Moses, Lester George, and Margaret Connell Szasz
1984a 'Indian Revitalization Movements of the Later-Nineteenth Century.' *Journal of the West* 23(1): 5–15

Moses, Lester George
1984b *The Indian Man: A Biography of James Mooney.* Chicago: Univ. of Ill. Press

Moses, Lester George
1984c 'Wild West Shows, Reformers, and the Image of the American Indian, 1887–1914.' *South Dakota History* 14(3): 193–221

Mozley, Anita Ventura, ed.
1972 *Eadweard Muybridge: The Stanford Years. 1872–1882.* San Francisco: Stanford Museum of Art

Murray, Keith A.
1959 *The Modocs and Their War.* Norman: Univ. of Okla. Press

Museum of Modern Art New York
1966 *The Hampton Album: Forty-four Photographs by Frances Benjamin Johnston from an Album of Hampton Institute.* Garden City, N.Y.: Doubleday & Co.

Musick, James B.
1939 'Billy Bowlegs by Carl Wimar.' *Bulletin of the City Art Museum of Saint Louis* 24(1): 8–11

Musick, James B.
1942 'Three Sketch Books of Carl Wimar.' *Bulletin of the City Art Museum of Saint Louis* 27(1 & 2): 10–14

Naef, Weston J., James N. Wood, and Therese Thau Heyman
1975 *Era of Exploration: The Rise of Landscape Photography in the American West, 1860–1885.* Buffalo, N.Y.: Albright-Knox Art Gallery and The Metropolitan Museum of Art; distributed by New York Graphic Society, Boston

Newcombe, Barbara T.
1976 '"A Portion of the American People": The Sioux Sign a Treaty in Washington in 1858.' *Minnesota History* 45(3): 82–96

Newhall, Beaumont
1954 'Minnesota Daguerreotypes.' *Minnesota History* 34(1): 28–33

Newhall, Beaumont
1964 *The History of Photography from 1839 to the Present Day.* N.Y.: The Museum of Modern Art in collaboration with the George Eastman House, Rochester

Newhall, Beaumont, and Diana E. Edkins
1974 *William H. Jackson.* Dobbs Ferry, N.Y.: Morgan & Morgan in association with Amon Carter Museum, Fort Worth, Texas

Newhall, Beaumont
1976 *The Daguerreotype in America.* N.Y.: Dover Publications

Newhall, Beaumont
1982 *The History of Photography from 1839 to the Present.* N.Y.: The Museum of Modern Art; distributed by New York Graphic Society Books & Little, Brown & Co., Boston

Niehardt, John G.
1972 *Black El Speaks: Being the Life Story of a Holy Man of the Oglala Sioux.* N.Y.: Simon & Schuster

Noelke, Virginia
1974 *The Origin and Early History of the B.A.E., 1879–1910.* Ph.D. diss., Univ. of Texas, Austin. Ann Arbor: Univ. Microfilms

Nye, Wilbur Sturtevant
1968 *Plains Indian Raiders: The Final Phases of Warfare From the Arkansas to the Red River.* Norman: Univ. of Okla. Press

Oehser, Paul H.
1977 'De Lancey Gill (1859–1940).' *Cosmos Club Bulletin* 30(7–8): 4–8

O'Neil, Paul and the Editors of Time-Life Books
1979 *The End and the Myth.* The Old West Series. Alexandria, Va.: Time-Life Books

Ostroff, Eugene
1981 *Western Views and Eastern Visions.* (Exhibition and catalog circulated by Smithsonian Institution Traveling Exhibition Service) Washington DC: SITES

Packard, Gar, and Maggy Packard
1970 *Southwest 1880 with Ben Wittick Pioneer Photographer of Indian and Frontier Life.* Santa Fe: Packard Publications

Palmquist, Peter
1977 'Imagemakers of the Modoc War: Louis Heller and Eadweard Muybridge.' *Journal of California Anthropology* 4(2): 206–21

Palmquist, Peter E.
1978 'Photographing the Modoc Indian War: Louis Heller versus Eadweard Muybridge.' *History of Photography* 2(3): 187–205

Peterson, Karen Daniels
1971 *Plains Indian Art from Fort Marion.* Norman: Univ. of Okla. Press

Photographs of the Principal Chiefs of the North American
[1865] *Indians, taken when they have visited Washington as Deputations from their Tribes.* Salisbury, England: Trustees of the Blackmore Museum

Pilling, Arnold R.
[1975] *William Henry Jackson, an Anthropological Photographer in the Southwest.* SINAA, Washington DC Mimeo

Polito, Ronald
1983 *A Directory of Boston Photographers: 1840–1900.* 2nd ed. Boston: Univ. Mass. at Boston

Porter, Eliot, ed.
1969 *Down the Colorado: Diary of the First Trip through the Grand Canyon, 1869.* N.Y.: E. P. Dutton

Powell, John Wesley
1969 *Down the Colorado: Diary of the First Trip through the Grand Canyon, 1869.* Edited by Eliot Porter. N.Y.: E. P. Dutton

Powell, Peter John (Father)
1981 *People of the Sacred Mountain: A History of the Northern Cheyenne Chiefs and Warrior Societies, 1830–1879, With an Epilogue 1969–1974.* 2 vols. San Francisco: Harper & Row

Powell, Walter Clement
1949 'Journal of John F. Steward, Edited by William Culp Darrah.' *Utah Historical Quarterly* 17–18(1–4): 181–251

Preuss, Charles
1958 *Exploring with Fremont: The Private Diaries of Charles Preuss, Cartographer for John C. Fremont on His First, Second, and Fourth Expeditions to the Far West.* Trans. and ed. by Erwin G. Gudde, and Elisabeth K. Gudde. Norman: Univ. of Okla. Press

Priest, Loring Benson
1942 *Uncle Sam's Stepchildren: The Reformation of United States Indian Policy, 1865–1887.* New Brunswick: Rutgers Univ. Press

Prucha, Francis Paul (S. J.)
1964 *A Guide to the Military Posts of the United States 1789–1895.* Madison: The State Hist. Soc. of Wisc.

Prucha, Francis Paul (S. J.)
1976 *American Indian Policy in Crisis: Christian Reformers and the Indian, 1865–1900.* Norman: Univ. of Okla. Press

Prucha, Francis Paul (S. J.)
1977 *A Bibliographical Guide to the History of Indian-White Relations in the United States.* Chicago: Univ. of Chicago Press

Prucha, Francis Paul (S. J.)
1984 *The Great Father: The United States Government and the American Indians.* 2 vols. Lincoln: Univ. of Neb. Press

Rahill, Peter J.
1953 *The Catholic Indian Missions and Grant's Peace Policy.* Washington DC: Catholic Univ. of America Press

Rathbone, Perry T.
1946 'Charles Wimar: 1828–1862.' *Bulletin of the City Art Museum of Saint Louis* 31(2&3): 5–77

Rinehart, Frank A.
1900 *Rinehart's Prints of American Indians.* Omaha, Neb.: Frank A. Rinehart

Roark, Carol
1984 'Ed Irwin (William E. Irwin).' Biography in letter to author, Oct., 1984. Typescript

Roberts, Gary L.
1978 'In Search of Little Wolf ... A Tangled Photographic Record.' *Montana, The Magazine of Western History* 27(3): 48–61

Roberts, Gary L.
1978 'The Shame of Little Wolf.' *Montana, The Magazine of Western History* 28(3): 36–47

Ruby, Jay
1981 'Photographs of the Piegan by Roland Reed.' *Studies in Visual Communication* 7(1): 48–62

Rudisill, Richard
1971 *Mirror Image: The Influence of the Daguerreotype on American Society.* Albuquerque: Univ. of New Mexico Press

Rudisill, Richard
1973 *Photographers of the New Mexico Territory 1854–1912.* Albuquerque: Univ. Printing Plant, Museum of New Mexico

Rudisill, Richard
1975 *A Problem in Attribution.* (Treats problem of attribution of Jackson photos.) Author's files, SINAA, Washington DC Mimeo

Sampson, John
1869 'Photographs from the High Rockies.' *Harper's New Monthly Magazine* 29(33): 466–73

Scherer, Joanna Cohan
1975a 'Introduction: Pictures as Documents (Resources for the Study of North American Ethnohistory).' *Studies in the Anthropology of Visual Communication* 2(2): 65–66

Scherer, Joanna Cohan
1975b 'You Can't Believe Your Eyes: Inaccuracies in Photographs of North American Indians.' *Studies in the Anthropology of Visual Communication* 2(2): 67–79

Scott, John C. (O.S.B.)
1984 'To Do Some Good Among the Indians: Nineteenth Century Benedictine Indian Missions.' *Journal of the West* 23(1): 26–36

[Shindler, Antonio Zeno]
1867 *Photographic Portraits of North American Indians in the Gallery of the Smithsonian Institution* [wrong pub. date of 1867 on cover] in Smithsonian Miscellaneous Collections, 1876, vol. 14(216).
[1869]

Slemmons, Rod
1983 *Frank Fiske and Western Photography.* Bismarck: N.D. Heritage Foundation, Inc.

Smith, Jane F., and Robert M. Kvasnicka, eds.
1976 *Indian-White Relations: A Persistent Paradox.* Washington DC: Howard Univ. Press. (Papers and Proceedings of the National Archives Conference on Research in the History of Indian-White Relations, sponsored by National Archive and Records Service, June 15, 1972)

Smith, Margaret Denton, and Mary Louise Tucker
1982 *Photography in New Orleans: The Early Years, 1840–1865.* Baton Rouge: Louisiana State Univ. Press

Snell, Joseph W.
1958 'Some Rare Western Photography by Albert Bierstadt Now in the Historical Society Collections.' *The Kansas Historical Quarterly* 24(1): 1–5

Sontag, Susan
1977 *On Photography.* N.Y.: Ferrar, Strauss & Gioroux

Steward, John F.
1949 'Journal of John F. Steward. Edited by William Culp Darrah.' *Utah Historical Quarterly* 17–18(1–4): 181–251

Stewart, Julian H.
1939 *Notes on Hillers' Photographs of the Paiute and Ute Indians Taken on the Powell Expedition of 1873.* Smithsonian Miscellaneous Collections, vol. 98, no. 18. Washington DC: G.P.O.

Stone, Elizabeth Arnold
[1924] *Uinta County: Its Place in History.* Glendale, Calif.: Arthur H. Clark Co.

Szasz, Margaret Connell and Lester George Moses
1984 *The Indian Man: A Biography of James Mooney.* Chicago: Univ. of Ill. Press

Taft, Robert
1934 'A Photographic History of Early Kansas.' *Kansas Historical Quarterly* 3(1): 3–14

Taft, Robert
1937 'Additional Notes on the Gardner Photographs of Kansas.' *Kansas Historical Quarterly* 6(2): 175–77

Taft, Robert
1938 *Photography and the American Scene: A Social History, 1839–1889.* N.Y.: Macmillan Co. [Reprinted 1964, Dover Pub.]

Taylor, Colin
1975 *The Warriors of the Plains.* N.Y.: Hamlyn

Thompson, Erwin N.
1971 *Modoc War: Its Military History and Topography.* Sacramento: Argus Books

Tilden, Freeman
1964 *Following the Frontier with F. Jay Haynes: Pioneer Photographer of the Old West.* N.Y.: Knopf

Tucker, Mary Louise and Margaret Denton Smith
1982 *Photography in New Orleans: The Early Years, 1840–1865.* Baton Rouge: Louisiana State Univ. Press

Ulke, Titus
1937 *Life and Works of the Portrait-Painter, Henry Ulke (1821–1910).* (Typescript in vertical file, National Portrait Gallery Library, SI, Washington DC)

Underhill, Ruth
1965 *Red Man's Religion.* Chicago: Univ. of Chicago Press

Utley, Robert M.
1963 *The Last Days of the Sioux Nation.* New Haven: Yale Univ. Press

Utley, Robert M.
1973 *Frontier Regulars: The United States Army and The Indian, 1866–1891.* N.Y.: Macmillan Co.

Utley, Robert M., and Wilcomb E. Washburn
1977 *The American Heritage History of the Indian Wars.* N.Y.: American Heritage Pub. Co.

Van Ravenswaay, Charles
1953 'The Pioneer Photographers of St. Louis.' *Bulletin of the Missouri Historical Society* 10(1): 48–71

Van Valkenburgh, Richard
1942 'Ben Wittick: Pioneer Photographer of the Southwest.' *Arizona Highways* 18(8): 36–39

Viola, Herman J.
1976 *The Indian Legacy of Charles Bird King.* Washington DC: Smithsonian Institution Press

Viola, Herman J.
1981 *Diplomats in Buckskins: A History of Indian Delegations in Washington City.* Washington DC: Smithsonian Institution Press

Viola, Herman J.
[c. 1981] [Notes relating to Indian Delegations] (Manuscript in SINAA)

Viola, Herman J. and Robert M. Kvasnicka, eds. *The Commissioners of Indian Affairs, 1824–1977.* Lincoln: Univ. of Neb. Press

Vyzralek, Frank E.
1971 'Down the Missouri in 1918: A Photographic Journey with Frank Fiske.' *North Dakota History* 38(4): 502–17

Vyzralek, Frank
1983 *Frank Bennett Fiske.* Bismarck: North Dakota Heritage Foundation

Wadsworth, Nelson B.
[1975] *Through Camera Eyes.* Provo, Utah: Brigham Young Univ. Press

Washburn, Wilcomb E.
1973 *The American Indian and the United States: A Documentary History.* 4 vols. N.Y.: Random House

Washburn, Wilcomb E. and Robert M. Utley
1977 *The American Heritage History of the Indian Wars.* N.Y.: American Heritage Pub. Co.

Watson, Elmo Scott
1948 'Photographing the Frontier.' *The Westerner's Brandbook,* 4(11): 61–68

Watson, Elmo Scott
1949 'Local Man Took First Picture of Sitting Bull in 1881.' *Bismarck Tribune,* May 12, 1949

Watson, Elmo Scott
1962 'Orlando Scott Goff, Pioneer Dakota Photographer.' *North Dakota History* 29(1 and 2): 210–15

Webb, William and Robert A. Weinstein
1973 *Dwellers at the Source: Southwestern Indian Photographs of A. C. Vroman, 1895–1904.* N.Y.: Grossman Publishers

Weinstein, Robert A.
1978 'Silent Witnesses'. *G. Ray Hawkins Gallery PhotoBulletin,* 1(4).

Weinstein, Robert A., and Russell E. Belous
1966 'Indian Portraits: Fort Sill, 1869.' *The American West* 3(1): 50–63

Weinstein, Robert A., and Russell E. Belous
1969 *Will Sonte: Indian Photographer at Ft. Sill, Oklahoma 1869–74,* Los Angeles: Ward Ritchie Press

Wheeler, George Montague
1874 *Progress Report Upon Geographical and Geological Explorations and Surveys West of the One Hundredth Meridian.* Washington DC: G.P.O.

Wheeler, George Montague
1875 *Report Upon United States Geographical and Geological Explorations and Surveys West of the One Hundredth Meridian, vol. 3, Geology.* Washington DC: G.P.O.

Wheeler, George Montague
1889 *Report Upon United States Geographical Surveys West of the One Hundredth Meridian, vol. 1, Geographical Report.* Washington DC: G.P.O.

Wheeler, George Montague
1983 *Wheeler's Photographic Survey of the American West, 1871–1873. With 50 Landscape Photographs by Timothy O'Sullivan and William Bell.* N.Y.: Dover

Wheeler, Keith, and the Editors of Time-Life Books
1976 *The Chroniclers.* The Old West series. N.Y.: Time-Life Books

Wheeler, Keith, and the Editors of Time-Life Books
1978 *The Scouts.* The Old West series, Alexandria, Va.: Time-Life Books

White, Helen McCann
1981 '"His World Was Art," Dr Andrew Falkenshield.' *Minnesota History* 47(5): 184–88

White, Leslie
1949 *The Science of Culture.* N.Y.: Farrar, Straus & Giroux: 15–16

Wilks, Claire Weissman
1980 *The Magic Box: The Eccentric Genius of Hannah Maynard, Photographer, 1834–1918,* Canada. Toronto: Exile Editions Ltd

Williams, Bradley, B.
1981 'Charles F. Lummis: Crusader with a Camera.' *History of Photography* 5(3): 207–21

Wilson, Joseph M.
1883 *A Eulogy on the Life and Character of Alexander Gardner, Delivered at a Stated Communication of Lebanon Lodge, No. 7, F.A.A.M., Jan. 19, 1883.* Washington DC: Beresford

Wissler, Clark
1923 *Man and Culture.* N.Y.: Thomas Y. Crowell

Witkin, Lee D. and Barbara London
1979 *The Photograph Collector's Guide.* Boston: New York Graphic Society

Wood, James N., Therese Thau Heyman and Weston J. Naef
1975 *Era of Exploration: The Rise of Landscape Photography in the American West, 1860–1885.* Buffalo, N.Y.: Albright-Knox Art Gallery and The Metropolitan Museum of Art; distributed by New York Graphic Society, Boston

Woodcock, Clarence, and Robert Bigart
1979 'The Trans-Mississippi Exposition of the Flathead Delegation.' *Montana, The Magazine of Western History* 29(4): 16–17

PICTURE CREDITS

Note: Negative numbers are given in brackets following plate numbers.

Amon Carter Museum: 1.1 (79.38)

Colorado Historical Society: 3.9 (834-WPA)

From the collection of Gail Dane Gomberg Propp: 2.8

Kansas State Historical Society: 1.3 (FO5); 3.23; 5.4

Library of Congress, Washington DC: 5.2 (10730; 262-9065); 9.1 (10731/K2-91)

Minnesota Historical Society: 3.7; 3.8

National Archives and Records Administration: 2.9 (111-B-4669); 3.22 (111-SC-82964); 4.2 (111-SC-87964); 5.6; 5.10; 5.19; 5.42 (57-PS-809-213)

National Museum of American Art: 2.3 (Catlin 474)

Princeton University Library, Western Americana, Sheldon Jackson Collection: 4.27 (50); 4.28 (72)

Seaver Center for Western History Research, Los Angeles County Museum of Natural History: 8.10

Smithsonian Institution National Anthropological Archives: 1.2 (85-12,590); 1.4 (741-A); 1.5 (498-D); 2.1 (3243-A-1); 2.2 (2860-ZZ-21); 2.4 (240-A); 2.5 (196); 2.6 (3671-B-5); 2.7 (3108); 2.10 (3505-B); 2.11 (3566-A); 2.12 (3509-A); 2.13 (3632); 2.14 (79-4274); 2.15 (3471); 2.16 (3545-A); 2.17 (3635); 2.18 (3135-C); 2.19 (3572); 2.20 (77-13,305); 2.21 (3686); 2.22 (691-B); 2.23 (1079); 2.24 (3120-A); 2.25 (3132-B); 2.26 (3121); 2.27 (3431-B); 2.28 (3419); 2.29 (source print 4420 v. 6; SPC 01 0091.00); 2.30 (2906); 2.31 (3307-C); 2.32 (3179-C); 3.1 (47,000); 3.2 (3485-D); 3.3 (43,631); 3.4 (3508); 3.5 (456); 3.6 (3469); 3.10 (2860-S-2); 3.11 (2860-W); 3.12 (3052-B); 3.13 (86-4130); 3.14 (84-5680); 3.15 (3051-B); 3.16 (3054-A); 3.17 (56,496); 3.18 (56,497); 3.19 (78/545); 3.20 (3711-N-2); 3.21 (56,193); 3.24 (75-8315); 3.25 (43,003-A); 3.26 (2575-F); 3.27 (43,003-B); 3.28 (75-8303); 3.29 (3200-B-15); 3.30 (3200-B-10); 3.31 (55,018); 3.32 (47,685-B); 3.33 (3200-B-1); 3.34 (3200-B-7); 3.35 (86-4131); 3.36 (86-4134); 3.37 (86-4133); 3.38 (86-4132); 3.39 (42,827); 4.1 (56,472); 4.3 (56,519); 4.4 (45,479-F); 4.5 (996-G-2); 4.6 (56,630); 4.7 (56,092); 4.8 (1063-F-2); 4.9 (76-6091); 4.10 (2575-i); 4.11 (75-8290); 4.12 (2575-J); 4.13 (43,005-B); 4.14 (2860-V-8); 4.15 (56,539); 4.16 (81-2171); 4.17 (72-514); 4.18 (38,583-C); 4.19 (3421-B-2); 4.20 (3649-B-2); 4.21 (2517-A); 4.22 (55,054); 4.23 (MHT 60,753); 4.24 (55,517); 4.25 (55,516); 4.26 (2251-D-2); 4.29 (53,502); 4.30 (53,378); 4.31 (53,380); 4.32 (53,374); 4.33 (53,372-B); 4.34 (53,340-C); 4.35 (53,413-C); 4.36 (78-2944); 4.37 (1169-N); 4.38 (72-496); 4.39 (56,280); 4.40 (56,258); 4.41 (75-10,326); 4.42 (4644); 5.1 (Coll. 78); 5.3 (Coll. 78); 5.5 (Coll. 78); 5.7 (Coll. 78); 5.8 (Coll. 78); 5.9 (Coll. 78); 5.11 (Coll. 78); 5.12 (Coll. 78); 5.13 (Coll. 78); 5.14 (Coll. 78); 5.15 (Coll. 78); 5.16 (Coll. 78); 5.17 (34,068D); 5.18 (34,068B); 5.20 (1713); 5.21 (1668); 5.22 (1663-A); 5.23 (1245-B); 5.24 (56,528); 5.25 (Hayden 9-B); 5.26 (1506); 5.27 (1827A); 5.28 (1841C); 5.29 (1712-A); 5.30 (Hayden 1); 5.31 (Hayden 7); 5.32 (Hayden SIA-7); 5.33 (1535); 5.34 (2395); 5.35 (1623); 5.36 (1592a); 5.37 (1653); 5.38 (1654); 5.39 (1599); 5.40 (1613-A-1); 5.41 (1632); 5.43 (1591); 5.44 (1636); 5.45 (1662-a); 5.46 (264); 6.1 (2145); 6.2 (2355); 6.3 (2267-E); 6.4 (2267A); 6.5 (2382); 6.6 (Portrait 22E); 6.7 (78-12,294); 6.8 (49,389-A); 6.9 (86-4099); 6.10 (1807A); 6.11 (1825A); 6.12 (1835A); 6.13 (2064); 6.14 (Arizona 120); 6.15 (1846); 6.16 (1817-A-5); 6.17 (2432); 6.18 (2189); 6.19 (2374); 6.20 (1983C); 6.21 (42,189-E); 6.22 (2107); 6.23 (2372-A-4); 6.24 (81-9625); 6.25 (2981-A); 6.26 (4459); 6.27 (1008); 6.28 (1044-B); 6.29 (55,298); 6.30 (1034-A-1); 6.31 (81-9626); 6.32 (1655-A); 6.33 (1659-A-1); 6.34 (56,782); 6.35 (1659-C); 6.36 (57,062); 6.37 (2458-F); 6.38 (2433); 6.39 (1878-B); 6.40 (79-8493); 6.41 (2412); 6.42 (1824-D); 6.43 (83-9704); 6.44 (86-4100); 6.45 (1426-A); 6.46 (4117); 6.47 (38,582-D); 6.48 (SI-3946); 6.49 (42,977A); 6.50 (4262); 6.51 (4277-A-1); 6.52 (4289-A-1); 7.1 (303-B); 7.2 (73-9466); 7.3 (3184-A); 7.5 (893); 7.6 (3834-A-1); 7.7 (3834-A-2); 7.8 (3461-A); 7.9 (3648-A); 7.10 (581-B-1); 7.11 (581-B-2); 7.12 (3115-B); 7.13 (3793-A); 7.14 (2969-A); 7.15 (1760-C); 7.16 (3159-A); 7.17 (56,072); 7.18 (2913-B); 7.19 (2506-B); 7.20 (3195-D-2); 8.1 (46,736-C); 8.2 (56,523); 8.3 (86-4102); 8.4 (74-3623); 8.5 (56,942); 8.6 (43,201-A); 8.7 (84-16,042); 8.8 (617); 8.9 (56,538); 8.11 (32,357); 8.12 (44,258); 8.13 (54,630); 8.14 (42,975-A); 8.15 (56,651); 8.16 (55,781); 8.17 (3656-B); 8.18 (3661-E); 8.19 (3189-B-10); 8.20 (55,719); 8.21 (85-13,352); 8.22 (1564); 8.23 (75-5659); 8.24 (56,720); 8.25 (43,114-A); 8.26 (3179-B-6); 8.27 (76-15,144); 8.28 (56,608); 8.29 (1911); 8.30 (2987-B-12); 8.31 (76-13,466); 8.32 (56,955); 8.33 (45,480-G); 9.2 (3696-E-172-B); 9.3 (75-11252); 9.4 (76-15853); 9.5 (75-11253); 9.6 (86-4103); 9.7 (83-9383); 9.8 (86-4101); 9.9 (86-4098); 9.10 (76-3396); 9.11 (86-2842); 9.12 (4703); 9.13 (4704); 9.14 (4710); 9.15 (4712); 9.16 (4711); 9.17 (47,702E); 9.18 (47,702B); 9.19 (47,704K); 9.20 (83-7809); 9.21 (83-7851); 9.22 (83-7759); 9.23 (83-7744); 9.24 (83-7819); 9.25 (83-7738)

Smithsonian Institution National Numismatic Collection: 7.4 (86-4812)

INDEX

Page numbers in *italic* refer to the illustrations